# The
# BLUFFER'S
# GUIDE

## Bluff your way in

ANTIQUES    Interior Decorating

Gourmet Cooking    THE THEATRE

FOOTBALL    TRAVELING

# The
# BLUFFER'S
# GUIDE

## SECOND SERIES

### Introduced by

# David Frost

Know your jargon and hold your own in any company

## Bluff your way in

ANTIQUES     Interior Decorating

Gourmet Cooking     THE THEATRE

FOOTBALL     TRAVELING

## INSTANT ERUDITION

© 1972 by Bluffer's Guides, Inc.

Library of Congress Catalog Card Number: 72-85694

ISBN: 0-517-500442

Printed in the United States of America

Published simultaneously in Canada by General Publishing Company Limited

# CONTENTS

# The BLUFFER'S GUIDE

Bluff your way in

ANTIQUES        Interior Decorating
Gourmet Cooking  THE THEATRE
FOOTBALL        TRAVELING

# The BLUFFER'S GUIDE to FOOTBALL

by **JOE SINGER**

Introduced by **DAVID FROST**

# INTRODUCTION

IN A NUMBER of respects football can be likened to that other great sport, politics.

Behind the scenes there are the coaches, or the party managers, working incessantly to make sure that every strategy has been considered and planned to perfection. Then there are the quarterbacks, the campaign managers if you like, calling the moves in the public arena itself, pitching their players, or delegates, into brutalizing conflict with their opponents . . . and in America, of course, the opponents would usually be Democrats and Republicans, though recently the opponents do seem to have been Democrats and Democrats . . . and all of this has but one intent that one man should cross the line to victory.

In one crucial respect though football does differ from politics: in football the man carries or kicks a bag of wind across the line; in politics the man who makes the winning move is frequently the bag of wind.

Actually this little book has already proved invaluable to me, because if I pressed I would have to admit that I probably don't know as much about American football as I do about cricket. . . . I've had some great conversations with superstars like Johnny Unitas, and I know from the times I've spent with him that Alex Karras is a very funny man. In fact, I should imagine that in his heyday with the Detroit Lions, if he wasn't able to prevent an attack physically, which I understand was very rare indeed, then he could always get off a couple of quick lines that would be enough to break anybody up.

And then, of course, there's that other great sportsman, Joe Namath. And they tell me he's a pretty good footballer as well.

But without this book I would never have realized, for instance, that the slant running play means that the ball carrier takes the hand off and runs at a slant, or at an angle, through the line of scrimmage. The difference between this and the cross buck (Question: Is a cross buck ever an angry dollar?) is that in the cross buck the

11

ball carrier merely hits the opposite side of the line, then continues in a straight direction which, on the slant run, he continues running on a slanting direction.

I'm not sure that I understand it but the point is that I would never have realized it and people look at you with a new respect when you drop that little tidbit into a Monday morning quarterbacking session . . . and if you reveal that you know what a quarterback sneak is—not a player who runs and tells tales about what the other players are up to in their hotel rooms when they are playing out of town—then you're in the Presidential class when it comes to handing out advice.

Of course, in Britain the great game is soccer, which for some reason or another never really caught on here. It's a game I love, in fact, I almost became a professional soccer player when I was eighteen. It's not as overtly a violent game as American football; the pressures and the plays tend to be a little more subtle. For instance, in soccer, if you haven't seen it, you are allowed to kick the ball and not head the ball, but touching it with the hand is a no-no, as they say, and I remember fondly two opposing players standing next to each other, waiting for the ball to come in their direction and just as they were about to move, one said to the other, "Hey, what's this I hear about this terrific new girl you've started going with?" The other man started to say, "What girl . . ." But it was too late. The first player had got the ball and scored a goal.

Enjoy this little book and inwardly digest. Because one day, you never know, you might meet Howard Cosell, and thanks to what you'll learn from these pages he's going to call you "Sir."

DAVID FROST

# FOREWORD

NOT TOO LONG AGO, when Americans still reveled in the grand self-delusion that we are a uniformly God-fearing, patriotic, clean-living, law-abiding people, baseball was commonly referred to and acknowledged as the National Pastime. Baseball suited the simplistic, parochial concept we had of ourselves. Its languid rituals connoted visions of Casey at the bat; of strawhatted, shirt-sleeved men sipping beer in sun-drenched bleachers; of little boys in torn overalls sliding into home plate on empty lots.

But like many other nostalgic myths this one too exploded in our faces in the social and cultural revolution of the sixties and seventies. We realized with shock and horror that America wasn't the homogeneous paradise of Norman Rockwell and Walt Disney, but a turbulent, seething society stirred by racial and class conflicts, by deep-rooted frustration, resentments, doubts, and disillusionment. To suit these fast-moving decades, a new spectator sport was needed. Baseball, with its torpid pace and antiquarian impedimenta, no longer fulfilled our emotional needs. Obviously, stronger fare was decreed to sate the growing American hunger for speed, scope, and violence. Basketball offered speed, but not the violence. Hockey, the speed and violence, but not the scope. Boxing had degenerated into a farce. Soccer, a sport that did offer these three requisites, somehow never caught on here. The Roller Derby did to some degree, yet it has remained a fringe entertainment.

What was left? Football.

Americans had been enamored of football since the 1890s, but it had remained essentially a local activity. Great rivalries had evolved in a number of states, counties, and communities, but outside of the Rose Bowl, the Army-Navy game, and several similar well-publicized events, there was limited interest in football on a *national* level. Then along came professional football and television.

Almost overnight, millions of American men, women, and children found something exciting to fill their Sunday afternoons. Football fans proliferated at a rate to ignite a spark in the eyes of network

executives. Astronomical sums were paid to peddle beer, cheese, and automobiles during time-outs. American bookies began to place orders on Lincoln Continentals and Swiss boarding schools for their daughters as millions learned the intricacies of the point spread. Football had arrived with a whoop and a holler, and in every corner tavern, on every construction gang, in executive meetings and country clubs men spoke knowledgeably of screen passes, safety blitzes, and shotgun formations. Boys in midwestern schoolyards, on city streets, and in suburban parks forgot Harmon Killebrew, Willie Mays, and Johnny Bench, and dreamed of becoming a second Joe Namath, Lance Alworth, or Dick Butkus.

But as with every effort from child-raising to swine husbandry, the terminology of football began to expand as experts, pseudo-experts, critics, psychologists, social commentators, and housewives launched the great American custom of probing, analyzing, dissecting, and classifying. Americans are never satisfied until they have picked a subject to its very bones and laid its guts bare, and a bewildering literature and mystique evolved concerning what is essentially a simple enterprise—carrying or kicking a bag of wind across a chalked line.

This volume, then, is designed to make you more comfortable in the Sea of Semantics surrounding football, so that the next time you find yourself at a gathering and some half-baked Monday quarterback hits you with a "belly series" or a "safety blitz" or a "trailing guard," you can pin back his ears and verbally stomp him into the ground. It won't teach you so much about the art of football as it will about the art of guile and deception, but isn't this what football is all about in the first place?

# HOW IT ALL BEGAN

IN ORDER TO BLUFF MEANINGFULLY in any subject, the practitioner must be able to dredge up obscure, little-known facts that will bewilder and throw his opponent off balance. It would, therefore, pay to commit as much of such trivia to memory, so that the next time there's a lull in the conversation, you can turn the conversation with the fact that the first more-or-less structured football game in America was played between Princeton and Rutgers in New Brunswick, New Jersey, on November 6, 1869, Rutgers winning 6–4.

After they have recovered from this tidbit, hit them with another. The early football teams didn't have a definite number of players—this could vary from fifteen to twenty-five. More trivia. It wasn't until the 1880s that eleven-man teams became more or less *de rigueur*. It wasn't until 1912 that the touchdown became worth six points.

It was around this time that modern football, more or less as we know it today, evolved. The forward pass had been introduced as a legal offensive weapon, and as any good fan remembers was used effectively by the Fighting Irish of Notre Dame against the frustrated Army team of 1913. The passer was Gus Dorais, the receiver—no one else than Knute Rockne.

A few such facts are guaranteed to spice up a football conversation—too many will tend to spoil the broth.

You might throw in the fact that the first *professional* football game in this country was played between Latrobe, Pennsylvania, and Jeannette, Pennsylvania, in Latrobe, on August 31, 1895, and that the hometown team won by a score of 12–0.

Now, it is most important for a dedicated bluffer to be able to bandy about names. Here are some good ones from that early era of football: Pudge Heffelfinger who played for Yale; Dr. Jon Brallier, one of the first "professional" players; Fielding Yost, an early player; Pop Warner, a player and later a prominent coach, and, of course, the fabulous Jim Thorpe, the ill-starred Indian athlete.

It's also not a generally known fact that Connie Mack, the pioneer owner and manager of the Philadelphia Athletics baseball team,

also organized and coached a professional football team bearing the very same name.

Walter Camp was an early player, then a coach at Yale. It was he who launched the term "All-America" back in the late 1880s and took it upon himself to make the selections for this singular honor. Appropriately enough, many of the early All-Americans were Yalies.

An excellent gambit is to announce the name of the first player in professional football to juggle bids from three different teams. His name was Billy Heston, and he showed the way for the gridders of the 1960s who played the AFL against the NFL until the two merged. Like many other eagerly sought college stars, he was a spectacular flop in pro football.

Speaking about football history, the alert bluffer will also score valuable points by sneaking in some nostalgic references to the Flying Wedge, which would fit beautifully into today's effort by owners and television programmers to inject more action and spectator appeal into the sport. In this dainty maneuver, ten beefy gentlemen seized each other's pants and thus interlocked, sailed spiritedly down the field ahead of a ballcarrier like some rock-ribbed Roman phalanx leaving havoc and destruction in its wake.

In 1920 the National Football League was formed (under another name) and such vulgar and unmannerly tactics would never again be tolerated, would they? The league even then was firmly dedicated to the principle that football was, in the words of its current commissioner, Pete Rozelle, a "science," not a free-for-all for a bunch of roughnecks who played the game merely for its enjoyment.

# RAH, RAH, RAH FOR DEAR OLD IOWA . . .

IT SHOULD BE AFFIRMED right here and now that no sincere football bluffer takes any interest whatsoever in collegiate or high-school football. This is left to primitive chauvinists who take pride in some local institution, to parents of boys who play for same institution, to aunts, uncles, cousins, and girl friends, and to scouts and directors of player

personnel for professional teams who sift the gridirons of amateuria for potential diamonds in the rough.

To a bluffer, football means professional football, nothing else.

# PLAY FOR PLAY

AS A NATION firmly dedicated to the profit system, we are a people who bear utter contempt for amateurs and who venerate professionalism. The term "amateur" somehow conjures up visions of dilettantism, frivolousness, and la-de-da-ism. Our Calvinist tradition has inculcated us with the notion that only when one is paid for one's efforts does this effort constitute a worthwhile and laudable enterprise. This concept carries over into football. We revere those men who earn the most money in the profession; we scoff at those who either cannot or will not become paid gladiators in one of history's more brutal sports.

A good football bluffer uses the word "pro" or "professional" as a supreme compliment for those who bleed and maim for the Almighty Dollar.

# THE ESTABLISHMENT

PROFESSIONAL FOOTBALL means the National Football League. There have been abortive efforts to launch other leagues—most notably, the Continental League, and there has long existed a Canadian Football League which has different rules and less expensive players, but to all intents and purposes the National Football League is it.

The only league to challenge the National successfully was the American Football League. At first the NFL ignored the upstart. In the end, when the child grew too bumptious, it absorbed it.

As of today there are twenty-six teams in the combined NFL—thirteen each in the American, and the National Football Conferences. They are further split up into divisions. This is how it all

looks on paper, subject to change from year to year as the owners' pocketbooks decree.

### AMERICAN FOOTBALL CONFERENCE

**CENTRAL DIVISION**

Cincinnati Bengals
Cleveland Browns
Houston Oilers
Pittsburgh Steelers

**WESTERN DIVISION**

Denver Broncos
Kansas City Chiefs
Oakland Raiders
San Diego Chargers

**EASTERN DIVISION**

Baltimore Colts
Buffalo Bills
Miami Dolphins
New England Patriots
New York Jets

### NATIONAL FOOTBALL CONFERENCE

**CENTRAL DIVISION**

Chicago Bears
Detroit Lions
Green Bay Packers
Minnesota Vikings

**WESTERN DIVISION**

Atlanta Falcons
Los Angeles Rams
New Orleans Saints
San Francisco 49ers

**EASTERN DIVISION**

Dallas Cowboys
New York Giants
Philadelphia Eagles
St. Louis Cardinals
Washington Redskins

Each team is permitted to keep forty players on its roster during the regular playing season. This comes to 1,040 men.

The overall czar shepherding this collective brain, brawn, and

muscle is National Football League Commissioner Pete Rozelle, whose job it is to keep the game honest, true blue, and profitable.

The way the whole *schmeer* works is that each team plays fourteen games during its regular season, half at home (that is, in its home stadium). Each team plays all the other teams in its own division twice during the season, and its remaining games are with teams outside of its division and even outside of its conference.

Let's take the Dallas Cowboys 1972 schedule, for example. As a member of the Eastern Division of the National Conference, Dallas plays the other teams in the Eastern Division—the New York Giants, Philadelphia, St. Louis, and Washington—twice each during the regular season. The remaining six games are played against Green Bay, Pittsburgh, Baltimore, Detroit, San Diego, and San Francisco— teams in other divisions, and some in the other conference.

At the end of all this effort, four teams from each conference are chosen for the playoffs. These include the three divisional champions, and the fourth team is selected on the basis of the best won and lost percentage in the division.

All this makes for a number of post-season games, which throws additional shekels into the already overflowing pot. These four top teams in each conference then slug it out for the conference championships, and the two conference champions ultimately meet for a prize that has come to represent a human attainment second only to the Holy Grail, the Super Bowl.

# THE MASSAS . . .

TO OPERATE SUCH A COMPLEX ORGANIZATION as a professional football team requires a horde of directors, specialists, assistants, and assorted underlings.

The average NFL team boasts a general manager, a head coach and his assistant coaches, a director of player personnel, a director of scouting, a business manager, a ticket manager, a director of public relations, a controller, and a trainer plus innumerable assistants, assistant assistants, etc.

There are also team physicians, equipment managers, traveling secretaries, groundskeepers, and an entire subspecies of peripheral janissaries.

No doubt it has all been computerized to the minutest decimal so that a specialist is engaged to tie the shoelaces of third-string quarterbacks, but since our chief concern here is with the game itself, let us briefly consider the average coaching staff of a NFL team.

The head coach is the absolute master of what ultimately goes on during the 60 minutes between the goalposts, unless—and this is a large unless—the owner and general manager are the kind that like to meddle in every facet of the game itself. In those instances the head coach has two options. One is to resign, the other to do exactly as he is told. Usually he listens.

Of course, there are some head coaches who won't brook interference from the front office, but these are those rare individuals who possess courage, pride, and a five-year, ironbound contract. The smartest way for a head coach to eliminate advice is to become the general manager himself, and to get a piece of the team. Paul Brown, Vince Lombardi, and Lou Saban were a few who have managed to straddle this dilemma.

Serving under the head coach are a pride of assistant coaches. These may include an offensive line coach, a defensive line coach, an offensive backfield coach, a defensive backfield coach, a kicking coach, and variations of the above.

Assistant coaches serve in a variety of ways. They occupy spotter's booths high above the stadium and phone down advice to the bench; they run the various team units through their drills; they call signals from the sidelines; they help formulate game plans; they scout opponents; they make up frequency charts; they grade players; etc.

Head coaches run the gamut from Attila the Hun to Little Mary Sunshine. Some have a remarkable knack for personal publicity and become as well known as their most fearsome gladiators. There's not a football fan in the United States who did not hear of Vince Lombardi. The late Mr. Lombardi has won a special place in the hearts of football aficionados who relish tales of his paternalistic oligarchy and total disregard for pain.

Tom Landry of the Dallas Cowboys exercises total control over his team by calling each offensive play from the bench, which he sends out by a substitute to his quarterback. Paul Brown and Lou

Saban have also been known to employ this privilege of power. Other head coaches pace the sidelines a lot and let their quarterbacks make their own mistakes.

The general manager is basically the guy who keeps the team well stocked with fresh, tender, young rookie meat. He turns this raw product over to the head coach who then welds it into the man-eating machine for which the fans shell out up to $13 apiece to watch it grind up enemy tacklers on the Day of the Lord.

Scouts stalk their prey in the playgrounds of academia and mark likely prospects for the great annual roundup known as the draft, which transpires toward the end of each season.

# AND THE SLAVES

FINALLY, these are the lads that bring the whole grand spectacle to life—the combatants, the gladiators, the jocks.

It has become the custom among professional football players to write their memoirs. Every locker room resounds with the click of the typewriter and the whir of the recorder. Men whose entire previous affiliation to pen and paper has been to issue an autograph to some pimple-faced delinquent are now busy chronicling their feats and travails. Mostly, these are apologetics for their own errant behavior, or indictments against the game of football by those no longer able to draw their income from the sport; or, simple pap describing the "love" that pervades a winning football team.

A good football bluffer might consider some direct quotes from some of these jocks whom small boys and big men have deified to the status of demigods.

Mike Curtis, in *Countdown to Super Bowl*, said: "I play football because it's the only way you can hit people and get away with it."

In *They Call It a Game*, former cornerman for Browns, Bernie Parrish, says with obvious pride: "I relished hitting people . . . I even enjoyed being hit . . ."

He speaks of a youthful experience on the gridiron: "I bust through the line . . . and only had to juke (fake) out one small, piti-

ful looking safety man. . . . Seeing the terror in his eyes, I was filled with contempt. I made no attempt to fake him. Instead, I cut directly at him, lowered my head, and ripped into him. . . . He looked unconscious the moment I hit him, but in that moment I slammed the ball in his face as hard as I could and as part of the same motion landed square on top of him. . . ."

Parrish then goes on to indict football owners for their callousness and lack of humanity.

Johnny Sample has said: "I got my kicks hitting guys" and describes one tender incident in his career in his *Confessions of a Dirty Ballplayer:* "I was covering Del Shofner that game. . . . On one play he came down on a short out-pattern. He dived for the ball and caught it about three yards inside and then started rolling out of bounds. Before he went out, however, I came into him, elbows and knees flying. Now I could have jumped over him, touching him just enough to down the ball. But I didn't. And the result was that I broke three of his ribs."

The artful bluffer can, therefore, take two tacks in regard to players. One is that they are healthy, vigorous, admirable young giants who represent the final frontier of discipline, self-sacrifice, Christianity, and the *Amurrican* way in a world gone to moral rot and decay.

The second is that they are quasi-fascist brutes who glorify violence, inhumanity, anti-individualism and commercial exploitation, and that the money spent on football could better be diverted to build recreational facilities for unwed grandmothers.

Which tack should you take? They are interchangeable. Either or both, whichever befits the situation.

Next best to hitting people, professional football players like to complain about how poorly they are compensated for their efforts. Here again, the calculating bluffer can swing in either direction. One argument is that an athlete's professional life is brief and he must, therefore, gather in the honey while he can. The opposite argument is that a jock is overpaid in the first place and that no one deserves such big money for having been born with a nineteen-inch neck while teachers are starving to death.

Choose one argument from Column A or one from Column B.

Incidentally, the players are represented by a union called the

National Football League Players Association. Also, many players today employ agents and lawyers to negotiate more advantageous contracts for them.

# THE SLAVE MARKET

DESPITE ALL THE PROTESTATIONS of inhuman conditions in the NFL, 99 percent of college football players stand around like perennial wallflowers waiting to be asked to join in the waltz. Frankly, most of them aren't overly endowed in the cerebral department and pro football represents perhaps their only pathway to fame and glory.

This is the way the whole thing works. Scouts from the pro teams have been observing and classifying the players from the day they started at dear old Swanee U.

If the boy shows promise, a card is kept in every pro team office, grading his skills, size, and attitude. Computers evaluate these statistics and by the time he is finished with his college eligibility, your college player is either accepted or rejected for the draft.

Toward the end of each pro season, the draft is held. The team that has finished last in that season's standing is given first choice of the crop. The next weakest team gets the second choice, and so on up the line.

The draft consists of seventeen rounds. By the time these are over, the pro teams have milked the current crop of potential players dry. Those who haven't been chosen are then free to try and catch on with any of the teams in the league as free agents. They are not committed to playing with any specific team as are those who have been selected.

Those that *were* picked may sign only with the team that has picked them. If they choose not to, they either try for the Canadian League or play out their option with the team to whom they belong. This means that they must play one season for the team that drafted them, then they are free to make a deal with another team. This also applies to older players who want to jump to other teams.

When a team no longer wants to employ a player it puts him out on waivers. This means that the other twenty-five teams have forty-eight hours during the season and a week off season to pick him up for a nominal fee.

There is also a so-called "Taxi squad," which consists of players under contract to a team who practice with the team, but who are not eligible to play in league games unless they are activated by the team in place of someone who has been injured or killed or whatnot.

It sometimes establishes one's expertise to bandy about such phrases as Joe Schmo is "playing out his option" or "he's a free agent" or "he's been put out on waivers" or "he's cleared waivers."

# THOSE LITTLE EXTRAS

DESPITE THE PLAYERS' LAMENT about their exploitation, many of them do very, very nicely in areas outside of, but directly evolving out of their football connections.

There are other advantages.

In his epic *Instant Replay,* Jerry Kramer touches on a very peculiar American institution—something that has been elegantly described as jock-sniffing. This is the idolatrous attitude that many otherwise clearheaded citizens adopt toward athletes, peculiarly enough, toward professional athletes who play the game basically for profit.

Kramer mentions the free services that are available to members of his team by people simply dying to be close to a jock. He gets his car washed for free, gets clothes and appliances at a discount.

Professional athletes could give lessons in *schnorring*. Fortunately for them, there are those anxious to lavish largess upon them. Jock-sniffing is a national affliction.

Between bonuses, endorsements, so-called "public-relations" jobs that entail nothing except the use of the player's name, "acting" jobs, television, franchise deals, and other such juicy plums, a smart football player can do very, very nicely indeed.

Remember, Joe Namath got $10,000 to shave a moustache.

# THE BOWLS

A BOWL IS A DISH that holds sugar. Occasionally it throws off sugar as well.

Following the regular season of fourteen games, the madcap post-season whirl commences. There are divisional play-offs and conference chamiponships and Super Bowls and Pro Bowls and All-Star games and whatnot.

Each attraction sells tickets and television time and each presumably draws profits for those involved.

# THE PATS AND KISSES

IN ADDITION to the reams of publicity and money they earn, NFL players are occasionally rewarded by being named for this or the other award. These can vary from the prestigious (All-Pro) selections to some cockamamie plaque given by a B'nai B'rith Father and Son group that employs a second-string guard to draw a crowd to a community-center breakfast.

Some of the better known awards include the George Halas Award for the Most Courageous Player of the Year, the Rookie of the Year Award, the Outstanding Professional Football Player of the Year Award, the Hickock Belt, the Most Valuable Player in the League Award, the Jim Thorpe Memorial Trophy Award, the Super Man Award, and a whole spate of other official and unofficial plaques, awards, commendations, selections, and approbations for such miniscule accomplishments as being the Surliest Quarterback with the Longest Toenails in the Eastern Conference of the AFC.

Football being the mass media enterprise that it is, its awards

are as an important part of the entire mystique as stars pasted in a book in kindergarten. A good bluffer can kill many minutes by rattling off the various recipients of awards and commendations.

There is, additionally, the Professional Football Hall of Fame located in Canton, Ohio, the site of the meeting that launched the NFL.

The Hall of Fame, dedicated in September 1963, lists some of the most famous gridiron heroes of bygone years—names legendary to dedicated followers of the sport such as Bronko Nagurski, Sammy Baugh, Don Hutson, and the one and only Jim Thorpe.

Furthermore, all victors of football's most prestigious prize, the Super Bowl, are presented with championship rings, and there is a Super Bowl trophy that consists of a silver football riding precariously atop a triangular base with the emblems of both conferences and a nameplate of the winner.

# THE PRESS AND THE TUBE

WITHOUT THE NEWSPAPERS AND TELEVISION, there'd be no professional football. Despite this condition, an uneasy truce exists between most players and reporters. Football players are like authors: they only want to read nice things about themselves. On the other hand, readers and viewers *demand* venom, and a smart sportswriter knows that people equate criticism with expertise. Since these good yeomen are most anxious to keep their jobs, they frequently knock players, second-guess coaches, and generally sound off about the game. Such ungrateful conduct has stimulated such a superstar as Joe Namath to dismiss reporters as "$100 a week creeps."

Other, less well-paid players are much more inhibited in their appraisal of the Fourth Estate. They know that publicity means extra dividends in commercials and other ancillary gains, and they'll contain themselves long enough to submit to stories and interviews.

There is nothing more inane than the usual television interview with a jock. A typical question asked of a sweaty bruiser who has just picked up some $15,000 in additional cash may be: "How do you feel

about winning the Super Bowl?" The rest of the interview continues in an equally brilliant vein. Those asking the questions are usually ex-jocks themselves and really should know better. The absolute apex of imbecilic hyperbole was attained at the post-1972 Super Bowl game interview in the Dallas Cowboy locker room, when a hyperactive Tom Brookshire rambled on for long minutes to a petulant Duane Thomas who had distinguished himself that year by coyly refusing to speak to his teammates and the press.

Still, the enforced marriage between press and football continues, and the assiduous bluffer should read and listen to football commentaries since it is there that the colorful jargon of the game is minted and refined.

# THE AFICIONADOS

THERE IS ACTUALLY NOTHING in the human experience to compare with the average, rabid football fan. He is chauvinistic, opinionated, argumentative, confounding, assertive. He thinks that he knows everything that there is to know about football—and he is probably right.

Since football is played in the winter months and frequently in stadiums beset by Siberian gales, there is a strong affinity between alcohol and football. As any bartender will tell you, football fans are terrific lushes.

There is also a species of football groupies, preadolescents who prowl the bars, discotheques, and hotel lobbies where jocks are prone to congregate, and who cause coaches incipient coronaries by tempting their heroes into criminal situations.

Football fans come in all ages, sexes, and levels of society. Even intellectuals who pretend scorn for the game have been known to sneak glimpses as Larry Csonka of Miami grinds up a middle linebacker barreling through on a cross buck.

Football has also captured the imagination of social scientists who have compared it to everything from war to a sexual encounter.

Hardhat or poet, grandmother or go-go girl, football fans are

growing at an unprecedented rate. Football is in, football is now—football is America.

# THE  PRELIMINARIES

TO PREPARE FOR THE fourteen weeks of the regular season, NFL teams spend some 8 grueling weeks practicing, training, perfecting skills, and weeding out the softies who can't cut the mustard. Players and coaches refer to such unfortunates as "pussies."

The preseason camp usually opens around the third week in July. It's often held on some college campus where there's a field and facilities to house and feed the players.

The first two weeks may be devoted to workouts, drills, classroom meetings, and the like. By the third week the intrasquad games commence.

There are only forty jobs on a NFL football team, and some sixty men fighting for them. As can be imagined, the competition is fierce.

To get the men into shape, the coaches race them through various drills and exercises. There are grass drills, agility drills, starting drills, wind sprints, calisthenics, tackling dummies, blocking sleds, nutcracker drills, blitz drills—all kinds of human and mechanical ploys and devices to harden muscles, eliminate suet, increase endurance and tolerance for pain.

There are weightlifting and isometrics, running tires and running laps, sit-ups and jumping jacks, side twists and push-ups.

The routine is Spartan and monastic.

An eleven o'clock curfew is strictly enforced, except for Saturday when the players are allowed to stay up until midnight.

Each player is given a playbook that he must guard like his very life. Loss or misplacement of same is subject to the heaviest fine, for the playbook is virtually the blood and guts of a team. It contains all its formations, plays, assignments, strategies, and secret machinations. The player must memorize this book and commit some hundreds of alignments and personal assignments to memory, so that he may respond automatically to any signal called by a pressured quar-

terback, often as a hurried alternative for a previously determined play.

The regimen is strict and occasionally the hands sneak out for a little fun and some games. It's exactly like boarding school except that in this case the youngsters are 270-pound citizens with falling hair and varicose veins. At times things grow so rugged in camp that a man will go home in the night without telling anybody.

To further the image of a boys' academy, the rookies are made to sing after dinner and there's a lot of hazing and promiscuous fanny slapping.

Despite all this horseplay, there's a frenzied rivalry for the jobs and the coaches skulk around taking notes and reporting to the headmaster. Soon the cutting begins as the incompetents are weeded out and the squad begins to pare down to its limit of forty men.

A schedule of five or six exhibition games is played and additional cuts, trades, and acquisitions are made in the rosters of eligible players.

# THE ARENA

PROFESSIONAL FOOTBALL IS PLAYED in a number of stadiums that vary in beauty, condition, and number of seats, but coincide as to the size of the football field itself, which is a uniform 100 yards long from goal line to goal line, and 160 feet wide from sideline to sideline.

Beyond the goal lines there lies an additional area that extends ten yards further and is called the end zone. The outside boundaries of this zone are called the end lines. A six-foot white border rims the sidelines and a flag marks each inside corner of the field.

The field is marked off with horizontal white lines placed five yards apart, commencing with each goal line. The middle, or fifty-yard line, separates the field into two halves, so that there is no such thing as a fifty-five-yard line, merely a five- to a forty-five-yard line, a set for each half of the field.

There are additional lines running the length of the field at one-yard intervals, at a distance of seventy feet, nine inches in from each

of the sidelines. There are the hash marks (inbound markers) where the ball is placed if it has been declared dead in the side zone (the area between these hash marks and the sideline) or gone out of bounds beyond the sidelines.*

In the center of each goal line are the goalposts, two uprights rising twenty feet above a crossbar that is eighteen feet, six inches wide, and ten feet high. The bottoms of the goalposts are padded to guard them from being smashed by players' heads.

The football field is covered with grass or with something called Astroturf, named after the plastic-domed Astrodome in Houston where it was found more expedient to replace God's good grass with ersatz greenery.

The players uniformly despise this plastic abomination that they claim causes knee injuries and flesh burns, and the Players Association has asked for a moratorium on any further installation of artificial grass.

There are benches running along the sidelines where the coaches, trainers, owner's nephews, and substitute players sit during the game. There is also a row of enclosed booths set high in each stadium from where members of the press observe the action. It is there too that assistant coaches sit in the so-called spotter's booths and phone down their findings to a player or coach on the bench, who then relays the information to the head coach and to the players on the field.

There are lockers below the stadium where the players dress and rest between halves. Long before the kickoff, the equipment manager lays out the players' uniforms, protective equipment, and whatever accouterments they might need for the game.

In a nearby room the trainer sets up a table where he treats injuries and dispenses goodies from his magic bag of tricks. Each player is assigned a locker with a marker designating his spot.

If the field is icy, the players wear sneakers instead of the usual cleated shoes in order to gain better footing, and there are heating pads and warmers by the benches to warm icy fingers and tootsies on frigid afternoons.

The players, having entered the stadium through the press gate, go directly to their lockers and begin to get ready. Either the trainer,

---

* When a team has the ball inside its own fifteen-yard line on fourth down, the ball is moved three yards beyond the hash marks so that the punter won't be as likely to kick the ball against the goalposts.

or they themselves, tapes their ankles, hands, wrists, knees, feet, or what have you. In order for the tape to stick, players shave the area beforehand. They might also spray on an adhesive to achieve better cohesion.

The protective equipment worn by players includes a helmet, an athletic supporter, shoulder pads that strap under the arms, rib pads, forearm pads, hip pads, thigh pads, kneepads, shin pads. Not all players wear all these items, of course. They are worn according to the demands of the player's position and to his personal idiosyncrasies. The helmets worn by linesmen have vertical and horizontal crossbars called cages to protect the face. Backfield men usually wear helmets with a single or double face bar running horizontally in front of the chin.

Some men improvise their own arm pads from various materials and use them as weapons to club down opponents.

The official uniform consists of the helmet, a jersey, pants, and stockings. Today the low oxford-type football shoe is the vogue. Players often tape these shoes to their feet. Some players cut the sleeves of their jerseys, others prefer to wear them long. The jerseys bear the players' numbers on the front, back, and sides (occasionally their names as well), along with the team colors. They come down low and snap under the player's crotch. The pants are of stretchy material that gives in the crotch. The stockings come up to the knee and have a stirrup that fits under the foot. White sweat socks that reach halfway up the calf are worn over the stockings.

Prior to the game the team physician goes around and checks out the sick, lame, and wounded. He gives sympathy to those who are nervous and injections of pain-killer to those who must play with injured parts.

The men suit up, swallow whatever pills are currently in vogue (more of that later), and about forty-five minutes before the game trot out onto the field and perform set drills and warm up. They run, stretch, loosen up, practice passing, receiving, getting off the line. They trot around the field to examine its condition. The ground crew would have rolled it as hard as possible, but it may be soggy and slow from rain or snow.

The numbers assigned to players follow a general pattern that makes it easier to identify their positions. This is the way it usually works in the NFL:

—Quarterbacks usually wear a number from 0 to 20
—Offensive halfbacks and defensive cornerbacks and safeties wear numbers in the 20s and 40s
—Fullbacks wear numbers in the 30s
—Centers wear numbers in the 50s
—Linebackers wear numbers in the 50s and 60s
—Guards wear numbers in the 60s
—Offensive and defensive tackles wear numbers in the 70s
—Offensive and defensive ends wear numbers in the 80s

Of course, if a player changes positions, he will usually keep his old number. Football players are fiercely possessive of their numbers and will not surrender them without a bloody struggle.

# ACHES AND PAINS

FOOTBALL BEING WHAT IT IS, players spend a good portion of the season cut, fractured, bruised, lacerated, separated, contused, concussioned and spasmed. They develop bone chips, they shed teeth as liberally as other men shed dandruff, their knees blow up and become duck ponds, their shoulders leave their moorings and go floating off into the night. Of course, there are diathermy machines, whirlpool baths, and infrared lamps to keep the athletes happy.

Every schoolboy knows that Joe Namath plays on knees as shaky as a chorus girl's virtue. Before the game he is perforated with enough needles to give Dr. Welby apoplexy.

The regular pounding football players take makes boxing seem like a game of hopscotch. Many football players spend time on queer street. They call this "being dinged" or "getting your bell rung."

But most coaches display a marvelous insouciance toward pain (not their own, of course) and the players abet this attitude by their juvenile determination to perform even if their privates are hanging by a hair.

The team physician, who works for the owner, goes cheerfully along with this hairy-chested posture and keeps the boys patched together with glue, spit, and liberal injections of this and that.

# THE FUZZ

WHENEVER TWENTY-TWO SEMI-SAVAGE MEN get together to knock each other's brains out in front of millions of people, there have to be a few cooler heads around to maintain law and order. Six officials are assigned by the NFL to every regulation game. These are: a referee, an umpire, a field judge, a line judge, a head linesman, and a back judge. They have all kinds of assignments to fulfill, but since their tasks are interrelated and interchangeable, the only thing that need concern you is that the referee is the head official and it is he who makes the final decision regarding penalties, fouls, etc.

There are, additionally, two men on the sidelines who are called the chain gang, the chain crew, or rodmen. They carry a ten-yard-long chain and measure whether a first down has been made if the point is in question. Another man called the boxman carries the down box, which shows which down is being played.

NFL officials wear a white cap, white football trousers, a black striped shirt, and a number on their back. They blow their whistle a lot and throw markers (pieces of weighted cloth) down on the field to indicate a foul. The proper thing to say at that time is: "There's a flag on the play."

# THE NO-NOS AND THE BOO-BOOS

THERE ARE SO MANY RULES and infractions in football that it would require a special book to list and explain them all.

The clever football bluffer must merely become familiar with a few of the more blatant or dramatic ones so that he can insert them into the conversation whenever a lull threatens.

33

A few important no-nos to remember are:

*Illegal Use of Hands and Arms on Offense.* Only the ballcarrier can ward off opponents with hands and arms; no other offensive player can do so. The penalty for holding, grasping, clutching, etc., by offensive players is fifteen yards.

*Clipping.* This means to throw a block from the rear, usually at the back of an opponent's legs. When this happens three yards in either direction beyond the line of scrimmage, the penalty is fifteen yards, and the clipped player loses some cartilage in his knee.

*Pass Interference.* If the defender hinders the progress of the pass receiver *before* he has caught the pass, the ball is put into play at the place where the foul has been committed.

*Ineligible Receiver Downfield.* Only the offensive backfield men and ends are eligible as forward pass receivers. The interior linemen (center, guards, tackles) are ineligible receivers.

Penalty—fifteen yards:

*Roughing the Kicker.* The defensive team should not make contact with the man punting or kicking a field goal. The penalty is fifteen yards (and an automatic first down). Strangely enough, it's perfectly kosher to rough up the kicker on kickoffs.

*Roughing the Passer.* A passer who has released the ball is protected from unnecessary roughness by a fifteen-yard penalty against the perpetrator (and an automatic first down). He is not protected against necessary roughness.

*Intentionally Grounding the Ball.* If a passer fears that his pass may be intercepted, he might intentionally throw the ball away or out of bounds. This is punishable by a fifteen-yard penalty (and a loss of a down).

Obviously there are dozens of other no-nos and boo-boos for which appropriate penalties are assessed and which we cannot discuss here for reasons of brevity. There are rules, exceptions to rules, and exceptions to exceptions. In addition, rules are frequently being revised and adjusted to help make the game more attractive for spectators. The artful bluffer will observe the progress of two or three games, then decide which of the fouls strikes his particular fancy. He can then adopt several as his very own and throw them into a conversation to demonstrate his expertise in the game.

# THE GAME

FOOTBALL IS PLAYED by two teams comprised of eleven men each. The game is divided into four quarters (periods), each of fifteen minutes' duration. There is a fifteen-minute * rest between halves and a two-minute rest between the first and second and between the third and fourth quarters.

Each half begins with a kickoff in that one side kicks the ball to the other, which then runs the ball back. From the point where the ball has been declared downed, the team holding the ball has four downs in which to advance the ball ten or more yards toward the other team's goal line. When the ten yards (or more) have been reached, the team in possession gets four more downs in which to advance another ten yards. And so it goes.

Between the first and second and the third and fourth quarters, the teams change goals. The ball is put down in the same place as before, except that the direction in which the teams are going has been reversed.

Each team is permitted three one and one-half minute (officially two minute) time-outs per each half. Other time-outs may be called by the officials to measure off yardage, to remove injured players, to check improper equipment, to assess penalties, etc.

The clock keeps running during the action, but is stopped when the ball goes out of bounds or following an incomplete pass. The offensive team has thirty seconds in which to get the ball into play. Failure to do so results in a five-yard penalty.

There is unlimited substitution, but players may only enter a game while the ball is dead (between plays).

The referee throws up a coin thirty minutes prior to the game. The captain (or coach) of the visiting team calls the toss. The winner of the toss may elect to either kick or receive, or to name the goal that his team will defend. The loser is then given the alternate choice.

---

* Officially it is twenty minutes, but the fifteen-minute period is observed.

At the end of the first half, the captains again meet with the referee to make the respective choices. This time the loser gets first choice.

The scoring consists of the following:

*Touchdown.* When a ball is run across the opponent's goal line or caught in the opponent's end zone or recovered in the opponent's end zone, the scoring team nets six points.

*Field Goal.* When the ball is kicked from anywhere in the field in a fixed position and over the crossbar of the opponent's goalpost, the scoring team nets three points.

*Point After Touchdown.* Following a touchdown, if the ball which is placed two yards from the scored-on team's goal line is kicked over the crossbar of the goalposts, the scoring team nets one point.

*Safety.* If a player downs the ball in his own team's end zone, and *the impetus for the play came from his own team,* it is considered a safety and gives the *opposing* team two points.

A variation on the safety is the touchback. This means that a player downs the ball in his team's end zone, but *the impetus came from the opposing team.* There is no score, and the ball is brought out to the nearest twenty-yard line and put into play there.

The average NFL game takes approximately two and one-half hours to play.

Approximately 150 plays are effected, perhaps 60 running, 60 passing, and 30 kicking.

Most professional games are played on Sunday afternoons, a few on Monday evenings, a few on Friday or Saturday afternoons or evenings. There is usually a game or two on Thanksgiving.

The season lasts fourteen regular weeks, with additional playing dates for teams getting into divisional playoffs, conference championships, and the Super Bowl.

The average team employs perhaps ten to twenty different running and fifteen to twenty-five passing plays per game. Quarterbacks complete perhaps 50 percent of their forward passes.

The ball, commonly called a pigskin, is made up of a rubber bladder with a leather (not necessarily pigskin) exterior. It is eleven inches by twenty-eight inches in diameter (in its middle) and weighs just under a pound.

The team that is in possession of the ball is called the offensive team, the team defending its goal line is called the defensive team.

Each time the ball changes hands, coaches put in an entirely new (or nearly new) team.

# THE OFFENSE

OF THE FORTY MEN that each team is allowed to carry during the regular season, perhaps twenty-two to twenty-five are assigned to offensive positions. In the old days a player was expected to play both on offense and defense. This practice went out with rolled stockings and hip flasks. Today's football player is a highly specialized specialist and usually plays only his position for the duration of his professional career. There have been cases of a left guard breaking out in hives upon being assigned to right guard.

To perpetuate the differences between them, the offensive and defensive players on professional teams maintain strong lines of demarcation when practicing, eating, or socializing. There is more than a trace of envy, rivalry, and resentment flowing from one side toward the other. Defensive backs and offensive linemen feel that they don't get their full share of appreciation. The glory boys of pro football are the offensive backs and the middle linebackers. It is mostly they who get the inflated salaries and the lucrative television commercials and speaking dates.

Be that as it may, the following are the offensive positions:

| | |
|---|---|
| (FL or WE) | Flanker (also called Wide Receiver) |
| (TE) | Tight End |
| (RT) | Right Tackle |
| (RG) | Right Guard |
| (C) | Center |
| (LG) | Left Guard |
| (LT) | Left Tackle |
| (SE or WE) | Split End (also called Wide Receiver) |
| (Q) | Quarterback |
| (HB) | Halfback } also called Setbacks or Running Backs |
| (FB) | Fullback } |

For kicking situations there are additionally a Place-kicker and a Punter, and a man who returns kicks.

Both the offensive and the defensive teams use formations from which they run their plays. A formation means the way a team lines up for the play. The usual offensive formation in pro football is the so-called T formation, popularized by the Chicago Bears in the 1930s. Today every NFL team uses the formation with some variations. In the split T formation the quarterback lines up just behind the center with either a back to each of his sides or the fullback directly behind him. The fourth back lines up just behind and some eight to fifteen yards from the tight end. He is called the flanker and is used primarily as a pass receiver.

There are variations on the T formation. There is the T with wingback, T with two wingbacks, T out of a slotback, a shotgun formation, an I formation, etc.

Since the offensive backs seldom line up in the exact same spot for every play (to confuse the defense) it's sufficient to know that most offensive formations are merely a variation of the T.

NFL rules demand at least seven men on the offensive line. It is usually three backfield men who vary their exact location. In addition, there is an offensive maneuver called "man in motion" in which a setback (usually the halfback) begins to run in a lateral direction before the ball is snapped. All this makes it more difficult to determine the precise formation assumed by the offensive team. However, for those who enjoy the minutiae of pro football, let us briefly consider some of the formations.

*The Balanced or Straight or Tight or Basic T*. The quarterback just behind the center. A halfback to each side of the quarterback; a fullback directly behind him. No flanker is used.

*T with Flanker*. The quarterback just behind center; the halfback and fullback behind and to each side of the quarterback; the flanker (fourth setback) lined up behind and to the side of the split end.

*T with Wingback*. The same as above, except that the wingback lines up closer to the end than he would in the standard position.

*T with Double Wingbacks*. The quarterback lines up behind the center and the two halfbacks line up as tight flankers behind each end of the line. The fullback lines up behind the quarterback.

*T Slotback*. In this formation the quarterback lines up behind

the center with a halfback and a fullback behind and to each side of him. The flanker (second halfback) lines up just behind the linemen but between the split end and the tackle.

*Shotgun Formation.* The quarterback lines up some seven yards behind the center and the three remaining backs line up just behind the line between the tackles and the ends. This formation poses innumerable dangers for the quarterback who is often left with little protection.

*I Formation.* The quarterback lines up behind the center, the halfback just behind him, and the fullback just behind the halfback to form a straight line. The fourth back lines up as a flanker.

Prior to the T formation, offensive football teams usually operated out of a single wing formation. In this formation the quarterback lines up between the center and end, the fullback and tailback (halfback) line up behind him along the center of the line, and the other halfback lines up outside of the end. This formation is as obsolete as spats and high-button shoes.

In order to simplify the attack, offensive teams use numbers to signify areas in the line through which they intend the runner to move. As an example, these holes may be designated as follows:

1 between the center and right guard
3 and 5 between the right guard and right tackle
7 off tackle
9 around the right end
0 between center and left guard
2 and 4 between left guard and left tackle
6 off tackle
8 around the left end

There are also numbers assigned to the backfield men so that the quarterback may be 1, the halfback 2, the fullback 3. (These numbers vary with teams.)

Thus, a running play number 26 might mean that the halfback rushes off (outside) left tackle.

Naturally different teams adopt codes of their own so that the same numbers wouldn't mean the same thing on different teams.

Offensive teams also use colors to designate formations so that a quarterback might bark something like: "Brown left . . . x fly . . . 29 on two."

Don't try to figure it out. It's designed to confuse defending

players who are paid good money to understand and often don't; it's surely too difficult for the nonplaying observer.

But before we go on to strategy and other refinements, let's first go back to the offensive positions and consider their basic responsibilities.

## FLANKER

This is basically a backfield man, a speedy halfback, who lines up one to two yards behind the linemen and some six to fifteen yards away from either the left or right end (usually the right).

The flanker's main job is to run out for long passes, his blocking ability is secondary. He will block the strong side linebacker or the strong side cornerback or the strong side safety on end-around sweeps or other running plays.

The flanker must be a swift runner and an expert on running pass patterns and faking out pass defenders.

The side on which he lines up is called the strong side, since it has four men on the line as compared to the three on the other side.

The flanker is also called a primary receiver, a split man, and a wide receiver.

## TIGHT END

The tight end lines up fairly close (between two and five yards) from the tackle on either the right or left side. Whichever side he lines up on is then called the strong side since the flanker always lines up behind and to the side of the tight end. Usually the tight end lines up on the right side.

The tight end must be fast enough to go out for short passes and strong enough to block the defensive end, tackle, or linebacker on running plays. His usual opponent is the strong side linebacker. He is also called a primary receiver.

## RIGHT TACKLE

This worthy lines up on the right side of the line next to the right guard. He is usually a big, powerful man, since his chief task is

to block the left defensive end on running or passing plays—whether to open up a hole for the ballcarrier or to protect the quarterback from the onrushing defensive player or players. At times he will block a linebacker, a cornerback, or a safety.

His counterpart, the left tackle, pretty much shares the same assignments. If the flanker lines up on the right side, the right tackle is called the strong side tackle. If the play action goes to the right side of the line, the right tackle is called the onside tackle.

## RIGHT GUARD

This is one of the most difficult and trying positions in pro football. The right guard lines up between the center and right tackle. He interlocks his feet with the center and stands there as a bulwark protecting the quarterback on passing plays. On certain running plays he will "pull," which means to go out of his position and lead the interference for the ballcarrier. Other times he might "trail," which means to follow his fellow (pulling) guard on a blocking assignment downfield. Of course, the first guard may merely be running a decoy course.

A right guard's chief opponent is the left defensive tackle, who is usually the biggest and strongest man on the defensive team.

Guards spend long afternoons butting helmets with defensive tackles. A disadvantage is that the defensive player can use his arms to slap the guard around while his (the guard's) hands are tied by law.

The left guard does the same things as the right, but on the opposite side.

If the flanker lines up on the right side, the right guard is called the strong side guard. If the play action goes to the right, the right guard is called the onside guard.

Smart defensemen try to "key" on guards to determine the upcoming play. An alert guard never alters his stance since if, inadvertently, he leans back, the defense may detect that a pass play is coming. A clever guard might tilt his head to one side or other to fake the defenders into believing that the play will be going in that direction.

By watching the guards the spectator can often tell where the play is going and what kind of play it will be. Generally speaking, if

he moves out, it's a run, and if he digs in, it's a pass. A good move by the guard is to slam his helmet into the defensive tackle's chest, then slide the helmet up and into his chin.

When running interference, a guard never looks back at the ballcarrier but plows gamely ahead.

## CENTER

This is an involved and exacting position. The center must snap the ball to the quarterback, the punter, or the man holding for the field goal or point after touchdown. In the old days he rolled or kicked it to them. In addition, he blocks to open up holes for a running play or to keep defenders from rushing the quarterback. His opponent may be a blitzing (charging) linebacker who is steamrolling ahead to demolish the quarterback. The center usually forms the *apex* of the pocket, which is the phalanx of linemen protecting the quarterback on passing plays.

He will often call the blocking signals for the other interior linemen (tackles and guards). Since the center must keep his head down at that time, he is a particularly vulnerable target on placement kick plays (field goals and points after touchdown).

## SPLIT END (SPREAD END)

The split end's job is basically the same as the flanker's, except that he lines up on the weak side of the line, directly on the line of scrimmage, but some eight to fifteen yards away from the tackle. The split end is often the best pass receiver on the team. He should be fast, sneaky, and good enough at blocking to help the tackle on certain plays.

He is also called a split man, a wide receiver, and a primary receiver.

## QUARTERBACK

Probably the most important player in the offensive lineup, the quarterback is literally the man in charge of a team's offense.

He chooses the plays for the team to execute; he handles the ball on every offensive play except for possibly the kicking plays; he decides what player should carry out which assignment, and generally runs the offensive attack.

A quarterback must be intelligent enough to remember dozens of plays, innovative enough to select the suitable one for the proper situation, and flexible enough to switch to a different play on the line of scrimmage if he notices some weakness or variance in the opponent's defense.

He must be an excellent passer and, hopefully, a good runner. Above all he must be a good leader so that he instills a desire to win and confidence in his teammates.

Although there have been good short quarterbacks—Eddie Le-Baron and Davey O'Brien are two that come immediately to mind—it's easier for a quarterback when he is a taller man, so that he can see over the heads of the linemen before him.

Due to the complexities of the position, it usually takes a pro quarterback five years to become proficient at his job.

There are essentially two kinds of quarterbacks—the drop-back and the roll-out (or scrambling). The chief difference is that the drop-back quarterback passes from a stationary position, while the roll-out type passes on the run. While the roll-out quarterback provides a more stimulating show for spectators, this is a less satisfactory way of getting the job done. The roll-out quarterback only sees that part of the field toward which he has scrambled and, additionally, is more prone to be manhandled than the drop-back quarterback who throws from behind a pocket formed by a phalanx of his linemen.

Fran Tarkenton is a prime example of a roll-out type of quarterback. (Often a quarterback rolls out because his offense line is too inept to defend him in the pocket.)

There are also those coaches who refuse to allow the quarterback to direct his own offense and who call each offensive play from the bench. Coach Tom Landry of the Dallas Cowboys has used this technique most effectively, as he demonstrated in the 1972 Super Bowl. Most coaches, however, rely on their quarterbacks' judgment.

Quarterbacks usually line up just behind the center, except in the shotgun formation when they go back some seven yards to receive the snap.

Quarterbacks being valuable and often fragile wear red jerseys during practice so that they won't be mauled by their teammates.

## HALFBACK

The halfback is a man who must be equally adept at running the ball, blocking, passing, and catching passes.

He is called upon to carry the ball either to the outside or through the middle. On the option play the quarterback hands off to the halfback who then throws a forward pass (or runs).

The halfback usually lines up three to four yards in back of and to the side of the quarterback. It is usually he who moves prior to the snap in the man-in-motion maneuver.

On many passing plays the halfback must block the strong side linebacker. On passing plays he must also serve as a safety valve for the quarterback if no eligible receiver is available downfield. This means that he must first complete his blocking assignment, then recover in time to catch the ball if need be. He also must help protect the quarterback against blitzing defenders.

Also called a setback.

## FULLBACK

A great bulk of the heavy running and blocking assignments are laid upon the burly shoulders of this stalwart of the offense.

When three or four essential yards are needed for a touchdown or a first down, the fullback is expected to plow into the line and get them. He must block for the halfback on sweeps and block out a defensive tackle or end or linebacker. He must protect the quarterback from blitzing linebackers, serve as a safety valve, and block the weak side linebacker on passing plays. He must also be able to catch a short pass when necessary.

The fullback lines up three to four yards behind the line of scrimmage and—usually—behind the quarterback.

Also called a setback.

These eleven men constitute the offensive team in its running and passing situations.

# OFFENSIVE PLAYS

THERE ARE TWO WAYS of advancing a ball across an opponent's goal line—by running and by passing. Of course, there is a third way of scoring—by kicking a field goal or point after touchdown—we will get to these tactics later.

Let us first consider the running attack. Technically, any man on the offensive team can advance the ball by running with it (provided it has been snapped, or passed, through the center's legs). But since the rules decree that there must be at least seven men on the offensive line of scrimmage at the snap, it is easier for the three backs (QB and two setbacks) to do the actual running.

On most running plays the quarterback will take the snap from the center and hand off to either the halfback or the fullback, who will then advance the ball by carrying it toward the opponent's goal line. There are three basic points of attack: through the middle, through either side of the line, and around each end.

The thrust through the direct middle of the line is called the line buck. This is a direct power maneuver in which the halfback or fullback takes the ball from the quarterback and hits straight into the line, hopefully finding some room to advance between the defending linemen. This may also be called a dive, a plunge, or a quick opener.

A variation on this is the cross buck, in which the quarterback fakes a handoff to one setback and hands off to the other back who is starting his run from one side (let us say the left) of the backfield and plunges into the other (right) side of the line.

You must remember at all times that the *right* offensive line always faces the *left* defensive line and vice versa.

The slant running play means that the ballcarrier takes the handoff and runs at a slant, or at an angle, through the line of scrimmage. The difference between this and the cross buck is that in the cross buck the ballcarrier merely hits the *opposite* side of the line, then continues in a straight direction, while on the slant run, he *continues* running in a slanting direction.

The trap play means that the defensive tackle is allowed to come roaring in past the line of scrimmage, then he is blocked from the side, and the ballcarrier runs through the hole left by his absence.

The outside, or end sweep, or end run is another basic running play. In this maneuver the two guards pull out of the line and lead the interference for the ballcarrier running around either end.

In the draw play the defensive linemen are lured or allowed to come charging in in the belief that the quarterback is going to pass. As they come racing in, the quarterback hands off to either setback who then goes straight into the line between the advancing defense men.

A reverse play means that a setback takes the ball from the quarterback and starts to run toward one end of the line. As the defense comes toward that side to catch him, he hands off to the other setback who then runs the ball in the opposite direction.

A double reverse merely means that two fake maneuvers are executed before the actual or true run commences.

The Quarterback Sneak. In this play the quarterback takes the snap from the center and without any ceremony plunges directly into the line.

In the bootleg play the quarterback fakes a handoff, then hides the ball behind his hip, and runs to the opposite direction as that taken by the alleged ballcarrier.

Occasionally, instead of handing off the ball to a setback, the quarterback will pitch (or toss or lateral) the ball to him from a distance. In this play the quarterback fakes a pass, then as the defense assumes a pass play position, he tosses the ball to the setback who is sweeping around one of the ends. It's a surprise maneuver and it's called a pitch-out play.

There is such a thing as a belly maneuver, in which the quarterback puts the ball into a back's midriff, holds it there for a moment, and either lets him run with it or pulls it back, to either hand off to another man or to pass.

A veer play means that the ballcarrier runs on the basis of how the defense shapes up. He is not bound to follow a predestined route but makes it up as the situation develops.

These then are the basic running plays. Naturally, since a team might carry between thirty or forty running plays in its playbook, there are variations and refinements of all these basic moves.

# PASSING PLAYS

THE AVERAGE NFL TEAM passes hundreds of times during its regular season. In recent years the forward pass has captured the imagination of the spectators, and team owners and general managers who will do almost anything to please the paying public have exerted special effort to sign up skilled passers and receivers.

These is nothing more satisfying visually than a long, completed forward pass. Here is how the passing attack shapes up.

In most instances the quarterback takes the snap from center, moves back ten yards or so, then steps forward into the so-called pocket, which is a shielding formation formed by the offensive linemen, with the center at the apex of the half circle or triangle of protective flesh and muscle.

If he is the roll-out type of quarterback, naturally he will scramble around behind the line of scrimmage and throw on the run without the pocket.

The offensive team has thirty seconds in which to put the play into work. Up to ten seconds might be used up for the huddle, leaving the quarterback twenty seconds to receive the snap from center. He actually has between three and four seconds to get the pass off before the wall of defensive linemen caves in on him. If he is lucky, and has an outstanding line in front of him, he might enjoy an additional second. A quarterback, therefore, in addition to all his other attributes, should be blessed with what is called a quick release—getting rid of the ball in a hurry.*

The three primary receivers on the offensive team are the split end, the flanker, and the tight end. The halfback and fullback might also be sent out to catch a pass. Actually, these five men in addition to the quarterback are the only men on the offensive team who may legally receive a forward pass. However, every man on the defensive team is eligible to intercept.

---

* If he gets it off *too* quickly, he is said to be forcing the pass.

Interceptions are a quarterback's nightmare.

The wide receivers, the flanker, and the split end do most of the long pass catching. They should be specialists in faking out the defending backs and in running pass patterns that will confuse and demoralize the cornerbacks and safeties whose job it is to break up pass receptions.

The tight end is more apt to catch the shorter pass due to his position in the offensive formation and to his blocking assignments. He will more likely receive in the short or deep middle of the field.

A halfback might be sent almost anywhere to receive, but more likely it would not be into the deeper zones. A fullback will also be more apt to go for the short or sideline pass.

There are literally dozens and dozens of pass patterns that receivers can run, most of which are variations of several basic moves.

Passes can be thrown to the short middle and the long middle, toward either sideline, toward either flat (the area just behind and to the sides of the line of scrimmage), and deep toward either corner of the field.

To list all the pass patterns would be nearly impossible, but to give you just a sampling, you have the:

| | |
|---|---|
| *Buttonhook* | *Acute out* |
| *Sideline* | *Acute in* |
| *Fly* | *Spot* |
| *Zig-out* | *Hitch* |
| *Post* | *Hitch and go* |
| *Down and out* | *Curl* |
| *Down and in* | *Turn in* |
| *Delay* | *Banana* |
| *Circle* | *Drag* |
| *Look in* | *Square in* |
| *Snake in* | *Square out* |
| *Snake out* | *Split* |

Had enough? I should hope so! The next question is—what does each pattern signify? The answer is—very little except that each is the peculiar route taken by the receiver to get to where he is going and is typical of the terminology adopted by the football fraternity that treasures its jargon above all else. The receiver might as easily say: "I'll run to the left side of the field, try to throw the ball to me."

But this would take away a lot of the mystique in which football players, coaches, and fans alike love to wallow.

If a quarterback wants to pick up a certain amount of yardage and wants to play safe, he will call a hook or buttonhook play—this merely means that the receiver will run straight downfield, then stop sharply and go back a few steps where the ball will hopefully be waiting for him.

In the same situation the quarterback may call a sideline pass, in which the receiver will catch the ball near the sideline, then go out of bounds with the necessary yardage already chalked up. These are the so-called safe passes that guarantee a first down but rarely result in a score.

In certain similar situations or in order to keep the defense loose, the quarterback might call a screen play. On this play the three primary receivers, and possibly one of the setbacks, run downfield taking the defending players with them. As the quarterback goes back to pass, the defending linemen and/or linebackers come charging in and the offensive linemen only make a superficial effort to stop them. Just before the quarterback is mashed into ground hamburger, he tosses a short pass to the remaining setback who has skipped into position unobserved. The offensive linemen are now in position to run interference for the ballcarrier.

This stratagem is frequently employed against blitzing defenses and keeps the defenders "honest."

Another deceptive tactic is the play pass or the play action pass.

It begins like any running play. The quarterback fakes a handoff, then as the defensive linebackers come forward to smother the runner, the quarterback throws a pass to an unprotected receiver.

The option play has the quarterback hand off to the halfback, who begins his sweep around end. As the defense reacts to an obviously running play, the halfback may either pass to an open receiver or continue running the ball.

There are other pass plays—the flare pass in which a back runs toward the sideline behind the line of scrimmage; the swing pass to a back who runs a short pattern out to the weak side, and others, ad infinitum. But a pass is a pass is a pass, and the procedure is basically the same—one man throws, another man catches or doesn't catch.

One forward pass is permitted per down, but it is legal to toss the ball to a teammate in a backward or lateral direction even beyond

the line of scrimmage. A ballcarrier may do this when he feels the breath of a charging tackler on his neck and either doesn't want to get creamed or hopes that his teammate will be able to gain additional yardage. Such a pass is called a lateral, a shuffle pass, a pitch, or pitch-out.

Another tactic employed by the quarterback when all his receivers are covered is to toss the ball to either of his backs who serve as his "safety valve."

Or, lacking even this alternative, a quarterback may "throw the ball away." This means to fling the football somewhere out of bounds or to an area where no one can intercept it. This is a most tricky maneuver, since the officials may penalize the offensive team for intentionally grounding the ball. It's a difficult call for the referee to make since he must determine if the quarterback deliberately threw the ball away to avoid being smeared by the defending linemen or to prevent a loss of yardage, or whether he was honestly trying to hit one of his receivers. There are some quarterbacks who are masters at this deception.

To "eat" a ball by a quarterback means to hold on to the ball at any cost rather than to throw it away. The safest way is to fall to the ground and hope not too many defenders will pile up on top or step on your face.

A good quarterback maintains a stoic demeanor in the face of onrushing defenders. This, in football lingo, is called poise. No matter how desperately the quarterback desires to rid himself of the ball, he stands there like Horatius coolly surveying the situation while his ulcers chew away sizable portions of his stomach lining.

Some teams employ the so-called count system. In this tactic both the passer and receiver count mentally to themselves and the ball is dispatched from point A on the count of such-and-such and intended to arrive at point B at the count of such-and-such. The timing is calculated to the split second, and the whole thing works out splendidly on paper and occasionally even on the field.

When a quarterback is said to flood a zone, it means that he has sent more than one receiver into a certain area of the field.

A receiver who catches passes more often than he drops them is said to have "good hands." If he gets to the ball ahead of the defender, he is said to have "a step on him."

A quarterback will usually prefer throwing a straight pass to a

diagonal (cross-field) one to cut down its chances of being intercepted.

If a receiver gets to where he wants to go without a defender hanging around his neck, he is said to have "broken into the clear."

If a quarterback's prime receivers (flanker, split end, tight end) are all covered, he will throw to a secondary receiver (halfback or fullback). However, if a setback has been designated to catch the ball in the first place, then he is automatically the prime receiver (on that particular play).

The long, deep pass (often thrown in desperation in a losing situation) is called a "bomb" or a "long bomb."

A swift, straight pass is called a "bullet" or a "clothesline." Its opposite is a soft pass.

Some passers "lead" a receiver—that is, throw the ball ahead of him and assume he will get there in time to catch it.

At times, after a quarterback has called a play in the huddle and has gone to the line of scrimmage to await the snap, he will "read" the defense and sense that it is anticipating the *planned* play, or that a blitz is imminent, or he detects a weakness in the defense that tells him that another play would be more successful. He then calls the signals in such a way that alerts his teammates to the fact that he has canceled the previously selected play and is calling a new one. This tactic is called an automatic, or an audible, or a checkoff.

Of course, the middle linebacker may smell out the automatic and call his own automatic to negate the quarterback's automatic. Four or five plays will have been selected beforehand for a possible automatic situation.

# DEFENSE

ALTHOUGH WEBSTER'S DICTIONARY clearly indicates that the word *defense* should be accented on the second syllable, no football aficionado would say it any other way but with the accent on the first. Thus, defensive linemen becomes *de'*fensive linemen and so on. If this seems

illogical, it merely reiterates the idiosyncratic character of everything pertaining to football.

Be that as it may, some of today's defensive players are receiving almost as much publicity as the offensive stars, and a good bluffer can carve a small niche for himself by reiterating at every opportunity that the real heart and soul of a football club is its *dee*fense.

The following are the defensive positions:

(LE or DE) —Left End
(LT or DT)—Left Tackle
(RT or DT)—Right Tackle
(RE or DE) —Right End
(SL or LB) —Strong Side Linebacker  (Outside Linebacker)
(ML or LB)—Middle Linebacker
(WL or LB)—Weak Side Linebacker  (Outside Linebacker)
(SC or DB) —Strong Side Cornerback
(WC or DB)—Weak Side Cornerback
(SS or DB) —Strong Side Safety (Tight Safety)
(FS or DB) —Free Safety (Weak Side Safety)

There are also defensive positions on kicking situations, but these will be discussed in the section on specialty teams.

Just as the offensive team employs formations at the line of scrimmage, so does the defensive team. There are basic defense formations, not so basic formations, and unorthodox formations.

The basic defense formation is the 4–3–4, known in football parlance as the 4–3, and means that the four linemen are in front, three linebackers are behind them, and the remaining four backs are behind *them.*

Like everything else in football, the 4–3 is a misnomer, because instead of the four men in the front line, there are actually five—the strong side linebacker lines up at the line of scrimmage next to the left end and facing the offensive tight end (usually, that is).

The basic 4–3, in most coaches' estimation, lends itself best to the two types of defense operations—against the running attack and against the passing attack. If the offense runs, the linebackers become linemen; if it passes, they fade back and become backs.

On paper, at least, the 4–3, if properly executed, should allow the offense not one yard of gained territory. It is a man-for-man de-

fense with each defensive player (except the free safety) assigned an offensive opponent to contain.

But things don't always go this smoothly. Maybe the offensive team has a receiver who is faster than anyone on the defense? Maybe the offense has an outstanding runner who gains fantastic yardage on sweeps around end? Maybe the offense pulls a couple of linebackers out of position with a fake and then makes its gain with a short pass? Maybe anything?

The defensive coach or the middle linebacker, who usually serves as the counterpart to the quarterback on the defensive team, may call a 5-2 to counteract the offense's strong running attack around end. In this formation *two* of the linebackers line up on the line of scrimmage, lending extra strength to the front line and allowing it to cover a wider area. Sometimes the middle linebacker lines up on the front line in the 5-2, then moves back into his normal slot if he sees a pass situation. However, by removing a man from his normal position, the defense leaves a possible gap in the middle against the quick, short pass. That's how it goes—you gain one advantage and lose another. It's much like chess—you move to check an opponent's strength and he countermoves to check your check; you react to him, he reacts to you.

Suppose the pass receiver is too fast or too tricky to be covered by one defender. You then double-team him or assign two men to cover him. This is also called the 2 on 1 and two-timing. But now you have lost a man in the defensive setup leaving another potential receiver uncovered, or only partially covered.

Suppose you decide to blitz. Your middle linebacker, or two linebackers, or all three linebackers (and/or safeties) go charging merrily in at the quarterback. What's the danger? He is liable to throw a quick pass to the middle that the linebacker would normally be guarding, or call an automatic draw or screen play.

Again, you gain an element of surprise and possibly a chance to mash the quarterback into jelly—at the same time you risk the danger of losing yardage or being scored upon.

If he fears a long pass, the coach or middle linebacker may call for a zone defense. In this maneuver the linebackers and secondaries (defensive backs), instead of covering a particular man, are assigned an area to cover. Any receiver who wanders into their zones automatically becomes their responsibility.

Usually the zone defense works out this way:

The weak side linebacker covers the area just ahead of the split end called the flat. The middle linebacker and the strong side linebacker cover the short middle, and the strong side cornerback covers the short zone in front of the flanker—the other flat.

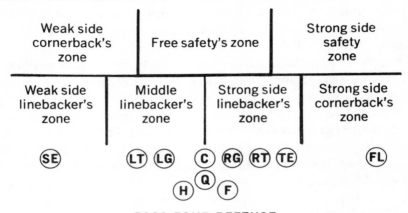

**PASS ZONE DEFENSE**

The weak side cornerman covers the deep area behind the weak side linebacker; the free safety covers the deep middle; and the strong side safety plays the deep zone behind the strong side cornerback.

To counter this defense, the quarterback will split his wide receivers even wider, drawing the defense out toward the sidelines, then send a receiver or two into the holes that have formed between the zones in the shorter middle.

Again—gain something, lose something.

At times the linemen and linebackers will pull a trick called stunting, or gaming, or looping. This simply means that they exchange assignments as the ball is snapped. The linebacker may come charging in and the lineman might fade back to cover a receiver.

Or, the middle linebacker may move toward the end of the line to compensate for a fullback who has lined up in the slotback or wingback position.

Or, the defense may adopt the so-called Frisco defense to check a running attack from the strong side. In this tactic the defensive front linemen shift toward the strong side, while the middle linebacker shifts the other way to cover the weak side.

Or, the defense might call a force, which means that a defensive back anticipating a running play to the outside would try to turn the

play inside before it has a chance to fully develop, and where it would be more easily contained by his teammates. He would accomplish this by confusing or distracting the men who will be running interference for the ballcarrier and causing them to botch up their blocking assignments.

The most famous defensive maneuver and one that delights football buffs every time is the blitz, also known as the red dog, the crash, the blast, or the shoot. In this two step of organized mayhem, the linebackers and defensive backs, singly or in packs, go roaring through the offensive line the second the ball is snapped, trying to smother the quarterback before he has a chance to pass or hand off. It's a stimulating sight to watch a half ton of enraged humanity bearing down on a startled quarterback, but knowledgeable football strategists consider it more of a grandstand play for the spectators than a viable defensive tactic. A superior defensive line of four good men and true negates the need for frequent blitzes.

By the way, if you want to score valuable points in the bluffing game, scream "blitz!" every so often as the ball is about to be snapped and sooner or later you will be proven right. A possible tip-off to a developing blitz, if you are sitting close to the action or watching on television, is when the linebackers seem to lean forward more than usual and running in place as the steam seems to be shooting out of their ears in anticipation of the charge.

Of course, they may only be *simulating* a blitz in order to worry the quarterback and force him to throw sooner than he would normally.

Another valuable trick in the defensive arsenal is forcing fumbles. Although ballcarriers and receivers are taught to hug the ball as if it were their sweetheart, a clever defensive player can sometimes part the man from the ball, especially when the officials aren't looking. A smart crack on the arm, a kick in the elbow, or a slam in the kidneys might persuade the ballcarrier to loosen his grip. Sometimes the defender simply tears the ball from the other's grasp.

Let's take up the defensive positions and their respective assignments and responsibilities on running and passing plays:

## LEFT END

One of the fearsome Front Four, or Fearsome Four, or whatever the sportswriters are calling them these days.

The left end is a cuddly creature who runs up to 260 pounds and loves to eat quarterbacks for breakfast.

His opponent on most plays is the offensive right tackle, over whom he must run in order to get to the quarterback in a passing situation. On running plays the defensive end must not only plug up the middle of the line but must be alert for end-around runs. His prime responsibility in running situations is to knock down the interference so that a teammate can go in and tackle the ballcarrier. He will also try to force all wide runs inside.

On pass plays he will belt the offensive tackle in the chops, or knock him down, or push or pull him out of the way, or jump around him to get at the quarterback, then rush in with his hands high to possibly block or deflect the pass and to screen the quarterback's view.

He is in a particularly good position to break up the short screen pass.

## LEFT TACKLE

These are the true behemoths of the game—it's not unusual to find 350-pounders playing the position.

Imagine the quarterback's reaction to two such brutes, bearing down on him with legal murder in their hearts!

A smart defensive tackle depends on several tools to gain his ends. One, his mammoth bulk. Second—his forearm, which is usually taped and padded and represents a truly lethal weapon. With this animated club, the defensive tackle stuns opponents into submission. He pounds it on a guard's helmet until the other's brain rattles like a glockenspiel. He brings it up from the floor under the guard's chin and cures all his postural defects in one mighty blow.

When he gets tired of working the forearm, he might butt the guard with his helmet, then pick him up by his shoulder pads and fling him aside like a sack of wheat.

There are two kinds of defensive tackles—those who tend toward strength and those who tend toward agility. A few fortunates combine both these desirable attributes.

On most plays the left defensive tackle will face the right guard. On passing plays he will rush straight through the middle with hands

high, trying to nail the quarterback. On running plays he plugs up the middle and by sheer bulk tries to halt the oncoming rush of two to four men.

He must be particularly alert against the trap play that would lure him inside away from the flow of the action.

A defensive tackle takes care that the position of his feet doesn't give away the direction from which he will be charging—inside or outside the guard.

## RIGHT TACKLE

Basically the same assignments as the offensive left tackle, but his opponent is the left guard.

## RIGHT END

Basically the same assignments as the offensive left end, but he lines up against the offensive left tackle.

## STRONG SIDE LINEBACKER

This gentleman usually lines up right on the line of scrimmage alongside the defensive end, so that he faces the offensive tight end. When the ball is snapped, he will, most likely, give the tight end a good ram in the brisket to slow him down should that worthy be thinking of running out for a pass. This is known as chucking. He is also alert for end-around runs and might force a wide running play to the inside. On a man-to-man pass defense, he will cover a setback in the shorter zone; in the zone pass defense, he will cover the strong side middle known as the hook zone, and knock down any receivers in that area.

Linebackers are the "utility men" of the defensive team. They must be equally adept at tackling runners, breaking up pass receptions, intercepting passes, and hitting people much larger than they are. The strong side linebacker may also blitz alone, or in company with his buddies.

## MIDDLE LINEBACKER

He is usually the defensive team leader, the guy who will call the defensive signals in the huddle or a defense automatic on the line of scrimmage.

Middlebackers are smart, tough, aggressive men who are seemingly growing bigger every season.

Actually the position represents a fairly recent development in football—there was no such thing as a linebacker until the 4–3 defense was adopted not too many years ago.

The middle linebacker must be particularly skilled at anticipating offensive plays and at making instant adjustments to the attack by alerting his teammates to the offensive strategy. He "keys" or reacts to the opponents' moves and decides counterplays to foil them.

The middle linebacker normally lines up a few yards behind the front four, generally between the defensive tackles and directly opposite the center. He is actually a cross between a lineman and a back—heavy enough to handle offensive linemen, quick enough to bat down passes. In some instances he may watch the fullback for clues to the type of upcoming play. If the fullback remains behind to block for the quarterback and a passing situation seems imminent, the middle linebacker may drop back to cover the short middle against receivers. If the fullback goes out as a receiver, the middle linebacker may defend against him or against the halfback in the short-pass zone.

He might jump around and shuffle his feet before the snap to confuse and frighten the quarterback into thinking that a blitz is imminent. He has to watch out for the line buck and be ready to bowl over the center in his rush for the ballcarrier or quarterback.

In the man-to-man pass defense, if both backs go short to the same side for a pass, the middle linebacker may pick up the second man, leaving the first to either the weak side or the strong side linebacker—depending upon which flat is the one flooded. In the zone pass defense, he usually covers the weak-side middle short zone, leaving the strong-side short middle to the strong side linebacker.

## WEAK SIDE LINEBACKER

He lines up a few yards behind the line of scrimmage, either facing the split end or halfway between the defensive end and the

split end. On running plays he covers the weak side end area. Since he has to keep his eyes on the split end in the flat and must generally move around more than his fellow linebackers, he is usually the fastest of the three linebackers. On pass defense plays he covers the halfback on short plays to the weak side flat, or any man entering that area in a zone defense situation. He will also blitz alone or in tandem.

## STRONG SIDE CORNERBACK

He lines up five to ten yards in back of the line of scrimmage and approximately opposite the flanker. It is his job to tackle the runners coming around his end and to cover the flanker on pass receptions in the man-to-man defense. He trails him as far as necessary and keeps him from catching passes in any way that he can.

In the zone pass defense, the strong side cornerback covers the strong side flat. He and his counterpart, the weak side cornerback, are usually the fastest men on a team.

## WEAK SIDE CORNERBACK

Lines up between five and ten yards back from the line of scrimmage, and opposite the split end. He will trail the split end wherever he goes in the man-to-man defense. In the zone pass defense he covers the deep, weak side area. He will also force a running play coming toward his end to turn inside, where it will be easier to contain.

## STRONG SIDE SAFETY

Lines up behind the strong side cornerback, but closer in, between the flanker and the tight end. His pass responsibility is the tight end, whom he usually covers on a man-to-man basis. In the zone pass defense he will cover the strong side, deep area. Occasionally, the strong side safety will blitz.

## FREE SAFETY (WEAK SIDE SAFETY)

This is one of the most important positions on the defensive lineup. Usually he isn't assigned a particular pass receiver to cover and must determine his assignment from the way the offensive play is developing.

He lines up on the weak side and approximately parallel to the strong side safety. When a pass situation develops, he looks around to see which of his teammates is not in good position and assists him in covering his assigned man. If a setback goes deep, it's usually the free safety's responsibility to cover him, but he must determine where the greatest danger exists and try to forestall it. In the pass zone defense his area is generally the deep middle.

In the case of a receiver who is so efficient as to be double-teamed, the free safety jumps in to help out. He is a kind of ambassador-at-large, and the final policeman between the offensive team and the defensive goal line.

At times the free safety will blitz, alone or in company (called a safety dog), but this is a most dangerous maneuver since it leaves the deep middle unprotected against the long bomb.

This completes the defensive lineup.

# KICKING OR SPECIALTY PLAYS

THERE ARE FOUR KINDS of kicking plays in modern football: the punt, the field goal, the point after touchdown, and the kickoff.

Let's consider these one at a time.

# PUNT AND PUNT RETURN

ON A FOURTH and long situation (fourth down and many yards to go for a first down), nine out of ten times an offensive team will punt.

This is especially true if the offensive team is close to its own goal line and knows that by losing the ball (in case it isn't able to

make the first down) it will give the other side an advantage when it takes over.

An important thing to remember is that the moment the ball leaves the punter's foot the offense becomes the defense, and vice versa. Therefore, on a fourth and kicking situation, whole or partially new teams come in on both sides. The kicking team is now composed of the kicker and a team whose job it is not only to protect the kicker, but also to tackle the punt return receiver.

The punt return team has its two deep receivers drop back between forty or fifty yards behind the line of scrimmage, or into its own end zone, and the one to whose side the ball sails, takes it for the run back. On punting situations the receiving team will usually field a front line of six men, with three men playing the middle, and two deep.

The kicker lines up some fifteen yards behind center and as several of the defenders come charging in hoping to block the punt, he kicks the ball without letting it touch the ground. The second he has the ball in the air, the linemen of the receiving team first bump opposing players, then run toward one or the other sideline and form a wall of blockers that runs parallel (not *perpendicular*) to the sideline. The backs also help in the blocking. The receiver who hasn't caught the ball hits the first opposing player to come downfield, and the punt returner now streaks along the sideline behind his wall of blockers, trying to gain as much yardage as possible.

At the same time, of course, the kicking team is racing to nail the receiver.

The purpose of a punt is to gain a position closer to the opposing team's goal line. If the return can be kept to a minimum, this puts the ball closer to the receiving team's goal line and when *it* is forced to punt, perhaps the first team's return will put the ball nearer the enemy's goal line than it was in its previous offensive position.

Two things are vital to a successful punt: the distance it is kicked and the time it hangs in the air before it is caught. Obviously, a high kick is desirable, since it allows the kicking team to get closer downfield to the receiver and to nail him on the spot of reception.

At times, when the receiver sees that the opponents are close enough to tackle him before he will have a chance to get very far, he will hold up his arm to signify a fair catch. This means that he cannot run with the ball once he has caught it, and his team will take over the ball on that spot. He must catch it, otherwise it's a free ball. It

also means that the opposing team can't tackle or otherwise rough him up.

Of course, the punt may be a fake in the first place.

# KICKOFF  AND  KICKOFF  RETURN

TO BEGIN THE FIRST and third quarters (the first and second halves); following any score such as a field goal and a point-after-touchdown attempt; and following a safety, and a free catch (optional), we have the kickoff (also called the free kick) and the resultant kickoff return.

The kickoff means that the kicking team lines up in one row, shoulder to shoulder, with the placekicker in the middle, then the fun begins.

Kickoffs are kicked from the kicking team's forty-yard line, except in the safety kick, where it is kicked from the kicking team's (the team scored-upon) twenty-yard line.

Only following a fair catch or a safety can the free kick be *either* a punt or a placement kick. In the other situations it *must* be a placement kick, in which it is permitted to use a kicking "T," which is a three-inch-long piece with two prongs, against which the football can be propped. Or the ball is simply fitted into a depression in the field and kicked from there.

Because the kickoff and the subsequent return are the most dangerous maneuvers in football (two teams of eleven men each running full tilt into each other) they call the kickoff team the suicide squad or the kamikaze squad or the bomb squad.

The way it works is that the kickoff team lines up in one row, shoulder to shoulder, about five yards apart, with the kicker somewhere in the middle and the safety man next to him. The safety man on the kicking team is the one who drops back to defend the goal line in case the kickoff returner gets through the rest of the team.

The placekicker on the team is usually the one who kicks off. He kicks, and the men go flying downfield maintaining a proper distance from each other so as not to leave a weak spot in the line.

The receiving team has been lined up with a five-man semicircle in front, with the center at the apex and stationed some ten yards in front of the kicker. The guards fan out to each side of the center and some yards back, and the ends complete the half circle.

Four of the roughest men on the team, usually tackles, form up in a four-man wedge some forty-five yards from the kicking line and ten to fifteen yards in front of the two deep receivers, who are spread left and right.

As the kicker boots the ball, the center comes tearing in to try to rip off his head. Although punters and field-goal kickers are protected by football law, the kicker on a kickoff is not and he must be agile to avoid being demolished by a charging center.

As the ball is caught by one of the deep receivers, the captain of the blocking wedge decides in which direction he will be running, and the merry chase commences (unless the receiver has called a fair catch).

To negate the usefulness of the wedge the defending (kicking) team employs a so-called wedge-breaker. This foolhardy man must haul his lonesome body at the four beefy gentlemen thundering down the meadow and, hopefully, break up their formation.

If the kick sails into the end zone, the receiver may either run it back or down it for a touchback. This means that the ball will be brought out to the receiving team's twenty-yard line, and there put into play. If the kick goes out of the end zone (beyond it), it is an automatic touchback.

If the kicking team is anxious to hold on to the ball (particularly in the closing minutes of a game that they are losing), it will attempt an onside kick, a short kickoff that will put the ball close enough on the field for the kicking team's men to recover—but it must travel at least ten yards before the kicking team may recover.

# FIELD GOALS

THE NEXT KICK TO CONSIDER is the all-important field goal.

When a team wants to chalk up three points on the scoreboard and is close enough to the opponent's goal line (usually forty yards is considered a safe distance), it calls for its elite specialist, the place-kicker.

These gentlemen often don't bear the slightly resemblance to football players. They may be skinny potbellied, baldheaded, aged,

or myopic; they may not know the first thing about running, blocking, tackling, passing, or receiving; they don't even have to know the football rules. All they need to know is how to kick the football over the crossbar.

Recently, foreign soccer stars have been hired by NFL teams to do the placekicking. Some kick with the side of the foot, some have even kicked in their stocking feet or barefoot. The most remarkable field goal in football history is the record kick made by a placekicker who has no toes on his kicking foot—the sixty-three-yard boot by Tom Dempsey of the New Orleans Saints in the November 8, 1970, game against the Detroit Lions.

Teams will attempt a field goal in many situations, and many games are won and lost on the basis of a field goal. This is the way it works. First, the offensive team will run the ball toward the middle of the field on the play preceding the field goal attempt. Then, having gained good position, they call for the placekicker. He takes a stand perhaps nine to ten yards behind the line of scrimmage. The man who will hold for him, often the quarterback, kneels about six-and-a-half yards behind center and awaits the snap. The center passes the ball in such a way that the laces of the ball will face upward and away from the kicker's toe, toward the goalposts. The ball is held by the holder's forefinger, the kicker takes two steps and kicks it out from under the finger and, hopefully, over the crossbar. Kickers wear special kicking shoes with square toes and make a big fuss over them.

The defending team will do anything within reason to block the kick. They'll try to block it from the inside, they'll try to block it from the outside. They might line up as many as ten of their men on the line of scrimmage and rush the kicker. The offensive line strains to hold them back for the few seconds it takes for the ball to leave the kicker's foot.

# THE POINT AFTER TOUCHDOWN

THE POINT AFTER TOUCHDOWN, or extra point, or conversion kick, is basically the same as the field goal, except that the center snaps the ball from the defending team's two-yard line. Otherwise the same principles apply.

# STRATEGY AND SEMANTICS

OBVIOUSLY IT WOULD TAKE a book hundreds of pages long to list all the strategies, tactics, inside dope, and terminology employed by the 1,500 players, coaches, and assorted personnel who chart, plan, and execute the 370 games played by professional teams each season. Each team formulates its own thick playbook and maps an individual game plan for every game that it plays. Hundreds of pages of scouting reports, hundreds of frequency charts, and hundreds of feet of film are graded, studied, and filed for future reference. Teams employ dozens if not hundreds of defensive and offensive formations, with a special code name for each. In addition, each team has its own philosophy, its own scouting methods, its own jargon.

A scholarly report analyzing, identifying, and classifying this various data is a job for some aspiring sports historian—we can but touch on some of these items in order to help you establish your authority as a qualified, respected football bluffer.

Here is a sampling:

If an offensive team tightens its formation (draws it closer together), it's a good bet that it will tend to run rather than pass. Vice is, of course, versa.

The first offensive play of the game is more likely to be a run. It's a kind of feeling-out maneuver to test the defensive capabilities.

When a quarterback needs that few yards he will go to a tried-and-true play and a tried-and-true runner or receiver. These are called bread-and-butter or hole-card plays.

Although a game plan is manufactured for each game, the quarterback will often adjust or completely discard it if things aren't going right.

If you see players before the game smacking their own teammates on the helmet and in the shoulder pads, don't become upset. This is designed to start the blood racing and to take the edge off the first contact against the enemy.

Most offensive teams have special goal line alignments planned for when they operate from within their opponent's ten-yard line.

The term "match up" means a man-to-man encounter between

two opposing players who will be butting helmets throughout the game on the line or waging a pass receiver-pass defender competition.

When a team is leading near the close of a game, its quarterback will delay as much as possible in order to hold on to the ball and to "run out the clock" or "eat the clock." At times like that, he will neither pass nor his ballcarrier run out of bounds since both these maneuvers will stop the clock, but will send his runners repeatedly through the middle to keep the clock running. The losing team will, naturally, do everything possible to stop the clock from running.

When an offensive team cannot make the required tenth yard on the fourth down and loses the ball to the other team, this is called a turnover.

Rookies who aren't completely accustomed to a team's codes and signals are often assigned to the specialty teams (kickoff, kickoff return, punt, punt return, field goal, etc.) where the tasks are much more basic.

There are many kinds of blocks, but very often not even an experienced coach knows precisely what kind of block a player has made out on the field—there's simply too much of a commotion going on out there to distinguish one block from another. However, a good football bluffer should be able to rattle off some of these. Basically they are either high or low blocks. The terms vary with teams and sometimes even players. They include a trap block, area block, fold block, cross block, cut block, wedge block, cut-off block, kick-out block, angle block, brush block, drive block, influence block, option block, slant block, zone block, spear block, scramble block, stab block, crab block, log block, ram block.

When a *post-season* game has ended in a tie, the teams go into a so-called "sudden-death" situation, which means that the first team scoring wins the game right then and there. At this writing the League's rules committee is debating whether to institute this practice into the regularly scheduled games.

The usual weekly schedule of a pro team may run something like this:

*Sunday*—Game
*Monday*—Rest for most players except those that need aspirins and Bandaids. By late Monday the scout returns with his report and the coaches view films of the team's performance and that of their next week's opponent, then break up the

films into segments—kicking, passing, running, receiving, etc. (To make things easy each team sends its films to their opponents.)

*Tuesday*—Movies for the team with each unit watching those parts that concern themselves.

A brief workout on the field for the players. The coaches read their scouting reports on the upcoming opponents; there are discussions, meetings, etc.

*Wednesday*—Heavy workouts with pads and equipment. More films, more meetings. The coaches have been preparing offensive and defensive frequency charts and individual file cards on the enemy, and by Wednesday night the game plan is completed.

*Thursday*—Another heavy workout. The strategic tactics formulated in the game plan are tested on the field. Films and meetings again.

*Friday*—A light workout, no pads, no rough stuff, yes movies, yes meetings.

*Saturday*—A light workout in the A.M. Big meeting, perhaps a communal dinner, then early to bed.

*Sunday*—Pregame meal, final meeting, prayers, game, and the whole process begins again.

To belly back means that an offensive ballcarrier retreats a step or two to allow his interference to form up before him for the running play.

When a man floats it means that a lineman or pass receiver takes his time moving forward instead of rushing to complete his assignment. It's usually a faking maneuver designed to confuse an opponent.

Frequency charts are statistical reports made on opposing teams, showing when and how a defensive or offensive team is most likely to react in any given situation.

Most teams keep report cards on their own players, grading their every move. At contract time these report cards show how well or poorly the player has executed his assignments the year before.

To be quick off the ball means to leave the line of scrimmage quickly once the ball has been snapped.

A no-cut contract means that the team is stuck with paying a player even if his performance falls below the acceptance level.

A long count or a quick count refers to the number on which the center snaps the ball to the quarterback. It may be on the second "Hut" or on the fifth. A long count is designed to draw the opponents offside before the snap.

The speed of NFL players is judged by the time it takes them to run forty yards. Thus, players are designated as being 4.6, 4.8, etc.

A clutch player is one who performs well under pressure. On the other hand, to clutch up means to wilt under pressure.

Players don't dress for a game, they "suit-up." Most players are very superstitious about this practice and go through an entire ritual before each game.

Two-a-days are the twice daily workouts most teams employ in training camp.

When a quarterback detects a blitz, he is said to "pick it up" or "pick up on it."

To read a defense means to decipher it.

When a quarterback is skilled at mixing his passing and running attack, he is said to move the ball well against the opposition.

When a receiver first pretends to block, then runs out on a pass return, this is called a delay.

Teams have special code names for opposing players. A middle linebacker may be called Meg, Mike, or Mac; a strong side linebacker, Sam, Sharon, or Sarah; a weak side linebacker, Wanda or Winnie.

To be waffled means to be blocked or tackled with gusto.

To clothesline somebody means to crack them (usually in the neck) and send them head over biscuit.

Pursuit, in football lingo, is the energy and aggressiveness with which a defensive player will chase a ballcarrier who is out of his immediate range of action. Coaches like to say about a boy that he has "good pursuit."

When a player has excellent attributes, it's said that he has "all the tools" to become a superstar.

To influence means to fake.

The extreme corners of the field are called the coffin areas.

To crawl means to try and advance the ball after the ballcarrier's body has hit the ground. It's illegal.

An overly cautious player is called a pussy, or gun shy, or a nice guy (in a derogatory sense).

A gap defense is one in which the defenders line up between rather than head on with the offensive linemen.

A high-low is when two men block or tackle one opponent—one hits high, one hits low.

Stutter means to run at half speed, to hesitate rather than run at full speed.

A loose ball is one still in play, but no one as yet has seized it. An in-flight ball is a loose ball that has yet to touch the ground.

A monster is a linebacker (particularly if he plays close to the offensive line).

A muffed ball is one that was never caught or held by the receiver, and can, therefore, be only advanced by the receiver's team.

## THE DIFFERENCE BETWEEN A MUFF AND AN INCOMPLETE PASS

A MUFF is the touching of a ball by a player in an unsuccessful attempt to obtain possession of a loose ball whose possession has never been established. A loose ball is a live ball that is not in player possession. A live ball is a ball in play after it has been legally snapped or free kicked. It continues in play until the down ends.

A ball that has been legally thrown in a forward pass becomes a dead ball the moment it strikes the ground or goes out of bounds. Therefore, if the ball has or hasn't been touched by the receiver and touches the ground, it is immediately declared dead and cannot be considered a muff. But if a receiver on a kickoff, for instance, lets the ball bounce from his fingers and rolls on the ground, this would be considered a muff since the receiver never actually held possession. In this instance only the members of the receiving team can pick up and advance the ball.

The neutral zone is that area between the offensive and defensive lines before the snap from center.

The picket is the wall of blockers formed by the punt return team.

Piling on means to leap on top of a player after he has been already downed. It's a no-no.

When a coach says that his team has overall depth, it means that he has good substitutes available at all positions in case the first-stringers are knocked out of the game.

A rotating defense is used to describe a maneuver in which the defensive secondary rolls over toward the strong side to countermand a play developing in that area.

A nervous or oversensitive pass receiver or ballcarrier who might look around to see if anyone is coming in to clobber him is said contemptuously to "hear footsteps."

# NAME DROPPING

AND FINALLY, the arduous bluffer must cherish a reservoir of names guaranteed to stir up excitement and generate lots of oohs, ahhs, and appreciative chuckles: they should be sprinkled like salt or pepper to spice up moribund football conversations.

Roll a few of these around your tongue and try them on for size:

BRONKO NAGURSKI—fullback and tackle, Chicago Bears (1930–1937, 1943)

SLINGIN' SAMMY BAUGH—quarterback, Washington Redskins (1937–1952)

DON HUTSON—split end, Green Bay Packers (1935–1945)

CRAZY LEGS HIRSCH—flanker, Chicago Rockets, Los Angeles Rams (1946–1948, 1949–1957)

FRANKIE ALBERT—quarterback, San Francisco 49ers (1946–1952)

MARION MOTLEY—fullback, Cleveland Browns, Pittsburgh Steelers (1946–1953, 1955)

OTTO GRAHAM—quarterback, Cleveland Browns (1946–1955)

TUFFY LEEMANS—fullback, New York Giants (1936–1943)

KEN STRONG—kicker, Staten Island Stapletons, New York Giants, New York Yankees (1929–1937, 1939, 1944–1947)

STEVE VAN BUREN—halfback, Philadelphia Eagles (1944–1952)

HUGH MC ELHENNY—halfback, San Francisco 49ers, Minnesota Vikings, New York Giants, Detroit Lions (1952–1964)

CECIL ISBELL—quarterback, Green Bay Packers (1938–1942)

MEL HEIN—center, New York Giants (1931–1945)

SID LUCKMAN—quarterback, Chicago Bears (1939–1950)

JIM BROWN—fullback, Cleveland Browns (1957–1965)

RED GRANGE—halfback, Chicago Bears, New York Yankees (1925–1937)

# The BLUFFER'S GUIDE

## *to*

## ANTIQUES

by **ANDRÉ LAUNAY**

American Editor: **JUNE FLAUM SINGER**

Introduced by **DAVID FROST**

# INTRODUCTION

Except for second-hand car salesmen, dealers in antiques are prob-ably more adept than any other at relieving the innocent and the unwary of their dollars whilst convincing them that they have just acquired the bargain of a lifetime. Of course they don't point out whose lifetime.

In fact, upon reflection they give you an even worse deal than your average second-hand car salesman . . . at least with him you get taken for a ride, even if it's a lot shorter than you hoped.

However, there are certain pointers that even the most un-knowledgeable of us should observe . . . and this little book of course will give you a lot more . . . when we are dealing with an-tiques, with people who are trying to sell us antiques or with friends who are boasting about the antiques they acquired for a song on a shopping spree through the backwoods of New England.

For instance, I suggest that you do not gladly put your trust in somebody who shows you:

George II's desk with the original Formica top.

The color chart that Michelangelo used to paint the
ceiling of the Sistine Chapel.

The original cast recording of Handel's *Messiah*.

George Washington's water bed.

Be wary of a friend who calls up and tells you that for only twenty-five dollars he managed to pick up an original Chippendale television cabinet with the name of the maker, and the date 1785 written inside a drawer with a Magic Marker; or of a once-only offer

73

of eighteenth century telephone tables, as used by the members of the court of Louis XV.

Of course it's true that in boxrooms and cellars and tucked away under the eaves of country houses there is probably a treasure horde of antiques, and indeed some dealers make a very good living just going around the country asking people, "How much do you want for the old chest in the attic."

One dealer collected a black eye earlier this year when he tried it at a house near Deerfield, Massachusetts . . . seems the owner's wife was upstairs at the time.

Interestingly many mobsters have invested their money in antique furniture and paintings . . . and they had better get the real thing or the antique dealer is likely to find himself at the bottom of the Hudson in the trunk of a genuine thirteenth century Cadillac.

I remember one man who was being shown around a reformed hood's mansion, stocked with treasures, out on Long Island. When they came to the art gallery the mobster, pointing to the various paintings, said: "Dis one is a genuine Stravinsky. . . . Dis one's a genuine Ravel . . . and dis one here's a Dubussy. . . ." Finally the man plucked up enough courage to say, "But Mr. [let's say] Jones, those men are all composers."

The mobster lifted him up by his lapels and said, "For me dey paint."

But do at all times remember your sense of history. In an antique shop in Philadelphia recently I saw a colonial bed priced at $30,000. "Why so high?", I asked the proprietor, and he said, "Oh, sir, this bed is very rare. It's the only colonial bed George Washington never slept in."

It has in fact been estimated that if ever he was to have slept in all the beds he was supposed to have slept in, Washington would have had to have made three roadside stops a night.

No wonder he's called the Father of his Country . . .

DAVID FROST

# FOREWORD

A thing of beauty is a joy for ever:
Its loveliness increases; it will never
Pass into nothingness . . .

Having thus quoted Keats while deftly handling a vase with poly-chrome painting reserved on dark blue ground reticulated in gilt, follow the recitation with a statement about the vase being an excellent example of 1770 Worcester, providing, of course, that you already have checked that it has the correct fretted square mark on the bottom.

Evidence of such knowledge, delivered with the right panache and a hint of admiration for the antique in question, will not only gain you respect among connoisseurs but, more importantly, could win you a fortune from your rich aunt.

Rich aunts invariably love animals and antiques. They tend to leave their cash to the SPCA and various foundling homes for cats and dogs, but antiques are usually handed on to the nephew or niece who has shown appreciation for the mid-eighteenth century silver Cripps chased rococo coffeepot, or gone into raptures over the mother-of-pearl-inlay papier-mâché cigarette box.

Since National Educational Television has shown a series of programs on various antique articles, and since much publicity has been given to "your treasures in the attic" in various media, the vast public has been rushing up to attics and down to cellars to unearth long-lost and better-forgotten bits of bric-à-brac, believing them to be worth a fortune.

The disdain with which consultants handle these precious belongings and declare them to be reproductions of no value has not only stunned the owners into permanent silence, but has awakened in many others a desire to be equally knowledgeable on the subject.

This book may not turn you, overnight, into a walking encyclopedia of antiques but it will help you to know whether a piece is old or new; if a table is made of oak, mahogany, or walnut; if it is sixteenth, seventeenth, or eighteenth century.

75

If you have a good memory you will be capable of throwing into a conversation such words as *epergne, marquetry,* and *vernis Martin.* This will make others think you know far more than you do—and to baffle the collector, the dealer, and your aunt is one sure step toward becoming an expert in their eyes.

## ANTIQUE DEALERS AND THEIR SHOPS

There are a number of ways of losing money. Buying antiques is one of them.

Enter an antique shop in the wrong frame of mind and you are bound to come out believing you have a bargain, when all you have done is overdraw your checking account and confirm your bank manager's opinion that you are an idiot.

The approach is all important when you decide to buy an antique. Leave behind your mink coat and your diamond rings. The well-dressed, well-Cadillacked customer is doomed from the start. Antique dealers look at your shoes and accessories before they look at the whites of your eyes. They can tell at a glance what sort of sucker you are. Bare feet or sandals in winter, stadium boots in summer, will throw them a bit. A well-practiced expression of disappointment at the pathetic show of objects on sale will get you a discount—except on Madison Avenue of course.

The main thing, wherever you may be, is to be as smart as the dealers. To be that, you have to sum them up within seconds of entering their kingdom. The following guide should help.

Basically there are two definite types of antique dealers. The professional and the amateur.

The professionals regard the amateurs with mixed feelings. On the one hand they are reliable suckers on whom the professionals can unload all their unwanted junk at a good profit. On the other hand, they get in the way at auctions, bidding at the wrong time and upping the prices when it is quite unnecessary.

It is wrong to believe that dealers compete with one another. Very much to the contrary. They are one strong brotherhood, united in the cause of ruining everyone except themselves. Once they have

done that they may start cutting each other to pieces, but that day has not yet come.

If one dealer advises you against going to the guy next door, it is not because he is a rotten cad knifing his competitor in the back; it is because you are a nonbuying pest and he doesn't want his friend in the next shop to be bothered by a time-consuming browser. A dealer *likes* to have other dealers on the same street. That makes it an "antique center." One shop on a street doesn't attract people from other towns or even from out of state. Many shops situated together do.

## THE AMATEUR ANTIQUE DEALER

The amateur antique dealer is easily recognizable and quite different from the professional. He comes in two distinct models—the Rich and the Poor.

The Rich are mean because they are collectors at heart and hate parting with their goodies and don't really have to. The Poor are mean because they can't afford to be anything else.

Both have private incomes on which they rely for their living. When they are ladies, it is usually their working husbands who make up the private income. When the dealers are men, they usually have a wife tucked away running the local beauty parlor and bringing in the bread. Their status as dealers depends entirely on how much of that income they pour into the business.

The Rich amateur antique dealer is the easiest to find. There is one to be found in every country or suburban town. There are hundreds cleverly hidden in remoter parts, usually surrounded by glorious windswept views.

These places are advertised in the "in" antique magazines with all the pretense of social standing one could wish for. The shop will be a converted barn or the dealer's own living room (or what appears to be his own living room with everything for sale).

In the place of honor, a fireplace fitted with glass shelves and floodlit, or a Victorian bath hung sideways on the wall and used as a display cabinet, will be the highly prized genuine pieces of porcelain,

all in prime condition, all of which can be bought most likely for less from a "professional" dealer with a proper business address which is where they probably came from in the first place.

Scattered about will be the lesser pieces, perhaps in less prime condition, that probably came from the Poor amateur antique dealer's abode.

Under the genuine-looking pieces of furniture will be found subtle price codes, or a "confidential" bit of information about them which will have been gathered from various old books after a great deal of research, and which may be totally wrong.

Don't buy here except in the opening week when the owners won't know what they are doing and will be so frightened at having actually to "take" money that they might give something away if you admire it enough. This attitude toward commerce, however, is short lived.

The Poor amateur antique dealer does not trade with such panache, but he is an intellectual with a Princeton degree in art history—which is why he is able to stand the life.

He has no shop, but a garage or an old woodshed next to his widowed mother's derelict house. In it he has vast quantities of useless furniture that he has bought cheap at country auctions. For years this merchandise has been waiting to be repaired, stripped, or revarnished, but he knows that his stock, once painted and repaired, will be worth a fortune.

He spends most of his time at such country auctions scoffing and sneering at his richer colleagues for buying rubbish he can't afford; he, being the scholar, is more knowledgeable; they, being commercial, make and spend money. His shop is generally closed as he is usually at these auctions. If you can find him "in," a bargain may be found inside a damp and moldy Victorian sideboard, or under a high stack of broken chairs. If you would like to purchase one of said broken chairs, forget it. They are usually not for sale as he is always going to repair and refinish same, sometime, and get the proper price for the very valuable article.

Take note. If you would purchase a bargain in an Early American brass candlesnuffer, be aware that brass purchased from Poor Amateur Antique Dealer takes approximately seventeen and a half days of continual rubbing to get clean.

## THE PROFESSIONALS

There are a number of different categories under this heading which can be narrowed down to six distinguishable types. All have one important thing in common—the fact that antiques are their bread and butter. They have to make a profit on everything in order to eat and pay the rent. Anyone who says differently is likely to get the jagged end of a halberd (edged and gilt, German, 1570) where it hurts most.

A professional's success is due not only to astute dealing but also —and much more—to knowledge. It is the man at an auction who spots that a table is an American Hepplewhite Mahogany Tilt-top, circa 1790, when everyone else there believes it to be a reproduction, or can confidently date a piece of silver because he knows the marks, who wins the day. Such knowledge can only be acquired by study and experience in the trade, and the people who have it deserve whatever small fortune occasionally comes their way—which is all the support they're going to get from me.

Let's start in the bargain basement.

## THE THRIFT SHOP

This shop might fool you. It is loaded down with old things; old furniture, old coffeepots, old clothes, old books, old magazines, and old records. And loads of assorted old pieces of china and chipped enamel pots. You are just positive that you will find a rare and precious antique there, somewhere, under that pile of old glass shades. You are positive that amongst the piles of dusty and dirty books you will find a first edition (illustrated, of course) of *Alice in Wonderland*. You most probably won't! An old chair, circa 1930, yes. A fine antique chair, no!

The proprietor of this store (be he a dirty old man in every sense of the word, or the Bohemian lady dressed in her Bohemian clothes of another era) is quicker to recognize that odd antique rarity that may show up in his odd-lot buying than you are. He is quick to sell it to a richer dealer who knows where the dog's bone is buried or, in other words, has a customer who is willing to shell out for the item in question.

These "thrift shops" or "secondhand stores" are located all over
—in the country and in the city.

Also to be included under this heading would be places like the
Salvation Army or Goodwill stores where you could find something
antique and rare maybe twenty or twenty-five years ago. Now, the
people who run these establishments are also sharp eyed and bushy
tailed. The antiques that fall into their hands are quickly turned
over to fancy dealers who are willing to pay a good price to get a *great*
price. The merely "good old" is priced quite high at the old stand.
Serviceable, secondhand, utilitarian goods are the only bargains
there.

## THE COUNTRY TOWN OR VILLAGE ANTIQUE SHOP

This is a different copper kettle of fish. In such places top
antique-dealers-to-be learn the tricks of the trade.

Here, reasonably knowledgeable people have had sufficient busi-
ness acumen to start trading. They are successful either because they
do not charge exorbitant prices—keeping to an SPQR policy (small
profit quick return)—or have perfected the art of buying their stock
cheaply. Such people come in different shapes and sizes, the most
popular being the young man who gives you the impression that you
are much cleverer than he, and so very artistic that a certain objet
d'art he has had hanging around since he opened could be beauti-
fully converted, only by you, into something frightfully improbable
but golly gee what fun!

When he buys (either something you have brought to his shop
to sell or invited him to see at your home), he will glance at it with
great disdain and make you realize straight away that he, as a dilet-
tante connoisseur, couldn't possibly ruin his aesthetic senses by hav-
ing such a thing on his premises.

He will, however, admire something you don't value, buy it for
an unexpected price, then offer you a little something for the piece
you originally wanted to sell—because he doesn't want to disappoint
you.

A year or so later you will learn that "your piece" was worth a

small fortune and that he sent it straight to an oil-money Texan in Houston or to a car-money society lady in Grosse Pointe.

## SOPHISTICATED, STUCK-UP, SNOBBY, SNOOTY SUBURBAN SET

In the oppressive and overcivilized areas, where colorful plaster gnomes and daily weeded flagstone paths are seen in the company of white-painted wheelbarrows overflowing with trailing geraniums and pair upon pair of carriage lamps hanging on either side of front doors with bell chimes, the collector can meet his doom.

Antique shops in such places are spotlessly clean, smell of lavender furniture polish, will have real flowers neatly arranged in a reproduction seventeenth century pewter tavern pot—and outrageous prices.

Genteel middle-aged, middle-class ladies, with blue hair and charm bracelets, will look down their noses at you through tinted spectacles, know nothing of what they are doing, and make no attempt to speak to you, get to know you, or sell you anything.

If you are really persistent you may get to know the price of a Meissen plate or a cream pitcher. But what you are really expected to do is walk in and say, "I'll take that and that and the secrétaire à abattant," without another word. I suppose they hope that by sheer intimidation that's exactly what you'll do. If you pay cash, they'll grab your money and then give you scornful glances—who but inferiors carry cash about these days? If you offer to pay by check, they will give you a knowing look and check out your credentials carefully. They will wrap your smaller pieces in pink tissue and take your address to which the secrétaire might be delivered in three months' time.

Be prepared to pay "top dollars" and hope that you got the genuine thing.

## THE MADISON AVENUE SET

This can be Madison Avenue, or Fifth Avenue, or Park Avenue, maybe just possibly Lexington Avenue in some minor cases. It can

be East Fifty-seventh Street, and all cosmopolitan centers have their counterparts.

You have to have special training to walk into one of these shops, and calling them "shops" may well disqualify me from entering any of them in the future.

I do assure you, however, that I use the word "shop" as a term of amused endearment.

If you haven't a founding-father name like a Van something or other, make one up. Dress expensively but soberly. Women should wear hats, men should remove theirs on entering, and children should never be seen or heard.

Arrive in a chauffeur-driven limousine, a taxi, or smart sports car of foreign make. Never talk money or ask a price. Admire and buy, or get out.

Try and find out beforehand who the sales manager knows whom you might have heard of, and don't ask to see the owner; he is always in the south of France or the Greek isles.

Try not to pick up the Georgian silver cigarette box which is not for sale, but placed there, full, for *reliable* customers only.

If you imprudently decide to buy anything, make sure the name of your bank is acceptable.

Don't ask for your purchases to be wrapped or expect to be allowed to take them away. Everything is sent to your Park Avenue address—whether you live in New York or not.

## THE FIRST AVENUE CROWD

These are the shops that stray away from the Madison Avenue beat eastward to the river. Some have an interesting mixture of interesting junk and interesting antiques. Some have a few interesting-looking antique pieces, in the window only. Inside they may have an unstrung harp, or an empty grandfather clock case, or a few pieces of interesting but not particularly valuable antique jewelry.

On entering these shops you will find bearded wonders in jeans reading Orwell's *Homage to Catalonia*. Or young girls wearing flowing robes and chanting.

How such places survive is a mystery and one can only presume that any pieces they get are immediately sent out of the state or even

out of the country or that they are a front for some illicit exporting or importing or whatever.

## THE FLEA MARKET OR FORMS THEREOF

There are the country flea markets where all the antique dealers from the countryside flock together on a Saturday or Sunday in spring or summer to try and take advantage of the cars whizzing by on the dusty roads. Here too will be the local farmers or the postmaster or even the man who runs the general store. Everyone has raided his attic and his ramshackle barn and brought out anything that is slightly aged or rusty or cracked and has set himself up for business at a stall or stand. They *know* how all those city folk have gone crazy about old things and they're going to get themselves a city slicker or two.

And they do. A rusty old horse bit? Why not? A very tarnished old cookie cutter? Why not? And that dirty wooden spoon. Very Early Americana. Betsy Ross stirred something up with it, when she wasn't sewing away.

I once stopped at a country flea market where a man was selling, among his other goods, two slightly ragged heads of cabbage along with three used tennis balls and one dented Ping-Pong ball. Scout's honor, and that's the truth.

## THE ANTIQUE FAIRS AND SHOWS

The New York Armory is the place where the grandest antique show takes place annually. The finest shops and galleries take booths there and if you want to window-shop, by all means put on your fanciest face and walk around. If you want to buy, take along your fanciest wallet.

The Madison Square Garden Antique Show is a challenge to your feet as well as to your shopping know-how and your checkbook. Don't expect to find any bargains anymore than you would at the shops of these selfsame dealers.

Then, on a somewhat smaller scale, there are the antique shows

or fairs that are taking place in every city, town, and suburb at the rate of at least one a day, in each and every locale.

The various diseases have their telethon campaigns. The Boy Scouts sell their candy and boxes of pansies from house to house. Any charity left over, be it an orphanage or a church, has a very well organized art auction or antique show sponsored on its behalf. Most have both alternately.

The dealers that flock to these shows bring their stock from their shops and the prices are practically the same in both places. They do like to bring the smaller articles with them, both because of the transportation difficulties and the fact that shoppers at these shows want to buy *something* to take home with them to show for their day. They have paid an admission fee and have walked around and they need a souvenir, if nothing else. So at these fairs many dealers will have buttons, little glass bottles, and little tin boxes (perhaps someone's little liver pills had been in the box around the turn of the century), or something of that nature that you can purchase for fifty cents, a dollar, or a couple of dollars.

Much of the dealing that goes on at these fairs is between the dealers themselves. They frequently are friends, they all know each other (they see each other at least every week at some fair or other), and when one dealer has something that another dealer knows he has a customer for, they will make a deal between themselves.

I have heard some dealers say they can't make a shop pay for itself without the help of the shows and some dealers who would rather just do the shows say they need the shop to help carry the load. In any case they love the shows: they drink coffee all day long with their friends and have a good gossip and the customers don't interfere too much with their socializing.

## THE ANTIQUE HYPERMARKET

For every thousand transient hotels there is a Ritz; likewise in the antique world. A couple of years ago it happened; an antique supermarket to end all supermarkets opened in New York City—the Antiques Center of America with 110 antique shops all together in one place.

This Hypermarket caters to the jet-set collector, the person in

a hurry who only has time to walk round the shops once, fast, yet who can be sure that what he purchases is genuine.

Such a place is not recommended to the person who does not know what he is looking for, but it is recommended to anyone who wants to kill time on a rainy day.

## THE ALL IMPORTANT AND SELDOM UNDERSTOOD TRADE DISCOUNT

TO THE QUESTION "Are you Trade?" or "Are you in the Trade?" always answer unflinchingly "Yes!"

You will then get a discount. If you answer No, it will be generally believed that you have enough money not to care what you are charged.

Antique dealers do more trade between themselves than with private customers (as has already been stated). Their prices are therefore calculated to make the necessary profit with the trade, but, as there is always a chance of making that little bit extra with the private customer, the private customer's price is quoted.

Dealers always make it known that they are "Trade" before asking a price. They are then quoted the private customer's price less about 10 percent, or even less—whatever the selling dealer thinks he can knock off without ruining himself.

To be "Trade" means that you buy antiques to resell, making a profit on the transaction. Whether you resell the pieces that day, within a week, a month, a year, or ten years is irrelevant. If you buy to resell, you are "Trade" and as you are bound to resell sooner or later, there is nothing to stop you calling yourself "Trade," except the pride of not wanting to be associated with the dealing trash.

## AUCTIONS

AS WITH SHOPS AND DEALERS there are different categories of auctions —good and terrible.

Unlike shops and shows, however, there is a good chance of getting a bargain at an auction providing you can keep your head.

## COUNTRY TOWN AUCTIONS

Once a week, or maybe more, an auction is held in many country towns to sell off the accumulated flotsam of someone's life—someone who has sold off his things and taken off for St. Petersburg, Florida, or maybe California or just plain joined the heavenly choir.

Such sales take place in a saleroom, or in some hall or other named the Corn Exchange or The Produce Market. Among the old Morris chairs (soiled, springs apoppin'), early twentieth century refrigerators and typewriters, threadbare carpets and rusty lawnmowers, a piece of porcelain or pottery or an old ice cream parlor chair might be found. This is rare, but it can happen. When it does, ten to one a dealer with a bankroll large enough to make a huge bulge in his pocket will be there to outbid you.

If you really have nothing to do, then an occasional visit to the viewing before the sale is worthwhile. If your time is limited, don't bother with this type of auction, or the next one either.

## NO. 23 MAPLE STREET

### "Sale of antiques and household effects"

In the spring and autumn when everyone's fancy turns to a change of environment, real estate agents are frantically busy selling houses for less or more than they are worth, and auctioneers are frantically busy selling the contents. Sometimes these small "residential" auctions are interesting. Most times they are deadly.

Houses in the suburbs are unlikely to be of great interest to the sharp collector, but small cottages lost in the country or farmhouses or old Victorian houses can be very rewarding. Here, a print or a piece of Staffordshire or maybe a piece of glass from Wistar's eighteenth century glassworks in southern New Jersey, which was given to Grandpa a hundred years ago, will have gained in value and maybe escaped the notice of the local people; but it may not.

Such auctions, unfortunately, are the lifeblood of the amateur antique dealer, and it is more than likely that you will get two rival ladies bidding for a piece of 1828 lacy glass (in fact made in Japan in 1926) and taking it up to an astronomical figure for purely emotional reasons. This invariably results in everyone catching the "I can outbid anyone" disease. The remaining lots will not go for a song but for a whole musical festival.

If you have seen what you want when viewing and can set a price on it and not go above it, then such an auction is worth a trip. A bluffer should always know what the professionals do: in this case the professional always has the lot number written down with the top price that he should pay, if he should have to go that high. This is all recorded in a tiny notebook that he allows no one to peek in (I have tried), and he always writes the price that the article goes for, finally, whether he gets it or not.

## THE ESTATE SALE

The sale will be announced in the Sunday *Times,* the local papers, and antique magazines. It will also be advertised on posters stuck in places where nobody sees them, and well-known dealers will be sent information by mail.

The first thing to do is go to the viewing. This will take place one, two, or three days before the auction, which itself may be spread over two or three days depending on the number of lots.

The house itself will probably be up for sale as well, so you can wander around at your leisure poking your nose into someone else's past. The place is yours until the new owners take over.

In the tool sheds and potting sheds and old icehouses you will find evidence of nineteenth century splendor; they had sixteen gardeners full time. In the kitchens, evidence of medieval slavery: the cook was fat and German and beat her eleven skivvies to death with her rolling pin (Victorian). The belowstairs quarters will be found under the roof—the amenities provided will appall you, but the stables will make you want to own a string of horses and ride across the distant fields every morning on the days when you're not racing. It is as well to remember at this juncture that the people who lived here couldn't afford it either (the property taxes make the head

spin and who can get servants these days), and that's why they are getting out and selling their house to an institution.

In the bedrooms, the magnificence of the ceilings will rival the polish on the parquet floors; in the drawing rooms, the dining rooms, the morning rooms, libraries, and billiard rooms you will find all the family heritage catalogued and numbered and exposed to the cultural eyes of hundreds of connoisseurs.

On the last day of viewing you may catch a glimpse of the famous "The Boys." This manifestation will take the shape of five or six characters (either highly disreputable looking or very "sharp" looking) in a huddle together, whispering and shaking their heads as though they were discussing something illegal in great secrecy. They give this impression because they are discussing something illegal (well, almost) in great secrecy. They are working out how best to lower the prices so that they can buy the goods cheap, and if you want to know how "The Boys" work, or how I think they work, read more about them later under "The Boys."

Here, if you bid right, and you are willing to pay a little more than the dealers (after all they can't go too high as they have to resell at a profit), you may, if you are very, very careful, end up with a fine antique at less than you would pay in a Madison Avenue shop.

## ST. PARKE-BERNET

We use the name Parke-Bernet here as it's the definitive auction gallery, but do keep in mind that there are many other prestigious auction galleries in New York and other metropolises that are as fine if not as famous.

As though entering a church, tiptoe into these sacrosanct premises with a solemn expression—that is all that is required of you. Treat everyone with great respect and if you feel the intense academic and antiquarian atmosphere too claustrophobic, leave.

There are several temples on these premises in which services are held at indeterminate times. A high priest stands in a pulpit with a hammer while a number of servers hold up other people's possessions for sacrifice.

The ritual is simple, quick, and silent. No one but the high priest is allowed to talk, but certain members of the congregation are

permitted to make offerings for the sacrifice. Intention to make an offering is signaled in various ways: the bowing of the head, the shaking of the head, the nodding of the same, the closing of one eye, or the sudden raising of the arm as though wishing to be excused.

When the high priest is satisfied that a suitable offering has been made, he attempts to hit his thumb with the hammer.

The congregation member who is most generous (money is usually found to be acceptable) is obliged to take the sacrifice away with him whether he likes it or not. This can cause some embarrassment if it is a grand piano and he has come that day only with a wheelbarrow.

Top auction rooms are a theatrical experience, a "happening" in the truest form. Students of drama should attend regularly and watch the faces of the bidders. Antique collectors should also attend regularly as this is where they will get best value and genuine antiques.

## THE LOCAL AUCTION GALLERY

This is your suburban or small city or just the corner neighborhood auction gallery. This can be your learning ground before you graduate to the "strict behavior" galleries.

The proprietor of said gallery will hold these auctions on a regular schedule, be it weekly, or every two weeks or whatever. He will not only put up for auction whatever people care to consign to him for his 25 or 33⅓ percentage; he will also buy up estates by himself and auction off the complete household goods, be it pots and pans or fine paintings or the master bedroom suite.

He is usually not above making a prior-to-auction private sale to an interested buyer. The buyer and the proprietor are both gambling here: the buyer is willing to pay a little more than he might at auction to insure that he will get it; the proprietor is gambling that he wouldn't get more at auction.

The auctioneer is usually not a scholarly man—his knowledge is that of experience, not of education. When you buy at Parke-Bernet you are guaranteed of getting exactly what you think you're getting. Here, while you are not usually deliberately misled, origin is usually "alleged" rather than certified.

But you can learn a lot by sitting through auction after auction, even if you don't bid on a thing. The "audience" here is made up of all kinds of people, many of whom never bid but watch the show or make complete notes and observations on the biddings, much like the racing fan who dopes the horses on paper but never makes a bet.

The local housewives come, the minor collectors may come, the amateur dealers certainly come, as well as the professional dealers. The better professional dealers only show up when a prominent local "patron" has departed this world and the word goes out that "fine" antiques and furnishings are going on the block. In these cases, the proprietor-auctioneer contacts the right people. If he has a collection of fine, antique rugs that week, the rug men from all over will show up. When you spot the New York dealers from the finer shops (usually in black suits, black ties, and high-collared white shirts) or "The Boys" you know it's a hot night.

If you attend week after week you will make friends even if you don't influence people. The rich amateur dealers will discuss their stocks with one another, the poor amateur dealer will try to learn what the next poor amateur dealer is interested in, the housewife will try to learn if the housewife sitting next to her is a dealer, amateur or professional, and to see if she can get some tips, and it's all as gay as the local tavern. The important thing is to come early, get a good seat, and have time for all the preauction conversation.

The nondealer bidder hates the dealers and vice versa. Both insist that the other drives up the prices and gets in the way of anyone getting a good bargain. Keep your mouth shut, never answer a direct question like "Are you a dealer?" and when asked your opinion on the value of a certain object smile ambiguously or mysteriously. Just listen!

If you want to be a good bluffer always smile in a superior fashion after having won a prize that you are now, after the heat of the battle of bidding, not sure at all is a prize.

And remember that this auctioneer is not beyond upping the bidding all by himself. When you see the selfsame article that went for a great price the previous sale back on the block again the following sale, you know the auctioneer was his own best customer.

# THE PRIVATE ANTIQUE COLLECTOR

THERE ARE NO PUBLIC ANTIQUE COLLECTORS.

All antique collecting is done in private, either in the depths of an early provincial style Louis XV corner cabinet, on the mantelpiece, or hanging from walls.

Private Antique Collectors usually start off life as little boys or girls collecting fireflies, Popsicle sticks, or bottle tops. Interest in the old develops in the late teens and becomes obsessive when the adolescent buys, with his own pocket money, something which is quite useless but very pretty to look at.

After that it is simply a question of income and how much can be spent on useless objects which are pretty to look at. The more enlightened collector buys tables, chairs, and chests which can be used, but he lavishes such care and attention on these pieces that in the end it is unwise to touch them, and they become even more of a bore to the family than the hundred and two silver items that must be polished regularly every Friday.

Private Collectors are usually quite unaware of what people think of them—especially other private collectors.

Unlike dealers, collectors are very unfriendly toward each other. They are jealous, mean, and sometimes definitely bitchy. As far as they are concerned, the only purpose other collectors serve is in amassing, over a number of years, a quantity of interesting objects which will eventually be sold, thus giving them a chance to amass, over a number of years, a similar quantity of interesting objects which they will eventually sell, thus giving other collectors a chance to amass . . . and so on, ad infinitum.

When buying from a collector, remember that you are buying part of his or her life.

You may be interested in a pair of Walton figures (made by John Walton in pottery from 1810 to 1835 with tree backgrounds decorated with bright enamel colors and black). You have heard of a pair which an elderly lady may sell. You are going to take a bit of her, a part of her life, away. Your approach, therefore, must be kind

and respectful, not as though you were going to take her pet dog to the vet to be put away because it bit the mailman but as though you were personally going to take care of her lovely little dog despite the fact that it bit the poor mailman and might well bite you.

Money is not always what matters most to a collector. A good home for his favorite items is more important, and you must therefore convey that you are a provider of good homes for Bennington Rockingham-ware dogs, Easter canary-yellow pressed Comet (Horn of Plenty) butter dishes, or Dorchester pottery cuspidors, or whatever it might be. A hint that you might in time sell them could totally ruin your purchasing opportunity.

## ANTIQUE  TEACH-INS

THIS IS JUST ANOTHER LABEL for lectures on antiques.

By all means desert me and learn from another source, or even better go and be seen carrying this little book in your hand. Can't hurt.

## THE  BOYS

TOM, DICK, HARRY, JACK, AND MRS. FANCY PANTS (affectionately nick-named all sorts of things by the Trade) are all antique dealers of one shape or another.

On a happy morning in May, or June, or any month you care to choose, these five individuals meet by chance at the viewing of a sale to be held at "The Corbies," Somerset Hills. The house is pseudo from top to bottom, but all the same has an old-world charm, due mainly to its surroundings at the end of a lovely postcard village, and its well-maintained gardens and huge sweep of lawn.

In the house the low-beamed drawing room is packed with neighbors who are curious to know what the late widow-owner left her daughter who has long since gone to greener fields in California where she is still trying to break into the movies. Naturally, the

daughter prefers cash to handed-down sentimental objets d'art, or knickknacks as the case may be.

Our five friends are now in the garage pretending like mad to be interested in an old gasoline can; but in fact they are discussing the English Regency Mahogany Sofa Table (on lyre-shaped supports having arched stretchers) hidden under Lots 46, 47, and 48 in the dining room. It's in poor condition but could be restored and is worth at least $1,000.

They decide that they all want it for less and are willing to risk

THE BOYS' ENGLISH REGENCY SOFA TABLE

up to $875 among them. They then pick Jack to do the bidding because he's the most likely to have a customer for it, and the auctioneer's suspicions must not be aroused.

The following morning, at eleven thirty, Jack, the only one of the five attending the auction, puts in an opening bid of $50. This irritates the auctioneer who knows his job well and suspects the table is worth at least $500. He suggests a more realistic opening bid of $250.

An unexpected New York dealer nods his head and a private buyer bids $260. Jack straight away puts in a bid of $350 scaring the pants off the private buyer and the New York dealer suggests $500. Jack says $600 and there is a pause. The local people are excited. No

one has ever paid so much money for a table before, and what a pity the widow isn't alive to hear it!

"Six ten," says the New York dealer and Jack tops it at $625. No one else bids. The auctioneer is annoyed. It is worth much more but none of the other local dealers seem to be there to compete. Reluctantly he ends the bidding. "Going, going . . . gone!" The hammer comes down and Jack gets the table for $625. He shows no emotion at all but he's secretly delighted.

In the bar of the local tavern, the five meet that evening. The purchase price of the sofa table was $625, so they each put in $125. The table now belongs to all of them, but Jack is rather eager to have it so he says he'll pay $690. Tom (who has a collector-customer willing to pay at least $1,000 without a doubt) bids $750.

Mrs. Fancy Pants suggests $775 and Dick, who must make a bid or get out of the game, mumbles $780. Harry, not interested, backs out. In so doing, Harry collects a share of the profit at that moment in time—the difference between $625 (the purchase price) and $780 —the current bid by the group. This is $155, a fifth of which is $31; he therefore collects $31 for having joined in the plan, plus the $125 he originally invested.

The bidding goes on. Dick backs out at $825 and collects his $42, his share of the profit which is now divided by four people. The table is finally bought by Tom for $885. Jack and Mrs. Fancy Pants each get $93, plus their original investment.

Tom is happy, getting a thousand-dollar table for $885. Harry regrets not having stayed in the bidding a little longer, thus getting more of the profit, but the others are all pleased.

Mrs. Fancy Pants sighs with relief deep inside. She likes to join in with "The Boys" as it makes her feel professional, but she remembers how the professional dealers got the better of her when they first invited her in. On that occasion they told her a mahogany dumbwaiter purchased for $60 was worth at least $375, and she had gladly bought it in The Boys' private auction for $300 thinking she had a bargain. The other members of the group shared the $250 or so clear profit and she had found herself with a reproduction dumbwaiter worth not more than $75.

Members of "The Boys" are sharks; they are sharp enough to do something almost illegal and get away with it, quick witted and mercenary enough to squeeze a fellow dealer if he's not on the ball.

Their game is a gamble for the members, a fair gamble, but unlike other gambles it has an innocent victim—the person selling the piece "The Boys" bid for.

If you have something in an auction worth $500, which you would get if the bidding was all out in the open, you will probably end up with $150 if "The Boys" are present.

# DATES

HAVING IMBIBED THE BACKGROUND to the Antique Trade, you are now equipped to go out into the world of buying and selling and wheeling and dealing and hope you won't get murdered.

Actually, the above does need much experience. At least you'll know how to put on the proper face when making timid forays into the world of the vultures.

But by acquiring certain bits and pieces of information, pure knowledge like dates and things like that, you should *sound* great.

If you can memorize the following dates and contemporary names, you will get a sense of history and gain the immediate respect of all those who can't remember when the first dolls were made in the United States. (Eighteen twenty-six and how about that?)

Our American antiques will start with the Colonial Period which was with us for the years 1620 to 1783.

American antiques are divided into three periods.

| | |
|---|---|
| Early American | 1620–1725 |
| Georgian | 1725–1790 |
| Federal | 1790–1825 |

And then of course, the Victorian period which covered the years 1837–1901.

A very essential thing to remember is that there is a world of difference between American antiques and European antiques. America is roughly three centuries old and Europe goes way back when. American antiques are rare while Italy, France, and England are literally crawling with the things.

Most of our American antiques follow the English style since

the early colonists were mostly from England and they knew and
loved all that was British.

So here are the dates and periods of things English:

| | |
|---|---|
| THE RENAISSANCE | *1450–1650* |
| | |
| TUDOR | *1485–1603* |
|     Henry VII | 1485–1509 |
|     Henry VIII | 1509–1547 |
|     Edward VI | 1547–1553 |
|     Mary I | 1553–1558 |
|     Elizabeth I | 1558–1603 |
| | |
| STUART | *1603–1714* |
|     James I | 1603–1625 |
|     Charles I | 1625–1649 |
|     Cromwell—Commonwealth | |
|         and Protectorate | 1649–1660 |
|     Charles II | 1660–1685 |
|     James II | 1685–1688 |
|     William & Mary | 1688–1694 |
|     William | 1694–1702 |
|     Anne | 1702–1714 |
| | |
| GEORGIAN | *1714–1800* |
|     George I | 1714–1727 |
|     George II | 1727–1760 |
|     George III | 1760–1820 |
| | |
| REGENCY | *1800–1830* |
|     George III | 1760–1820 |
|     George IV | 1820–1830 |
| | |
| VICTORIAN | *1830–1901* |
|     William IV | 1830–1837 |
|     Victoria | 1837–1901 |

Looking at these dates, it is interesting to note how American
styles closely followed the English, almost to the year. It was our
Federal Period that gave us a pause from the British way. After we
put the Revolutionary War out of the way and our Constitution was
launched, we sought to break away from England and the Colonial
past. But more of that later.

While the British are very chauvinistic about their antiques, not recognizing anything else, we must be very thorough and recognize that French antiques are perhaps without equal when it comes to pure beauty. Therefore, *their* dates are very important to the true blue antique bluffer.

| | |
|---|---|
| Louis XIII | 1610–1643 |
| Louis XIV | 1643–1715 |
| Regency | 1700–1730 |
| Louis XV | 1715–1774 |
| Louis XVI | 1775–1793 |
| Directoire | 1795–1804 |
| Empire | 1804–1814 |

To round out the picture here are the important Italian and Spanish dates:

ITALY

| | |
|---|---|
| Renaissance Period | 1400–1600 |
| Baroque Period | 1550–1750 |
| Rococo Period | 1715–1775 |

SPAIN

| | |
|---|---|
| Hispano-Moorish | 8th to 15th century |
| Plateresco | 1500–1550 |
| Spanish | 1550–1650 |

# TRUE ANTIQUES

ANYTHING MADE AFTER 1830 is not considered to be antique by the purists. (If you're not so pure you can roughly consider anything one hundred years old an antique.) But as a fine bluffer, you should really turn your nose up whenever anyone mentions Victorian.

Your attitude toward anyone collecting Victoriana should be one of amused interest. If you are wise, however, you should collect Victoriana yourself: in twenty years' time anything Victorian will be regarded as *truly* antique by those who decide such things—and who they are, only they know. (If you do decide to collect it, for its future worth, of course, do it secretly so that in public you may scoff.)

# FURNITURE

TREES ARE REGIONAL. Certain trees grow only in certain areas of the world. These areas had to be discovered and the woods shipped to the countries that wanted them. All this took time and therefore the type of wood used for a piece of furniture is a primary indicator as to its date.

For example, the walnut tree was not introduced into England until 1587. Therefore no piece of English furniture made of walnut is likely to be older than that date.

*Woods used in antique furniture:*

|  |  |
|---|---|
| DARK WOODS | Mahogany |
|  | Oak |
|  | Rosewood |
|  | Walnut |
|  | Yew |
| LIGHT WOODS | Applewood |
|  | Beech |
|  | Birch |
|  | Elm |
|  | Pine |
|  | Satinwood |

To this list must be added the woods that the early Americans found most convenient to use—convenient because they were there! Chestnut, ash, cherry, maple, cedar, and cypress were utilized as much as the very popular pine and oak.

## THE TUDOR PERIOD

When the Tudors took over in England there were big houses with remarkably little furniture. There was a bed or two, benches, stools, tables, a couple of chairs maybe, but only the master and mistress of the house were allowed to sit on them. Large boxes of all shapes and sizes were popular and they served as seats, tables, and sometimes beds. ("Climb in and see the etching I've done on the inside of this box, my dear.") They are now called chests.

All such furniture was made of oak.

The better pieces were crudely carved and often gilded and gaily painted. This helped to protect the wood against the damp and the insects.

When Henry VIII was crowned, things improved tremendously. He was hell-bent on impressing foreigners and ladies, so he dissolved the monasteries and used their money to build palaces and double beds. The carpenter came more into his own and the practice of joinery ousted heavy plank construction, and paneling for walls became fashionable. To the usual Gothic linenfold and Tudor Rose designs of the carvings were added garlands and profiled heads in roundels, influenced by the Italian artists.

Obvious examples of Tudor furniture to drop names about are:

PLANK CHEST: Box made of hewn planks strapped together with iron bands, the lid attached by wires to make hinges. Iron locks usually fitted. The sides, lower than the front and back, acted as feet.

PLANK CHEST

WAINSCOT CHAIR

WAINSCOT CHAIR: Armchair on a box. Used only by the master of the house. The box on which the person sat was usually a locker—big enough to put a potty in.

GLASTONBURY CHAIR: A folding chair with elbowed arms. Until late in the sixteenth century all chairs had arms. Chairs without arms were regarded as stools with backs and were called back stools.

TRESTLE TABLE: Large rectangular board resting on uprights, or trestles, linked by a rail held in position by pegs. The top, known as the board, gave its name to "Board and Lodging" meaning breakfast and bed. These tables were taken to pieces and stacked when the meal was over.

ELIZABETHAN DRAW TABLE: A massive table with a draw-leaf device for extending when the Queen came unexpectedly for lunch. Huge bulbous legs, heavy carving round edge of top. Often referred to as Refectory Tables—historians smile at this however as being "dealer's jargon." Always refer to Draw Tables, therefore, as refectory tables.

ELIZABETHAN POSTED BED: Usually known as the four-poster. Use of the right term will distinguish you from the rabble. Within four posts and a back, a bed frame made of cords is stretched across, on which the mattress rests. Remarkably uncomfortable.

ELIZABETHAN POSTED BED

DESK BOX: When printed books made their appearance, portable desks made their appearance too. They were just like school desks without legs. Later someone invented the legs and the desk box became a school desk.

The Tudor-style houses evolved into the famous English country house with its charming, equally famous gardens. Americans live in Tudor-style houses that are solid, good looking, and comfortable. But the early Americans did not choose to utilize the Tudor furniture—probably because it was so uncomfortable.

What furniture they brought with them to the new land was Jacobean—which was very little, the transportation problem being what it was. But they constructed their own Jacobean here with certain changes. Tools and facilities for fine cabinetmaking were less complete than in England. American oak and walnut (the two woods used for the Jacobean furniture in England) were lighter in grain. Also they used whatever else they found lying around in the forests. Several different kinds of wood were used for one piece of furniture. The general tendency was toward simplification. The American pieces were often smaller than the British counterparts: the poor colonists had smaller rooms and lower ceilings. They did maintain the general rectangular quality of the English pieces; they were just a more primitive version as to workmanship and decoration.

Now, when confronted with a Jacobean antique you should be able to say, "American, of course" or "Those British, such pretension!" Examples of the Jacobean furniture are now presented:

JACOBEAN LONG TABLE: A less elaborate type of refectory table than its Elizabethan predecessor. Some were so long that they had eight

JACOBEAN LONG TABLE

legs. Though they were mostly made of oak, yew and elm were some-
times used.

FARTHINGALE CHAIR: A single chair, or back stool, with high broad
seat and low padded back with strong rake. The upholstery was hand-
somely embroidered and the chair was called farthingale because it
showed off to advantage the women's hooped and whaleboned dresses.

FARTHINGALE CHAIR

The English next had their Carolean Period which was roughly
twenty-five years long and their carpenters went back to making un-
amusing stuff, and farmhouse furniture replaced the comfort that
people had begun to enjoy, all because the Puritans of the period
were mighty powerful, and the enjoyment of comfort was not their
strong point.

Important, however, was their Gate-Leg Table, also known as a
falling table. If you sit down suddenly, and you are not careful where
you put your knees, you'll not only give them a mighty crack but half
the table will drop in your lap along with Aunt Molly's best china tea
set and her homemade fruitcake. There are many copies of this table
around but the originals had nails holding the hinges of the flaps.
Elsewhere the joints were secured by oak pins. A round table with
folding flaps.

GATE-LEG TABLE

The Restoration Period in England followed. In 1660 Charles II and his court came over from France and brought with them all the swinging ideas that Louis XIV had been dreaming up for Versailles.

Walnut and beech replaced oak, and foreign cabinetmakers flooded in with their crafts knowing they were on to a good thing. They introduced the techniques of veneering, marquetry, and lacquer. Everything was so beautiful around the house that people stopped baiting bears in the marketplace and started baiting each other in fashionable drawing rooms. They haven't stopped since.

CHARLES II CHAIR

CHARLES II CHAIRS: Exuberant S-scrolls flank the back panels with twist turning in flamboyant forms. Cane seats, front stretchers matching the cresting rail.

CAROLEAN DAY BED

CAROLEAN DAYBED: Just to mix everyone up, this was made after the Carolean age was over. Blame the historians—they made the names. You could lie full length on it if you really wanted to be uncomfortable.

PEPYSIAN BOOKCASE: Obviously Mr. Pepys needed a bookcase to keep all his diaries in, and determined to be remembered in every field, he had a bookcase made up for him which was copied for others. It was made of solid oak with glass doors, in two sections, one tall cabinet resting on a chest-shaped cabinet. Carved frieze decorated the jutting-out cornice.

Meanwhile, back at the colonies, the Americans were busy putting their personal touch to the English designs.

The chair came into its own in colonial life after 1660. In New England they produced the pine settle and the turned-stick chairs that are today generally characterized as the Brewster and Carver chairs. They also made the more comfortable stick chair known as the Windsor. The Windsor chair, one of the best-known styles in American antique history, was originated in Pennsylvania.

Wainscot chairs were made in New England, New York, and Pennsylvania. The successors to these were the ladder-back and slat-back chairs and these were made in most of the colonies.

Other styles included the Carolean, the Cromwellian, and Flemish.

# THE WILLIAM AND MARY PERIOD

This royal couple moved into the royal palace after having lived in Holland and thus were influenced by the Dutch. They furnished their British abodes with pieces designed by Dutch craftsmen who liked tied stretchers on chairs and domed tops for cabinets. They left behind them the following styles, most usually made of walnut:

WILLIAM & MARY STOOL. Upholstered in velvet, heavily carved legs and front stretchers, made to match the rest of the furniture in the drawing room. The sort of comfortable piece of furniture one cannot resist sitting on in front of the fire on Christmas Day.

WILLIAM & MARY
CHEST OF DRAWERS
ON STAND

WILLIAM & MARY
STOOL

WILLIAM & MARY CHEST OF DRAWERS ON STAND: Speaks for itself. Two adjacent small drawers under a cornice, three large drawers under that, the whole standing on spirally turned legs. Walnut veneered, sometimes covered with marquetry.

WILLIAM & MARY BUREAU CABINET

WILLIAM & MARY BUREAU CABINET: A desk with drawers and a flap that opens down to reveal pigeonholes and a cabinet with doors placed on top. The higher ceilings encouraged this sort of piece. The arched doors had glass and inside you placed your favorite ornaments.

## THE QUEEN ANNE PERIOD

Queen Anne herself was said to be a dull, staid sort of person not very interested in design or furniture, but all the furniture and mirrors named after her proved very popular. And a lot of furniture

was made in her time, both in England and in America. The most important thing about Queen Anne was her cabriole leg. As few people can tell the difference between late William & Mary, Queen Anne, and early Georgian, it's a safe bet to say "That's a fine example of Queen Anne." Walnut, though; always walnut.

QUEEN ANNE CHAIR

QUEEN ANNE GRANDFATHER CHAIR

QUEEN ANNE CHAIR: Violin-shaped centerpiece in a hoop forms the curving back, drop-in seat (which means you can take it out to re-cover), unstretched cabriole legs, ball-and-claw feet, scallop-shell decoration at the top of the front legs, back legs square.

QUEEN ANNE GRANDFATHER CHAIR: High-backed winged easy chair copied and recopied by the Victorians. Period pieces however have needlework upholstery and if they've been in constant use this won't be in too good a condition.

QUEEN ANNE DRESSING TABLE: You can be fooled on this one. It's been reproduced by everyone, sometimes very badly. It's a walnut veneered table with drawers. When you sit at it you'll crack your knee on the arch-shaped frontpiece under the center drawer.

## THE ALL IMPORTANT AND ABUSED GEORGIAN PERIOD

Cabriole legs became sturdier, probably because George I was a man. Mahogany was imported from Cuba and mahogany became the wood of the period.

In England the majority of antiques, be they furniture, porcelain, glass, or silver, date from this period. It's a well-studied and well-documented period and therefore safe: you can check up on everything.

The Georgian period was the age of classical education, and houses were built carefully, grandly, with gardens to match, and the furniture and ornaments had to be of a very high standard to please the new fussier generation. The screws, for example, were all hand-made.

Four names stand out during this period and their legacy is perhaps what gives England its reputation for fine furniture.

There is the *Family Chippendale.* Grandfather and Junior, and in between Thomas, the most famous one. He innovated Chinese Chippendale, the "piecrust" table, the upholstered wing chair, and the camelback sofa. He was the author of *The Gentleman and Cabinet Maker's Director.*

There were *Robert Adam* and his three brothers. They were not cabinetmakers, per se. They were architects primarily, but the name "Adam style" became connected with interiors and a certain type of chair, mirror, and fireplace. A general delicate classicism prevailed.

*Thomas Sheraton* was the author of *The Cabinet Maker's and Upholsterer's Drawing Book.* He favored the straight line and rectilinear forms. To him we are in debt for the Serpentine sideboard and the Pembroke table (which he made for the Earl of Pembroke), and I suppose we can safely say it was then named after same.

*George Hepplewhite* authored *The Cabinet Maker's and Up-*

*holsterer's Guide.* His furniture was reportedly weak in construction, but strong on grace, elegance, and beauty, and he frequently produced the furniture that the Brothers Adam designed. No authenticated examples of his work are to be found in the modern world.

Both Mr. Hepplewhite and Mr. Sheraton used an awful lot of satinwood.

## THE ENGLISH REGENCY PERIOD

Though Prince George was Regent from 1811 to 1820, the label "Regency" is attached to any antique dating from the first thirty years of the nineteenth century. (It is attached to the Victorian reproductions as well, but only by scurrilous or ignorant dealers.)

During the Regency period designers were nearly all inspired by the French and their Napoleonic styles. Brass on wood was one of the main features and on seeing any brass embellishments you may well exclaim, "Ah, Regency," or if you wish to imply a knowledge of French antiques, "Ah, Empire." The word *Empire,* however, must not be pronounced as in the British Empire, but as the French do it, "am-peer."

Much of the original Regency furniture made to sit on was upholstered with Regency stripes. Stripes, therefore, are a fair indicator to the period. Whether the piece is imitation or genuine will require more knowledge.

THE GRECIAN COUCH: A usual part of the well-to-do Regency interior. Ladies used to recline on them and have their hands asked for in marriage.

GRECIAN COUCH

PILLAR AND CLAW DINING TABLE: Single pillar with four splayed legs each with a brass wheel as a foot. Tables were supplied in units; you went on adding, depending on the number of guests you had for dinner.

PILLAR AND CLAW DINING TABLE

DRUM TABLE: All kinds of round tables became popular in the Regency period; the drum, or capstan, was a table on a pillar with splayed legs, as above, and drawers fitted all round under the top.

DRUM TABLE

TEAPOY: A tea chest standing on a small table. The Regency ones became very ornamented with brass inlay and rosewood. It was fitted with three or four canisters and a couple of mixing bowls. Fortunately, no section was reserved for tea bags.

TEAPOY

CANTERBURY

CANTERBURY: A castered stand for sheet music or cutlery. The sheet music one became popular during the Regency period because that was when young ladies began to read music and bore everyone stiff while Mommy was fixing tea at the old teapoy stand. The piece of furniture consists of a drawer on wheels on top of which is fitted openworked filing sections. Today it is used to hold magazines—those you are not embarrassed to expose to the world, that is.

Meanwhile, back again at the farmhouses and plantations, the Americans were busy refining their furniture. During the Georgian period the colonists were concentrating more on the beauty of their furnishings, whereas before they had been confined to functional considerations. The furniture styles of Chippendale, Hepplewhite, and Sheraton began to be produced in America, and there were

many fine cabinetmakers in New York, New England, and Philadelphia, as well as in Virginia.

Came the Revolution and the Federal Period manifested itself in a Greek revival (anything to get away from those British!), and produced Duncan Phyfe, our most famous furniture maker.

## AMERICAN CABINETMAKERS

*William Savery*—Eighteenth century. Prominent in the Philadelphia-Chippendale School and noted for his highboys.

*Thomas Affleck*—Philadelphia-Chippendale School.

*John Goddard*—Late eighteenth century. Worked in Newport, Rhode Island, in the Chippendale School.

*Benjamin Randolph*—Last half of the eighteenth century. Philadelphia-Chippendale.

*John Folwell*—Last quarter of the eighteenth century. Made the furniture for the Continental Congress. He was called the Chippendale of America. (That's a goodie to repeat often in the right circles.)

*Duncan Phyfe*—Worked in New York around the beginning of the nineteenth century and designed and produced furniture of English and Empire styles .

*G. Miller*—New York, early nineteenth century, Greek Revival.

*H. L. Lannuier*—Frenchman who produced Directoire-type furniture in New York early in the nineteenth century.

And last, but certainly not least, was *John Belter* who in the nineteenth century introduced his Belter furniture in New York. This furniture was noted for its carved laminated forms in rosewood. (Belter was a brighter light in the Victorian picture.)

## THE VICTORIAN PERIOD

After England's Regency Period and America's Federal Period they both lapsed into the Victorian Period and the only thing to do with the Victorian Period is forget it, for the moment.

Whereas in previous periods everything was handmade by

craftsmen who lavished love and attention on what they were making, in the Victorian era the industrial revolution turned everyone machine-mad and furniture was mass produced.

Reproductions came into their own and ruined everyone's taste and the craftsmen's initiative to invent. Today Victorian reproductions of Queen Anne furniture are gaining value as antiques and are much better made than that stuff turned out as poor imitations of Victorian imitations; but they are still a very far cry from the genuine article.

The Victorian reproduction is the piece of furniture on which a dealer can lose money at an auction. These reproductions are difficult to recognize, some being cleverly made, but there can be a difference of several hundreds of dollars between the real thing and the copy.

The interior decorator buff, or bluff, may say that it is perfectly fine to have fine reproductions. The antique bluffer must never say anything but that antiques are the *only* possessions to possess. No one who reads this book should allow himself to live with reproduction furniture. Far better to sleep on the floor.

## THE FRENCH

No one can be an antique bluffer without being able to tell a Louis XV chair from a Louis XVI (and it's mostly in the leg, my dear). The English are supposed to have been fine cabinetmakers, but when it comes to pure style and design, as in fine cuisine and wine, the French lead all the rest.

*Louis XIV*—His style was called *baroque,* which means grotesque or fantastic in shape. This was a very grand style and the other royal courts of Europe modeled themselves after *le style Louis XIV*. Versailles was the Sun King's legacy to the French people as it made France the center and showcase of all the fine arts for centuries to come.

*Louis XV*—The Baroque was supplanted by the Rococo movement in which rock and shell motifs adorned a more graceful and smaller-scaled furniture. The cabriole leg is an important feature of the Louis XV bergère, and there is much emphasis on delicate curves.

Madame Pompadour, the old boy's mistress, was a patron of the arts and was a great influence on the styles of her day.

*Louis XVI*—Influenced by poor little Marie Antoinette, who is said to have had great taste even if she wasn't very clever. She preferred the pastels to the richer colors of the preceding reigns. Louis XVI furniture was distinguished by the Classic, a reversal of the Rococo. It featured straight lines and compass curves. The chair leg is straight, as opposed to the curved cabriole leg of Louis XV.

Then, of course, came *their* Revolution and the *Directoire* period. The *Directoire Period* expressed itself in military motifs and a simplification of the Louis XVI style. In accord with a time of political economy, much use was made of painted furniture in place of expensive woods. They weren't about to lose *their* heads.

Napoleon came along and with him the *Empire Style*. A classical form. Battlefield motifs, Egyptian motifs, symbols of Roman and Grecian architecture. As the Americans wished to get away from the English style in their Federal period, Napoleon wished to depart from the styles of the monarchs. His furniture had a very masculine feeling and mahogany was the wood of the Empire. Steel furniture was also popular: Napoleon's officers took it with them to the battlefields as it was both elegant and portable.

Before leaving the French, a slight note about the *Regency Period*. The art style *Regency* does not coincide with the political period of the same name. It was a transitional period between the scale and grandeur of Louis XIV and the graceful curves of Louis XV. The *Regency* antiques are very popular today on the West Coast, for some reason, or as the more cynical antique bluffer would say, *pseudo-French Regency*. (About *other* people's antiques of course, not their own.)

## A QUICK NOTE ON ITALIAN FURNITURE

Actually, if you're counting, Italian antiques had to come first, before the French and the English. Art influences that had their start in Egypt took root in Italy and thus came the Renaissance. The Renaissance marked the first time that Italian houses really had fur-

niture and other such embellishments. The Medici family is reported to have had some really great furniture. From the High Renaissance period you have some of the greatest names in the antique arts, like Benvenuto Cellini, goldsmith and sculptor without peer. Or how about the great Leonardo?

The Italians' Baroque period occurred somewhere around 1550–1750. This term originated in France where they had their fun with it too. But it described what the French considered a strange type of Italian decoration and architecture. As in France, this style evolved into the Rococo, a style which started in Italy, but had its greatest development in France.

An apt way to describe what happened is that the creation was Italian, the French developed it well, and then the Italians copied the French and went a little bit further in the areas of color, decoration, and much flourish. What they lacked in exquisite workmanship, they made up in gusto.

Italian Rococo decoration and furniture is often labeled "Venetian" because it was there during the eighteenth century that the Italians went mad, quite mad, in an orgy of decoration.

Any antiquer would be quite proud to possess a great Venetian mirror or a very fancy Venetian sofa.

## USEFUL TERMS TO FACE FURNITURE WITH

ART NOUVEAU: Stiff vertical style of furniture. Can be pronounced as in "Ah, nouveau riche."

BALUSTER: Turned pillar to support rail. See "Turning."

BAROQUE: Grotesque style developed in the seventeenth century. I like it.

BEADING: Small semicircular ridge.

CORNICE: Upper projection on pieces of furniture.

DENTILS: Guess what? Teeth under the cornice.

FILLET: Narrow strip. Not edible.

FINIAL: Knob on top of post.

GADROONING: Edging of carved, identical, oval shapes.

JAPANNING: Tea drinking ceremony or oriental glossy lacquer finish achieved by shellac dissolved in spirits.

JOINERY: Work that has joints.

MARQUETRY: Inlay.

MORTISE: Round peg in round hole.

MOLDING: Raised ornamental band.

OGEE: Concave/convex shape of a support.

ORMOLU: Gilded metal mounts.

PATERA: Classical oval disc stuck on furniture.

PEDIMENT: Ornamental structure surmounting cornice on bookcase in middle of road.

PLINTH: Low base of a piece of furniture.

REEDING: Slim pipes, series of, as decoration. Also what you are doing if you can stand it.

ROCOCO: Somewhat overdone ornamental work of shells, scrolls, curves.

SPLAT: Ancient sign of annoyance by cabinetmakers, as in "He hit his thumb and splat." Also middle of the back of chairs.

STRETCHER: Horizontal bar joining chair legs or device for carrying sleeping dealers out of salesroom.

TURNING: Working wood with cutting tools as it rotates on a lathe.

## FRENCH FURNITURE TERMS

To be really knowledgeable, or at least to sound as though you are, about antiques, it is unthinkable not to have a French vocabulary for furniture at your tongue tip.

*Acajou:* Mahogany

*Armoire:* Clothes wardrobe

*Banquette:* Bench

*Bergère:* All-upholstered armchair

*Bibliothèque:* Bookcase

*Bombé:* A swelling curve; when the curve is applied to the front of a piece of furniture, it swells outward toward the center, at which point it recedes again.

*Bonnetière:* Hat cabinet.

*Bouillotte:* Small table with gallery edge. Foot warmer, too. (Louis XVI.)

*Buffet:* Sideboard or cupboard.

*Bureau:* Desk.

*Cabinet-vitrine:* Cabinet with glass doors.

*Canapé:* Sofa.

*Canapé-à-corbeille:* Kidney-shaped sofa.

*Chaise:* Side chair.

*Chaise longue:* A "long chair" or a chair for reclining.

*Chandelier:* French for you know what kind of a light that hangs down.

*Chêne:* Oak.

*Coffre:* Chest.

*Confortable:* Name used for the first all-upholstered chair and now I have learned something new, and I bet you have too.

*Console:* Wall table.

*Desserte:* Serving table or sideboard.

*Écran:* Screen.

*Escabelle:* Chair supported on trestles (Early Renaissance).

*Fauteuil:* Upholstered armchair with open arms.

*Guéridon:* Small ornamental stand or pedestal.

*Huche:* Hutch or chest.

*Lit:* Bed.

*Lit canapé:* Sofa bed.

*Marquise:* Small sofa.

*Meridienne:* Sofa with one arm higher than the other (Empire).

*Miroir:* Mirror.

*Poudreuse:* Powder or toilet table.

*Rafraîchissoir:* Refrigerator, and yes, I know, that's no antique.

*Secrétaire:* Desk.

*Vis-à-vis:* Two seats facing in opposite directions, attached in the center.

# POTTERY AND PORCELAIN

You can't see through pottery. You can't see through porcelain either but it is transluscent—that is, if you hold it up to the light you can see the shadow of a finger through it.

While Europeans would tell you there are three accepted forms of pottery and porcelain, English, Continental, and Chinese; col-

lectors of American antique china would probably hit them over the head with a nice, hefty piece of pottery, but English—not their own.

Pottery is usually fairly thick and heavy; porcelain is usually light and delicate. Porcelain is also made in two forms, soft paste and hard paste. It is important to find out whether a piece of porcelain is made of soft or hard paste, for this is an instant indicator as to where it comes from. Hard paste is Continental, soft paste is English. There are exceptions to this rule, as in all rules. But if one chooses to put down a British snob, just remember that there was actually a race among the British, French, and Germans to find a hard-paste formula and the English lost. That's why soft-paste is English.

To tell the difference between the two, a nail file should be sawed into the base of any piece of porcelain; if you manage to make an impression without too much effort, then the paste is soft. If you are incapable of making any impression at all or blunt the nail file or drop the piece because you've applied too much pressure, the piece is made of hard paste.

An amateur collector can be spotted a mile off by the way he handles porcelain. The professional can likewise be recognized. Pieces of pottery or porcelain should always be approached with a certain amount of ruthlessness; you must not be frightened of dropping it. The impression, at all times, must be given that if you do drop it, it just doesn't matter—you can always buy the pieces.

To achieve this confidence (you *need* confidence when lifting a $10,000 Han Dynasty stoneware pot from a high shelf in a store), you must practice juggling with plastic plates at home. Empty beer bottles are a good thing to practice with as well.

When you graduate to more valuable pieces, always lift them with two hands, placing one hand at the bottom and one hand on the top, at the same time checking that the head, the lid, or any other part is firmly held. If there is a lid or a part which is removable, remove it.

Once the piece is firmly held in both hands, examine it with a smirk, then turn it upside down abruptly to look at the mark. The mark will tell you all, that is if you have a computer memory. If you haven't got a computer memory, it won't tell you a thing. There are approximately fifteen hundred ceramic marks to remember and, if you don't know what ceramics is, ceramics is pottery and porcelain.

It is impolite to drop other people's pieces of pottery or porcelain. Drop these words and phrases instead:

BISCUIT: Fired but unglazed pottery or porcelain.

BOCAGES: Foliage or tree backgrounds to pottery or porcelain figures.

EARTHENWARE: Pottery.

GLAZE: Glassy material applied to earthenware and porcelain that makes it waterproof and smooth to touch. Glaze is versatile, for it can be dull or matte or brilliant, translucent or opaque, or shot through with brilliant colors.

IRONSTONE: A white earthenware alleged to contain slag.

JAPAN: Not to be confused with Japan work on furniture—which as you know is a type of oriental lacquer. In pottery and porcelain this implies an oriental pattern and style.

LUSTER: Decoration on pottery or porcelain made with thin films of metal. A metallic look.

POTTERY: That nontranslucent stuff we're talking about.

SLIP: Clay reduced to a liquid applied as an extra coating on pottery for decorative purposes. Hence the old saying, "There's many a slip 'twixt cup and lip."

STONE CHINA: A hard white pottery made as a cheap substitute porcelain.

# ENGLISH POTTERY TO REMEMBER

BRISTOL: 1683–1770. Early Bristol is like Lambeth. Late Bristol is like Liverpool. So don't comment on Bristol, Lambeth, or Liverpool; you might make a fool of yourself, or worse, if right, make a fool of the collector.

COPELAND: See Spode.

DAVENPORT: 1793. Cream-colored earthenware. Also name of Georgian small writing desk with characteristic set of drawers pulling out sideways. The two have no connection.

DENBY: 1833. Brown stoneware.

DERBYSHIRE: Indistinguishable from Nottingham.

DOULTON: 1818. Brown stoneware.

FULHAM: 1670–1693. Huge brown and grey mugs with applied reliefs depicting hunting scenes.

LAMBETH: See Bristol.

LEEDS: 1750. Frequently enameled creamware. Pierced decorations, also figures.

LIVERPOOL: See Lambeth.

MASON: Ironstone china. 1813. Usually blue and red. The name is written in full on the bottom of plates and mugs. You can't go wrong, but neither can anyone else.

MINTON: 1756–1836. The willow pattern people. Blue painted pottery—also porcelain. Much reproduced.

NOTTINGHAM: See Derbyshire.

PRATT WARE: Late eighteenth, early nineteenth. Lead-glazed pottery mainly in brown, orange, blue, and green. Also red, yellow, indigo, and violet.

ROCKINGHAM: 1750–1806. Similar to Leeds but distinctive streaky dark brown glaze. Also porcelain.

SPODE: Some of the finest British porcelain, including bone china.

STAFFORDSHIRE: To say that a piece of pottery is Staffordshire will not be wrong, but it cannot impress. Most potters worked in Staffordshire, and the area where they worked is known as the Potteries.

TOBY JUGS: Originally made by one Ralph Wood; hundreds of other potters have copied them. A good line to deliver when and if you break one is "It wasn't an original Ralph Wood anyway." Unless, of course, it was.

WALTON: 1820–1830. Small earthenware figures with background of flowers.

WEDGWOOD: 1730–1795. Pick any bit of pottery up and say it's Wedgwood; you may be right. Anything from green and yellow cauliflower wares to silver luster.

## ENGLISH PORCELAIN

If by now you have not given up the idea of antique collecting, then you should go, like a bull, into a china shop and ask to see some examples. Or buy the hundreds of specialized books on the subject which will confuse you no end.

The following factories were established when stated:

BOW—1750.

BRISTOL—1749.

CAUGHLEY—1772.

CHELSEA—1745.

COALPORT—1780.

DERBY—1751.

LIMEHOUSE—1750.

Limehouse porcelain is a fabulous name for the bluffer to use. The factory, established in 1750, was a short-lived one and its products are unidentified. Wherever you may be and whenever you see a piece of porcelain you're not sure of, say "Limehouse." No one can contradict you, and that's the general idea, isn't it?

LIVERPOOL—1710.

LONGTON HALL—1750.

LOWESTOFT—1757.

NANTGARW—1813.

PINXTON—1796.

ROCKINGHAM—1820.

WORCESTER—1745.

## GERMAN PORCELAIN

BERLIN—1752.

FRANKENTHAL—1755.

HOECHST—1750.

LUDWIGSBURG—1758.

MEISSEN—1710.

NYMPHENBURG—1753.

When discussing German porcelain, Meissen is the important name because it was the first porcelain made on the European continent. Meissen porcelain is often referred to as Dresden: this is because the Meissen factory was near Dresden. Some bitchy people like to say smugly, after you have used the name Dresden, "There's no such *thing* as Dresden, it's only the name of a town in Germany." Or if someone else uses the name Dresden, you can be that bitchy

person who uses the above line. Either way, the names Dresden and Meissen are interchangeable—your choice.

Hard-paste porcelain was also made in Zurich in 1763.

## FRENCH PORCELAIN

The first great Renaissance potter in France and one of the finest craftsmen ever in this field was Bernard Palissy (1510–1589). The value of original Palissy pieces is so great that many forgeries have been made.

Edmé Poterat, who worked in Rouen, made the first soft-paste porcelain in France in 1673.

The factory in St. Cloud produced a pottery similar to Rouen, but closed its doors in 1766.

The most important of the French ceramic factories was founded at Vincennes near Paris in 1738. Louis XV granted the firm the privilege of the words *Manufacture Royale de Porcelaine de France* in 1753. In 1756 they moved to Sèvres and the factory made use of the most capable painters and sculptors of the time, and all of European royalty wanted their products. They began to make hard-paste porcelain in 1769.

Frequently seen in antique shops today is a porcelain called *Vieux Paris* and most of it was made during the nineteenth century. But beware—the craftsmanship is crude and it must be classified as a commercial product.

Also to be kept in mind are the Limoges factories in Limoges, naturally. They first became famous for their enamelware between the twelfth and fourteenth centuries.

## CHINESE POTTERY AND PORCELAIN

China was first made in China.

They made pottery about 2000 B.C. and invented porcelain during the T'ang Dynasty; that's between A.D. 618 and A.D. 906. Dynasties are hurled around wholesale when talking Chinese China, so remember these:

SHANG-YIN—1766–1122 B.C.
CHOU—1122–249 B.C.
HAN—206 B.C.–A.D. 220.
SIX DYNASTIES—220–589.
T'ANG—616–906.
FIVE DYNASTIES—907–960.
SUNG—960–1279.
YUAN—1279–1368.
MING—1368–1644.
CH'ING—1644–1912.

You will note that the famous Ming Dynasty corresponds with the Tudor, Jacobean, and Carolean periods in England and the beginnings of our Colonial period, apropos of nothing.

Other highly mentioned names connected with Chinese China are the colorful families:

FAMILLE NOIRE and FAMILLE VERTE—1662–1722.
FAMILLE ROSE—1723–1735.

All three are of the Ch'ing Dynasty.

# AMERICAN POTTERY AND PORCELAIN

Useful pottery was produced in the colonies during the seventeenth century. But decoratively speaking it wasn't much.

The earliest pottery that was of the slightest interest was sgraffito ware, made in Pennsylvania in the middle of the eighteenth century by Germans.

At first the imports from England were so popular that local craftsmen had to imitate them and even disguise their own marks to obscure their local origins.

But by 1800 attempts to produce china of a better quality in America were finally successful in many cities here, and especially in Vermont where the Bennington factory was located. They produced a salt-glazed stoneware, then an imitation Rockingham ware, and then many interesting items like hound-handled pitchers, toby jars, poodles, toy banks, cuspidors, candlesticks, and so on.

The first true porcelain made in the United States was produced in Jersey City, New Jersey, in the early part of the nineteenth century. Other cities that produced both porcelain and earthenware thereafter were Trenton and South Amboy, New Jersey; East Liverpool, Ohio; Baltimore, Maryland; and Kaolin, South Carolina.

Unfortunately, it wasn't *art*, but only china. But a lot of collectors are still interested in collecting American china, and antique shops are full of examples.

I understand that there are even people that are making a collection of china marked "Made in Occupied Japan." That's not *art*, and that's not *antique*, but it's a collection, I guess.

# SILVER

THE COLLECTOR crazy enough to decide on silver as his main interest in antiques will land himself with a load of research work, lots of polishing, and much frustration—unless he is very rich. Collecting silver was always an expensive hobby; today it is becoming prohibitive.

Most of the antique silver that is available today is of English and American origin. English silver survives from the sixteenth century in great quantities for two reasons. One: silver is money and therefore has always been well looked after. Portions of the family fortunes were kept in these useful, decorative articles. Two: it is comparatively indestructible.

It has one redeeming feature certainly, that of increasing value. Buy some silver today and you can sell it at a profit tomorrow—if you know what you're doing. If you don't, then don't sell it. The trouble with silver is its sheer quantity, and the very many different types in existence.

There are the different periods, and within the periods, there are the different styles of the different silversmiths. Within the categories of style and silversmith, there are the different types of objects they specialized in, and then there are the different categories of weight, and so on.

As with all other sections of antique collecting, silver has a language of its own. Whereas in furniture one talks of beading, molding,

and turning, and in pottery and porcelain one mentions glazing and hard and soft pastes, in silver one talks of gadrooning, ovolo, and wrigglework. (Please note that words like beading, gadrooning, and fluting are used in other than silverwork but don't always mean the same thing.)

When handling a footed waiter (a flat cakestand thing with a pedestal that usually had the place of honor on the sideboard), be careful not to leave your fingermarks all over the mirror-clean surface. Then comment on the fine pricking (delicate needlepoint engraving). All this before turning it over to look at the all-important hallmark.

No silver collector worth his 1721 punchbowl is ever seen without an eyeglass. This essential piece of equipment should, of course, be made of silver.

When the eyepiece has been fixed firmly in the eye, the hallmark should be examined and a grunt grunted. The eyepiece should then be carefully and slowly removed and very carefully and slowly put away. Without comment the footed waiter should be replaced on the sideboard and a smile directed towards the owner. "Paul Revere did his best work in that period" will suffice. If the footed waiter was smithed by Paul Revere, you get 100 points. If it wasn't, you still score 100 points for not having committed yourself to saying that it was. There are scores and scores of silversmiths you could mention, and the best place to find them is in a book that records only the names of the silversmiths and their marks.

## ENGLISH HALLMARKS

Four marks are usually found stamped on the English silver. The *hall,* or town, mark. The *maker's* mark. The *annual* mark or date letter. The *standard* mark, indicating the sterling quality.

As there are more than two thousand permutations of these marks, I do not propose to list them. I will however, give you the key marks for the halls, or towns.

LONDON: Leopard's Head Crowned. 1558–1716.
  Britannia. 1716–1719.

Leopard's Head Crowned. 1719–1836.

Leopard's Head Uncrowned. 1836–Present.

BIRMINGHAM: Anchor.

CHESTER: Three wheatsheaves with sword.

DUBLIN: Crowned harp.

EDINBURGH: Three-towered castle.

EXETER: Roman Capital letter "X," sometimes crowned for sixteenth and seventeenth centuries. After that, three-towered castle, as for Edinburgh.

GLASGOW: Tree, fish, and bell (city arms).

NEWCASTLE: Three separate castle towers.

NORWICH: Castle over lion passant (or lion passing the time of day by ambling gently with right foreleg clawing the air).

SHEFFIELD: Crown. But, between 1815 and 1819 they stamped it upside down.

YORK: Half leopard's head, half fleur de lys. 1562–1631.

Half rose crowned half fleur de lys. 1632–1698.

Cross with five lions passant. 1700 on.

If you still wish to continue an insane interest in English silver, your troubles can be greatly reduced by specializing in a particular form. Below are some interesting silversmith's wares that can be found at shops that specialize in the king's silver:

*Almsdish, asparagus tongs, blackjacks, bleeding bowls, caudle cups, chalices, douters, freedom box, muffineer, papboat (for babies), pomander, pouncebox, sandbox, waxjack.*

Or you can go in for English spoons, which is certainly simplifying things: *Apostle, basting, caddy, dessert, egg, gravy, lion sejant, maidenhead (whatever that is), marrow, mulberry, mustard, olive, puritan, rattail, salt, seal-top, slip-top, snuff, straining (mulberry), stump-top, table, tea, tray, trifid, writhen-top.*

## EARLY AMERICAN SILVER

The silversmiths of America did not have all these marks. Sometimes you found initials, sometimes a name of the silversmith, once in a while the locale, and sometimes the initials of the people the article was made for. So American silver cannot be identified as easily

as English. While there was no law that required marking of quality or the date of manufacture, the silversmiths themselves tried to maintain a standard of quality. (In 1865 it became obligatory to use the word *sterling* on all American silver productions of a certain quality.)

Famous names in Early American Silver are John Coney of Boston (1655–1722), Cornelius Kierstead of New York (1674–1753), and Paul Revere (who else?) of Boston (1735–1818). While Mr. Revere has an unqualified reputation as a silversmith, it is said that there were many other silversmiths his equal (if not his better—but that's unpatriotic). Much of his reputation is due to his place in history as a very sentimental and popular folk hero.

Bluffer, take note: Be an expert on Revere silverware by telling of Mr. Revere's worthiness as a businessman. While busily working away himself, Paul also had loads of little elves in the form of other lesser-known silversmiths working away for him. He then put his name on the articles as the selling jeweler (a very legitimate and usual practice today). As Mr. Paul Revere led a long and productive life, his silver business almost amounted to mass production.

Needless to say, there is much Revere silverware in the antique silver market.

The finest American silverware is seen in tankards, beakers, mugs, caudle and candle cups, punch bowls, kettles, tea-, chocolate-, and coffeepots, inkstands, sauceboats, and salvers.

# PEWTER

Pewter is an alloy, whose principal ingredient is tin, with minor additions of brass, lead, and antimony, or copper.

The Romans started the pewter fad in Great Britain and by 1503 it was so popular that someone decided that each bit of pewter should have its maker's mark—and it's not called a mark but a "touch."

One of the earliest colonial pewterers was Thomas Danforth, who lived from 1703 to 1786. His wares varied from tea- and coffee-pots to lamps and candlesticks, besides flatware and porringers, and are treasured by collectors.

John Christopher Heyne made pewter circa 1750 to 1780 and

his wares are probably the rarest pieces of pewter in America. "I. C. H. Lancaster" is the mark that means pewter more valuable than silver.

Other famous pewter names: Nathaniel Austen, Boston; John Holden, New York; Francis Basset, New York; Colonel William Will is listed in the Philadelphia City Directory of 1785.

The fact for the pewter bluffer to remember is that there is not that much American pewter about because a lot of it was melted down for ammunition during the Revolutionary War.

Pewter has often been called the poor man's silver, and as people in the early nineteenth century became more affluent, pewter was generally left behind as china began to be used more and more for the daily meal.

# GLASS

The first thing to remember about glass is that when you pick up a piece of glass the first thing to do is flick it nonchalantly with thumb and finger till it emits a resonant tone loud enough for the person who owns it to wince. If you break the glass in doing this, then it is a sign that you are overdoing the glassmanship business. Fingernails have, however, been known to break before glass.

Nearly all antique glass was made by blowing while the glass was hot and soft and malleable. While blown, each piece was placed on an iron rod called a pontil. When it had cooled, the glass was removed from the pontil, and a roughness was left where it had rested on the rod, hence the *pontil mark*.

The age of the glass piece is revealed by this pontil mark. The rougher and the larger, the older the glass.

Other things to say about glass are:

Glass is never perfectly transparent. There is always a tint, although only an expert may be able to detect it. Like hair and the hair colorist, only your expert knows for sure.

Glass may be ornamented by cutting, engraving, painting, gilding, pressing, and enameling. And if you've wondered what separates the crystal from the glass, it's the combination of flint and lead oxide. Crystal is very hard and usually cut into prisms and it sparkles like crazy.

# THE ALL IMPORTANT KNOP

The swollen member on the pillar or stem of a glass is a knop. There are many differently shaped knops and here are some of the ones you could finger:

ACORN KNOP: Shape of an acorn, sometimes inverted.

ANGULAR KNOP: A round-edged, flattened knop, placed horizontally.

ANNULATED KNOP: A flat knop sandwiched between two, four, or six flattened knops, each pair progressively less in size.

BALL KNOP: Large and spherical.

BLADED KNOP: Thin, sharp-edged knop, placed horizontally.

BULLET KNOP: Small, round, sometimes called an olive button.

CYLINDER KNOP: Cylindrical shaped, often containing a tear.

MERESE KNOP: Sharp-edged, connecting bowl and stem.

QUATREFOIL KNOP: A short knop pressed into four vertical wings. The wings are upright or twisted.

SWELLING KNOP: A slight stem protuberance containing a tear.

# TEARS, PONTILS, AND AGE

If you cut your finger on your pontil, you know your glass is old. From 1750, the pontil mark was ground and polished, but not always. From 1780, they always were. So you can't possibly cut your finger on a glass that dates from 1780 on unless you break it (the glass, that is).

Tears are those bubbles of air enclosed within the glass for decorative purposes and are usually in the shape of a tear. In England you can date a glass by tears. From 1715 to about 1760, clusters of spherical and tear-shaped tears appeared in bowl bases and knops.

# GLASS TO BE KNOWLEDGEABLE ABOUT, OR NAME DROP ANYHOW

VENETIAN GLASS. Venice has been famous for its glass since the Middle Ages and who else or where else can make that statement? Exceptionally light and delicate.

GERMAN AND BOHEMIAN GLASS. The Germans invented a very hard

form of glass which was cut into many shapes and enriched by engraving and stippling. Beakers, wineglasses, flasks and cups, as well as figures were made.

IRISH GLASS. Usually known as Waterford, which came from the famous Waterford works, but also made in Belfast, Cork, and Dublin. Usually ornamented by cutting. Used for chandeliers and tableware.

ENGLISH GLASS. The famous English glass was chiefly made at Bristol and Nailsea. Bristol glass is considered better than Nailsea, but as workers often changed their locale, similarity often exists.

AMERICAN GLASS. The most famous American glass was made by a German who came to America in 1750, Henry William *Stiegel*. He was a romantic figure and many stories were told about his activities. He started the manufacture of flint glass, the first of its kind in America, in Manheim, Pennsylvania, and brought apprentimes from Bristol, Venice, and Cologne, Germany. When Stiegel went bankrupt (he was that kind of guy), his employees picked up and established their own factories in Ohio, New England, and New York. There is probably more imitation Stiegel around than the real stuff.

JERSEY GLASS. In 1739, the south Jerseyites became very busy with glass and there were several factories. Their output all together was known as "South Jersey glass."

SANDWICH GLASS. Sandwich, Massachusetts, was the place and there was an avalanche of production (a lot of breakage too, I would guess) due to cheap methods of manufacturing. Mostly known for *Pressed Glass* which imitated cut glass, for pieces with political symbols and portrait heads, and for ornamental pieces that imitated animals.

BOTTLES AND FLASKS. Very important as "Americana." Nineteenth century. Ohio, Pennsylvania, Kentucky, Maryland, Virginia, and New York. Collected for color, shape, or design. Shapes such as log cabins were not unusual.

If you'd really like to go into the glass-collecting business, you can try pattern-hunting in the pressed-glass field. There are many patterns to be found and people usually specialize in one pattern, like the daisy one. Then you go around to garage sales, and barn sales, and farmhouse sales, and say, "I'm looking for a daisy."

# OIL PAINTINGS

THIS SECTION, devoted to oil paintings, is not for the collector who goes to Parke-Bernet to purchase a cheap Goya (or a Rembrandt, for that matter), but for the more humble who might consider sinking his life savings on a $100 canvas hoping it will be worth $500 in his lifetime.

If you wish to discuss the great masters you had best consult THE BLUFFER'S GUIDE TO ART. What should concern you about antique paintings is not your ability to recognize the Italian, German, French, Flemish, or English schools, nor to discuss the Renaissance artist's merit compared with the Impressionist, Fauvist, Dadaist, Cubist, Futurist, Vorticist, or Surrealist, but your capabilities of knowing a genuine oil, a copy, or an oleograph when you see one.

"What is an oleograph?" you ask. An oleograph is another name for a chromolithograph. Of course. And a chromolithograph, in the simplest terms, is a manufactured reproduction of an oil painting, usually on canvas, and usually very well done too.

I will presume that everyone knows that an oil painting is one painted with oil paints. I will also presume that the collector of old oils will want to know a quick way of telling a genuine one from a reproduction. There isn't a quick way—that is why specialists occasionally make a lot of money and everyone complains about it.

Stories in the papers usually have it that Artzortz Guttheimer, a sixty-three-year-old Hungarian of German extraction living in Surbiton, found this bit of rolled up canvas in a junk shop in Maple Hills, instantly recognized it as a Titian, offered $5 for it to the poor old widow—who gratefully accepted—sold it immediately for $200,000 to fellow dealer Joseph Zeimenhopfner, a thirty-six-year-old German of Hungarian extraction living in New York City, who in turn sold it to an English-born industrialist living in Switzerland for obvious reasons and now the poor old widow who runs the junk shop is suing Guttheimer who is suing Zeimenhopfner for selling a property which didn't legally belong to him.

The truth is that an art dealer with a life's knowledge of his

subject has for years and years been hunting in bric-à-brac and junk shops, as well as in respectable antique shops, for old oils hoping to find something worth $150 for $10. On this occasion he spotted an old oil. After examining it carefully he suspected that the canvas was much older than the subject depicted (it's all in the weave), and guessed, because of the pigments in the paint, that there was probably something else underneath.

Because he buys hundreds of such paintings, he bought this one risking $5. The fact that after a month's cleaning by a highly paid expert, a genuine old master was found underneath, was not luck but the result of a calculated and successful gamble. The year it took to prove the painting's authenticity, researching back through collections and tracing its history, could only be achieved with the knowledge acquired by a lifetime's study.

To become an expert, therefore, you will have to learn about canvases, paint pigments, depicted scenes, brushstrokes, framemanship and artists' signatures. When you've done all that you'll be about a hundred and thirty and may not care. So try watercolors.

## WATERCOLORS

Everyone has painted watercolors sometime in his youth. It is the man or woman who has persevered and after the age of six actually painted something recognizable to others with his toy box of watercolor paints who interests the collector.

Acquiring knowledge on the subject is, in fact, dead easy. Few people talk about watercolors because it's so boring and you need to have pretty good eyesight to appreciate one hanging in somebody's living room (when you really came to watch the Mets on television, and drink beer with old Bill).

Most Americans worked in oil, and watercolor wasn't a part of their general training, but Winslow Homer and George Inness, among other artists, were supposedly self-trained in the art of watercolor. Two good names to remember, at any rate, when discussing this subject. Other great names to associate with American watercolors are:

JOHN SINGER SARGENT (1856–1925). Quoted as saying that watercolor

was his best medium and capable of greater artistic expression than oil. (It is quotes like that that separate the boy from the bluffer.)

CHILDE HASSAM (1859–1935). Impressionistic. First president of the New York Water Color Club.

GEORGE (POP) HART (1868–1933). Say that he searched out the gloomy feeling in life.

ARTHUR B. DAVIES (1862–1928). Talk about the mystery and romance found in his watercolors.

# OLD DRAWINGS AND PRINTS

Drawings are pictures drawn with pencil, pen and ink, black or red charcoal or chalk, or dry-washed with India ink in gray, blue, or sepia.

A print is a drawing or painting transferred to a copper or zinc plate, a block of wood, or a stone. The word print applies to several methods: line engraving, etching, soft ground etching, drypoint, aquatint, mezzotint, and lithography.

It is rather important if you're going to take an interest in this field to know a bit about each, especially if you are a young lady, because you will then be able to tell that dirty old man that what he has hanging above his dirty old bed are not etchings but rotten, old mezzotints. That should stop him in his tracks.

There are loads of names to bandy about, but only mention the biggies—*Constable, Gainsborough,* and *Rowlandson*—in ambiguous statements, such as "Well, *that* certainly is no Gainsborough, is it?" and sneer. Then, you certainly can't go wrong, can you? Unless, of course, it is a Gainsborough.

# MINIATURES

When you spot the portrait of a minified female, and her face is pretty, you should say knowingly, "Hmmm, another unknown lady."

Miniature artists (who were not necessarily miniature themselves) never seem to have known the women they painted—which

leads one to imagine the worst. Or perhaps, they were just too small to recognize.

Holbein, the first fashionable artist to do miniatures, produced them as far back as 1532.

There were as many miniaturists as there are watercolorists and the only thing to keep in mind is that the Victorians went mad and overdid that reproduction bit and covered their walls with them. The invention of the camera did away with the miniatures of all these unknown female relatives. Many that survived that liquidation do have some merit.

The earlier miniatures are more valuable and were painted on vellum or very thin ivory, and the frames are an indication of their date—if you can find a way of telling if it's the original frame.

## WORDS AND PHRASES TO UTTER WHEN EXAMINING OTHER ANTIQUES

ASTROLOGICAL DIALS: Quartiles. Sextiles. Conjunction. Opposition.

BOOKS: "What is its provenance?"

CLOCKS: "The truly isochronus swing of a pendulum is not the true arc of a circle but of a cycloid." Also mention the name Willard. This could be Simon, Benjamin, Aaron, or Ephraim.

JEWELRY: Just say Fabergé.

MUSICAL BOXES: When they are opened and play some tune, just say "Hmmm."

TAPESTRY: Gobelins.

PORTRAITS: If the subject looks colonial, say, "It must be a Peale!" (If the thing is unsigned, of course.) The painting Peales were a prolific family (three generations of them, in fact), of whom the best known are Charles, James, Raphaelle, and Rembrandt. How wrong can you be; at least you have multiple chances.

PORTRAIT OF GEORGE WASHINGTON: Gilbert Stuart, of course.

PORTRAIT OF MARTHA WASHINGTON: You still murmur Gilbert Stuart.

# The
# BLUFFER'S
# GUIDE
## to
# Interior Decorating

by **JUNE FLAUM SINGER**

Introduced by **DAVID FROST**

# INTRODUCTION

ALONG WITH LADIES' hairdressers, it seems to me that in the past couple of years interior decorators have been on the receiving end of a lot of jokes and, with the exception of a few feet that were stamped when Bruce and his friends positively seethed with anger out on Fire Island on a hot summer's night, they've taken it pretty well.

But I think a cautionary word is in order. Because look what happened the last time people started poking fun at an interior decorator . . . of course in those days, back in 1933, they used to call them house painters.

So if you hear your interior decorator muttering to himself, "Today the romper room . . . tomorrow the world!" be careful what you say in front of him. Especially if he's trying to grow a small moustache.

Because you don't think it was coincidence do you that they all marched with a goose step.

But interior decorators . . . if you can afford them and can't be bothered with all the hassle of deciding just where the miniature waterfall should be placed in the living room, which really can be a hassle if you live on the seventeenth floor of a high-rise building in the Bronx . . . must be chosen with care. In just the same way that I wouldn't totally trust a bald-headed barber's advice about what to do with my hair, then if I wanted a quiet restful home, I'm not sure I would put it in the hands of a man wearing purple bell-bottomed trousers, an orange body shirt slashed to the navel, with a green sash at his waist, a red bandanna around his forehead and a huge yellow button proclaiming "Hi, I'm a Love Machine" . . . especially when he suggests a special closet for the man of the house. "Well, he's going to need somewhere to keep his purses."

Then of course you can do it yourself.

Or choose any of the other many ways that are available to the average man to drive himself out of his mind, like teaching his wife to drive or trying to roller-skate in the subway during the rush hour.

But if you decide to do the interior decorating yourself anyway, don't do it with a loved one . . . preferably choose somebody you are totally indifferent to, or, better yet, an enemy with whom you have a score to settle.

I've known of wives who have somehow got themselves so in-

extricably involved with papering a wall that they've ended up pasted to the wall themselves, under the paper . . . or a fiancée who was spraying a wall when her husband-to-be walked into the room and asked a simple question and the girl just turned to give him a simple answer forgetting as she turned that the paint spray was turning with her.

Many a lover's suit in both senses of the word has been ruined like that.

Of course there are super men and women who can actually do all these things well, indeed even like doing them, in their spare time. Such people should be admired and flattered and encouraged to the point where it would be churlish of them to refuse your request that they come over to your house and show you exactly how it's done . . . and provided you work hard at being a very slow learner and really put some effort into the simplest of mistakes, they will rapidly become so contemptuous of your bungling ineptitude that you'll end up with getting your whole house redecorated without lifting a finger.

The moment they say "My six-year-old son could do a better job than you," then you know you are home free. And if for some reason they don't turn up the next night, call up and ask the six-year-old son to come over.

Be wary in this whole interior decorating caper of following the trendies too closely . . . you know suddenly this year's look is Chinese, and you're trapped because all your friends are switching to the Oriental look and you're still paying the installments on last year's Guatemalan Renaissance look.

But if you do find yourself on this treadmill there is one way to get off. Just take it all . . . Chinese, Guatemalan, lapsed English, Early American, and overdeveloped Italian . . . mix it up in one room and simply call it the Garbage Look. Within days someone will have taken you seriously and suddenly everyone will be trying to achieve the ultimate in the Garbage Look.

But interior decorating, and its attendant problems, has been with us for centuries. On the night that he finished the ceiling of the Sistine Chapel, Michelangelo put down his brushes and his palette and shouted down to Pope Julius III, "What do you think?"

There was a silence, then back came the shout: "I said I wanted it done in green."

DAVID FROST

# FOREWORD

A house painter can call himself an interior decorator.

The house painter who does the wood graining and stenciling on apartment house corridor walls *does* call himself an interior decorator.

Little slipcover stores in little towns and large, *always* call themselves interior decorators.

Furniture stores, prestigious and otherwise, go them even one better—they call themselves interior designers.

The "percenters" call themselves interior decorators. They are legion. They usually have no formal training or education. What they do have are little business cards that proclaim them to be decorators. Those little cards are better known as "entrée." Entrée takes them into the world of dealers, manufacturers, and elite little shops that proclaim on their doors "to the trade only." *They can get it for you wholesale!* They take you by your very hot hand, lead you inside, and after you've taken your pick, they proceed to take you by tacking on their 10, 15, or 20 percent. They usually also have an arrangement with the dealer, and you knowest not what that arrangement may be. They will make a big show of advising you as to the principles of design; they will help you make up your mind—but what they are really any good at is figuring up percentages.

Then there are the real professionals, usually members of the American Institute of Decorators or the National Society of Interior Decorators. They are people who have studied and "passed the bar." They are also supposed to possess high professional standards. You can see pictures of their work in interior design books and on the pages of the Home Lovely magazines.

In his book *Elements of Interior Design and Decoration* (J. B. Lippincott Co., Philadelphia) Sherrill Whiton quotes the American Institute of Decorators' definition of an interior decorator: "An interior decorator is one who through training and professional experience is skilled in the solution of problems related to the design and execution of interiors of buildings or other structures and their furnishing, and qualified to supervise the arts and crafts employed in the production and installation of decorative and practical details necessary to consummate a planned result."

Now *that's* an interior decorator!

But what are you?

You are neither house painter, nor slipcoverer, nor, as far as I know, a "percenter."

This guide is dedicated to making you an instant expert. After reading it, you will not be able to join the AID, but you will talk as if you belong there. You will be able to give advice to friends and foes. You will be able to decorate your own home and so gorgeously that your critics will cry. People will walk within your interiors and *know* that you are an authority. Your house will have *flair*, your house will have *taste*, your house will have *elegance*. Your vocabulary will reek with the right word for every occasion, and you will be able to ask the right questions, such as: "But, darling, does it *function?*"

# WORDS TO WAX PHILOSOPHICAL ABOUT

CERTAIN WORDS ARE BASIC to the designer's vocabulary. They are words one can readily understand, but may be hard put to define. Any designer worth his salt can supply his own interpretation. You will certainly have to have your own feelings about them to be worth *your* salt, so we will discuss them here.

The first word that comes to mind in any discussion of interior design is *taste.* You might define taste as a choice—choosing between alternatives. To have taste is to be discriminating—again the matter of choice is implied. Taste can mean accepting or rejecting the objectionable.

The phrase "she has taste" connotes "good taste." If you wanted to say that one had bad taste, you would have to interject the word "bad"—as: "She has bad taste." Or "She has no taste."

Much used is the expression "Good taste does not mean spending a lot of money." That means good taste is reflected when choosing inexpensive items, just as well as when selecting expensive ones. Then again, people say: "Rich or poor, it's good to have money."

To say that someone is nouveau riche is to say more than that they are newly rich. It is generally felt that the nouveaux riches can have no taste that is good, that they merely imitate the old rich without the shadings and subtleties that spell the difference between imitation and the real thing.

Good taste is a blend of thinking and feeling—a blend of the mental (knowledge) with the emotional.

Some people insist that you have to be born with good taste. Others say that it is environmental, and that you can become conditioned to it. And some feel that it can be acquired through training and application.

The most profound thing you can ever say about taste is to quote the Latin remark: *de gustibus . . . non disputandum.* (There is no accounting for taste.)

Having *flair* is something one is born with—like having a natural talent for dancing. You wouldn't necessarily know the steps—you would dance when you heard the music play. If you have flair, you could probably design a good room without knowing too much about line or form. He who has flair may lack taste, and obviously, vice versa.

People who have flair usually have strong personalities—they make everything they touch automatically "theirs."

Every designer talks about the *personality* of a room. It can have none, of course, like lots of people you know and lots of rooms you've seen. Obviously, it is desirable for the room to have a *distinctive* personality, one that separates it from the other rooms. A room can be *distinctively* cheerful, *distinctively* elegant, *distinctively* dramatic.

To say that a room is *elegant* is comparable to describing a woman. The details look expensive, but never ostentatious; the colors are brilliant, but not blatant; everything is subtle, but never dull. You might even say that elegance is the epitome of refinement and grace.

*Style.* Here too, a comparison can be made between a woman and a room. A woman may possess great fashion and great style, but she can have style and not be fashionable but can't be fashionable without having style. After you have digested this, you can understand that a fashionable room today may not be the fashionable room tomorrow. But once it has style, it will always have it.

# WORDS TO AVOID

THERE ARE CERTAIN WORDS that are basic to the working professional, but for the bluffer they are *non grata*—dreary dull. Here is a list of same:

*Function*—Does the decoration of the room lend itself to the necessary function of the room? Can a person really sleep in this bedroom? It matters but do we really want to talk about it?

*Dimensions*—Measurements? A bore!

*Traffic*—Can people walk through this room or will they hit their knees on the furniture? Hire a traffic cop.

*Budget*—How much do we have to spend and how are we going to allocate it? Pick up your abacus and go be a CPA.

*Scale*—The size of things. You might say that it's all a matter of significance or insignificance, or how big a thing you want to make of it. Best you consider your own scale in selecting the scale of the things in your room. If you yourself are large, don't choose underscaled pieces or you'll look like Gulliver in your own living room.

*Proportion*—The word that automatically follows scale. This is the

relationship of one factor to another, such as the size of the furniture to the length of the wall, or the size and placement of windows in relation to the walls. Things like that should be considered, but kept in proportion to the more important things.

*Maintenance*—Upkeep and housekeeping. If this is what's on your mind, then you're reading the wrong book.

# WORDS AND PHRASES TO SLING AROUND

KINDLY DIFFERENTIATE between this list and the glossary of technical terms that will eventually follow. These are simply words to use in place of other words, or phrases to interject into conversations when things begin to lull somewhat.

To begin with, you *decorate* a room. Then you get promoted and *design* a room. And then comes graduation, and you *create* a room.

Try this on for size: "Decorating is an art, not a science."

Here's another—you never hang drapes, you *drape* draperies. Hope, just hope that someone uses the word drapes as a noun so you can correct them. "Sweetie, there is no such thing as drapes. It's something you do, not something you have."

Better still, you hang *curtains*. That is a beautiful piece of reverse snobbery. Those who don't know always think curtains are the things that you hang ruffled in kitchens. But the beautiful people have only curtains in their drawing rooms, and if need be, they have overcurtains over their curtains.

And if you don't feel like hanging draperies, curtains, or overcurtains, you can have them *installed. Installations* sounds bigger and better and more expensive. You can have installations of draperies, bookshelves, and units of chests.

As you pick up a piece of porcelain (always pick up pieces of porcelain) look at the mark on the bottom. You might see the words: "Limoges Haviland China." Certain things like Aubusson rugs, or Limoges porcelain, were made centuries ago in Aubusson and Limoges, respectively, and are still being made there today. The phrase to use when looking at the article is: "Old or new?" This shows that you are informed, that you know that they're still making these things in those places today.

Or instead, if you're on sure ground, you say disdainfully: "New!" and dismiss the whole thing.

Or, better yet, when you know that it's old: "Is it signed?" or "*Where* is it signed?"

There is always a word or a phrase that will do more for your reputation than the unassuming one.

## MORE  GOOD  WORDS

THESE ARE EXPRESSIONS that don't need definition. They simply have a feel to them. Throw them into the conversation to score additional points in your favor.

a textural mixture
a Sybaritic feeling  (luxurious, hedonistic)
a play of textures  (rough against smooth, hard against soft)
a tactile quality
a pattern mix
great verve
aesthetic quality

## NAMES  THAT  ARE  DROPPABLE

SOMETIME IN YOUR CAREER as a decorating bluffer you will be called upon to acknowledge the name of a prominent decorator or to use a name or two yourself.

These are the well-known decorators whose names appear frequently in the pages of the House Something under pictures of stunning rooms that you secretly believe nobody can possibly own—Bebe Winkler, Bob Patino, Aaron Ast, Gary Crain, Armin Postler, J. Robert Moore, Robert Metzger, Renny B. Saltzman, Bert Wayne and John Koktor, Zajac and Callahan (who like to do mixes of pattern), Ruben deSaavedra, and Val Arnold.

There are many more—Melanie Kahane, Ellen McCluskey and Dorothy Draper & Co. Inc. . . .

There are surprisingly more names than you would imagine. I could go on and on.

Bloomingdale's is the only department store whose decorating

deserves a name-dropping and its Barbara D'Arcy is quite well known.

There are bigger names in decorating whose names you don't see too often in the magazines—quite possibly because their clients don't want or need the publicity. Michael Greer, who is not only AID but NIAD too, William Pahlmann, Marian Hall of Tate and Hall, George Stacey. Rose Cumming is a long-honored name. Mrs. Eleanor S. Brown heads the firm of McMillen, Inc., which includes many fine decorators. The name to use in England is David Hicks.

And then there are those whose names are more frequently seen in the gossip columns as they flit from continent to continent "doing" the houses of Jet Set stars; these include William Baldwin, and do call him Billy as Jackie does, and Mrs. Henry Parish II, better known as Sister Parish, who also knows Jackie.

The "firstees" in Decorating include Elsie de Wolfe, who set herself up in business just around the turn of the century. Edith Wharton, better known as a novelist, wrote a couple of books on Interiors. I bet you didn't know *that*. Mrs. Ruby Ross Wood was quite well known in the thirties, and Syrie Maugham, wife of the novelist, W. Somerset Maugham, was once the decorating rage of England.

# CLICHÉS AND WHAT TO DO ABOUT THEM

THERE ARE LOADS of clichés in decorating and they usually come from home decorating magazines, or from the pens of otherwise original decorators. The trouble with clichés is that they are usually true. This being the case, you can make use of them practically speaking, if you have to. But the more important thing here is that you *repeat* them. When the recipient of such golden advice analyzes them, he'll have to admit that you are right, right, right.

All these are clichés:

You can raise a ceiling by painting it a lighter shade than the walls. This, naturally, applies to low-ceilinged rooms. Conversely, to lower the ceilings in high-ceilinged rooms in order to impart a cozier, warmer atmosphere (a foolish act, since high-ceilinged rooms are so grand) you would paint the ceilings a darker shade than the walls.

Paradoxically, in a low-ceilinged room you could paint the

ceiling such a dark shade that it would wipe out the ceiling visually and thus give a feeling of limitless height.

You can make any room larger by the use of mirrors. You can use mirrors on facing walls, or a whole wall of mirrored panels.

You can even mirror a ceiling, which lends a tremendously large feeling to a room. They say Errol Flynn had a mirrored ceiling in his bedroom and he must have known. Of course, some smart alec is sure to say that it reminds him of a fancy bordello in Paris or Budapest. Ignore him! It is glamorous and quite an eyeful.

There's a whole string of clichés concerning stripes. Narrow stripes on large pieces of furniture will make them look smaller. As on a fat lady, stripes that run horizontally on a wall or on a floor will stretch it out, making it appear wider. Stripes that run vertically will stretch that old ceiling up. We could go on and on about stripes, but why keep stretching the subject?

To create an illusion of space, of depth, or of a vista, use scenic wall panels.

If your windows are small, you can make them look larger by placing your draperies on the face of the frame.

If your windows are long and narrow, you still hang the draperies on the face of the frame to give them width.

Tall plants will push up your ceilings.

Tall, narrow doors will push up your ceilings. (But try getting your furniture through them.)

Tall, narrow paintings will push up your ceilings.

Curved stairways lend an airy, elegant look to a room.

Red excites.

Green calms.

Yellow brings the sunshine into your room.

Gray takes it out. (I just made that one up. Sounds good.)

# DOS AND DON'TS

ONE OF THE DOS regularly extolled by home economics majors is: DO decorate for the life you lead. Which, translated, means that if you have little people running around with bowls of water and finger paints or semiadults (sloppy teen-agers) eating straight out of the re-

frigerator onto the floor, you have to live in a plastic, vinyl, washable world. This is great if you're a washable type of person yourself and want the reputation of "honestly, you could eat off her floor" sort of thing. But if you want to knock people's eyes out and convince them that you've got the taste and elegance of a Jet-setter, forget it. DON'T decorate for the life you lead, but for the life you'd like to lead. After all, out of man's dreams comes reality.

I have a better DO for the above situation. If you have semi-adults (sloppy teen-agers) eating straight out of the refrigerator onto the floor, repeat in soft, elegant tones: "DO wash up that floor, you slob!" or "DO get your feet the hell off that chair."

DON'T ever tell where you bought anything, even when friends persist. And people will ask, especially if they're stunned or stung by the beauty of your rooms. They suffer under the delusion that if they will go where you go to buy, they will end up with something equally breathtaking. Or they may be asking just for the hell of it. You shrug a shoulder and say—"this little shop on Madison" or "that little shop off Madison." It will suffice. If pressed for addresses, you might say: "Oh, God, I pick up a thing here, a thing there, who can remember?"

Of course, you can always say "Parke-Bernet." That's good. It not only carries with it the implication of money and quality (Parke-Bernet wouldn't bother auctioning off anything less), but also implies a certain amount of knowledgeable sophistication. You immediately stamp yourself as a guy or gal who knows his way around the big auction rooms where Rembrandts are sold and Burton bought that diamond for Liz.

Pianos bring about a barrage of DOS and DON'TS to make your head play a sonata in ragtime. DON'T treat a piano as if it belonged to Liberace. It is not a religious relic and doesn't need the reverence of a raised platform or half the living room to itself. DO let it be a piano and not some awe-inspiring artifact. If it did belong to Beethoven, all right then, DO give it half the room, spotlights and maybe even trumpet blares.

DO prop up the top of the grand piano all the way *only* when and if it is being played in earnest (not for chopsticks).

DON'T ever completely close the top of the grand piano, is another rule. The people who made this rule also say that pictures and other accessories DON'T belong on top of the piano. Sara Roosevelt did not see fit to obey this rule at Hyde Park. Perhaps no one ever told her DON'T. Or maybe Sara did it before someone made

up the rule. In her Dresden-filled little sitting room, there was scarcely room for another picture of some king or other (all *signed* too) on her piano.

DO have a small, pretty chair at your grand piano, instead of a rectangular bench. And those little revolving round stools that ladies have fashioned into dressing table benches DO belong only in Victorian rooms.

One of the favorite ploys of the supermarket decorating-hints magazines is an entire wall of framed pictures, called an "arrangement." Please DON'T do this arrangement unless you have cut and culled the very same pictures out of the very same magazine in which you found the idea, because then you deserve whatever happens to you. This arrangement crowds out everything else in the room, including any good pictures you may own. They will get lost in the crowd.

One big DON'T laid down by snobby decorators is: DON'T ever use artificial flowers. This can be amended. DON'T use plastic flowers, but silk or porcelain flowers can be lovely. DO keep the arrangements simple. It is far better to have artificial flowers in pretty materials than to have no flowers at all.

DON'T call a table a console and DON'T call a console a table. A table is something you eat off or put something useful down on, like a lamp or an ashtray. A console is something decorative that's placed against a wall, under a picture or mirror, and is there merely to look pretty. You may, occasionally and only incidentally, put something useful down on it. I think it would be permissible to have something decorative placed on the console, like a vase, which is decorative and only useful if flowers are placed in it, which are decorative anyway.

I could go on and on but since you will find DOS and DON'TS sprinkled throughout the text, I DON'T think I will.

# STRATAGEMS

A STRATAGEM IS A TACTIC. A tactic is good for impressing and/or convincing others of your inherent worth as a decorator.

# THE COMPLIMENTING OTHERS STRATAGEM

There are those miserly souls who are deathly afraid of complimenting anyone else's decorating (or anyone else's anything) for fear it might take something away from them or theirs. This is a large mistake.

Tell somebody that something of theirs is exquisite—their curtains, their sofa, their rug. You may not know it, but you've just paid yourself the supreme compliment. To acknowledge that something is in exquisite taste is to say that you, yourself, have even more exquisite taste. By complimenting their style or their flair, you establish your own flair, your own expertise.

When you compliment, you judge. And when you judge, you immediately place yourself up and above in the judge's chair, higher than the others. When you put yourself above others, this makes you an authority. When they accept your compliment (and who doesn't, gladly?) they're accepting your authority. And there you are, you authority you.

# THE BE CORRECT STRATAGEM

Judeo-Christian man started out with the Ten Commandments as a set of rules governing his behavior. From there, he diversified with sets of rules for every possible situation. These rules were guidelines, and they were changed, enlarged, and embellished so that they kept growing. Often, man was completely unaware of how and where these rules started, and was moved to ask, "Who says so?"

If the rule proved sensible, it stuck. But as man matured, some rules proved ridiculous and were abandoned.

There are certain irrefutable rules in decorating that who knows where they started, and who was the culprit responsible for them. Some are silly, just as some rules of etiquette are silly, but the "purist," the "be correct" person clings to them, and is acknowledged as a man of integrity who doesn't compromise.

My advice to you is that when it comes to your own doings, cut corners, be ingenious, save time, save money—the final showy result is what counts. But when it comes to others—"be correct." Tell them how it should be done *by the book*.

In the section on walls, for instance, you will be told that when fabric is applied to walls, it should be properly "upholstered" on with an interlining. It will look better, I'm sure, than fabric just stapled, taped, or glued on, and it will last indefinitely. However, practically speaking, does it look double the price better? Do we really care if it lasts forever? We are now the "mobile" society, here today and across the country tomorrow. When you are moving, and selling your house, will you tell the prospective buyer that he will have to pay more because your wall fabric is "upholstered" on, not merely pasted like wallpaper? Sure, you will. And even if *he* will be impressed with the upholstering job, *she* just might hate your print.

So you, yourself, can do it the fast way, the less expensive way, but be sure to tell Glenda or Brenda the *correct* way. She will respect you for clinging to high moral standards.

## THE QUOTING RULES AT THE DROP OF A HAT STRATAGEM

This is slightly different from the "be correct" stratagem. In the "be correct" stratagem, the matter of choice is subtly implied. The implication is "be correct" as I tell you, or be lazy, sloppy, and corrupt. In the "quoting rules" there is no choice—the implication is Follow the rule—or nothing. Do—or die!

The "quoting rules" stratagem should mimic perpetual motion. You keep doing it constantly. You shoot them out with the rapidity of machine gun bullets.

"The draperies should not quite touch the floor."

"The draperies should fall onto the floor with a few good inches to spare."

I have heard both rules quoted as frequently, which should give you a good notion about rules in general. If you can't think of any such quotes offhand, make them up as you go along. What is pertinent about quotes is not the quality of the statement, but the voice in which it is made, the tone and quality of the delivery.

You arrive at a dinner party for eight guests in addition to the host and hostess. There are two candles lit at each end of the table. You immediately quote in a no-nonsense tone: "There should be from eight to ten candles for each group of ten people at a table." This makes for instant popularity. You will be respected for your

erudition, but you probably won't be invited to too many dinner parties.

## THE CARRY A TAPE MEASURE
## WITH YOU STRATAGEM

You will carry a tape measure with you at all times, the metal, flexible kind that pulls out and snaps back. It has a nice businesslike snappiness about it. You whip it out at a moment's notice and constantly take measurements. You reflect a moment, then presumably mark down the measurements.

You may be in a friend's home and you whip out the old tape measure. She screams, "What are you doing?"

"I am simply measuring the distance from the dining room table to the tip of the chandelier," you tell her.

She holds her breath for an agonized few seconds. You write. She says, "Well?" fearing the worst.

"You are exactly one-half inch off," you tell her.

"What do you mean? What do you mean?" she cries.

"Your chandelier is thirty-seven and one-half inches from the table."

"Well?"

"You are one-half inch off. The proper distance is thirty-seven inches."

"Exactly?"

"Exactly."

"Who says?"

"It's the rule."

The next time—if there is a next time—when you whip out the old tape measure she will beg, "No, no, please, not the tape measure."

This stratagem will make you revered, respected, and very, very lonesome.

## THE BE SOMETHING STRATAGEM

This book is designed to make you an instant authority on every phase of decorating. But you really should have a specialty, if pressed on the subject. Be known for some phase of decorating that is especially *you*. This might be architectural design, or you could be a

scholar on the history of design. Or you could be known as a collector of fine furnishings, or of some specific item such as Limoges plates.

I know a plump and cheerful lady who swears that she has a diploma from a correspondence school in decorating. She did have a position as an advisor in a large furniture store whose owners called themselves interior designers, only she got the sack because she once took the wrong measurements and the draperies that a customer ordered came out a yard or two short.

And if you think that the point of this story is that in order to be a decorator you have to be able to take correct measurements, you're wrong. That was just coincidental.

The lady is well fixed and lives in an extraspecial old house on one of the most beautifully housed streets in town. (POINT—A big, fine house is always a big help.)

The minute you stepped into her house, a false note struck with the force of a dull gong. The foyer had a tasteful floor, white vinyl with green geometric insets. But there in the middle of the room sat a really huge plaster reproduction of that man picking the bottom of his foot, and all this surrounded by a mass of plastic palms. (POINT—If you must have reproductions of sculptures, do avoid the more famous ones, keep the scale down, and have it reproduced in a less obvious material than plaster.) (Another POINT—Do not use plastic plants where you can use real ones.)

A tour of the rest of the house revealed one tremendous, glaring fault. There was not one object that was truly fine in the whole house. (POINT—If you can't have the real thing, well-made reproductions of good design are very much in order. But *do* have one or two things that are unquestionably the best obtainable. Economize someplace else, but have something that shouts quality.)

Even her wall-to-wall carpeting was of obviously poor quality. (POINT—As a decorator of any training, she should have known that it would have been far, far better to have had one good small rug on well-polished *dark* bare floors. (The key word in that phrase is *dark*.)

The walls of the house were hung with one reproduction after another, whereas one or two fairly good originals would have sufficed. Though she could have afforded originals, she cheerfully bragged that her husband was stingy. (POINT—Never, never have a stingy mate.)

Some of the paintings were original, hers. Which is fine. Anyone who does anything in the way of the arts has a perfect right to display

them, or hang them, or as in this case, to hang with them. One could only wish that she had been a better artist.

Her color scheme *was* refreshing, and all the curtains, upholstery, carpeting, and glass in the house needed just that—refreshing. Everything was slightly soiled, which reminded me of Louis Bromfield's novels about seedy aristocracy—they always had "soiled diamonds." And the point here is that nothing is going to look gorgeous if it's somewhat grimy.

Decoratively, at least, her house was a failure. But the lady, herself, wasn't. *She was a scholar.* She had a terrific memory and a bent for books. She knew the history of every design and period. She could recognize any silhouette and provide a story to go with it—charming little vignettes of how Louie fell off his bergère laughing when Marie told the people to eat cake.

The lady in question had no taste, no discernment, and her sense of the elegant was all screwed up; but besides being a scholar, she could toss off French words like *trompe l'oeil* and *toiles-de-Jouy*, with a perfect accent, and somehow, I had the feeling that she could spell them too. This was her saving grace—she was *a something*, a scholar.

I went to another woman's house to purchase a custom-made planter that she had advertised for sale in the local paper. This planter was sitting in the garage among other purchasable and attractive items. (This represents a quaint surburban custom called a garage sale, in which the lady of the house gets rid of the junk that she has either tired of, chipped, cracked, scratched, or outgrown as she moved up the financial ladder.)

She invited me into her house, finally, to look at some other purchasable items that were still part of her decor. At this point, the wave crashed—she *was* a dealer in disguise. I didn't mind—the things that were in her garage were lovely—what she had in her house had to be more so. I was itching to get inside.

It was perfection. The house was furnished with some of the most beautiful things I had ever seen.

It wasn't a house that screamed "I've been decorated!" It was a house that said in modulated tones—"I am fine." Most of it was done in eighteenth-century furniture, and even the kitchen was perfect to the last detail in country French.

"Are you a dealer?" I asked right out. (Many dealers will never admit that they are and she didn't.)

"I'm not *rigid* in my decorating," she said. "When I see something that I like better than that which I already have, I replace it. I sell what I'm replacing, or I trade with a dealer for something I have that he wants for something that he has in his shop that I want. I love everything in my house—but I don't have to love it forever."

I wanted to pigeonhole the lady and I tried again. "Are you a decorator?"

She shrugged. "Of course I could be one if I chose."

Of course. I acknowledged that. It was a fair statement. Whether she was trained or not trained (I did not ask for her credentials), her *flair* and her *taste* were evident all around us.

Proudly she said, "I guess what you could call me is a collector—a collector of fine furnishings."

I bought the discarded custom-made planter in her garage.

Like the woman who said, "This year, when we went on our trip around the world, instead of just island-hopping as we did last year, and not just to Tibet, like we did the summer before that, I stopped off in India to buy this beautiful handmade carpet and lost the six-carat diamond out of my diamond bracelet and later found it caught in the hem of my sable coat," there's a lot of points to be made in my story.

The woman's house wasn't *obviously* decorated; it didn't need flashy color schemes or gimmicky decorating tricks to advertise its decorative worth. "I'm not *rigid* in my decorating" is an excellent phrase. Use it!

Improve! Move up! Trade up! Replace one object with another that may be more fitting. In Decorating, nothing should be forever.

But the most important point of all, she was not only a decorator, she was a *collector*. Very impressive.

So—find your little niche in decorating, and be something!

## THE DROPPING FRENCH WORDS STRATAGEM OR THE FRENCH HAVE A WORD FOR IT

In bluffing, it is always chic to drop a French word in place of an English word even if the latter will do. So here you have a small glossary of some French words that should prove useful.

*bergère*—an armchair that is completely upholstered.

*bibelot*—a small art object.

*boiserie*—carved woodwork, or paneling.

*bureau*—not a chest of drawers as you may think (that's a *chiffonier*) but a desk.

A *canapé* is a sofa and a *lit* is a bed and a *lit canapé* is a sofa bed which makes delightful sense. A *lit à la française* is a canopied bed that is placed sideways against the wall. A *lit à travers* is a bed placed sideways against a wall but without a canopy. A *lit d'ange* is a bed with a small canopy, and a *lit duchesse* is a bed with a large canopy. A *lit à la polonaise* is a bed with pointed crown canopy. And *lit* that suffice.

*chêne*—oak.

*chinoiserie*—decorative motif in the Chinese manner.

*commode*—low chest of drawers—some people who enjoy using euphemisms call their john a commode.

*étagère*—open shelves, either hanging or standing—much used currently as a synonym for bookcase.

*objet d'art*—a piece of art, small.

*ormolu*—brass or bronze doré applied decoration.

*poudreuse*—a toilet table.

*secrétaire*—is a desk of course, and a *secrétaire à abattant* is a drop-lid.

*singerie*—is the decorative motif using the monkey as a subject matter, and I bet that's a surprise.

*tôle*—is painted sheet metal or tinware.

*trumeau*—is paneling that goes over a mantel or over a door, and usually consists of a mirror with a superimposed painting.

*vitrine*—curio cabinet with a glass front.

There are others that you could probably employ, but half the fun is finding out for yourself.

## THE ITALIANS HAVE A WORD TOO

Everybody knows that decorators use a lot of French words, but how much more chi-chi it is to drop a few Italian words! And if you have trouble pronouncing French, you'll probably have an easier time with the Italian. Use great flair and wave your hands a lot.

*amorini*—figures used for ornamental purposes such as cupids or cherubs.

*arazzi*—Italian for Arras, actually a town in France, famous for its tapestries, but used in Italy as a synonym for Gothic tapestry.

*cassone*—a chest or a box with a hinged lid.

*certosina*—an inlay upon a dark background. Can be ivory, pearl, or even a light wood.

*letto*—bed.

*loggia*—an area or a room with an open colonnade on one side.

*sedia*—a chair.

*sgabello*—a small, wooden Renaissance chair, with a carved splat back and carved trestle supports.

*sgraffito*—a method of decorating a surface. (And just think, from this kids learn to scribble dirty words on walls.)

*tazza*—an ornamental cup.

## BUT THE ENGLISH HAVE A FEW WORDS TOO

If it's chic to use French words and chi-chi to use Italian words, it really is the very end to use English words instead of English words, if you get my meaning.

It's a chimney instead of a fireplace, and a chimneypiece instead of a mantel. And one Englishman calls the objects you arrange on the mantel a chimneyscape, and that's really charming.

It's elbow chairs instead of you know what, and perspex is Plexiglas, I think. A pelmet is a valance and they talk of a drink table which is rather nice sounding.

I'm still working on *close-carpeting* and I just wonder if it's wall-to-wall they're talking about. When I find out for sure, I can assure you, that's the word I'll use.

## DECORATING ONE STEP AT A TIME

WHERE DOES ONE BEGIN when actually "doing a home"? First, you must consider the general architecture, the general path of decorating design that will be taken—traditional, contemporary, or what-have-you—as to furniture and to feeling, color choice, walls, ceilings, floors,

selection of accessories, etc. This represents choices, choices, decisions, decisions.

## ARCHITECTURE

Ordinarily, this would be your first step. However, if it's architecture you want, you have come to the wrong place. We can't possibly give you an instant course in architecture right here and now. I will say this to you. Make the most of what you have. I can also give you a good line to use. A friend came to me with what appeared to be the top of a three-paneled screen made of carved wood. She said that she had bought it in an antique shop because it looked interesting and it was inexpensive—what should she do with it?

No, I didn't say *that*.

An expert never fails to respond to a call for help. I looked around her house—a plain, expanded Cape Cod. Immediately I pointed to the top of the arch that framed the entrance to the dining room from the living room. "Put it there—these houses need architectural interest."

Now my friend goes around giving out free advice, saying, "The houses we live in today need architectural interest, you know."

## TRADITIONAL

"Deriving from tradition . . . of the past . . ." Even if you don't decorate in the traditional style, you are undoubtedly familiar with the hackneyed phrase "we learn from the past." We do, and that's a fact. Everything we have about us and will have in the future is built step by step on what has existed before. So if we take a look at what has existed before in design, we can understand where we're going. Let's get on with it.

## A HISTORY OF FURNITURE AND DECORATION STYLES

A complete history of period styles would have to begin with B.C. But to keep us all from going out of our minds we will deal here only with the major, pertinent periods starting around the fifteenth century. For reasons of clarification, we will proceed country by country. Just try to keep in mind that while one development or an-

other was taking place in one country, other developments were simultaneously happening elsewhere. Here is a chart to help you understand things in relationship to developments in other countries.

You can see how history and design went hand in hand, how revolutions affected the periods, and the effect one country's artistic development had upon the other's.

This whole shmear is great for the decorator-bluffer who wants to pose as a history buff in the decorating game.

### It Happened in Italy

Art influences that started in Egypt flitted around the Mediterranean countries and sort of took root in Italy.

First came the Italian Renaissance. The Early Renaissance period took place between the years 1420 to 1500, and the High Renaissance between 1500 and 1580. The Renaissance period marked the first time that Italian houses were really furnished. The name to remember in connection with the Early Renaissance period is Medici, a family that owned some very spiffy furniture. The High Renaissance was highlighted by the era of most of Italy's greatest artists.

The Baroque period came next. The term "Baroque" originated in France to describe what the French considered a strange type of Italian architecture and decoration. This style evolved into the Rococo, which had its roots in Italy, but had its greatest development in France. Italian Rococo decoration and furniture is often labeled "Venetian" because it was there during the eighteenth century that the Italians ran wild in a virtual orgy of decoration.

### And Then It Happened in Spain

The Spanish had their Renaissance too. Their furniture was simply made, but big on ornamentation. Much use was made of silver, iron, nailheads, ivory, and leather. Italian Renaissance motifs were often mixed with Moorish patterns.

Many crafts were established in Spain during their three periods, the Hispano-Moorish, the Plateresco, and the Renaissance, and this influence is felt today. Tiling, carving, inlay work, metalwork including iron, steel, tin, silver, and gold are all part of the Spanish Mediterranean trend that is part of the contemporary picture in design.

### France and Politics

When Louis XIII died and left his son, Louis XIV, to reign for seventy-two years, France became established as the cultural center

# HISTORY AND DESIGN

| English | | American | | French | |
|---|---|---|---|---|---|
| Tudor | 16th century | | | | |
| Jacobean | 1603–1649 | Colonial | 1620–1783 | Louis XIII | 1610–1643 |
| Charles II | 1660–1685 | | | | |
| William and Mary | 1689–1702 | Early American | 1620–1725 | Louis XIV | 1643–1715 |
| Queen Anne | 1702–1714 | | | | |
| Early Georgian | 1714–1760 | Georgian | 1725–1790 | Regency | 1700–1730 |
| | | | | Louis XV | 1715–1774 |
| 18th Century | | | | | |
| Georgian | 1760–1820 | | | | |
| Chippendale | 1754 | | | | |
| Adam Brothers | 1768 | | | | |
| Hepplewhite | 1789 | Federal | 1790–1825 | Directoire | 1795–1804 |
| Sheraton | 1791 | | | | |
| English Regency | 1800–1810 | | | | |
| Victorian | 1837–1901 | Victorian | 1837–1901 | Empire | 1804–1814 |

| Italian | | Spanish | |
|---|---|---|---|
| Renaissance | 1400–1600 | Hispano-Moorish | 8th–15th century |
| Baroque | 1550–1750 | Plateresco | 1500–1550 |
| Rococo | 1715–1775 | Spanish Renaissance | 1550–1650 |

of Europe. The kings of France promoted the art industries of France out of their own desire for beauty and sumptuous luxury, and also to improve the economic condition of the country. As nowhere else in the world, politics and design went hand in hand here. Each succeeding political regime had its finger in the French decorative arts that are so particularly admired in American decor today.

**The Louies**

As in fine cuisine and fine wine, the French seem to lead the pack in period decoration. And the kings Louis are the lads that have made the most impact in this area. They certainly were a fascinating bunch, but the important thing is to tell them apart.

Under Louis XIII French decor fell under the influence of the Italian Renaissance. Versailles began as a hunting lodge built by him to get away from it all, especially women. (He didn't like them, unlike his namesakes that followed.)

Louis XIV was the fanciest dude of them all. His style was called Baroque, which means grotesque or fantastic in shape. The Louis XIV style was never popular with the rank and file; it was a style for kings. Today, in the United States, it is not used nearly as much as Louis XV or Louis XVI.

It was a grandiose style, and the other royal courts of Europe adopted it as a model. When the Sun King (so called because his residence was the radiant center of Europe and thus of Western civilization) died, the people rejoiced—he had left a France burdened with debts and its people impoverished. But he also left France a great heritage—Versailles, the palace and its gardens that he had transformed into the greatest living museum of a vanished life, a collection of all the fine arts that flourished in the name of *le style Louis XIV*.

Next came a brief period called the *French Régence,* during which a regent served in place of the infant king Louis XV. The closing days of Louis XIV's life were saddened by financial and personal difficulties which were reflected in a period of austerity that somewhat restricted the grandiose style for which he was famous. This austerity continued into the Regency and there was a slight overlapping between the historical and the design periods.

Louis XV is the style most admired in this country currently. The Baroque was supplanted by the Rococo movement in which rock and shell motifs adorned a more graceful, and smaller-scaled

furniture. The cabriole leg was an important feature, and the emphasis was on delicate curves. Louis XV's two favorite mistresses, Pompadour and Du Barry, also had a hand in influencing style and they too lavished great sums on favorite things. Madame Pompadour, in particular, was a grand patron of the arts.

And then, of course, came those two unfortunates, Louis XVI and his bride, Marie Antoinette, who were on their way out before they knew it, mostly because of the excesses of the two Louies before them. It was said that Marie had more taste than brains. She preferred cake to bread, and pastels to the richer colors of the preceding reigns. The Louis XVI reign was distinguished by the Classical, a reversal of the Rococo; it featured straight lines and compass curves.

Came the Revolution, and then the *Directoire,* which expressed itself by military motifs, simplification of the Louis XVI style, and the use of painted furniture in place of expensive woods, in accord with a time of political economy. Marie Antoinette had lost her head partly because of her spendthrift ways and those of her predecessors, and the new rulers weren't about to take any chances.

Then came little old Napoleon and the *Empire* style, a classical form that abounded in motifs of Napoleon's battlefield victories, Egyptian motifs, and symbols of Roman and Grecian architecture. Napoleon wasn't averse to spending money either, and he wanted everything to be different from what it had been under the monarchs. A definite masculine feeling prevailed in the Empire period. Mahogany was its wood, and steel furniture was also popular at the time. Napoleon and his officers took steel furniture with them into the battlegrounds. It was strong, portable, and elegant as per Napoleon's instructions.

When Napoleon went his way the heyday of French period furniture was over. It was all downhill after that.

While we are talking French, let us add a pertinent note.

## Provincial Furniture, Be It French, Spanish, Italian, or Even Portuguese

Provincial furniture is furniture made in the provinces for use in the provinces, provinces being the outlying lands or countryside where the less chic reside. Thus, it would be a more simplified style, less elegant in ornamentation and upholstery materials than its city cousin.

There is a general misunderstanding regarding French Pro-

vincial. Some people (mostly furniture salesmen) assume the term refers to a certain period. Not at all. Each period had both its city version and its provincial version. Any piece of furniture would be true to the *general line or silhouette of its period* regardless of its locale.

Those who understand that Provincial is not a period by itself, but a country version of a period, sometimes err in thinking that this period is *only* Louis XV. Not so. It can be any period.

Hasten to correct anyone who errs in this direction, and you're one up in the bluffing game.

**The English Way**

Although we wouldn't want to live with Tudor style furniture today, it is worth mentioning because a lot of people live in Tudor style houses in America. Tudor style furniture was heavy, massive, and rather stern, but the houses were charming—the originals of the famous English country house with its equally famous English gardens.

We mention *Jacobean* furniture, because this was what the first colonists who sailed to America took with them, if they were able to carry any furniture at all. The gateleg and drop leaf tables of that period are still with us today. Suffice it to say that Jacobean furniture was made for service rather than for comfort.

There was a Restoration period in England with Charles II at the helm, and the English got a little bit jealous of the elegance that was France's, so austerity was out and they jollied up the place a bit.

*Mary* of England loved *William* of Orange and they married and lived happily ever after in Holland until they took over the throne of England in 1689. They preferred simplicity, and much of the Charles II influence went out the window. Mary had collected china (probably Delft) while whiling away the time in the land of the tulips, and when she went back to Merrie Olde England, she needed cabinets to display same, hence the William and Mary cabinets and the introduction of the highboy. She also liked needlework, and there was much crewelwork about on draperies, bedspreads, and upholstery. She made the ladies at court do it too because she couldn't be expected to do everything, now could she? This period was known as the "Age of Walnut" due to William's love for the Flemish influence, which leaned heavily toward that wood.

*Queen Anne* was really not interested in design or furniture but

they named one of England's most famous furniture periods after her anyway. The cyma curve, the cabriole leg, and the use of mahogany was what it was all about, and Queen Anne chairs, mirrors, and wallpaper are still around an awful lot.

*Eighteenth-century Georgian* stands for four names of *ébonistes*, or cabinetmakers. Foremost would be the Chippendale family, and there was Grandpa Chippendale, *Thomas Chippendale*, and Junior. The whole family were designers, but Thomas was the famous one. It is said that Chippendale furniture is truly elegant, but Thomas was a money-grubbing cat and he made the kind of furniture that he thought would sell. He did and it did. He followed many styles— Louis XIV, Louis XV, oriental, and he innovated Chinese Chippendale. The upholstered wing chair is his, as well as the "piecrust" table, and the camelback sofa. Mahogany was his wood.

The *Adam brothers* were four in number; Robert was the most famous. They were not cabinetmakers, per se—they were architects primarily, but the "Adam style" became connected with interiors and certain types of chairs, mirrors, and fireplace mantels. Delicate classicism is the key phrase here.

*Hepplewhite* furniture was reportedly weak in construction, but strong on grace, elegance, and beauty. Mr. H. frequently produced the furniture that the Adam brothers designed. Authenticated examples of his work, unfortunately, are no longer about, perhaps because of the weak construction.

*Thomas Sheraton* rounds out the list of this Georgian period. Straight line and rectilinear forms were his bit. We owe the serpentine sideboard and the Pembroke table (made for the Earl of Pembroke, darling) all to him. For those of you who want facts to quote, the last quarter of the eighteenth century and the first quarter of the nineteenth century may be called the "Age of Satinwood."

Both Mr. Hepplewhite and Mr. Sheraton used satinwood extensively, and both published books of their designs.

With the *Regency* began the gradual decline of English furniture design, a return to classicism—Greek, Doric, and Ionic, and then into the *Victorian*. Hardly anyone has a good word to say for Victorian. Queen Victoria was straitlaced and well behaved but her interest in the arts was practically nil.

Victorian furniture, like the houses of the period, was a mixture of many styles. Bric-a-brac was dearly loved, gingerbread ornaments abounded, and a slightly vulgar tone pervaded it all.

There are a few pieces from that period that are not too horrible,

and it seems that the Victorians did some fine work in the area of chintzes. And that's just chintzy.

## America the Beautiful

The first thing we have to understand about *Early American* furniture and style is that there was no style that was completely American, except for Shaker furniture and perhaps the stylized decorative designs of the Pennsylvania Dutch. All other designs had their origin in England, and to a much lesser extent France.

The first American furniture mimicked the Jacobean style, but on a more provincial note than that of England. It had to be more primitive because it was built by carpenters, not cabinetmakers.

The American colonists used bright colors, crewel embroidery, tapestry, homespun rugs, banjo clocks made by the Willards, and oak, maple, and pine woods.

In the eighteenth century, the Georgian period concentrated more on the beauty of furnishings whereas, before, it had been confined to functional considerations only. The furniture styles of Chippendale, Hepplewhite, and Sheraton began to be produced here, and America boasted its share of fine cabinetmakers in Philadelphia, New England, and New York.

With the Revolution, America sought to break away from its English and colonial past. The *Federal Period* here manifested itself in a Greek revival, and produced Duncan Phyfe, America's most famous furniture maker.

The *Victorian* period made a big splash in America. It was a Romantic period, what with cabbage roses, marble hands holding little vases, and windows swathed in so many draperies that the room never saw the light of day.

Out of the Victorian morass came Louis Comfort Tiffany, who designed the famous Tiffany glass and led the "art nouveau" movement which sought to break away from the heavy, ornamented Victorian style.

The late Victorian era saw the emergence of Belter furniture, which was a brighter light in Victoria's picture.

## A Note from Germany

Before we take leave of the nineteenth century, a last good-bye.

It seems the German personality did not lend itself too easily to the field of design and decor. But there was one notable contribution—a style of furniture called Biedermeier, which was introduced

by Goethe at the time of the Directoire-Empire period in France. It took its name from a popular comic strip character of the time, Papa Biedermeier. It was sturdy in style and had little in the way of ornamentation.

## CONTEMPORARY

This means "of our age," "of today," "twentieth-century." In this book, we are discussing American interior decoration, but there also has to be an awareness of what is going on elsewhere in the world. The contemporary room in America would reflect designs from all over the world, and would take into consideration all kinds of trends.

Contemporary furniture has its "history" too. This history goes hand in hand with the development of contemporary architecture.

Frank Lloyd Wright was the man who "liberated architecture." But in addition to his landscape and architecture designs, he contributed greatly to contemporary furniture. When his designs first reached the public, they were considered "very modern." Today, they are *very* contemporary, very "now." Would you believe that he first set up office eighty years ago?

The Bauhaus was an international center of crafts, architecture, painting, sculpture, and music in Germany in the 1920s, and it originated many concepts used today—streamlined metal furniture, modern textiles, lamps, dishes, all very "in" things these days.

Other architects who were already active in the early part of the century and whose designs for furniture are considered very "now" today are Le Corbusier, Van der Rohe (of the Barcelona chair), and Breuer.

Thonet invented the bentwood process for furniture in 1840. Bentwood is definitely contemporary. Today, Thonet Industries manufactures furniture of bentwood, plywood, steel, and aluminum.

The Scandinavian countries made a large contribution to the contemporary picture. Some names to remember are Alvar Aalto, Mathsson, and Klint.

More names of contemporary designers: Charles Eames, Eero Saarinen, Hans Wegener, Jens Risom, Edward Wormley, and Paul McCobb.

Much modern or contemporary design is influenced by the oriental. There is a type of architecture and furniture that is a blend of the Chinese, Japanese, Korean, and Polynesian melded into something called the Hawaiian style.

One concept of contemporary design is American-in-a-hurry. Less clutter, less to dust and polish; structural lines that allow for clean, structural thinking: materials that make easier living possible. This style features dual-purpose furniture—the desk that can be a dining table, the sofa that is both a sofa and a bed, a bed designed so that it can go into the living room or the bedroom. Good old American know-how, to strike a chauvinistic note.

## THE MODERN TREND

You can always say—if you want to be facetious—that what was going on in decorating in 1830 was modern for 1830, and so on and so on, but in decorating, modern has a definite meaning.

"Art Deco" in the twenties and thirties was modern—or better still—"moderne" (accent on second syllable). There is a revival of Art Deco today as part of the nostalgia bit. Many a woman has not only done her house completely in Art Deco—blue mirrors, figurines of women, and the pottery and glass of that era—but has also done *herself* up as the Art Deco woman, hairdo, clothes, and all.

Some critics like to distinguish between modern and "modernistic," "modernistic" being the dirty word, or being modern for the sake of being modern for the sake of design and better utility.

The Paris Exposition of Decorative Arts in 1925 was credited with marking the beginning of a new and functional modernism.

As a final definition, you can say that modern is contemporary peeking into the future, or would you rather say that modern is a projection of the future?

## THE ECLECTIC TREND

Eclectic means mixed. This mixture can consist of traditional and contemporary. It can combine periods of different countries; it can be a mixture of period furniture with contemporary paintings, or modern furniture with old Persian rugs and French Impressionist paintings.

It is a delightful, exciting way of decorating. A lot of people who did with what they had (hand-me-downs, old things that were left over or inherited) mixed the old with a few new things that they bought and didn't even know that they were being fashionable.

Eclectic is very high style today. The "intellectuals" do it. They

adorn a room with books, a contemporary glass dining table, a Barcelona chair, Louis XV bergères, and an Indian rug.

"Suburban ladies" do it. They have an Early American kitchen with a pedestal table and chairs of Saarinen design.

"Society ladies" do it. A bedroom with chintz draperies of English design, wall-to-wall carpeting in contemporary nylon, a lacquered dressing table with chinoiserie ornamentation, and a Queen Anne chair sitting in front of it.

Eclectic is putting modern upholstery fabrics on antique furniture.

Eclectic is putting a collection of pre-Columbian pottery on shelves of lucite.

Eclectic means freedom from the old decorating taboos.

Eclectic is visual excitement.

## COLOR

In decorating a house or an apartment or whatever, color may well be where it all begins. You might say, it is your best weapon. It certainly can be the most inexpensive expedient you can use in achieving fantastic results. There is an expression used by the young folk today—"getting it all together." Color is the tool that gets it all together in decorating.

Color Wheel

There are certain basics that should sink in before we get on to the interpretations. The color wheel is divided into twelve colors. These consist of three primary colors which I refuse to name because if you don't know them, forget it. The secondary colors are of course, green, purple, orange, made by mixing the primary colors, and in kindergarten we all learned which ones to mix to get which. The tertiary colors are six in number, made by mixing primary and secondary colors in equal parts; they are yellow-green, blue-green, blue-purple, red-purple, red-orange, and yellow-orange.

Now by keeping this in mind, we can analyze the three most-used color systems.

*Complementary color* schemes. Colors which are opposite on the wheel from each other. The extreme of this would be green and red, which is fine if you like Christmas all year round, or yellow and violet which is also fine, if you like jelly beans. These colors are diametrically opposed to each other. You can tone down these combinations by not using those colors that are exactly opposite, but by using colors more or less opposite.

*Analogous color* schemes are those made up of colors located side by side or close to each other on the wheel, like yellow and orange. By choosing those colors close to each other, you'll be safe rather than sorry.

*Monochromatic* is the use of one color, or tints and shades of one color. This effect is tricky; you can end up with one hell of an exciting room, or die a slow agonizing death from tedium.

There are certain truisms about color that are constantly being proselytized. Like most truisms, a lot of them make a lot of sense. The thing to do with truisms here is to use them if they make sense to you; to blow them to bits to achieve extraordinary results, but above all to quote them liberally to others. Even if a truism is not true, it always sounds as if it should be, and this is what establishes one as an authority. Here are a few truisms.

A room with a northern exposure should have a predominantly warm color scheme. *Why not?*

Light colors promote a feeling of spaciousness and airiness. *That sounds sensible.*

In smaller houses, or in small apartments, using one general color scheme throughout unifies the whole and makes the whole thing flow. *Very possibly. But do you really want to eat your three meals a day looking at the same colors that you looked at when you washed your hands and then again when you went to bed?* It might become

such a bore that you'll overdose on sleeping pills to keep from being bored all over again.

Dark colors absorb light. *That's a good rule for bedrooms if the early morning light keeps you from sleeping.*

Another favorite color truism in the homey magazines that you buy at the supermarket is that if you really want to be safe and avoid making any decorating errors, decorate in beige or other neutral tones. *If you wish to be one screaming bore and live in another, by all means follow this advice!*

I can't think of anything drearier than one room after another done in shades of brown or gray, or whatever other neutrals you can think of, with the exception of black and white. The effect of all-white, or all-black (relieved here and there) or a combination of black and white only is smashing (good monochromatics). But for some reason, only the very brave dare take this step.

An all-white room is not quite as extravagant as it may sound or look. When Syrie Maugham introduced this stunning effect in the twenties (I wasn't there) materials were not as cleanable nor cleaning materials as effective. Today, you can be a beautiful person in a beautiful setting with a minimum of upkeep.

Vivid colors are exciting and tire the eye, so use them sparingly. *Do so and confine yourself to a lifetime of drabness.* Ruby Ross Wood never spared the reds. Her own apartment was said (I was never there either) to have been done in at least twelve different shades of red (monochromatic to say the least.)

Color changes visually when applied in large, extensive areas; a red becomes more intense, redder, etc. *A fair statement.*

Certain color combinations have been used so much that they have become clichés all by themselves. Brown and orange come to mind immediately. How many suburban rooms have you seen decorated in brown and orange? How many in brown and olive green? Olive green and orange? Certain color schemes become the rage in the second-class furniture stores, aided and abetted by second-class decorating magazines. Follow the other poor lambs, and you will have last year's second-class color scheme for years ahead.

Sherrill Whiton, long-time director of the New York School of Interior Design, talks about "the language of color" and gives a sweet list of the symbolism of certain colors.

White—Purity, peace, faith, joy, cleanliness
Red—Passion, anger, warmth, gaiety, martyrdom, revolution

Blue—Restfulness, coolness, sky, constancy, truth
Black—Darkness, despair, sorrow, mourning
Green—Spring, hope, restfulness, coolness
Yellow—Warmth, cheerfulness, fruitfulness, jealousy
Gray—Humility and penance
Purple—Justice, royalty, depression, suffering, church color
Gold—Royalty, luxury, power
Pale blue—Male child
Pink—Female child

I think the best color choice you can make is, as the more eloquent and exuberant decorators might say: "Let it be you!"

## WINDOWS, CURTAINS, BUT NEVER, NEVER "DRAPES"!

The dictionary defines fenestration as a wall of windows in a building. Some decorators describe the whole business of windows, what to do with them and what to cover them with, as "fenestration." It's an ugly sort of word anyhow, that sounds like some bodily function that's best not discussed.

The number of ways you can cover your windows are many: shades—plain, Austrian, or Roman; screens, louvers, shutters, Venetian blinds, all with or without curtains, overcurtains, undercurtains, or combinations thereof. I have seen beautiful rooms without any kind of window covering at all. If the shapes of your windows are interesting by themselves, or the windows are of stained glass, or something good like that, and the matter of privacy is not a concern, leave them alone. Certain rooms benefit from the austere look this curtainless state will create.

Roman shades and Austrian shades operate on the same principle. The Roman shade is tailored and neat and made of fabrics that lend themselves to being tailored and neat. Austrian shades are made of luxurious fabrics, and give a luxurious effect. The fact that certain people may say that they remind them of a lavender and gold waiting room in a beauty salon needn't affect your decision. If they make you feel all luxurious and delicious, by all means install them.

The early colonists in America lived in cottages and didn't have anything besides the fireplace to keep them warm. As a result, they put in small windows to keep the wintry wind out as much as possible. Therefore they used small squares of material called cottage

curtains for their small windows. Today, we have large windows and there is no excuse for using "cottage" curtains unless you're furnishing a real cottage.

If you don't like a whole wall of windows, even if you are fortunate enough to have one, you can break up the whole-wall effect by putting columns or panels between the windows and then draping each window separately.

There are some bluffers who like to make snide remarks about picture windows; one being that all they do is let you look into your neighbors' picture windows. (There can be advantages to this too—if your TV set is broken.) I think this is a particularly vicious canard, especially after all the trouble builders went to to install them so that they could advertise the picture window as one of the features of their houses. Personally, I feel that the picture window may be one of the better things you can say about most of the split-levels in which they are installed. Let the picture window be decorated by a lot of huge plants in the daytime, and have plain draw draperies to cover them at night, and there should be no problem about picture windows.

There is a general rule that curtains should be made of materials relating to the period in which you are furnishing. For a Louis XV room, you might use brocade, silks, or velvets; for a Victorian room, rep, plush, or calico would be fitting. But we've got so many crazy fabrics in our time that you could use mattress ticking and achieve great results.

It is usual to have a valance with one's draperies, though there are times when they can be eliminated, as for instance, when using a large or decorative rod from which the draperies would hang. You then reveal the rod, not hide it. But correct is correct—do try to have a proper valance, terrible dust catchers that they may be.

People who make curtains and decorators who make a percentage on the curtains would like you to have a three-way menace consisting of stationary draw curtains close to the glass (which is why they are called glass curtains) of some thin, sheer material; over this, draw draperies in a heavier, costlier material; and finally, the stationary side draperies which would bear the burden of the trim, fringes, tassels and tie-back cords. And would you believe that some people have a *simple* shade in perhaps a white or ivory underneath all this?

Beds are sometimes draped as well as windows. This could consist of a canopy, or draped posters, or a drapery centered on the wall against which the headboard rests.

Beds were draped originally for the sake of warmth, to keep out

drafts. In the eighteenth century, these draperies were terribly fancy and impressive, since royalty received guests before arising from their state beds. These beds had corner posts, swags, festoons, jabots, fringes, cascades, and whatever else they could think of. If you have a very large bedroom and want to lie in state, you could emulate the kings. But it seems to go against the American male (opposed to the female) puritan ethic to be caught in any bed for whatever reason.

There are probably a hundred other things you can do with your walls. You can put vinyl floor tiles on them (which I would never do). There are metal tiles of all colors, and ceramic tiles of all kinds, shapes, colors, and various national origins. You can mirror them. You can carpet them (which sound-proofs them, sort of).

And if after all this you are still at a loss you might even paint them.

Just remember what Samuel Pepys said about his wife's flocked paper (the kind that looks and feels like cut velvet). He described it in his diary as *counterfeit damask*. Adorable?

## FLOORS AND FLOOR COVERINGS

A favorite perennial bone of contention in the decorating field is bare floors versus rugs or carpets versus wall-to-wall carpeting.

If the floor is to be bare, it should be especially beautiful, waxed and gleaming; and if it is wood, it is the general consensus that it should be dark. The yellow-like varnishes that are frequently applied in apartment houses are to be avoided like poison ivy. The darker the stain, the more elegant. *Black* stained wood floors are the most elegant, but it needs maximum maintenance or the black will stand for nightmare.

There are parquet floors and parquet floors. They are parquet when the boards are laid in a pattern which may be of any geometric design—herringbone, or even flowerlike. The lovelier the design, the more important the parquet, and it would be ridiculous to cover a floor of that importance with anything but a very small, fine rug. In the truest sense of the word, a parquet floor should have a border all around.

Versailles made parquet famous.

If you have a floor with boards simply laid down next to each other, what you have is a plain old wooden floor to do with it what you will. Old country houses may have old oaken or pine floors with pegs. That's good—the pegs make the difference.

Then we have terra-cotta tile floors, ceramic tile floors, and quarried tile floors. Terra-cotta tiles are prestigious since they can be made to order, any size or shape you prefer. Marble floors are regal if you can afford them, of course; and if you'd like to name-drop (you'd better if you want to bluff) you can say that Averell Harriman has a travertine floor in his home at Hobe Sound.

You will be happy to learn that you don't have to apologize for vinyl floors anymore. They have come out of the kitchen, or should we say, the closet.

The important thing to worry about concerning rugs is the border. If the rug doesn't have one, it is not worthy of the name. The border may be only a fringe, or a separately woven band applied to the rug, or part and parcel of the rug itself. If the rug does not have a border and is not wall-to-wall carpeting (incidentally, to be truly correct, wall-to-wall should have a border too, but we won't press the point) then it is only a piece of something. You could substitute an "a" for the "u" and simply call it a rag.

Round rugs look more important in a room than the usual rectangular or square ones. By the nature of their shape alone they take on a more dominant role in the total decorative picture.

Some people love wall-to-wall carpeting since they consider it luxurious. Others look down on wall-to-wall carpeting as nouveau-riche. The fairly safe evaluation of wall-to-wall is that it is far easier to maintain than a bare floor, and is suited for the badly or odd-shaped room, although it can never match a really great rug.

Carpeted stairs should have the brass bar laid on each step to keep the rug snug against the rise of the stair. Why? Because it's correct, that's why.

Rugs go back a long way. Homer mentioned rugs in his writings and so did the Biblical writers.

The great names in rugs are Aubusson and Savonnerie. And for the bluffers who tend toward the historical, be advised that the Moors came from Spain to establish the first rug looms in France at Aubusson in the thirteenth century, hence the claim that the finest antique rugs come from Aubusson. The Savonnerie factory was established in 1618. Both the Aubussons and Savonneries are still being made.

You have probably heard that any room with a beautiful oriental rug needs very little else in the way of decoration. Obviously said by those with a bias. An oriental rug does go with any style or period and no good eclectic home would be without one. In the most modern

of homes that are all redwood and glass, you will see oriental rugs looking quite at home.

The six classifications of oriental rugs are: Persian, Caucasian, Indian, Chinese, Turkoman, and Turkish. The Kerman, in soft cream, rose, and light blue, and the Sarouk, with dark reds and blues mixed with the lighter colors, are probably the best known designs of the Persian rugs. The Kashmir is the best known of the Indian rugs.

While animal skins are being used with the most modern of furnishings, they are the perfect rug for the perfect eclectic room. The paradox here is that fur skins were the first kind of floor covering used, naturally going back to the caveman, but the vogue is certainly twentieth century all the way.

Here, of course, there is a struggle between the ecology-minded and I-must-have-what-I-want school. If you choose to have the fur rugs yourself, be prepared for the youngest voters and the conservation-minded to advise you that you have used the worst possible taste.

Aha, but if you don't have them yourself and want to put down someone who does, all you have to say is, "Darling, it's in bad taste to tell Polish jokes and it's in even worst taste to have those poor animals spread out all over the place."

## CEILINGS

At one time, ceilings were magnificent, an important part of the architecture and design of the house. Today, in new houses, they are mostly nothing. Actually, it is incorrect to say "new." Any house built after World War II, which is almost thirty years gone, is lacking in the interior architectural niceties such as cornices, and detailed ceilings.

It is all a matter of economics, and most people are not disposed to spend their designing money on ceilings.

If you want to sound like an authority on ceilings, tell little stories of how Michelangelo kept begging to get off that ladder and the Church used every pressure in the book to keep him up there. Or you could tell how George Washington liked ornamental plaster ceilings and hired a Frenchman to create them for his sister Betty's house at Fredericksburg, Virginia.

Old country houses, New England farmhouses, and Spanish-type houses in the Southwest leave architectural beams exposed. They should be left in their natural state. Some people think natural

is always best, which is a lie, but in this case, it is true. All kinds of sins have been perpetrated against those beams—tiling, painting, material-swathing, and it's just not nice. Some people are building glass-and-wood houses and Swiss-type chalet ski houses with great natural architectural beams exposed. That's nice.

There are some town houses and mansions left over from the early part of the century that do have particularly beautiful painted ceilings. There are women who have lain on an examining table of a certain obstetrician in Jersey City who could look at a really delightful ceiling of blue skies, white clouds, angels, and cherubs while he did what he did to them. His offices are in a converted old mansion, and luckily, the ceilings were left intact, and because he is a very busy doctor, you could lie on that table waiting for a half hour. It is a great time for deep introspection. The doctor must be of the school who believes that thinking beautiful thoughts and looking at beautiful things while enceinte will produce beautiful babies.

There is another town house standing in New Jersey, dwarfed by the high-rise apartment next to it, that was the home of a silent movie star, from, I suppose, the days when they made movies in Fort Lee. The house is resplendent with formal gardens, statuary, marble walls, gilded cornices and moldings, and with painted ceilings in every room of the house. The ceilings are awash with angels and princesses and stalwart men on white horses riding in a field of blue skies and clouds. And I suppose there must be some old movie palaces with similar ceilings untouched by modern hands.

There are decorators of certain persuasion who touch their modern hands to ceilings with great folds of different materials, swathing them into tentlike or canopied effects. Usually this penchant is reserved (happily) for bathrooms.

## LIGHTING

Chandeliers should be exactly thirty-seven inches above the dining room table. *Who* decided this is not really important. What is important, is *why* they decided to add that extra inch to an otherwise perfect yard. And what is really important, is that you must tell other people that a chandelier in a dining room must be thirty-seven inches above the table, and say it in a voice that leaves no room for argument.

Chandeliers in other than dining rooms have no such arbitrary limitations. Some people like to hang them low over a coffee table, for instance. God help those who dare move that coffee table! A safe

rule would be that chandeliers in other than dining rooms should clear the head of the tallest person you know. Absolutely so, if your son happens to be a basketball player.

People often fret about a choice between floor lamps and table lamps. The thing to remember is that floor lamps tend to provide a more overall illumination, while table lamps light up a more specific area.

Some people like to have the newest in lighting fixtures because they like the newest in anything that science can engineer. They are akin to people who are gadget-happy—the newest item on the market leaves them ecstatic. If you tend toward the modern in lighting, such as spotlights, eyeballs in the ceiling, or ceiling tracks, the best thing is to investigate the market at the precise time you are ready to buy and install. Heaven pity the poor gadget-happy soul who buys today, and reads of something newer tomorrow.

The trouble with many new lighting methods is that they tend to be indirect and to eliminate shadows, which is sad. Shadows are beautiful, elusive, romantic things at best and decorative at the least.

You may have candles to match your dinnerware and/or your dining room chairs' upholstery, but be sure to tell *others* that it is correct to have only white, cream, or natural tallow-colored candles.

Some purists prefer to have no chandeliers or candelabra electrified, not even wall sconces. Candlelight is romantic and sometimes it doesn't pay to see things too clearly; but here I think one should really prefer being flameproof to being pure. After all, good taste is good sense.

Down-lighters are excellent, especially if your room is contemporary. But if period is your thing, and you want your period room to be very, very period, have lampshades made with the rings outside the shade, instead of inside where they are normally placed.

The "in" thing to say about lampshades is that the French and the Americans (and you say the word "Americans" as if you were not an American yourself, but a Briton to whom American is not exactly a dirty word, but just slightly déclassé) make them much too large and overscaled.

## IT'S THE LITTLE THINGS
## THAT COUNT

There are a lot of smart-sounding phrases you can use about accessories. Accessories are more *you* than anything else. It's all those

little things that add up—but to what? Accessories are the things that can make the difference between a room that is you and a hotel suite. Accessories are the mirrors of our taste (use that one a lot—it's a winner).

The truth of the matter is that we can't always be completely discriminating about the large things that go into our decoration. Most of us can't live in the type and design of house that we would have chosen if we had no other considerations besides taste and aesthetics. We can't always have the furniture, the rugs, the "large pieces" that we would have preferred. We do have a much wider choice in the little things; they can be pure, intrinsically true. Let not the smallest object escape your keen eye—that book of matches lying in the ashtray. Does its color offend? How about your doorknobs? Are they the right texture, the right color, of superior quality? Neglecting even the smallest object in one's house is akin to the original sin. Let it not be your sin!

*Flowers*

Flowers are the accessories most of us would wish for every day of our lives. All too frequently we can't have them.

If you love flowers and can't fill your home with them because you can't afford them and you go to the home of one who can and does, you can always wrinkle your nose and say, "Mmmm—smells like a funeral in here!"

Formal flower arrangements are out! Informal are in! Jackie made informal flower arrangements fashionable when she was Jackie K. She is said to have adored daisies thrown into a vase.

An anemone is probably *the* flower of the professional decorator. It comes by this high position honestly. It is available in many gorgeous colors; it boasts great sophistication and lends itself easily to the most formal period room or otherwise. All this despite its humble origins—tiny little bulbs called "wind flowers."

Strawflowers are, of course, dried flowers. They seem to be the preference of those who can't always have live flowers about and eschew artificial ones. They are a compromise between the living and the dead. They are all right, I suppose, and are much favored by those who favor provincial rooms. But watch those dried grasses! All kinds of weeds and long grasses are dried and dyed these days. Many of them are dirty, messy horrors which are forever shedding bits of dusty debris.

## Plants

Plants are fresh, alive things. They are instant decoration. They are an economical decoration. They are, at the same time, a sophisticated and a homey decoration.

To those who object to masses of plants, likening this to a jungle, you say with a faint, ethereal little smile, "They live, and are of God." Only the crummiest atheist would dare malign God's own.

## Collections

Anything that you collect is a collection, and if it's your living room, you have every right to use your collection to decorate it. Too many people regard the living room as something belonging to guests, no matter how infrequent these may be. These misguided people feel that personal things don't belong in the guests' room. Pooh to that! If you enjoy your collection (and I would assume that you do, otherwise why collect?), take pleasure in displaying that collection with any other objets d'art that you may possess.

## Ashtrays

Ashtrays are decorative and useful little things. Everyone you know protests that he has really stopped smoking, but the first thing anyone does when he comes into your living room is ask for an ashtray as he drops the ash already dangling from his cigarette. You must have ashtrays about, even if you and yours don't smoke.

An ashtray is a dish is a plate is a saucer is an ashtray. There are practically no ashtrays per se that are attractive, except maybe some large, crystal, basically-shaped ones.

Old pretty saucers or dishes are preferable. If your leanings are not to the old, there are certainly enough contemporary saucers, small bowls, or such that would make attractive, useful ashtrays. As long as it will wash, the most gorgeous piece of porcelain can be used.

I assume that it is superfluous to add that ashtrays stolen from hotels and restaurants are beneath mention. You might—just possibly—use an ashtray, say, from a famous place like Harry's American Bar in Paris in your own bar (that is, if you have such an item of questionable taste as a large built-in bar in the basement with cute little double-entendre plaques). There are some things that are people's own business, good taste or not; if you like it and must have it, thumb your nose at your critics and have it. That takes flair too!

## Boxes

These can be large (as in chests or trunks) or small (as in cigarette, candy, or just a box) and there because they are pretty, or antique, or a collection thereof.

To be used as a decorative accessory, a trunk would have to be old, antique, or extremely interesting looking.

Little boxes can be of wood or papier-mâché or tole or crystal or porcelain, or you can take a nondescript box, apply decoupage of your own liking, then varnish it. There's a special pride taken in any object to which you have added your own touches.

## Pillows

These may be round or square, large or small, or even rectangular but they may not be triangular. Who says so? The rule book says so. I believe the decorating faux pas of making triangular pillows is perpetuated by upholsterers who have odd shapes of material left over and are applying the American principle of make-do.

Large, overstuffed, unwelted, squashy pillows are very "in."

## Objets d'art

Vases, African sculptures, artifacts, figurines, pieces of anything you like that have artistic value to you, should be arranged like a still life painting. Here is your chance to make a beautiful work of art without getting paint on your best peignoir.

## Crystal

Crystal can safely be called the diamond of interior design. This sounds very witty if you care to repeat it and it also happens to be true. The glitter and sparkle that a mass of crystal can provide to a room lends ultraglamorous enchantment.

One woman showing off her new house that her husband (a contractor) had built and leading us from room to room, ended the tour in the foyer, where a curving staircase led upstairs. The balustrade at the bottom held a large and multifaceted crystal.

"And there's my diamond ring," she said proudly. We quickly looked to her engagement ring finger and sure enough, it was bare. We had immediately been brainwashed into thinking, "Boy, how much did that crystal ball cost?"

A good ploy.

*Mirrors*

Mirrors can add great magnificence to any room. Eyes are supposed to be the mirrors of our souls. You might say, mirrors are the eyes of the soul of a room. Sounds interesting, anyway.

Mirrors can enlarge a room visually, as we have already learned. Mirrors can bring light into a dark room if used on the wall facing the window. If the window looks out on something green and scenic, so much the better.

Especially beautiful mirrors can be a focal point of a room, and there are mirrors that in themselves are as beautiful as a painting.

Venice was the center of the ornamental glass industry, and small wall mirrors were introduced there in the fifteenth century. Great attention was paid to the frames of these mirrors. Today, Venetian mirrors are particularly valued by collectors and interior designers.

In the eighteenth century, the French made much use of an overmantel called the *trumeau,* which combined woodwork, mirror, and usually a painting above the mirror. If you are in possession of a *trumeau,* you must always use the French word for it. It's deadly for a bluffer to call any mirror with a painting overhead, "the mirror with the painting on top."

*Your Signature*

These are the things that tell something about you—what you do and what you like. If you paint pictures, for God's sake, hang them! If you have published books, display them. If you have a typewriter on which you write your books, and your living room also serves as your study, leave it out in plain view—it has intrinsic value. It mustn't be hidden away like some skeleton in the closet or your looney old aunt in the attic.

*The Arts in Decorating*

Some people build their homes around the art concept—their home is one big showcase for their art. We cannot judge this concept here—since this is a whole new bag of cats. We are only prepared to discuss art as it affects decoration.

Your room should display a fair representation of the arts in order to qualify as a "decorated" room. The easiest thing one can say is that reproductions are to be avoided at all costs. I know of one person whose furniture and accessories are merely blah but who has been known to say, "I wouldn't have a reproduction in the house!"

And while her paintings are op and pop and slop, and her pieces of sculpture can charitably be described as early Atlantic City, they *are* originals and she talks about them a great deal. She has a "collection" and a peg on which to hang her hat.

There are always the goody-goodies who will say, "I would rather have a good reproduction, than a bad original." Good for them, but a terrible philosophy for the bluffer. The bluffer must always have originals and must never admit that they may be less than adequate.

If you can't manage a Picasso, try for a Luigi Klutz. Who is he? Nobody, but there's only one like him—himself. If the work is not so God-awful that any peasant can immediately tell, leave it there. Who knows? Klutz may even become famous.

The important trick here is to have the name of your particular artist—and this goes for anything that is signed—on the tip of your tongue. Rattle it off, and be superciliously surprised if the visitor is not familiar with the name. Name a school—Neo-Impressionism, Post-Impressionism, Anti-Impressionism—it doesn't matter as long as your friend is not an art bluff. If he is, leave out the school, and say confidentially, "We know it's a good investment."

In the world of decorating, a row of portraits—either oil or pastel and importantly framed—is mighty impressive. Witness the homes of America's first families that have become museums as part of the National Trust. And if your ancestors got off the boat just recently and were not able to take their portraits with them since they were only one step ahead of the bill collector, worry not. Who'd dare call you a liar if you refer to some old biddy in a portrait as "Grand-auntie Edna," or to some whiskery old goat as "Uncle Horace on Daddy's side of the family." As long as he is not *their* "Uncle Horace."

A portrait of the lady of the house over the mantel is stylish and turns other ladies slightly green.

## Frames

Frames are half the battle with unimpressive works of art. The less unimpressive the painting, the more imposing the frame is a good maxim. It is nice to have elaborate frames that are antiques, especially for portraits. The younger the frame, the less elaborate it should be. Most oil paintings look well in the gilt frames of the Barbizon school, which just preceded French Impressionism. Old prints can be framed in the silver-gilt frames used for prints and etchings

in the eighteenth century. These are narrow and used with board or linen mats.

Modern art has developed the use of strip moldings for contemporary paintings.

## Chinoiserie

If we are talking about accessories, it is necessary to mention ornamentation in the Chinese manner. It is a fashion that has retained its chic through the centuries. The important thing to remember about it is that if a Chinese uses this decoration, it is not chinoiserie. Only the Occidental can fashion chinoiserie. Incidentally, chinoiserie does not have to limit itself to accessories; it lends itself to bigger things too such as screens, furniture, and wallpaper.

## Antiques

This is not a book about antiques and we really can't even begin to go into that scene. But I would feel amiss if I did not mention that in order to be a decorating bluffer, you should have at least a nodding acquaintance with the whole business of antiques.

A very essential thing to remember is that there is a world of difference between American antiques and European antiques—this is quite a basic and obvious matter. We are roughly three centuries old, and since anything antique is at least a hundred years old, or in some cases dating back to 1830, we don't have the same amount of past time to draw upon.

American antiques are few in number and therefore rarer, and every grammar school boy knows about the law of supply and demand.

Most of our American antiques are of the English style since the early colonists were mostly from England, and they knew and loved the things from their mother country.

Old World antiques go all the way back to antiquity, and from Egypt on, nearly every country added its own influences and specialties. Therefore, you would have to take into consideration English antiques, French, Italian, Spanish, Dutch, and the splendors of the Czars. Some people just love those Russian Easter eggs, particularly if they are Fabergé, and are of gold encrusted with precious stones.

Then, if we are to start with our inheritance from the Orient, there is simply no end to it.

Antiques include china, silver, pewter, paintings, furniture, tapestries, rugs, and so on.

There are antiques, and there is old. There are genuine antiques

that are signed, and equally genuine antiques that are not. Victorian stuff barely makes it as antiques; they get in just under the wire.

As a good designing bluffer, the best thing you can do about antiques is to concentrate on one thing such as china, or even narrow it down more, and stick to one kind of china, such as Sheffield or Limoges, and become a quick-study-bluffer-expert in that particular area.

Toward this end you will also find our section on the history of furniture and design helpful.

A well-decorated house would certainly have some old or antique furniture or accessories in it. And antiques are more fashionable today than perhaps ever before, although *Godey's Lady's Book* (a popular magazine of the time) wrote in 1878 that antiques were "the latest mania among fashionable people."

# ROOM BY ROOM

NOW THAT WE HAVE ALL THAT behind us, let us consider the house, room by room.

## THE ENTRANCE HALL

What will you call it? *Foyer* is a popular term for it. If you do use a French word for a little old hall, then the hall should be at least a little grand. If you live in a fancy apartment, it might be the *elevator hall* (when it is *your* elevator hall inside your *own* apartment). I should think that should be pretty grand. Some prefer to call the entrance hall a *gallery*. Very high-tone. It absolutely should be decorated in a *very* grand manner. And if you dare call it a *reception hall* or *reception room,* you'd better be prepared to do it up with marble floors and other palatial effects.

Or you can simply call it the entrance hall.

Some apartments and some houses have no halls at all. You walk straight into the living room. In such a case, you fashion an entrance hall with the use of dividers or screens or a large piece of furniture, and avoid calling it anything.

This room, whatever its name, is by tradition the best decorated room in the house. The old canard, "first impressions are lasting impressions" is, I am sure, true. If not, how about "last impressions"?

He who comes in must go out and also has another chance to gain an impression. (Unless he goes out the back way.)

Tradition also dictates a mirror in the hall so that a guest may make a quick check of his appearance and smooth down his hair. There should be a chair or a bench (if there is room for it), so that a caller can take off his wet boots or put them on before going outside. There should be a console or a table of some kind where you can lay down the mail or a handbag or the keys while you put on your coat.

We assume that there is a closet there, for obvious reasons. It is called a guest closet—but I never saw one that wasn't crammed with family coats, jackets, sports gear, etc. So be it. If there is no room for any furniture at all, cover the floor luxuriously, cover the walls with mirrors or paintings, stick a couple of plants in the corners, and let dangle a magnificent chandelier.

## POWDER ROOM OR BATHROOM

The powder room is the bathroom (without the bathtub) for guests. But in an era when we can never have too many bathrooms, chances are that your powder room is going to see more family than guests. Either way, bathroom or powder room, it is your patriotic duty to make it spectacular. The bathroom is America's finest contribution to the world. Let people ascribe all the great cultural accomplishments to Europe and the East—the science of plumbing is exclusively ours.

Let every man be a king in his own bathroom.

It's the best place to throw caution to the winds and make it everything you've always wanted a bathroom to be. Oodles of people like to read in the bathroom, and for some ridiculous reason there's a stigma attached to this practice. Forget it! Be frankly literate, if you like! You can go so far as to have bookshelves built right in. If you like to meditate in your bath or on the throne, the perfect place to hang framed pictures is a bathroom gallery. They can be paintings or they can be prints or they can be all the family photographs you never got around to doing anything about. Statues or sculpture and plants are also soothing to the senses.

If you have telephonitis, is it not très chic to have a phone in your bathroom? Some of the best hotels have a phone near every john, accompanied by a pad and a gold pencil. Phoning in the bathtub is also very smart (provided you don't get electrocuted).

Listening to music in the bath is delightful.

So just let yourself go and let it be as Sybaritic as you like.

One final word. If you are playing host or hostess for a weekend, it is considered the last word to supply houseguests with terrycloth robes.

When enjoying someone else's powder room accommodations and feeling a trifle bitchy, you can score valuable points with a scathing, "What, no bidet?"

## THE GUEST ROOM

I think it is madness to let a perfectly good room sit around waiting for a guest, unless it's one of those rooms where all the junky, used-up furniture and broken sewing machines are. But you would never have that kind of a room in your house, anyway, now would you?

A guest room should be a stunning library, or a study, or something else quite useful when there is no guest around. A leather, suede, or even velvet-covered sofa bed will serve both the members of the household and the guests.

A guest should have comfort (most of them, anyway) I'd agree, but not at a tremendous sacrifice to you, you, you! And doing yourself out of a room that can contribute to your gracious living all year long is just not sensible.

There are books still being printed that list what the proper guest room should include—a writing desk equipped with pens, pencils, and stationery for both masculine and feminine correspondents. And stamps yet! (Let him buy his own stamps!) Also, a night table with books (latest best sellers), magazines (current, of course), a bowl of fruit (with plate, knife, and napkins), a lamp, a radio, a clock, a Thermos jug and glasses, a telephone (you're just begging for long-distance toll calls). One famous hostess even puts flashlights and candles in the drawer. Suit, coat, skirt, and dress hangers are not to be forgotten. A toothbrush (in case they forget theirs), their own new tube of toothpaste. And my goodness, a drink table, a TV to call their own, and do not forget their own copy of the morning newspaper, so that it will neither be wrinkled nor have its crossword puzzle already done.

You are supposed to keep the closet bare just waiting for your guest's clothes. This is really the last straw. Who among us can afford the luxury of an empty closet?

As far as I'm concerned the only thing you owe a guest is a mattress without lumps and a good-sized bulb in the reading lamp (unless you yearn for the man who came to dinner and stayed forever).

# THE FAMILY ROOM (DEN, LIBRARY, REC ROOM, MORNING ROOM, GARDEN ROOM, CONSERVATORY, MUSIC ROOM, TV ROOM, SUN-ROOM, PORCH, OR STUDY)

This is the second living room, or the auxiliary living room.

It doesn't matter so much what you put into it or what style you use to decorate it or what is going to be its predominant color scheme. The important matter is what you are going to call it.

Elsie de Wolfe was the first recognized authority to call a room a "cozy corner"; hers was done in a Turkish opulent style. You could call yours a "cozy corner" if you don't mind sounding a little foolish.

Library is a better term. A fine word. It connotes a great English manor house and a life of relaxed leisure that the country squire was able to afford in times gone by.

If you choose to call this room a library, you can use such expressions as: "Let us have our coffee in the library," or "Shall we have our sherry in the library?" It's not quite the same thing to say, "Shall we have our sherry in the family room?"

But make sure of one thing if you are calling this room a library—have a few books in it. Real books. I know someone who has an authentically Victorian room with lovely *boiserie* that she refers to as either her Victorian room or her library. The only literary work in it is the TV guide and the town's schedule of garbage collection days.

One whole wall of beautifully bound books is much better than a few books. A library furnished in modern or eclectic style doesn't need leather-bound books; the regular colorful paper jackets will do just fine. If it is certain colors you're seeking, you can always put together a properly hued collection from the so-called remaindered books, which are the leftover books that publishers cruelly (cruel to the poor authors) release to the stores for a buck apiece. Then if you need orange, you buy an orange jacket. (The hell with what's inside.)

*Den* is one of the older terms born of the time when it was *de rigueur* for a man to get away from the rest of the house and all the females fussin' about. Still used quite a bit—but a little passé.

*Rec room* is an awful name. This is what it was called in the

thirties, when suburbia was just beginning to compile its terminology. Though rec stands for recreation, it always suggests a wreck and you immediately envision a dreary beige or brown linoleum floor and furniture with springs and stuffing popping.

*Family room* is the most popular name today. It brings to mind a beige or brown vinyl floor with a certain type of modern Danish furniture peculiar to the highway supermarket furniture store. Family rooms are *always* paneled in knotty pine (if they were done twenty to thirty years ago) and in plank, plywood, or wood-look vinyl (if done more recently). It's all right to have a family room if you must and to call it a family room within the confines of the family, but don't talk about it in company.

*Garden room* is very nice, and lots of swanky, in-people call their second living room by this name. Naturally, you would have lots of green plants there, and if you're blessed with a green thumb besides, you might even have plants that actually flower indoors.

French doors leading out to the garden or terrace help a lot. But if you lack French doors, a large number of large windows are very good. Victorian wicker furniture, or faux bamboo chairs and settees, or plumply cushioned green or black iron furniture will help promote the garden ambience. Lots of green for grass or yellow for sunshine does wonders to create that nice outdoorsy feeling.

*Sun-room* is another good name for garden room.

The use of the word "porch," as in sun porch or back porch, is tolerated in certain instances. If you live in a large, conspicuously gingerbread house, this can be regarded as part of the overall "quaint" picture, and is permissible. Or in a large, verandaed Newport type of house, you might go campy and refer to your back porch. Or in a converted nonworking farmhouse.

One has to be careful if one has spent one's childhood on an honest-to-goodness working farm not to slip and call a plain old sun porch a sun porch, when all the time one meant to say sun-room.

*Music room* is not bad, provided you have at least two musical instruments about. Any type of piano will do here. If you own a spinet, a studio, or even a player piano, you would put it here; and not in the living room. If you have a grand piano, you might put it in the living room *or* in the music room, if you wanted it to be a *grand* music room. A harp would go beautifully here, or even a serious-looking guitar. A violin or a viola might be propped against a stand, but a drum is definitely out. You might have plants and books about to add to the general cultural impression.

What you certainly *wouldn't* have would be cutesy musical ref-

erences as wall decorations in the shape of musical notes, or a tambourine conspicuously lying around on the table.

*Study* is very, very good. A perfect word, perhaps, for an eclectic arrangement of furniture and accessories. It would be appropriate to have a desk in this room. A globe, provided it is a very nice one in nongarish colors or an antique one, might go well here. Collections, such as paperweights, would certainly be appropriate, and books, of course. Special consideration should be given lamps, as it is important to be able to read in this room too.

*Conservatory* is not bad, although it is rather grand and pretentious. I would really like to see you use this name only if you lived in a large and grand house. Happily, it can refer to either a roomful of plants (you would need a large amount of glass, be it doors or windows or, wonderfully, ceilings) or to a room used for the pursuit of music (see music room).

*Morning room* falls into the same category as conservatory—to be reserved for large and pretentious houses. It would be decorated much as a living room might be, but leaning toward flowered chintz and comfortable sofas and chairs. Should have a desk for writing letters. Gentry, boasting morning rooms, always write their letters at desks in same. In the morning of course, silly.

*Florida room* or *California room* (there are *Texas rooms* too, I have heard) sound kind of foolish. If you insist on having a Florida room, you must have jalousied windows, and if you have a California room you must have a collection of cacti and other succulents. I'm not sure what you would have in a Texas room, but I would guess that it would contain an indoor barbecue pit of sorts.

There is something called a *game room* too. It is usually in the basement and children play there, with a hopscotch game laid out on the linoleum floor. It's great for kids, but if you want to have a game room for the use of adults, you may, but only if you have a billiard table with a Tiffany shade or Tiffany-type shade overhead, dark oak or pine paneling, and a really fine card table with comfortable chairs, preferably leather covered. One decorator goes so far as to refer to this as a gaming installation, and I think that really sounds gamey.

## THE KITCHEN

There isn't too much to say about kitchens. We all know what belongs there and we must have one, even if we go out a lot to eat.

The concept of decorating a kitchen depends on what you're trying to prove. The kitchen is a projector, giving off pictures of *you*.

Are you the "I'm a great cook" person? If so, then you should have a really kitcheny type of place, with the pots and pans hanging in plain sight (the trouble with this is that the pots and pans should be polished if hanging in plain sight); a big, old country-style stove, or an old large, black restaurant stove. (These stoves only *look* old—they function like crazy.) Your kitchen looks as though you mean business; you've got all the necessary tools showing such as French whips and wire lettuce baskets, and you're going to cook up a storm. If that's your image—fine and good.

Are you the "I'm so efficient" type? In that case, you own every appliance ever made, each gleaming in its own proper place. You have cabinet after cabinet, row upon row, all lined up. You have no-nonsense counter tops, without adornment except for the small appliances, toaster, blender, etc., lined up like little soldiers. And everything is very, very clean!

If your image is the "I'm rich!" type, you have every kitchen gadget, every bit of machinery that can be put to use in a kitchen, in the latest model, in the latest shade. If it's self-cleaning ovens this year, then you have at least two. If they add an extra cycle in dishwashers to wash only peanut butter spoons, you throw out last year's model and add the newer one to the clan. If avocado-colored appliances were in last year, but are now out, you rip out the whole works and make them all apricot peach. One can only hope you're as good at cooking as you are at ripping.

If your cooking is good, but your working methods are sloppy, call your image "slob," and get some nicely detailed doors and close the whole mess off from human sight.

## NOTES ON LIVING ROOMS

What to put in a living room? I think I should quote William Baldwin, one of our biggies in interior decoration, with his almost poetic specifications: "Something to sit upon—which must have beauty and comfort; something to look upon—which must reflect the personal taste of the owner; and something to put upon—which means tables of comfortable height, conveniently arranged."

The upper classes in England refer to the living room as the drawing room, which is supposed to be short for "withdrawing room" from the times when ladies withdrew from the dining room to the

drawing room to leave the men to their cigars and brandy and "man talk."

In all fairness, I must report that I have heard the powder room also called the "withdrawing room" where one is supposed to withdraw, collect oneself, contemplate same in the mirror, and pull oneself together in face, body, and spirit.

A good rule for living rooms is to have something for a focal point such as a fireplace, around which you would arrange a seating group. This is especially nice if you manage to have a fire going in the fireplace once in a while. Some of the best people won't have this as they fear soot. It is really too bad of them and they are missing an opportunity of imparting great warmth to their room or to the entertaining they do in the room.

A special painting can serve as a focal point.

The newest rage is life-sized sculptures of oneself made from all kinds of crazy materials. This would not only serve as a focal point— it would impart a certain amount of shock value to the room. A little shock value is always good—it lends drama to everyday living, gives a little extra "punch" to the room.

The last word on the living room is that it should have the proper ambience, the feeling that you want to have around you and the feeling that you wish to exude to the outside world.

## DINING ROOMS

If the architecture of houses could be altered, I would make the living room the smaller, and the dining room the larger. Living rooms should be intimate enough so that people won't drift apart from one another, and dining rooms should be large enough so that you can always seat all the people you'd like to.

In English movies, the characters at breakfast always help themselves from a huge sideboard laden with silver dishes. The lower classes, of course, drink their tea huddled around the kitchen stove. I would certainly strive to have a large sideboard in my dining room since the first picture is definitely more appealing.

I know of a family that lives in a self-consciously decorated house with their biggest and best color TV set (of their six TVs) located in their very decorated dining room. They have been much criticized for this breach of taste, but if watching color TV at dinner aids their digestion, I say why not? Good digestion is always in good taste. It's

better that they are actually using their very decorated dining room rather than eating in the kitchen where so many people with very decorated dining rooms do most of their eating.

A friend of a friend has a French Regency dining room, resplendent with silver, gleaming with crystal, walled with little paintings of Dutch interiors that she insists are the genuine article. She also has a *period* kitchen with a modern table and chairs and a breakfast room that could pass for a very nice dining room. The family *always* eats in the kitchen, along with the domestic help. If there are dinner guests, they use the breakfast room. If there are more than eight people altogether, she calls it a party and sends everybody to the basement room which is decorated like a Montmartre café.

## BEDROOMS

There are trends today regarding bedroom decoration. One is the uncluttered look, in which all furniture except for the bed is either nonexistent or built in and painted the colors of the walls so that it blends into them. In this style, you *might* have a bedside table for the things you can't possibly manage without—an ashtray, a lamp, a clock, a box of tissues, or a bowl of flowers. A shelf might be cantilevered from the wall to take care of this problem, or the light could be furnished from chandeliers suspended from the ceiling hanging on either side of the bed, or from wall sconces affixed on either side of the bed. There might be one slender chair to take care of a guest visiting when you are ill or for some other purpose. A bedroom of this sort with no visible means of support might very well have a large dressing room of its own where the necessary chests and dressing table equipment could be placed.

There usually is a provincial look to this type of bedroom, with a simple throw of white cotton on the bed and white curtains at the window. Or there might be a Mediterranean influence with a colorful throw on the bed and ironwork wall sconces. Or just a plain old fur throw on the bed and a fur pelt or two spread on the floor.

The opposite is the cluttered bedroom look. This is not necessarily the opulent look, but the combined sitting room–study–bedroom look—a place to retire, not only to sleep, but to sit, relax, read, watch television, write a letter, brood, or what have you.

Now, we can have all kinds of things scattered about besides the

usual stuff found in a bedroom: sofas, desk, pillows, screens, coffee tables, end tables, etc.

If you like to watch television in bed, admit this failing frankly. So many people feel they have to *hide* the TV from view. It doesn't have to be pushed into the closet as many pseudointellectuals insist on doing, or hidden under a draped table.

# PUT-DOWNS

I WOULD COMPARE the "put-down" to the cream off the top of the bottle—it's the cream of the bluffing game.

The best put-downs will come to you as an inspiration on the spur of the moment at the very time you need them. It's all a matter of conditioning—you have to learn to *think* this way.

Just to help you *learn* to think this way, I'll give you a couple of examples.

When people are showing off their houses, keep murmuring, "Cute, darling," or "Isn't that cute?" or "Isn't that precious?"

Or when that palls, you can switch to "Kitsch, darling." Kitsch is camp, or kitsch actually stands for anything that is in such horribly bad taste that it reaches a plateau of high camp. Your object of attack will never be quite sure whether you mean to compliment him or insult him. For instance, upon seeing a wine cooler used as a magazine holder, you say, "Oh, isn't that clever kitsch!"

When faced with a room that is clearly attempting to imitate Versailles, resplendent with gold and gilt, crystal and silk, taffeta and mirrors, you murmur, "Oh, Louis the Fourteenth Street!"

Or, a friend is all thrilled with her new decorating scheme and she pulls you off to see her bedroom the minute you step in the door. You take in the elegance of a fur-rugged floor, the magnificence of the eighteenth-century bed, the antique wallpaper and you say, "But I'm not interested in the maid's room, I want to see *your* room."

Or, the usual tour people insist you take when you come to their home for the first time. You know—"this is the living room, this is the dining room, this is the bathroom, and, surprise—this is the kitchen" kind of tour. This time, the people in question, being as pretentious as you are, point to the entrance hall, "Spanish Provincial," and then on to the living room, "French Empire," to the dining room, "English Gothic," to the powder room, "Italian Renais-

sance," and finally to the kitchen where everything, naturally, is modern and shiny and new, and you say, "Don't tell me—United States Steel."

# AN INCOMPLETE GLOSSARY OF WORDS YOU ALREADY KNOW, SHOULD KNOW, AND SOME YOU'LL NEVER HAVE THE NERVE TO USE

**Accessories**—Those little things that make a house a home.

**Adaptation**—Captures the flavor of the original, but is not necessarily authentic.

**Americana**—Anything referring to the "good old days" or having to do with our folksy ancestors.

**Armoire**—Cabinet for storage, preferably clothes.

**Artifact**—An ancient antique, a relic.

**Asymmetric**—An off-balance arrangement that should still have a good sense of proportion.

**Avant-garde**—First in a fashion before others know it is going to be fashion.

**Authentic**—Precisely perfect.

**Baccarat**—Famous "crystal" from the town of the same name, where glassware is still being made today.

**Bergère**—See "The French Have a Word for It"—a chair—actually the French word for shepherdess.

**Bibelot**—Don't you know a French word when you see it?

**Cabriole**—That leg which Queen Anne and Louis XV could never have stood without.

**Campaign furniture**—Military style, should be collapsible, Napoleon made it popular.

**Chic**—Not pronounced like the baby of a chicken, or you are not.

**Chinoiserie**—In the style of the Chinese, and very chic.

**Chintz**—Shiny or unshiny floral patterned design—can be chic.

**Chintzy**—Cutey-pie or tacky, something not to be—is not chic.

**Chippendale**—We have already discussed this at length.

**Conversation pit**—A seating group dropped below the level of the rest of the room—not to be confused with a snake pit.

**Coromandel**—A dark wood, often lacquered, as in a coromandel screen.

**Documentary print**—Reproduction of an antique theme.

**Epergne**—A dish or centerpiece of different levels—can hold flowers and candy, nuts and fruits, fruits and flowers.

**Empire**—Of Napoleon.

**Fabergé**—A jeweler whose jewelry and bibelots were commissioned by the Czars.

**Faux-bois**—Anything that simulates wood.

**Faux-anything**—Anything that simulates anything else, i.e., faux-bamboo.

**Folk Art**—Crafts that influence art design, usually regional.

**Gallery**—Miniature railing used on table edge.

**Gallery**—Entrance hall.

**Gallery**—A room to hang and view works of art.

**Galley**—A long, narrow room—from the kitchen of a ship.

**Galloon**—Braids, tapes used on upholstery or draperies.

**Gimp**—Upholstery trim.

**Girandole**—Originally a wall bracket for candles, usually with a mirror behind it (in today's usage, a mirror with candleholders playing second fiddle).

**Hitchcock**—A chair named after its originator, an American cabinetmaker; it has gold stenciled designs.

**Hunt table**—Semicircular table used for serving food or as a working desk.

**Klismos**—A classic chair of Greek origin.

**Lavabo**—A washbowl with a water supply, supposedly—now placed on walls, usually with hanging plants.

**Mélange**—A mixture, an eclectic arrangement.

**Mies chair**—Leather and chrome chair designed by Mies van der Rohe, better known as the Barcelona chair, as it was first exhibited in Barcelona.

**Module**—From the language of architecture, now meaning furniture that can be fitted together to provide a built-in look.

**Mondrian**—The artist whose paintings made use of blocks and lines of colors in asymmetrical composition; a concept now used in contemporary design.

**Motif**—A decorative design or a theme used repeatedly in a room.

**Niche**—Recess in a wall—a large one for a bed, or a small one for a sculpture.

**Nostalgia**—Those objects which remind us of something in the past (usually favorable). Now, the forties are popular and nostalgic for those whose are in their forties. Not a terribly good style for decorating since today's nostalgia is tomorrow's yesterday's newspaper.

**Ottoman**—Upholstered footrest.

**Paperweights**—People like to make collections of them. They particularly love the kind which you shake and stir up a snowstorm in a little village encased within. In movies, the heroine picks one up, gives a little shake and this brings back total recall and flashback, and that's how movies are made.

**Pattern-on-pattern**—A new madness very popular with mad designers who throw flowers on top of plaids on top of stripes and so on—très chic for the mad sophisticate.

**Pedestal**—You put a bowl of flowers on it, or a piece of sculpture, or even a table top—of either period or contemporary design. It takes the place of something with four legs.

**Pegboard**—A building material with lots of little holes that you can hang many things from—not nearly as attractive as people must think it is.

**Pier glass**—A wall mirror, usually full-length, often placed between two windows.

**Platform**—A sort of split-level within a room. In a combination living room-dining room, the dining room can be platformed.

**Pop Art**—Campbell soup cans. Some people feel that the artists should be popped one on the nose.

**Potpourri**—A mixture, a melange, eclectic—all right?

**Pouf**—Resembling an ottoman, but poufier—can be cloth, carved wood, or ceramic. I think it's terribly cold and hard to sit on a ceramic pouf.

**Pre-Columbian**—Artifacts of the American Indians, North, South, and Central, prior to the white man's coming.
**Primitive**—Arts of an unsophisticated culture. Did you know that a person can be a primitive too?

**Queen Anne**—We have discussed that lady.

**Room Divider**—Did you figure out that it divides a room? If it reaches to the ceiling, it is no longer a room divider, it is a wall.
**Rya rug**—Long-haired rug that is Finnish. Isn't that the end?

**Scandinavian**—Contemporary influence in design.
**Shoji**—Sliding wood and paper panels—from the Japanese, of course.
**Spotlights**—Lights usually installed in the ceiling to "spotlight" works of art, or whatever else you choose to spotlight.
**Storage wall**—This must be one of the most popular art forms that America gave to the world.
**Studied**—A studied arrangement is one that looks as though you stood there for hours making the arrangement, and not a particle of dust is allowed to move itself for fear of spoiling the carefully arranged plan—very big in nouveau riche suburbia.
**Symmetrical**—Everything even, balanced, in twos or fours—exactly.

**Tabouret**—A type of steel, or a low table that can be used for serving —drum-shaped.
**Tiffany**—We did him.
**Treillage**—Latticework, actually—used indoors for a garden room to give the effect of outdoors.
**Trundle bed**—A bed which fits under another bed. Good for when you feel you are being annoyed by a child—you put him in the trundle bed and zip him away.
**Turn-of-the-century**—Around 1900—escaping from the Victorian.

**Venetian**—The Italian style of decorating at its most brilliant.
**Vertical blinds**—Up and down, instead of from side to side. Clever?

**Whatnot**—Ornamental shelf to put what things on.
**Wicker**—Very big with the biggie decorators.

**Zebra skins**—Needed a Z to end this list.

There now, I've told you everything you have to know—now go and impress the others.

# The BLUFFER'S GUIDE

## *to*

## GOURMET COOKING

by **DIXIE DEAN TRAINER**

Introduced by **DAVID FROST**

# INTRODUCTION

I have been fortunate enough to have eaten some truly great meals but my first experience with haute cuisine was a very startling one . . . I'd just been seated in a restaurant when to the table on my left was brought a great silver salver that was lifted to reveal a sauce-covered, mushroom-garnished dish that the solitary diner immediately tucked into with great enthusiasm. And I didn't blame him. It looked terrific.

Six minutes later the waiter came to collect the empty plate, the completely empty plate that had been wiped clean with two pieces of bread and as he took it away he said out of the corner of his mouth, with as much astonishment as he could muster under the circumstances to the waiter who was serving me: *"He ate it."*

My waiter was stunned, which was enough to stop me from ordering it, and there was something in the way he looked at the man at the next table, a mixture of incredulity and almost pity, that even prevented me from asking him what it was. After all I was just going to eat . . .

And, of course, many important social and philosophical experiments have taken place in gourmet restaurants. In 1925 Professor Hans Belcher walked into a restaurant in Vienna and ordered roast chicken and an omelette. He wanted to see which came first—the chicken or the egg.

Gourmet cooking at its best is sensational, but be sure you know what's under all those wondrously aromatic sauces before you start eating. And, if you're not sure about an item on a foreign language menu, don't be afraid to ask the waiter what it is . . . on many a menu behind all those fancy Italian and French descriptions there lurks a good old-fashioned meat loaf . . . which ranks alongside the tale of the *Marie Celeste* as one of the great unsolved mysteries of all time.

Hiding your ignorance can be expensive and embarrassing . . . one friend of mine fresh out of school and very bright at math but not too hot on the mysteries of the kitchen went to a restaurant with

his girl friend and cheerfully ordered vichyssoise and then tried to get the waiter to take it back because it was cold.

He didn't impress his girl friend much on the next course either when he ordered . . . no, not a steak tartare, well done, but a dreaded veal cutlet. If you are going to use the terms, get them right.

And there are a great many cookbooks to help you, including three new additions—the Irish cookbook, *150 Ways to Boil a Potato;* the Polish cookbook, *What to Do with Spoiled Food;* and, of course, the English cookbook, *How to Spoil It.*

It's the proliferation of cookbooks like these that have led to this current craze for gourmet cooking at home . . . in the old days when you were invited to friends' for a meal you could be fairly sure of some good barbecued spareribs and hamburgers in the summer and some solid beef or a great stew in the winter . . . now it might be anything from Wanton Fung Yu Chow Shaki, Szechwan Style to canard à la mode du prince de Versailles, which is highly suspicious to say the least.

And, of course, these dishes take a great deal of preparation, which involves very careful reading and understanding of the recipe. One associate of mine returned to his home in Connecticut to find his wife lying in a bath, not filled exactly, but respectably flooded with white wine.

"What on earth are you doing?" he asked.

"Well," she said, "in the cookbook it said to clean and prepare the chicken and then soak in white wine for four hours . . ."

The famous gastronome, Brillat-Savarin, said: "You tell me what you eat and I will tell you what you are." If you eat German food, you're German . . . if you eat Chinese food, you're Jewish . . . and if you eat German and Chinese food, half an hour later you're hungry for power.

DAVID FROST

TALLEYRAND ONCE SAID that two things are essential in life—to give good dinners and to keep on fair terms with women.

Keeping on fair terms with women is another book—if not a life's work—but this book is concerned with the subject of good dinners: how to recognize them, how to enjoy them, how to give them.

# WHAT IS GOURMET COOKING ANYWAY?

DESPITE THE MILLIONS of words written, spoken, and no doubt shouted upon the subject, a final definition is still up for grabs, which is good news for the bluffer, for he can cite any authority he wishes (or even make up his own).

Michael Field, one of the pillars of the American food establishment, said flatly: "There is no such thing as gourmet cooking. . . . Having started as a perfectly respectable part of the French language, it has been abused to serve as a label for the worst eccentricities and superficial elaborations of modern American cooking. Unfortunately, it commonly serves to label the best, too. The contradiction has left the word without any justifiable meaning."

Having delivered himself of this harsh judgment, Field then gave a clue to the ideal: "Tradition, taste, technical skill, and respect for ingredients are the standards of good cooks everywhere."

The antithesis of Field's dictum is a typical recipe from a typical instant-gourmet cookbook that combines canned gefilte fish balls and frozen shrimp soup (with a dash of sherry, since it's gourmet) and calls the result *quenelles de brochet Nantua*.

# WHO OR WHAT IS A GOURMET?

PROBABLY THE BEST all-purpose definition of a proper gourmet is the following from Prosper Montagné, author of the monumental *Larousse Gastronomique.* The great Montagné would no doubt spin in his grave if he knew that his description exactly described the bluffer as well.

"The true gastronome," he says, "while esteeming the most refined products of the culinary arts, enjoys them in moderation, and for his normal fare, seeks out the simplest dishes, those which, moreover, are the most difficult to prepare to perfection. While he is not himself a practitioner of the culinary art, he knows enough of its methods to be able to pass judgment on a dish and to recognize, more or less, the ingredients of which it is composed.

"The false gastronome," he admonishes, "is always a gross eater, fat and proud of it, who is almost totally ignorant in matters of cookery.

"It is the false gastronome who believes in 'the tricks of the trade' . . ."

# HOW DOES ONE BECOME A GOURMET?

SOME ARE TO THE MANNER born, as it were. Brillat-Savarin, that most famous of French gourmands, says that "there is a privileged class of persons who are physically and organically predestined to enjoy the pleasures of taste"; and James Beard, the contemporary American cookbook author, speaks of a "taste memory" possessed only by a favored few who can accurately and precisely recall the exact taste of a dish.

The great chef Escoffier, for instance, apparently had a "perfect

palate," much in the same way that certain musicians have "perfect pitch," that enabled him to detect exactly the ingredients of a dish, or to add the few grains of salt that turned a modest effort into a celestial creation.

Still others become gastronomes through more unorthodox methods—if one can believe Georges Simenon, author of many highly praised novels about the French criminal world. Simenon contends that being a gourmet is the principal characteristic of the French gangster.

"You see, they usually come from a working class background," he explains, "and the only way they can rise on the social ladder and eat better is to become gangsters to satisfy a gastronomic vocation.

"Their greatest dread is not a violent death at the hands of the police or a rival gang, but prison food. In prison they dream of good food, they compose fantastic menus, and some have been known to break out because they craved a decent meal. The best restaurants in Paris are those frequented by criminal elements."

The rest of us ordinary mortals can learn. Even if the bluffer has never ventured beyond a timid brush with a third-class French restaurant, the world of gastronomy is surprisingly easy to enter—if you keep your wits about you.

"The first condition of learning how to eat is to talk about it," says Lin Yutang, the Chinese scholar. "Only in a society wherein people of culture and refinement inquire after their cooks' health instead of talking about the weather can the art of cuisine be developed. No food is really enjoyed unless it is keenly anticipated, discussed, eaten, and then commented upon."

Gourmets like to talk about food almost as much as they like eating it, and one of the great gourmet pastimes is reminiscing about past dinners or making up menus for future perfect dinners, in which the wishful gourmet can command whatever he likes, without regard to mundane considerations of price, availability, or season.

This passion for talking about food is probably one of the reasons why French and Chinese cuisines have reached such peaks, whereas in Anglo-Saxon countries, where food is no more talked about than sex or heaven (as Ford Madox Ford once remarked), the level of cuisine remains relatively low.

# HOW TO SOUND LIKE
# A GOURMET

BE READY, NAY EAGER, to discuss the merits of French and Chinese cooking, generally considered the two greatest cuisines in the world. (To a Westerner brought up on egg rolls and chop suey, this is understandably difficult to believe, but the true exotic glories of the Chinese kitchen do exist.)

One critic says there is no best cuisine in the world, but what the French have is variety. Ditto Chinese. Not so Irish or Estonian or Eskimo.

But whereas the French began with a superabundance of raw materials from its amazingly fertile countryside and surrounding oceans, the Chinese began from economic necessity. "We are too overpopulated and famine is too common for us not to eat everything we can lay our hands on," said one Chinese cook.

Now consider what each did with very simple ingredients—a duck, some modest seasoning, a bit of wine, a piece of fruit, and a handful of scallions. The French created the world-famous *canard à l'orange,* and the Chinese invented the equally famous Peking duck.

In some ways the Chinese and the French are similar—both use all parts of an animal, including the liver, kidney, and sweetbreads; both cuisines have a basic white and a basic brown sauce, and both use wine for cooking.

Beyond these similarities the differences are great. Two principles distinguish Chinese from French, or European, cooking. One is that the Chinese eat food for its texture, the elastic or crisp effect it has on the teeth, as well as for fragrance, flavor, and color.

The second principle is that of mixing flavors. Everyone knows the banality of sweet and sour pork in the ordinary chop suey joint; a more subtle example is cabbage cooked with chicken, in which the chicken flavor has gone into the cabbage and the cabbage flavor has gone into the chicken.

A peculiar difference is that the one thing the Chinese will not

eat is cheese, despite Brillat-Savarin's aphorism that "dessert without cheese, is like a pretty girl with only one eye."

# MORE NOTES ON SOUNDING LIKE A GOURMET

THE BLUFFER WILL BE surprised how much he really knows about the subject of eating. But after all, the annals of history, art, music, literature, political science, movies, and opera are simply packed with people sitting down to meals or snacks.

The bluffer with a literary turn of mind can recall Emma Bovary's wedding feast; Virginia Woolf's famous luncheon party in *A Room of One's Own;* Simenon's Inspector Maigret tracking down a criminal thanks to a piece of menu left in his coat pocket with only the word "mayonnaise" on it.

The historian has an equally rich vein to work. As Brillat-Savarin pointed out, "... it will be seen that, without even excepting conspiracies, no great event ever took place that was not previously concocted, planned, and determined upon at a banquet."

Certainly the fate of nations has been sealed by the requirements of dining. When Louis XVI fled revolutionary Paris in 1791, he stopped for his usual three-hour lunch at which he consumed twenty-four cutlets. The delay led to his subsequent capture at Varennes.

Some contend that because Napoleon's chef left him when he was in exile on Saint Helena, the Little General was forced to eat English food, which soon killed him.

Artistic? There is Watteau's famous painting *Embarquement pour Cythère,* showing eighteenth-century courtiers on a picnic and, of course, Manet's famous *Déjeuner sur l'herbe.* In cinema there is the hilarious seduction scene from *Tom Jones,* in which Tom and his lady love seduce each other by their sexy manner of consuming a huge repast.

The bluffer can even indulge in idle political gossip with a culinary cachet: Richard Nixon's reputed predilection for cottage cheese and

catsup; Jacqueline Kennedy astounding the Kennedy clan and the American public by serving *oeufs en gelée* instead of peanut butter sandwiches on a sailing picnic; the late Charles de Gaulle's habit of breaking up bubbles in his bouillon with his knife.

# SUPER JIFFY TRICKS FOR THE BLUFFER

THESE WON'T GET YOU through a whole evening, but at least they will help the bluffer avoid the most common faux pas that mark him as a parvenu from McDonald's.

• If oysters are available as an appetizer, order nine, as this is considered the perfect number. If you don't like oysters on the half shell, forget it.

• Ask for all your meats, especially lamb, on the rare side (except pork, of course). Thin slices of pink, rare lamb are a gourmet's delight and bear no resemblance to the gray, overcooked stuff so often served.

• Order vegetables as a separate course, but only if they are fresh and at the height of the season.

• Your favorite cheese should be Brie (see page 238). Don't espouse Muenster, which is the first choice of every teenager just venturing past the realm of American and Swiss.

• Care about what crosses your palate and return it if it is indifferently or poorly cooked.

• Quote Plutarch, who attributes the following statement to Aemilius Paulus, the conqueror of Persia: "The same intelligence is required to marshal an army in battle as to order a good dinner. The first must be as formidable as possible; the second as pleasant as possible, to the participants."

In his appreciation of food, Aemilius Paulus was not unusual among the ancients, as you will see.

# A BRIEF HISTORY OF GASTRONOMY

## FEASTING AMONG THE ANCIENTS

As the literature on gastronomy is enormous, the bluffer would do well to content himself with a few tidbits; a first course, as it were, to the truly gargantuan, mind-boggling gluttony of Rome.

Know then that Xerxes ruined two cities for a single feast and that Belshazzar of Babylonia once threw a magnificent feast for his thousand wives and concubines, treating them to rare and exotic foods, music, dancing, and revelry. Good King Solomon kept no less than twelve stewards for his table, eleven of whom did nothing but search the ancient world for new dainties to set before the king.

## FEASTING AMONG THE GREEKS

At last, word of these delights reached Greece, where the locals had been getting along on black broth and boiled fish. Not surprisingly, they enthusiastically embraced the victuals of the East, and before long Athenians were lolling on soft couches in airy banquet halls and feeding themselves from perfumed fingers.

Socrates may have preferred his meager dish of salted olives, but those who could afford it wasted no time tucking into sweet honey biscuits, cheeses, peacocks, pork, and, upon the advice of their wise physician Hippocrates, young, plump dogs, which he thought to be light and wholesome fare.

As men began to take more of an interest in eating, others began writing about it. The leader of the literary gourmets was Athenaeus, who berated his cooks in hopes of inspiring them and carefully reported state dinners at which the first course displayed large basins containing the intestines of animals tastefully garlanded. He also left some exotic recipes including bird brains, eggs, wine, and spices pounded together with fragrant roses and cooked in oil.

# BANQUETING AMONG THE ROMANS (A.D. 100-400)

At last, word of *these* delights reached Rome, where the locals had been getting along on cottage cheese made of goat's milk, and millet mush, called *puls* or *pulmentum* (the direct ancestor of the present-day Italian polenta).

The Romans dispatched still another delegation to learn from the Greeks, and, inevitably, dispatched an army to the Near East. The conquering soldiers returned to Rome in 185 B.C. with their appetites whetted for oriental sybaritism and cuisine. "The Army of Asia," Titus Livy wrote severely, "introduced foreign luxury to Rome."

And what didn't go under the heading of luxury! Writers such as Petronius, Juvenal, and Martial recorded that peacocks, flamingos, and herons were, in fact, served with their full plumage carefully replaced after cooking; that hedgehogs and puppies were considered choice eating; that dormice (small rodents resembling squirrels) were confined in barrels to keep them from exercising and were force fed for the table. Birds and fish appeared by the thousands on tables; wild boar, wolves, and other game showed up whole. Table stewards ransacked the empire for apricots from Armenia, peaches from Persia, quinces from Sidon, and raspberries from the slopes of Mount Ida.

Onward and onward they raced, trying for ever more delicate and refined pleasures to tempt their palates. And at last appeared . . .

## LUCULLUS AND TRIMALCHIO

Although there were many noted Roman banqueters, probably the two most famous were Lucullus and Trimalchio.

Lucullus, best known of all the Roman bon vivants, thought nothing of spending $1,000 per person (for his pets, to be sure) at incredible banquets served in his exquisite Apollo Room, where the goblets were hollowed out of natural gems. There he treated his guests to the ultrarefined pleasure of watching their next course die—rosy pink snappers from local lakes evolved through a spectrum

of iridescent colors as they gasped and flapped their way to death before the admiring crowd.

Once when he tired of friends and feasting, Lucullus ordered a solitary meal. Horrors! It was not up to his usual standards. Lucullus screamed for his chef, who tremblingly explained that he assumed the master would not want anything fancy since he was dining alone. Whereupon Lucullus intoned dramatically that the chef should have taken especial care for his lonely repast, "for tonight Lucullus dines with Lucullus!"

It is hard to imagine anything weirder than Trimalchio's famous feast, as described by Petronius in his *Satyricon*.* One course featured a boar stuffed with live thrushes, which flew out amidst a great squawking and flapping of wings when the beast was carved. But it is what one would expect from the nouveau riche, for Trimalchio was actually a Levantine freedman—ostensibly a shipping magnate— but actually a profiteer in every shady traffic known to an age of license.

## ADVANCED ROMAN BANQUETING

As Rome festered and fattened on the treasures of the Empire, the feasts grew longer and longer; the entertainments more bizarre and erotic; the courses more numerous (24 was a fair number); and the quantities of food ever larger. To give you an idea, the actor Farone, in order to amuse the Emperor Aurelian, once ate a whole sheep, a suckling pig, and a wild boar, along with one hundred buns. He downed this repast with one hundred bottles of wine.

How could it be possible to hold this amount of food? Simple. Emetics were customarily served at the beginning of a particularly large course (as they had been in Greece) because of the difficulty of digesting in a reclining position.

As things began to get out of hand, someone came up with the idea of serving an emetic before *each* course, and before you could say "boo," or "Zeus," the first course was well out of the way before the second appeared.

Hosts had to cope somehow, and thus *vomitoria* were invented

* Shown in Federico Fellini's movie *Satyricon*.

and erected, as prized an architectural feature as the gazebo of Victorian England.

Actually, the fabled Roman banquets must have been pretty messy. The banqueters were squeezed three on a couch (the favored position being in the middle), each guest lying on the left side, and supported by an elbow, which becomes quickly tiring. While it's hard enough to eat in that position, drinking is nearly impossible, especially if the heavy golden goblet is brimming with wine. Here probably was coined the maxim "There is many a slip 'twixt the cup and the lip."

One can only imagine what the Romans, in their togas, looked like after a few hours of feasting.

There were other problems, too, as the great French gourmand Brillat-Savarin noted from the safe distance of the eighteenth-century. "We also think that modesty," he commented, "was not always respected during such banquets, when people so frequently overstepped the limits of intemperance, when men and women were reclining on the same couches, and when it was not rare to see some of the guests asleep."

Brillat-Savarin then primly quotes a Latin verse from the period:

> *Nam pransus jaceo, et satur supinus*
> *Pertundo tunicamque, palliumque.*

Of which one translation is: "I'm lying here after lunch, flat on my back and full of food, boring a hole through tunic and cloak."

## A FEW NOTABLE NAMES

The excesses of the Romans can fill several books, but a few other noted diners will suffice for instant name-dropping.

• The Emperor Heliogabalus fancied ostrich brains and once consumed six hundred of them as a single course.

• A banquet for the player-poet Aesop featured a dish of five hundred tongues from talking birds, supposedly all the tastier because of their power to mimic human voices.

• Heliogabalus delighted in serving camel's foot.

• Heliogabalus (and some say the Emperor Crassus) fancied conger eels, which were kept in large tanks and either fed elegantly

by jeweled hand or not so elegantly by pushing in a particularly obdurate or insolent slave.

• Apicius, a famous banqueter, upon finding that he had squandered over $2,800,000 on banquets and had but a tithe left, committed suicide.

• Garum was not a person, but a sauce much favored by the Romans, who sprinkled it over everything. It was apparently made from rotted fish entrails, preferably mackerel.

## THE DARK AGES (A.D. 1000–1400)

After the fall of Rome, the lights went out all over Europe and that included the great banqueting halls. People ate simply to stay alive, and it was probably a good thing after the excesses of Rome.

Good cooking survived in the monasteries and the convents, for the good monks saved recipes and cookbooks along with other manuscripts. The literary gourmet M. F. K. Fisher has observed, rather unkindly, that "since the strict observance of every fast day would have reduced every priest in Europe to a stringy skeleton, the plump brothers spent much time and thought on making delicious dishes appear frugal." And so the twin requirements of asceticism and limited supplies forced the friars to turn even the meanest of vegetables (such as the turnip) into a tasty dish.

Meanwhile, back in the castles, the knights and their ladies were tearing at great joints of meat with fingers and knives, drinking sweet, sticky mead and wine punches, and desperately trying to mask the flavors of food that had spoiled.

## CATHERINE DE MÉDICIS GOES TO PARIS

Even *Larousse Gastronomique,* that incredible encyclopedia for Francophile cooks, conceded that "Italian cooking can be considered, for all the countries of Latin Europe, as a veritable mother cuisine."

The date was 1533, when Catherine de Médicis journeyed from Florence to France for her marriage to the future King Henry II.

With her she brought a large retinue of cooks, who did more to change a civilization than many a conquering army.

Once in Paris, she—and no less her cooks—were scandalized by the bad manners of the French nobility and the poor food they shoveled down in the raucous banqueting halls.

A revolution was called for. Catherine threw out the buffoons and jugglers and substituted ballet dancers. She persuaded the French to accept the effeminate Florentine custom of using forks instead of fingers.

For their part, her cooks artfully plied the French barbarians with delicate puffed pastries and refreshingly cold ices. They introduced artichokes and broccoli and tiny fresh peas and imported truffles from Italy.

The French learned avidly, and as the century rolled on, learned to cherish their cooks almost as much as their mistresses. The great chefs would soon appear, and the pupils would outstrip their teacher.

# THE GREAT CHEFS

IF COOKING ITSELF is an ephemeral art, the chefs who created it emerge from the pages of history brimming with life, eccentricities, and temperament.

Here is Vatel, committing suicide when enough fish did not arrive on time; there is Carême, moaning, "The charcoal is killing me, but what does it matter? The fewer the years, the greater the glory!" Here again is the great Escoffier, wearing lifts in his shoes so his head would be above his ovens.

"A fractious and insolent race," says Robert Contine, the vitriolic food correspondent for *Le Monde*. And why not? A great chef is sought passionately by princes, courtesans, heads of state, and great financiers, for his reputation must rest upon his soufflés, and an ill-fed plenipotentiary or prospective lover will wreak his revenge later.

Although most knowledgeable people have at least heard of Escoffier, Brillat-Savarin (who was not a chef but a magistrate in a

sleepy French town) and Henri Soule, the bluffer should know at least the following:

La Varenne, the great chef to Louis XIV, the Sun King. Varenne's 1655 book *Le Cuisinier français* made a giant stride toward the classic French cuisine. His cookbook, the first to be presented in alphabetical order, emphasized the goal of bringing out the natural flavors of food, instead of disguising them with heavy spices to mask off flavorings; or using coarse ingredients, such as meat fat in pastries.

Vatel (1635–1671). He wasn't much of a cook, but he sure was dramatic.

In April 1671, Vatel's employer, Le Grand Condé, planned a round of festivities at his château outside Paris in honor of his cousin, Louis XIV. When all the guests were feasting their first night, Vatel discovered that there was no roast meat at a few tables, because of unexpected extra guests. A tragedy!

Overwrought, inconsolable, Vatel retired to his room, but at 4 A.M. he got up and wandered around the grounds, where he chanced upon one of the fish purveyors with only two loads of fish.

"Is that all?" cried Vatel.

"Yes," replied the fishmonger, unaware that more fish was arriving from other ports.

Vatel ran back to his room, and setting the hilt of his sword against the door, killed himself on the third try. At that instant the carriers arrived with the rest of the fish, and a boy was sent to fetch Vatel, but it was too late.

(Probably the most famous account of this incident is in the *Letters* of Mme de Sévigné.)

Marie-Antoine Carême (1784–1833). Often referred to as "the architect de cuisine," a rather delicate pun. Carême is the founder of the great, classic cuisine, for which he prescribed the recipes, menus, and kitchen techniques in a monumental series of cookbooks.

He also had the soul and temperament of an architect and imposed order, formal patterns, and classic designs on his creations and food displays.

Here is Alexandre Dumas's famous account in his *Grand Dictionnaire de Cuisine* of Carême's melodramatic entrance into the world of kitchens.

Carême was one of fifteen children born to a poor Parisian woodcutter, who did not know how to feed all those hungry mouths.

"One day," writes Dumas, "when Marie-Antoine was eleven years old, his father took him to the town gate for dinner. Then, leaving him in the middle of the street, he said to him: 'Go, little one. There are good trades in this world. Let the rest of us languish in the misery in which we are doomed to die. This is a time when fortunes are made by those who have the wit, and that you have. Tonight or tomorrow, find a good house that may open its doors to you. Go with what God has given you and what I may add to that.' And the good man gave him his blessing.

"From that time on, Marie-Antoine never again saw his father and mother . . ."

As luck would have it, he knocked at the door of a tavern, where the owner took him on as a kitchen helper. Man had met his fate. In six years Carême went from potboy to chief pastry cook at Bailly's, owned by the great pastry chef who excelled in cream tarts and catered to the Prince de Talleyrand.

One of the features of banquet tables at the time was *pièces montées,* or mounted pieces, great constructions of edibles in the shapes of castles, ships, temples, pavilions, and whatnot that were brought in between courses to delight and surprise the guests.

Some of them were incredibly vulgar; an English banquet featured a pastry ship that fired real gunpowder and a castle made of pies filled with live frogs and birds.

It was Carême's mission to impose beauty and order upon chaos. And so he spent his nights studying classical drawings of Roman and Greek buildings for his *pièces montées,* creating miniature temples and classical ruins out of marzipan and spun sugar, pastry, and chocolate. No wonder that he finally reached the conclusion that "architecture['s] . . . main branch is confectionery."

His architect's temperament for order and symmetry gave him a passion to organize the display and serving of food and to create a harmonious whole from the start to finish of each meal—instead of putting everything on the table at once with no particular plan.

Carême served only the best or the most important men and women in Europe. He eventually left Bailly's to work for Talleyrand, whom he admired greatly, because, he wrote, "M. de Talleyrand understands the genius of a cook." From there he went to Brighton

where England's Prince Regent had built his bizarre pleasure palace. But the English climate and cooking depressed him, despite the fabulously appointed kitchen hung with its gleaming battery of copper pots.

He then became chef to Czar Alexander in Russia, but he didn't like the Russian climate or the Russian style of serving, which was individual plate service. His beautiful architectural designs were hacked up in the kitchen, and the whole point was lost.

Carême returned to France, where he joined the household of the Baroness de Rothschild, and where he achieved his highest refinements and wrote his books.

He died in 1833 at the age of fifty, "burned out by the flame of his genius and the charcoal of his rotisseries."

Jules Gouffé (1807–1877). Carême's leading disciple and *officier de bouchers* of the Jockey Club of Paris. His *Livre de Cuisine* and *Livre de Pâtisserie* are unexcelled as guides for the professional chef.

Urbain Dubois (1818–1901). Author of six important works on cookery, he popularized the Russian table service that Carême so disliked.

Prosper Montagné (1865–1948). He argued that the *pièces montées* be removed, and that everything not part of the food itself should go. One of France's greatest chefs, he left a lasting legacy, the *Larousse Gastronomique,* the basic encyclopedia of French cooking.

Philéas Gilbert (1857–1934). A friend of the great Escoffier and his collaborator on *Le Guide Culinaire* and other works. Gilbert was a leading chef and gastronomic writer, who founded and edited a famous periodical called *La Revue de l'Art Culinaire.* He persuaded Escoffier that Montagné was right in calling for reform of the classic cuisine.

Auguste Escoffier (1847–1935). Known as the "king of chefs and the chef of kings," he was responsible for the creation of over seven thousand brand-new dishes. Despite this, his constant admonition to his disciples was *"Faites simple!*—"Make it simple!" His motto was "Good cooking is the basis of true happiness."

Escoffier was born in the tiny village of Villeneuve-Loubet on

the Côte d'Azur on October 28, 1847. At the age of twelve he was apprenticed to his uncle's restaurant in Nice—a typical setup with punishing hours, back-breaking work, a furnace for a kitchen, coarseness and vulgarity the norm. His early experiences inspired the social reforms he later introduced into his own kitchens.

As a young man he spent almost seven years in the army, including a stint as *chef de cuisine* for the French Rhine army headquarters during the Franco-Prussian War of 1870–1871.

He could do wonderful things for his men with a couple of onions, a rabbit, and a glass of cognac, when the war was going well for the French. When they came under siege, he did the best he could with horsemeat, which he served up in almost every imaginable form—stewed, braised, scalded, minced, pâtéed, so that in later years he could say with unimpeachable authority that "horsemeat is delicious when one is in the right circumstances to appreciate it."

After the war ended, he went to the Riviera to open his own restaurant. There he met César Ritz, a former cattle herder turned *hôtelier,* who hired him to run the food operation at his Grand Hôtel in Monte Carlo.

Their relationship has been called "a partnership for the gods," for they created a string of luxury hotels whose kitchens were often called "gastronomic shrines." Ritz hotels glittered around the world —Lucerne, Rome, Paris, London, Budapest, Madrid, Montreal, New York, Philadelphia, and even Pittsburgh.

The restaurant of their London hotel, the Savoy, became the nightly hangout for the most famous people of British and international society.

It was there that Escoffier created Pêche Melba for the Australian opera singer Nellie Melba; and later invented and named Melba toast for her as she was always on a diet.

He created Tournedos Rossini, in honor of the great Italian opera composer—a sort of celestial Dagwood sandwich composed of a slice of fillet of beef topped with foie gras and a truffle slice under a coating of Madeira sauce.

Of his writings (*Le Livre des Menus, Ma Cuisine,* and *Le Guide Culinaire*), former *New York Times* food editor Craig Claiborne declared: "They were to classic cooking what Blackstone was to the law. Once they appeared, even the most complicated culinary arguments could readily be resolved. Chefs who disagreed would

settle their differences by resorting to Escoffier instead of coming to blows."

He trained literally thousands of chefs, who, with their disciples, took French cooking all over the world. He streamlined the kitchen staff into an assembly line instead of having one man responsible for making the entire dish.

Escoffier died at the age of eighty-nine, and was buried next to his wife in Villeneuve-Loubet.

He used to joke that his epitaph could be one of Brillat-Savarin's maxims: "Beasts feed, man eats; but only the man of intelligence and true perceptiveness really dines."

Adolph Dugléré, chef at the Café Anglais, which in its time was the hangout for all the bon vivants in Europe. He created potage Germiny, a classic consommé with shredded sorrel leaves, enriched with egg yolks and cream; and sole Dugléré, a fillet of sole baked with chopped onions, tomatoes, seasonings, and white wine, served with a sauce prepared from the fish's cooking liquid, thickened with a *velouté*, butter, and a few drops of lemon juice.

Fernand Point (1897–1955). In the early 1950s Point loomed larger than any other restaurateur in France—not only because he weighed three hundred pounds, but because his restaurant, La Pyramide, in Vienne, was widely regarded as the finest in the world. Leading chefs called him "Le Roi," and he trained many of the country's outstanding culinary artists. The restaurant continues under the direction of his wife, Mme ("Mado") Point.

Alexandre Dumaine (1895–    ). Known as Alexandre the Great to his admirers. His restaurant, la Côte d'Or, in the provincial town of Saulieu in northeastern France was a gastronomic shrine for thirty-two years. Except for the war years, his restaurant always received the maximum three stars from the *Michelin Guide* from 1931 to 1963, when he retired.

## THE AMERICAN ESTABLISHMENT

Louis Diat (1885–1957). Diat worked at Ritz hotels in London and Paris before coming to America to serve as the *chef de cuisine* at the

old Ritz Carlton in New York from its opening in 1910 until its closing in 1951. He created the cold leek and potato soup enriched with cream known as vichyssoise.

Henri Soulé (1904–1966). Soulé arrived in the United States to run the French government's restaurant at the New York World's Fair in 1939. After the fair closed in 1940, Soulé remained in Manhattan with most of his staff, and opened Le Pavilion, naming it after the restaurant at the fair.

He was a brilliant organizer, a perfectionist, and an overwhelming tyrant who made no compromise with quality. He founded La Côte Basque, and his disciples fanned out over New York City to open the finest French restaurants in the country—La Seine, Lutèce, La Grenouille, Le Veau d'Or, and a dozen others.

# THE NEW WAVE OF FRENCH CUISINE

THE LEADER OF THE New Wave is Paul Bocuse, who was chosen *meilleur ouvrier* of France in 1961, an infrequently awarded title given to the best chef in a nationwide contest.

Under his informal leadership from his kitchen at Chez Paul Bocuse near Lyon, he and his friends—the Troisgros brothers in nearby Roanne, the Haeberlin brothers at Illhaeusern in Alsace, and a growing number of other widely celebrated restaurateurs—are in the process of subtly revolutionizing their art.

Basically, they are working toward a radical simplification of the heavy, formal style of Escoffier's cooking with its truffles, artichoke bottoms, foie gras, and fluted mushrooms.

They are stressing raw materials; lighter, purer sauces; and a technique purged of irrelevancies that lets the pure goodness of the finest, freshest ingredients shine through.

The Bocuse family has been running restaurants for seven generations along the same stretch of riverbank since 1765. Most French critics feel he is not breaking tradition in his pursuit of the

natural way, but has enhanced tradition, as befits a chef they customarily rank with Carême and Escoffier.

# A  FEW  WORDS  ABOUT  WINES

A FRENCH GENERAL IS reputed to have ordered his troops to present arms every time they marched past his favorite vineyard. Alexandre Dumas, himself a famous chef, declared that certain wines should only be drunk kneeling, with head bared.

And that's only the beginning of the complications. While any neophyte knows that Lafite Rothschild is a hotshot label, and that 1959 was a great year, we can only suggest that the serious bluffer run out and get *The Bluffer's Guide to Wine,* as soon as he has finished reading this necessarily brief treatise. If you start becoming serious on the subject, invest in Schoonmaker's *Encyclopedia of Wine.*

## BUYING  WINES

The best advice for a novice wine buyer is: "If you don't know your wine, know your wine merchant." Choose a store that stocks a wide range of wines and has the proper facilities to store them correctly, i.e., lying down on their sides with the wine touching the cork so that it will not dry out and admit air. If it's a California wine with a twist-on top, it doesn't make any difference. Unfortunately, a lot of wine is sold in delicatessens and strange little stores whose proprietors know nothing about wine except the price. They hustle the bottle out like so many cans of pork and beans.

## STORING  WINES  AT  HOME

Look for a cool, dark spot with a constant temperature—a closet or under the cellar stairs of a house. The ideal temperature for storing and aging wine is about 55 degrees, although you can keep

wines at a higher temperature for a few months. Make sure the hot water pipes don't run through your closet; the worst enemy of wine is a sudden change in temperature.

Invest in a wine rack so you can store bottles on their sides.

## HOW TO SERVE WINE

The old rule of thumb is to serve a red wine with red meats, and a white one with white, such as chicken or fish. Champagne is the only wine that can be served from start to finish.

Of course, there are rules within rules, like Chinese puzzle boxes.

A very heavy robust meat, stew, or strong game should be complemented by a full-bodied red wine, such as a Burgundy, Bordeaux, or Côtes du Rhône. Lighter meats and delicate game are best set off by one of the lighter reds, like a Beaujolais, Graves, Médoc, or Pommard.

Strongly flavored fish or shellfish cooked in a rich wine sauce go well with a full-bodied dry white, such as a white Burgundy like a Corton or Meursault, or a Graves from the Bordeaux region. You could spring for a Montrachet from Burgundy, considered the finest white wine and consequently quite expensive.

Light-bodied whites are the best foil for light-textured fish such as sole meunière, poached trout or salmon, or egg dishes such as soufflés. You could try a Chablis or Pouilly-Fuissé (both Burgundies), or a Muscadet. If you like fruitier wines, select a Riesling, Pouilly-Fumé, or a Sancerre.

Rosés are light red wines that, logically enough, bridge the gap between the fuller reds and whites. They do not, however, "go with" everything. They shine especially when served with hors d'oeuvres, egg dishes, and lighter meats such as veal, ham, or pork. Rose d'Anjou is a popular choice, and Tavel, a rosé from the Côtes du Rhône, is widely available and popular in the United States.

Dessert wines are naturally sweet and generally are the Sauternes from Bordeaux. The good ones age extraordinarily well, and some may be drunk when over forty years old. The really great ones, such as Château-d'Yquem, are considered truly noble wines.

Champagnes, as we noted above, can be served all through the

meal, at weddings and christenings, at breakfast with a pretty girl, or just for the hell of it.

The better French brands are Bollinger, Moët et Chandon, Mumm, Piper-Heidsieck, and Taittinger.

Champagnes are marked by their relative dryness or sweetness. The driest are those marked *brut* or *nature;* then *sec* (literally "dry," but really moderately sweet; and *demi-sec,* or sweet.

## TEMPERATURE

Red wines should be served at room temperature—between 64 and 68 degrees—but in this era of overheated homes and apartments, that's often impossible. An hour in the refrigerator before uncorking will usually bring them down to the right temperature.

Most reds profit from being opened an hour or so before serving so that the wine gets a chance to "breathe."

Dry white wines and rosés should be served chilled, between 44 and 54 degrees, and opened immediately before pouring. They will need two to three hours in the refrigerator. Champagnes and sweet wines should be served thoroughly chilled, either by spending three to four hours in the refrigerator or half an hour in an ice bucket. Serve immediately upon uncorking.

## WHAT TO SERVE WINE IN

The best, all-purpose wineglass is a stemmed, six- to eight-ounce globet, preferably tulip-shaped to catch the full bouquet of the wine. The glasses should be clear, not colored, so that you can appreciate the color and substance of the wine.

## WHEN NOT TO SERVE WINE

Wine is never served with courses that include asparagus, artichokes, salads made with vinegar, vinaigretted foods, curries, or oranges, as they all kill the taste of the wine. Fish with a pronounced fishy flavor and strongly flavored sauces such as Diable, Rémoulade,

Poivrade, Chasseur, and Provençale do much to destroy the subtleties of the wine served with them.

# BLUFFING YOUR WAY THROUGH A FRENCH MENU

My husband grew up eating lox in New Jersey
But now he eats *saumon fumé.*
The noshes he once used to nosh before dinner
He's calling hors d'oeuvres variés.
And food is cuisine since he learned how to be a gourmet.
                                                —Judith Viorst

In this immortal verse, the bard of Irvington, New Jersey, has limned the problem and the goal for the gourmet bluffer.

Let's assume that you've learned (from any French language instruction book) that *rognons d'agneau* are not lamb chops, but lamb kidneys, and that you did not weep when the *pamplemousse* on the dessert menu was not a mousse of exotic pamples but just plain old grapefruit.

The next step is to master the really *haut* terms of *haute cuisine,* so that when you order *ris de veau à la financière au vol au vent,* you'll know at once that you'll be getting sweetbreads served in the banker's style (*à la financière*), i.e., very rich and thus garnished with olives, fluted mushrooms, and veal *quenelles,* and served in the flaky pastry known as *vol au vent.*

## SAUCES

*Allemande.* A sauce made with veal *velouté,* cream, egg yolks, lemon juice, and nutmeg.

*Béarnaise.* A version of hollandaise sauce flavored with a reduction of shallots, wine vinegar, and tarragon, to which chopped parsley and more tarragon are added. After Béarn, a region of the Pyrenees in southwestern France.

*Beurre Noir.* A hot sauce of butter cooked until it turns dark brown and served immediately.

*Beurre Noisette* (hazelnut butter). A hot sauce of butter that is cooked until it is light hazelnut brown and served immediately.

*Bigarade.* Sauce Bigarade, a brown sauce flavored with Bigarade oranges (from Seville) and caramel, is served with duck.

*à la Bordelaise.* Sauce Bordelaise is made with red wine, usually Bordeaux (hence the name), and a brown glaze, to which are added chopped shallots, pepper, thyme, and bay leaf.

*Diane.* Sauce Diane is a pepper sauce with truffles, cream, and chopped hard-cooked egg whites.

*Mornay.* A white sauce with cream and grated cheese. One source says this is named for De Plessis Mornay. Another source says it was invented by Joseph Voiron in the 1860s when he was chef at the Restaurant Durand. Your move.

*Nantua.* Sauce Nantua is a béchamel with cream and crayfish butter, usually served with eggs, fish, and shellfish.

*Rouennais.* Sauce Rouennaise is a Sauce Bordelaise with puree of raw duck livers, ground hot red pepper, and lemon juice.

*Suprême.* A sauce of chicken *velouté* enriched with cream.

*Velouté.* Literally rich and velvety. A basic white sauce based on poultry, veal, or fish stock; or a cream soup made the same general way.

## GARNISHES

*Bouquetière.* A colorful garnish of peas, green beans, cauliflower with hollandaise, château potatoes, and artichoke bottoms filled with pieces of carrots and turnips. Literally a flower girl.

*Cressonnière.* Garnished or prepared with watercress.

*Duchesse.* Garnish of mashed potatoes mixed with egg yolks, usually decoratively arranged with a pastry tube.

*à la Financière.* Usually a garnish for poultry and sweetbreads of chicken or veal *quenelles,* truffles, cockscombs, mushrooms, and olives.

*Henri IV.* (1) A garnish of artichoke bottoms with Béarnaise sauce and potatoes for *noisettes* and *tournedos.* (2) A chicken consommé with vegetables, chicken, and chervil.

*à la Jardinière.* A vegetable garnish for large entrees, consisting of diced carrots, turnips, and green beans, plus white kidney beans, peas, and cauliflower with hollandaise.

*à la Lyonnaise.* Anything with onions. Generally refers to a garnish for red meat consisting of braised onions, potatoes sautéed with onions and Lyonnaise sauce, made with more onions, white wine, and meat glaze.

*Rachel.* A garnish of artichoke bottoms and beef marrow served with *tournedos* or *noisettes* and accompanied by Sauce Bordelaise. Probably named after Elisa Félix, a nineteenth-century French actress whose stage name was Rachel.

## GENERAL

*Argenteuil.* Anything with asparagus. The name derives from the commune of Argenteuil in north France, famous for its asparagus.

*Bonne Femme.* Home style; usually a dish simply cooked, accompanied by or garnished with several vegetables.

*Confit.* Preserved; as *confit d'oie,* pieces of goose, cooked and then preserved in their own fat; or as *fruits confits,* fruits cooked and preserved in sugar or alcohol, or vegetables in vinegar.

*Coquille Saint-Jacques.* A fish dish in cream sauce served in a scallop shell. *Coquille* is the French word for scallop. The shell is a symbol of Saint James the Apostle.

*Crécy.* Anything with carrots. Named after a region of France that grows exceptionally fine carrots. *Potage Crécy* is a carrot soup.

*Crème Chantilly.* Whipped cream, sweetened and usually flavored with vanilla or a liqueur.

*à la Dauphine.* Generally deep-fried potato balls made of a mixture of mashed potatoes and puff paste. The Dauphiné region is known for its potato and gratin dishes.

*Demi-deuil.* A French attempt at black humor. It literally means half mourning; it usually describes a poached or roasted chicken with slivers of black truffles inserted under the skin before cooking.

*à la Dieppoise.* Seafood with shrimp, mussels, and mushroom caps in white wine sauce.

*Du Barry.* Anything with cauliflower.

*Duxelles.* A mixture of finely chopped mushrooms sautéed with chopped shallots.

*à la Florentine.* Anything with spinach. Catherine de Médicis's Florentine cooks are believed to have introduced spinach from Italy to France.

*Gelée.* Jelly; *en gelée* means food served with a gelatin coating, as in *oeufs en gelée,* or eggs in aspic.

*à l'Impératrice.* Dishes named after Eugénie, empress of France. The most famous is *riz à l'impératrice* (empress rice), a dessert of rice and glacéed fruits.

*Julienne.* Thin matchlike strips of food. Attributed to Jean Julien, an eighteenth-century chef.

*Maître d'hôtel.* Headwaiter, in real life; in menus, food served with butter flavored with lemon juice and parsley.

*Marengo.* Usually with peppers, tomatoes, onions, and mushrooms. Named after the dish created by Napoleon's chef from ingredients scrounged from the countryside to celebrate Napoleon's victory at the battle of Marengo.

*Montreuil.* Usually with peaches. Named for a suburb of Paris famous for its peaches.

*à la Niçoise.* A dish with tomatoes and usually garlic.

*à la Normande.* Fish garnished with mussels, oysters, shrimp, crayfish, strips of fillet of sole, mushrooms, and truffles. Or, meat, poultry, and game dishes with a sauce of apple cider, cream, and Calvados brandy.

*Parmentier.* Anything with potatoes.

*Périgourdine, Périgueux.* With truffles. Périgueux is the former capital of the Périgord region in southwest France, which produces the finest black truffles in the world.

*Poivrade.* With pepper (poivre), plus salt and vinegar.

*Printanière.* A consommé with carrots, turnips, peas, beans, and sometimes asparagus spears.

*Quenelles.* Small, light dumplings of finely minced meat, fish, or fowl, bound with eggs, then poached and served in a sauce.

*à la Reine.* Anything with chicken; literally queenly style.

*Saint-Germain.* With fresh green peas. Named after a suburb of Paris.

*Saint-Hubert.* A game dish, named after Saint-Hubert, patron saint of hunters.

*Soubise.* A puree of cooked onions or onions and rice with béchamel,
nutmeg, salt, and pepper.
*Suprême de volaille.* Boneless breast of chicken.
*Véronique.* With white grapes.
*Vichy.* Carrots cooked in Vichy water (mineral water). After a noted
spa in central France.

## THE GOURMET'S BASIC LIBRARY

A BLUFFER WHOSE CULINARY library includes only *The Instant Gour-
met* and *The Drinking Man's Diet* will not exactly impress the local
kitchen mavens.

An eclectic selection of the top cookbooks will show that you
take gourmet cooking seriously, and nearly everyone will assume
that you have used them. (You can always wrinkle the pages and
splatter the covers with a little gravy if you haven't.) If you actually
get out the pots and pans, these books can either save or make your
reputation.

In addition to knowing how to cook, the serious bluffer should
know how to eat. As William Makepeace Thackeray remarked,
"Next to eating good dinners, a healthy man with a benevolent turn
of mind must like, I think, to read about them."

The gastronomical classics in the second section of this chapter
are handsome enough for the coffee table (indeed, some of them
are large enough to make a coffee table). And for instant impression,
what better than a copy of *Chinese Gastronomy* or *The Foods of
France* lying casually in full view?

But first, a basic selection from the acknowledged masters of
the kitchen.

If you really don't know what you're doing, get a copy of the
wise, venerable *Joy of Cooking,* now in its thirty-fourth edition
(Bobbs-Merrill, $6.95). Mmes Rombauer and Becker's index ranges
from "à Blanc, to cook" all the way to "Zwieback." There are fre-
quent pauses and digressions in the book regaling you with informa-
tion on eels, sorrel, former family cooks and dinner parties, anecdotes

on particular dishes, the techniques of skinning squirrels and carving turkeys. A solid book for the beginner, and usually a soup-stained essential for the expert.

It is almost impossible to fail if you can read and follow the simple, concise directions of *The James Beard Cookbook* (Dell, $1.25), now in its seventeenth printing. The Big Daddy of the American food establishment says it is intended to help two sorts of people: those who are just beginning to cook and those who have a long string of failures or indifferent meals behind them. For those who say they "have never boiled water," he actually tells them; but he also ranges further afield into delights like Oysters Rockefeller and Pot au feu.

*Mastering the Art of French Cooking* by Julia Child and Simone Beck (Knopf, $12.50) and *MTAOFC* Vol. II (ditto) are utterly intoxicating, occasionally overwhelming, and indispensable for those wishing to cook *à la français*. More than one determined person has become an excellent cook by plowing through the entire first volume, chapter by chapter, from soups to stocks to Orange Bavarian Cream and Pâté Brisée.

*Michael Field's Cooking School* (William Morrow, $10.95; $2.95 in paperback) reads almost like a witty, thoughtful lecture and gives the impression that Mr. Field is standing at your elbow. His *Culinary Classics and Improvisations* starts off with classic roast meats and fowl, then describes how to use every scrap to make more beautiful, tasty meals. Leftovers were never like this!

Craig Claiborne, formerly *The New York Times* food critic, has authored *The New York Times Cook Book* (Harper & Row, $9.95), and his subsequent *The New York Times International Cook Book* (ditto, $12.50). Both are lucid, lavish, and will have you drooling.

Probably the most underrated cookbook project of the decade is the Time-Life series underrated by everybody but Time-Life, which had the audacity to sell *The Cooking of Provincial France* in provincial France. Each book is $7.95, and comes encased in cardboard slipcovers. On one side is a large coffee-table book filled with glorious photographs, knowledgeable text and recipes; on the other, a small, spiral-bound recipe booklet to keep in the kitchen.

Time-Life boodle seduced some of the best food writers around —M. F. K. Fisher on *The Cooking of Provincial France;* Craig Clai-

borne and Pierre Franey on *Classic French Cooking;* Waverley Root on *The Cooking of Italy;* Emily Hahn on *The Cooking of China;* Santha Rama Rau, Joseph Wechsberg, Nika Hazelton, James Beard, all contributed their expertise.

An old-new series has just been reissued by Penguin Books in paperback—the complete works of Elizabeth David, deified and celebrated by the American food establishment. The set of her five books now comes in a tidy box for $6.50 (individual volumes are $1.25) and includes *French Provincial Cooking, French Country Cooking, Italian Food, A Book of Mediterranean Food,* and *Summer Cooking.* She is wise, passionate, unaffected, and addicted to cross references and cooking lore. One word of warning: her instructions often presume knowledge, so the real novice might have some trouble.

The granddaddy of the cookbook series is the one put out by Crown Publishers, which twenty-six years ago had the happy idea of taking the best cookbook in each of various countries, translating it, and adapting it for American usage. Their first venture was Ada Boni's *The Talisman Italian Cook Book* ($3.95), which is the standard work in Italy for Italian cuisine. Fourteen have been published to date, including *The Escoffier Cook Book* ($5.95, a compilation of the master's recipes), and *Viennese Cooking* by O. and A. Hess ($3.95) with an especially ravishing section on those sumptuous Viennese pastries.

Some other good, sworn-by cookbooks are Maria Lo Pinto, *The Art of Italian Cooking,* and Jack Denton Scott, *The Complete Book of Pasta* for pasta freaks.

For Chinese, try *Mrs. Ma's Chinese Cookbook* by Nancy Chih Ma, and *An Encyclopedia of Chinese Food and Cooking* by the Changs and Kutschers, an exhaustive, detailed reference work of over a thousand recipes ranging from snack to banquet. If you've always wanted to try Freckled Ma Po Bean Curd, the *Encyclopedia* will tell you how to make it.

## THE LITERARY GOURMET

Fortunately, gastronomes and gourmets like to write about the pleasures of the table almost as much as they enjoy sitting at it and

talking about it. This makes for pleasant, witty, informative reading, and the serious bluffer can learn enough truffle lore and banqueting anecdotes to keep him in dinner invitations for a year.

No serious bluffer can be ignorant of any of the following authors, and even a nodding acquaintance with them and their works will secure your bona fides. (This selection by no means exhausts the list, by the way.)

All together now alphabetically:

Beard, James, *Delights and Prejudices* (Simon and Schuster, $3.95 paperback) is a loving gastronomic journal. Beard's engaging, fascinating memoirs of growing up in the Pacific Northwest where his mother ran the Gladstone Hotel in Portland, Oregon, are liberally laced with recipes, nuggets of information, and reminiscences of New York and Paris as they used to be.

Brillat-Savarin, Jean Anthelme, *The Philosopher in the Kitchen* (Penguin, $1.65). The delightful, timeless philosopher, Mayor of Belley, cousin of Madame Récamier, Chevalier de l'Empire, author of a history of dueling and a number of racy stories (unfortunately lost), whose sister died in her hundredth year having just finished a good meal and shouting loudly for her dessert, is now best known for his *Physiologie du goût,* here translated as *The Philosopher in the Kitchen.* (M. F. K. Fisher (see below) has a new translation out under the title of *The Physiology of Taste,* at $7.95 from Knopf).

Brillat-Savarin emerges as a most charming, endearing fellow, who loves to tell a good tale and who adores his subject, gastronomy, which he believed was the noblest of all the sciences. His treatise on Frying is as pertinent today as it ever was.

Fisher, M. F. K., *The Art of Eating* (Macmillan, $9.95). This newly reissued volume comprises five of her out-of-print books, *Serve It Forth, Consider the Oyster, How to Cook a Wolf, The Gastronomical Me,* and an *Alphabet for Gourmets.* As James Beard aptly puts it: "For an art as transitory as gastronomy, there can be no record except for a keen taste and the printed word. [She] writes about fleeting tastes vividly, excitingly, sensuously, exquisitely. There is almost a wicked thrill in following her uninhibited track through the glories of the good life."

Mrs. Fisher is the author of *With Bold Knife and Fork* and is a prolific contributor to gourmet magazines.

Lang, George, *The Cuisine of Hungary* (Atheneum, $17.50).

In his introduction, Joseph Wechsberg (see below) observes: "There may be somebody in Hungary or elsewhere who knows more than George Lang about the cuisine of Hungary, but I doubt it." It seems unbelievable that he had to cut six hundred pages from the text, for he still has twelve pages alone devoted to a treatise on paprika. His recipe collection is astounding, a far journey from the goulash and noodles most people associate with Hungarian cooking.

As one reviewer wrote: "His book is exactly what a visit to an unexplored kitchen ought to be: history, anthropology, sociology, gossip and speculation, a travel guide and a cooking primer. There are even poetic *digestifs:* an ode to a 400 pound sow."

An excellent choice for esoterica.

Lin, Hsiang Ju, and Lin, Tsuifeng, *Chinese Gastronomy* (Hastings House, $10.00).

The introduction is by the famous Chinese scholar Lin Yutang, which is not surprising, since the authors are his wife and daughter. George Lang (see above) helped formulate the recipes and check the text.

This is a broad survey of the evolution of Chinese food, tracing its history from ancient to modern times, from formal classical cuisine to simple home cooking. The text is interwoven with a liberal supply of recipes that illustrate what the Chinese really have in mind when they discuss the balance of flavor, taste, texture, aroma, mixing tastes, and so on. Each region of China contributes a unique style of cooking—e.g., Mandarin, Cantonese, Szechuan, Fukien—and the authors not only chronicle what makes these foods different from each other, they explain why.

Hsiang Ju Lin's book, *The Secrets of Chinese Cooking,* won the Gastronomische Akademie Deutschlands award. Make of it what you will.

Montagné, Prosper, *Larousse Gastronomique* (Crown, $20.00), Absolutely overwhelming, this enormous volume fully realizes its sub-

title, *The Encyclopedia of Food, Wine and Cookery*. Highly recommended for insomniacs.

Norman, Barbara, *Tales of the Table—A History of Western Cuisine* (Prentice-Hall, $9.95). This is a fun, fully documented trip down the kitchen corridors of history. It is loaded with anecdotes on eating, dining, banqueting, food preparation, and ingredients. Especially good for those with a historical turn of mind.

Root, Waverley, *The Food of France* (Knopf, $12.95). A brilliant traveling companion for the actual or armchair gourmet. His starting point was a recent gastronomic tour through France; his accomplishment was to illuminate the differences with meaning, merging geography, history, and regional appetites.

Root, Waverley, *The Food of Italy* (Atheneum, $16.95). In this companion volume, Mr. Root tackles Italy, weaving together history, architecture, nomenclature, anthropology, regional customs and preferences as seen from the perspective of the table.

Seranne, Ann, and Tebbel, John, eds., *The Epicure's Companion* (David McKay, $7.95). A truly literary banquet of gastronomic writing, culled from Juvenal to Thomas Wolfe. It will provide the bluffer with instant erudition on an astonishing range of subjects—table manners, customs, and cuisines both ancient and modern; aphrodisiacs; exotica (such as the cabbage as an ancient remedy and cannibalism), literary references, famous banquets, philosophy, and more.

Wechsberg, Joseph, *Blue Trout and Black Truffles* (Knopf, $5.95). This is a witty and sensitive series of vignettes subtitled *The Peregrinations of an Epicure,* and what a journey—from a childhood diet of cocoa and hot dogs to an adulthood of *haute cuisine.* Wechsberg, long a writer on gastronomy, treats lovingly and knowledgeably of black truffles, foie gras, the making of bouillabaisse, a visit to Fernand Point's Restaurant de la Pyramide, and other fine subjects.

Wechsberg has written at least half a dozen other books and is now a contributing editor to *Gourmet* magazine.

*Books out of print, but worth knowing about*
*Hon-Zo.* This great cookbook was written by the wise Chinese Emperor Shennung in 2800 B.C. In forty-seven centuries we have not learned much more than it can tell.

*De Re Coquinaria.* The earliest traceable manuscript on cooking dating from the ninth century. It is believed to have some connection with Marcus Gavius Apicius, the Roman gastronome of the first century and one of the most famous cookbook writers.

# LA BATTERIE DE CUISINE

WHAT A NOBLE, STIRRING PHRASE! The bluffer with a *batterie de cuisine* at his command can feel confident, powerful, worthy of an Escoffier, whereas the poor wretch wrestling with his lowly "kitchen equipment" feels only incompetent and rather cabbagy.

The true bluffer, even if he possesses only the barest minimum of beat-up utensils, knows what his kitchen should possess, and so speaks longingly of aluminum fish poachers from Dehillerin's in Paris and seductive little Limoges *pots de crème.*

Here's a checklist for the basic bluffer's kitchen. For maximum impact, let it all hang out—on the walls, from the ceiling, in spiffy containers, on the counters. You'll impress the locals and you won't forget to use it.

*What you should know about copper pots.* They are very beautiful, very expensive, and very statusy. They are excellent conductors of heat, but to do any good, they must be heavy and at least ⅛ inch thick. The thin, glittery tourist stuff with brass handles is strictly for amateurs and will be burn your food anyway.

Copper pots also must be scoured after each use, because they tarnish easily, and retinned when the tin wash on the inside wears out, which it will eventually. The pots must be retinned or you will expire of copper poisoning.

The next best choice is the enameled cast-iron cookware from Europe, such as Le Creuset or Copco, and for the budget-minded,

plain black cast-iron or aluminum utensils are reliable and sturdy, with an old-fashioned, plain-folks chic.

*Things to cook in:*
- A heavy iron or enameled cast-iron frying pan, about 10 inches in diameter
- A heavy saucepan (1½-quart capacity)
- A double boiler
- A 3-quart ovenproof casserole with a tight-fitting lid, also known as a Dutch oven
- A large 8- to 10-quart kettle for cooking soups, stock, spaghetti, or enough rice to last forever
- A medium-sized roasting pan (the glass ones from France that come with their own wicker serving baskets are practical and inexpensive)
- A big roasting pan (for turkeys and large roasts) preferably of aluminum so you won't break your back taking it out of the oven
- A coffee maker. Drip pots make the finest, foolproof coffee. The nicest are the Melitta coffee makers from Italy, which are white china pots with a conical drip basket that uses disposable filter papers. The pot itself can double as a teapot.

*Knives:*

With just two sharp knives you can do almost all the chopping, slicing, paring, cutting, and so on that will be required. The best are made of old-fashioned, rustable carbon steel (not stainless) that sharpens easily and holds a good edge. A knife is really sharp if just the weight of it, drawn across a tomato, slits the skin.

- An 8- or 10-inch French butcher's knife
- A small paring knife

Assuming you already possess an assortment of vegetable parers, measuring spoons, metal and rubber spatulas, can and bottle openers, etc., here is what you need to qualify as a gourmet cook:

- A garlic press
- A parsley grater
- A hand cheese grater (or several, to put at each place if you're a pasta freak)
- A French wire salad basket

- A wire whisk (two, one large and one small, if you really want to be fancy)
- Some wooden spoons
- A big copper bowl to beat egg whites in (using the wire whisks)
- An omelet pan, used only for omelets, and wiped out with paper towels and salt after using
- A 2-quart soufflé dish
- 6 small china soufflé dishes
- 6 medium-sized soufflé dishes

*Unmentionable essentials:*

Like Mr. Rochester, you must never tell what's really up in the attic, or, in this case, placed unobtrusively near your working area. But these three electrical appliances will make all the difference in the world for the bluffer cook.

- An electric hand beater or mixing set, which is what you will really use to beat the egg whites in
- An electric blender. "The technique for making blender hollandaise is well within the capability of an eight-year-old," sniffs Julia Child, but don't knock it. With a blender you can make hollandaise, mayonnaise, and vichyssoise, without fear of failure. Let your guests think you did it all by hand; they won't know the difference.
- An electric can opener with a knife sharpener. The knife sharpener is the key—to keep your carbon steel knives sharp, of course. Besides, dull kitchen knives are dangerous.

*Mail-order sources:*

For the serious or would-be serious cook, nothing beats mooning over catalogs of exotic kitchen equipment—except for ordering stuff from the catalog.

For the ultimate in drop-dead chic, order your *batterie* from E. Dehillerin at 18–20 rue Coquillière in Paris. Dehillerin's is so famous and so powerful that it has been granted a cable address by the French government: *Dehilbatri*. Just in case you're in a rush.

Three reliable and oft-used American sources for European cooking utensils are:

Bazar Français, 666 Sixth Avenue, New York, New York 10010

Bazaar De La Cuisine, 160 East 55th Street, New York, New York 10022

Paprikas Weiss, 1546 Second Avenue, New York, New York 10021

# BLUFFING YOUR WAY AROUND THE KITCHEN

HAVING GOTTEN THIS FAR, the bluffer must eventually enter the kitchen for a serious confrontation with pots, pans, foodstuffs, and seasonings.

Frightful as this may appear, there are many things that you can do to assure success before you even lift a knife.

1. *Buy only the best ingredients.* Search out the finest butter and heavy cream; the freshest eggs; the plumpest, tastiest chickens; seasonal vegetables at the peak of their perfection; prime beef well marbled with fat; the palest veal; the freshest fish.

You can absolutely forget margarine, whipped cream substitutes, most canned vegetables, dehydrated mashed potatoes; in short, nearly all processed foods.

The point of this passion for quality ingredients was once explained by Charles Gundel, a Hungarian restaurateur ranked by connoisseurs all over the world as being in a class with Escoffier and Fernand Point.

"People often appreciate a superb meal," he said, "without quite realizing what makes it better than another meal of apparently much the same sort.

"You can't distinguish between fresh fruits and the very freshest ones unless you have eaten, let us say, wood strawberries newly picked in a sunny glade, or tasted a ripe apricot straight from the tree.

"Yet it is this almost imperceptible difference between fresh and freshest that is all important. . . . Beef is always a problem for one who buys. It must be aged, but it mustn't be frozen. Did you ever take meat from a freezer and watch it thaw out? The little bit of pink juice that has formed under it now is lost, and that little bit makes so much difference in the taste!"

2. *Cook what you've got to bring out their best qualities and flavors.*

Cooking does not have to be elaborate to qualify as gourmet cooking; indeed, many connoisseurs judge a restaurant by the quality of its plain roast chicken. Perfectly done, it should be crisp and crackling brown on the outside, moist and tender within. Loused up, it will be dry and stringy.

A mark of the accomplished chef is to make the same dish the same way every time—perfectly.

Briefly, this means no mushy, overcooked vegetables, leathery omelets, or overdone roasts.

To bring out the best qualities and flavors of each dish, remember the cardinal principle of menu making: contrast in color, texture, and flavor. A menu of creamed soup, creamed chicken, and ice cream manages to cancel itself out completely. If creamed soup is on the menu for the first course, follow it instead with a crisp, dark brown grilled steak garnished with red tomatoes and watercress.

3. *Minimize or, even better, avoid the difficulties in cooking so that you can do your best for yourself and favorite friends.*

For the bluffer, this means: make friends with the butcher. Even if you're not friends, you can ask him to do some things for you. Sometimes there is an extra charge, sometimes not.

But think what he can do easily that would take you countless hours, Band-Aids, and curses. He can bone and skin chicken breasts for *suprêmes de volaille;* bone and tie a loin of pork; butterfly a leg of lamb; pound veal scallops into thin, thin slices.

While you're at it, make friends with the greengrocer who can help you select the best produce; and the fishmonger, who can open clams, fillet fish, peel shrimp, and boil lobsters for you.

For ingredients, rely on canned beef and chicken stock instead of making it from scratch.

Use the blender to make sauces—mayonnaise and hollandaise for instance—and to puree soups. Hollandaise in particular is the making of many a meal, and it is a cinch in the blender.

Mass-produce when you can. Make spaghetti sauce in quantity, put it in pint containers, freeze it. Make parsley butter (*beurre maître d'hôtel*) or herb butter for garlic bread in small quantities and freeze that for easy use.

*Instant, Drop-dead Chic*
• Have little pots of fresh herbs growing in the kitchen—chives,

basil, tarragon. Someone's Victorian grandmother used to have a centerpiece of pots of chives whenever she served vichyssoise. Each guest was supplied with a pair of tiny grape scissors so that he could snip as much of the chives as he wanted straight onto the soup.

• Pay particularly attention to your spices, and be a real snob about having the freshest available. Throw out all those two-year-old jars of cayenne pepper whose fiery red color has faded into a facsimile of Georgia clay.

• Serve cold dishes or soups on cold china that has been chilled in the refrigerator.

• Serve hot dishes on hot plates—any oven set at 250 degrees will do fine as a warming oven.

• Serve with a flourish—but not necessarily *flambé*—proudly, dramatically. Many chefs watch suspiciously from their kitchen doors to make sure the maître d'hôtel and the waiters do a proper job of presenting their masterpieces, and heaven help them if they don't. Serve soups in handsome china tureens, antipasto on colorful earthenware platters, salads as a separate course to refresh the palate after the entree.

• Collect individual serving dishes—tiny *pots de crème,* individual soufflés or scallop shells, individual cheese graters—at the table.

• Present your guests with a handwritten menu as a pleasant souvenir of the evening. Escoffier did it and James Beard does it, so why not you?

# THE MOST FABLED, FABULOUS FOODS IN THE WORLD

NEARLY EVERYTHING THAT man has decided to put in his mouth has a story connected with it. There's George Washington and the cherry tree; Marcel Proust's *petite madeleines;* Miss Muffet's curds and whey.

But only a handful of comestibles has inspired whole bodies of literature and have attracted hordes of partisan followers who

extol their quality, defend their reputations, argue their merits, and happily bankrupt themselves for a final truffle or bluepoint oyster.

These few—Brie among the cheeses, caviar, truffles, oysters, foie gras—occupy exalted places in Western cuisine. To know the best of these is the mark of the discerning gourmet—or the accomplished bluffer.

## BRIE

The undisputed queen of cheeses is Brie, specifically Brie de Meaux, made on the outskirts of Paris. Brie has an illustrious history: Prince Metternich and his jury of men from thirty nations named her the "royal cheese" during the Congress of Vienna in 1815.

More charming, and certainly more heartfelt, is the following poem by Saint-Amant, a seventeenth-century French poet. Saint-Amant—surnamed Le Gros—was an illustrious member of the *Société Bachique,* and a devoted fancier of Brie.

> And may I, every time I think
> Of cheese, be moved to take a drink!
> Kneel, sinners all, and on your knees,
> Sharers of my discrepancies
> Loudly and boldly yell with me
> "Heaven bless the boil that gives us Brie!"
>
> Get far behind me, Pont l'Eveque
> Cheese of Auvergne . . . Milan . . . betake
> Those charms elsewhere, for only Brie
> Deserves my matchless minstrelsy.
> Golden its glory! Golden, too,
> Pure yellow is my cheese's hue
> Yet not from spleen! The moment after
> You press its skin, it splits with laughter
> And richest cream, no stay, no stint
> Oozes beneath your fingerprint.

In point of fact, Brie does not travel well, and only since air transport brings it to this country speedily and at the right temperature can it be enjoyed here at its best.

It is a delicate and elusive cheese, unfortunately more often immature and caked into layers or overly ripe and runny than perfect satiny *crème*. Although connoisseurs never expect to find a perfect Brie more than one time in ten, a perfect Brie at its peak pales the memory of former disappointments.

Brie is best bought between October and April—preferably between December and March if you really want to make a thing about it—and only in the best cheese shops.

Because it keeps about as well as leftover champagne, plan to buy only as much as will be used at one time. Don't refrigerate it after it has started to run; instead cover it at room temperature and eat it as soon as possible.

How to serve Brie: It is a perfect after-dinner cheese or small snack, served simply with plenty of crusty fresh French bread, a selection of fruits (especially ripe pears), and a red wine.

(N.B. For your own protection, you should know that Roquefort, that sharp, green-veined, crumbly cheese, has been called the "king of cheeses." It is made entirely of sheep's milk, and is aged in damp, drafty caves carved from craggy mountainsides by fierce, forbidding winds.)

## CAVIAR

Among experts there is a saying: "You don't eat caviar with the eyes but with the palate." The mark of the novice is to look for the caviar with the biggest grain and the lightest color, but the connoisseur depends strictly upon his taste buds.

Caviar is the eggs or roe of the sturgeon, but not all sturgeon roe is caviar. To become caviar, it must be prepared within a half an hour after the fish has been killed. It is immediately taken from the fish by experienced preparers, who are as famous as a good chef in their field. The preparers, who have a very light "hand," take the roe out of the fish, put it briefly into a brine, and remove the sinews. The caviar is then shaken through a sieve to separate the grains by size and packed into four-pound tins. As one expert said: "It is one thing to know how to prepare caviar, but another thing to do it well."

The three kinds of caviar are:

• Beluga, which is the large or giant grain sold either fresh or in jars. Malossol is a slightly saltier Beluga.
• Osetre, which is little known in this country, but very popular in Europe.
• Sevruga, which has a large grain, but not as large as Beluga.

Pressed caviar is prepared from broken eggs and pressed into a jar or tin. It is sold fresh as well as in jars and is not as expensive.

Anything else called caviar is strictly imitation. "Danish caviar" is just fish roe—whether whitefish, lumpfish, or cod—and "red caviar" is salmon roe.

Fresh caviar is very expensive—at this writing $69 for a fourteen-ounce tin of fresh Beluga. The twin factors of increasing demand (both here and in a more prosperous Europe) and dwindling supply because of the pollution of the Caspian Sea—which is the main catch place—have pushed up prices.

Fresh caviar must have absolutely proper refrigeration—not below 28 degrees and not above 35 degrees. It stays fresh for a year if properly kept under proper refrigeration and because the slight amount of brine acts as a preservative.

Canned caviar, which actually comes in glass jars, is a cheaper grade than fresh, tastes saltier because of extra brine in the preparing, and has been pasteurized. It is not as fragile, but very tasty.

Caviar cannot be frozen, by the way.

The best place to buy it is from a store that knows what it's selling and that sells only the best.

*How to serve caviar:*

Caviar should be served on a bed of crushed ice. You can either push the container up to the rim in a pretty bowl of crushed ice or transfer the caviar to a small bowl or dish and then push it into the ice.

The classic accompaniments are lemon wedges, parsley, and thinly sliced black bread or toast. Spread caviar on the bread or toast, sprinkle with lemon juice and parsley, and enjoy.

Very often small dishes of egg whites, yolks, and onions, all minced very fine, are served as a garnish, but the true connoisseur favors the simple lemon juice-parsley route.

A good accompaniment to this is iced champagne or chilled champagne or icy cold vodka.

### Blini with Caviar

A popular version of this is a favorite at New York's Russian Tea Room, which likes to say that it stands a little to the left of Carnegie Hall.

Blini are thin buckwheat pancakes.

1 dozen thin buckwheat pancakes (hot)
4 tablespoons hot melted butter
½ pint cold dairy sour cream
6 tablespoons pressed black caviar or "red caviar"

You should really make the pancakes from scratch, but probably no one will notice if you start with a mix. Follow the directions on the package for the pancakes, making them about 3 inches in diameter and as thin as possible.

Pile the pancakes on a warm plate, keeping them warm on the back of the stove.

The rest is an assembly job: Pour a little melted butter over each pancake, add a dollop of sour cream and a spoonful of caviar, roll the pancakes, place them seam side down on a plate, and serve.

This will serve six as an appetizer, two as an unbelievably filling extravaganza or late-night supper.

## TRUFFLES

The sanctum sanctorum of foods, the "black diamonds of the kitchen" in Brillat-Savarin's oft-quoted phrase, truffles remain a poetic mystery of the gastronomic world.

The truffle is actually a fungus, and a very unusual one at that. It grows completely underground, and, as it has no chlorophyll, must live in symbiotic partnership with some other growing thing that does possess chlorophyll.

In France truffles grow near the roots of oak trees, but not under all oak trees and not under the same oak tree each year. The best ones are found around Périgord in the Périgueux region of north

central France—these are black truffles hunted by specially trained pigs who can sniff them out underground.

In Italy truffles are seemingly more adaptable, for they grow under oaks, chestnuts, willows, hazels, and poplars at altitudes of between 1,300 and 1,900 feet. These are the white truffles, but white only in comparison to the best French blacks, for they are really pale brown and beige. They are hunted by dogs, many of whom attend a "university" for truffle hounds at Rhodes. The most prized are the beautiful white truffles of Alba.

Truffles—especially fresh truffles—are most appreciated where they are grown. In Italy they lock them up in hotel safes, and in the eighteenth century truffles were escorted through the streets of Paris by armed guards.

At that time in Paris there was a terrific enthusiasm not only for truffles but also for anything from the New World, especially American turkey, *le coq d'Inde.*

One fateful day a hostess assayed the best of both possible worlds by stuffing a turkey with truffles as the *pièce de résistance,* and for several months no dinner party was anything without a *dinde truffée* as one of the courses. Many a man went bankrupt to retain his social standing by serving a *dinde truffée,* and then the fashion vanished as quickly as it had appeared.

Brillat-Savarin begins his essay on truffles with the stirring words: "Whoever says truffle utters a grand word which awakens erotic and gastronomic ideas both in the sex wearing petticoats and in the bearded portion of humanity.

"This honour of awaking two ideas results from the fact that this eminent tubercle is not only delicious to the taste, but also because we think that it excites a power of which the exercise is accompanied by the most delicious pleasures."

Whether the truffle is indeed an aphrodisiac has not been resolved, although Brillat-Savarin relates a charming story of a lady who nearly succumbed to the charms of a family friend after a dinner of truffled fowl.

There are also lurking suspicions that the tuber can be as deadly as some mushrooms, which has led certain commentators to caution that "even as a youth with weak lungs should refrain from the violent excitement of rowing, the epicure of weak stomach should avoid the perilous delight of the truffle-gourmand."

The most famous story concerns Louis XVIII's chef, who was reputedly done in by an overdose of *truffles à la purée d'ortolans.* (Ortolans are tiny birds, considered a delicacy.) Both king and chef had labored mightily over the dish, eaten it with satisfaction, and retired to rest with easy consciences.

In the middle of the night Louis le Désiré was awakened by the news that his faithful chef was already in the arms of death and had sent a warning to his king to rid himself of the truffles by the time-honored method. The sovereign sat up and observed: "Dying! And of my *truffe à la purée!* Poor man! Then he sees I did him no injustice. I always said I had the better stomach of the two."

Fresh truffles, imported from France and Italy, are sometimes available in the fall and winter months—especially around Christmas-time—in gourmet food shops.

To prepare fresh truffles, wash them in several waters, scrubbing them vigorously as the skin is very rough. They should be sliced very thin as their aroma is overpowering. To take advantage of this, place the thin truffle slices in a closed container in the refrigerator and store overnight.

Canned truffles packed in water in tins and jars of varying size and quality are available the year round.

The best grade is *peeled:* large round dark brown truffles with no holes. In this category are *extra peeled* and *peeled first choice.* Generally, a seven- to eight-ounce container will hold a single truffle approximately the size of the container.

The second quality is *brushed;* not quite as perfect, round, or dark as the peeled. In this category you will also find *extra brushed, brushed first choice,* and *brushed fancy.*

Truffle pieces and truffle peelings are also available and are of much poorer quality, and truffle puree is sold in tubes and cans and used on toast.

Since a one-ounce can of white truffles costs about $4.95 in the United States, it is not surprising that every last bit of the truffle—including the juice—is used. All parings can be minced and used to flavor soup or sauce, and the juice itself can be used to flavor sauces.

If you open a can and use only a portion, cover the remainder with dry Madeira wine, which will take on the truffle flavor.

Here are two recipes that employ the *Tuber magnatum.*

## SUPRÊMES DE VOLAILLE AU TRUFFE *
(Chicken breasts with truffles)

This recipe uses black French truffles and is from Julia Child's *Mastering the Art of French Cooking* (Vol. 1). It is simple, elegant, and expensive. She suggests as an accompaniment grilled or stuffed tomatoes, buttered green peas or beans, and potato balls sautéed in butter. For wine, a red Bordeaux-Médoc.

    2 whole chicken breasts, split, boned, and skinned
    4 *suprêmes* (boned breasts from 2 fryers)
    ¼ tsp salt
    Big pinch of pepper
    1 cup flour spread on an 8-inch plate
    ½ cup clarified butter (see note below)
    1 tb  minced shallot or green onion
    ¼ cup port or Madeira
    ⅔ cup brown stock or canned beef bouillon
    2 tb  minced parsley
    1 minced canned truffle and the juice from its can

Have the butcher bone and skin the chicken breasts for you, making sure that he removes the long white tendon.

Just before sautéing, sprinkle the *suprêmes* with salt and pepper, roll them in the flour, and shake off excess flour.

Pour clarified butter into skillet to a depth of about ¹⁄₁₆ inch. Set over moderately high heat. When the butter begins to deepen in color very slightly, put in the *suprêmes*. Regulate heat so butter is always hot but does not turn more than a deep yellow. After 3 minutes, turn the *suprêmes* and sauté on the other side. In two minutes, press tops of *suprêmes* with your finger. As soon as they are springy to the touch, they are done. Remove to a hot platter, leaving the butter in the skillet.

After removing the sautéed *suprêmes*, stir minced shallot or onion into skillet and sauté a moment. Then pour in the wine and

---

* Julia Child, *Mastering the Art of French Cooking*. New York: Alfred A. Knopf, 1966.

stock or bouillon and boil down rapidly over high heat until liquid is slightly syrupy. Pour over the *suprêmes,* sprinkle with parsley, and serve.

Note: How to clarify butter. (This is so it won't burn and form little black specks all over the *suprêmes.*) Melt the butter in a saucepan. Pour or skim off the yellow liquid, which is the clear, or clarified, butter. The milky residue in the bottom can be used to flavor vegetables or sauces later.

## VERMICELLI ALL'ALBA *

Jack Denton Scott includes the following recipe for white truffles in his opus *The Complete Book of Pasta.* Of truffles, he says: "What these brownish gray bits of fungi, usually no larger than a walnut, do is to bring a sweet perfume to any dish they decorate, a flavor that is difficult to describe, piquant, different."

This is a favorite dish in the district of Alba in the Piedmont region, where the finest truffles are found.

    1 white truffle (canned or fresh)
    ¼ pound butter
    1 pound *vermicelli*
    ½ cup grated Parmesan cheese

Slice the trufflle as thin as a razor-sharp knife can. Melt the butter in a pan, stirring in half of the truffle. Cook the *vermicelli al dente,* drain, and place in a warm bowl. Pour in half of the melted butter and truffle and all of the cheese; toss well but gently. Serve in hot soup bowls, with the remaining butter-truffle mixture poured over, and the rest of the sliced truffle atop. Serves 4 to 6.

Note: If the truffle is canned, add the liquid to the butter in the first stage of cooking.

---

* Jack Denton Scott, *The Complete Book of Pasta.* New York: William Morrow and Company, 1968.

## OYSTERS

"He was a bold man that first ate an oyster," said Jonathan Swift, and this curious bivalve has fascinated and repelled men throughout the ages.

Oysters are reputed to have aphrodisiacal qualities, and their high phosphorus content has endowed them with a reputation for being "brain food," so that Louis XI forced his advisers to consume great quantities of oysters each day, the better to serve him.

Although nine oysters are now considered the perfect number as an appetizer, people used to eat them by the dozens of dozens.

There is a curious little book by W. R. Hare called *On the Search for a Dinner,* published in London in 1857. He tells the story of an English milord who dined at the celebrated restaurant Rocher du Cancale upon a hearty meal of twenty-nine dozen oysters, after which milord died suddenly.

When the staff had brought him down, with great difficulty, to his carriage, his groom remarked coolly, "It is the third time that Milord gives himself the pleasure of dying of indigestion." "He will not die a fourth time," answered the *patron* with sorrow. Milord was buried at Père-Lachaise, where each year his friends deposit upon his grave enormous quantities of oyster shells. His epitaph reads: "Here lies ————, dead for the third time in a duel with the oysters of Rocher du Cancale."

Consuming gargantuan quantities of oysters was so popular in the seventeenth century (Brillat-Savarin naturally has a few words on the subject) that the oyster beds of Arcachon near Bordeaux were nearly destroyed (environmentalists, take note)! At last the French government had to station a warship with cannon to protect the oysters while a delegation was sent to Italy to learn the techniques of cultivating the mollusk.

Probably the best way of eating oysters is on the half shell. Prosper Montagné writes lovingly in *Larousse Gastronomique:* "However sumptuous or delicate the manner in which this mollusk may be prepared, the true connoisseur values nothing so much as a plain, raw, absolutely fresh oyster."

Served simply, it might be added, with lemon juice and thin slices of buttered brown or white bread.

As an oyster buff in good standing, M. F. K. Fisher waxes lyrical in her definitive *Consider the Oyster:*

"The flavor of an oyster depends upon several things. First, if it is fresh and sweet and healthy, it will taste good, quite simply . . . good, that is, if the taster likes oyster.

"Then it will taste like a Chincoteague or a bluepoint or a mild oyster from the Louisiana bayous or perhaps a metallic tiny Olympia from the Western coast. Or it may have a clear, harsh flavor, straight from a stall in a wintry French town, a stall piled herringbone style with Portugaises and Garennes, green as death to the uninitiated and twice as toothsome. Or it may taste firm and yet fat, like the English oysters from around Plymouth."

If you really can't bear oysters, just relate the story of William Makepeace Thackeray, who went to Boston in 1852. Although somewhat appalled by the very large American oysters, he nevertheless managed once to get one down in one gulp. A friend asked him how he felt. "Profoundly grateful," said Thackeray, "as if I had swallowed a small baby."

Or you can make oyster stew, a traditional, elegant supper dish, on which there are apparently as many variations as there are oysters. Here is a standard, delicious version from James Beard.

OYSTER STEW (serves 4)

   1½  pints of oysters and their liquor
    4  tablespoons of butter
   ½  pint of milk
    1  pint of cream
    Salt, pepper and cayenne

Drain the liquor from the oysters and heat it with the milk and cream. While it is cooking, heat 4 bowls and add 1 tablespoon of butter to each bowl to melt. Season the hot cream and oyster liquor with salt, pepper and cayenne and add the oysters. Let it come just to the boiling point but do not boil. When steaming hot pour into the bowls and serve with toasted French bread.

---

\* James Beard, *The James Beard Cookbook*. New York: Dell Publishing Company, 1969.

## FOIE GRAS

Literally, foie gras means "fat liver." In cookery it refers only to the livers of geese and ducks that have been fattened in a special way.

The "special way" is force-feeding, which used to be done by hand, but now, alas, is done by special machines that pour a steady stream of grain down the gullets of the birds.

Lest you think this is too cruel, list to the words of an eighteenth-century gourmet who said: "The goose itself is nothing, but man has made of it an instrument for the output of a marvelous product, a kind of living hothouse in which grows the supreme fruit of gastronomy. It is *foie gras . . .*" and so on in a similar rhapsodic vein.

The livers—especially those of geese—grow to a considerable size. Tolouse and Strasbourg goose livers sometimes weigh up to four pounds apiece and are literally worth their weight in gold.

The finest goose foie gras comes from Alsace in southwestern France, with the foie gras from Toulouse running a close second. Larousse gives a nod to that produced by Austria, Czechoslovakia, and the Duchy of Luxembourg.

Foie gras is judged primarily by its texture and color. It should be creamy white, tinged with pink, and very firm.

(Duck liver, while very delicate, tends to fall apart in cooking.)

*What you should know about foie gras.*

Limited quantities of fresh foie gras are available on special order from gourmet shops during the Christmas season, when it is produced in France. It is $49 a pound at this writing.

Canned foie gras is available at these shops the year round in the following sizes and qualities.

The best-quality pure goose foie gras is called *foie gras naturel en bloc.* It comes only in large oval cans ranging from 5¼ to 28 ounces. The 5¼-ounce tin costs $11.50.

The next best is a mixture of the best quality and lesser quality foie gras, called *bloc de foie gras.* It is usually encased in a thin layer of lard and sometimes contains truffles, in which case it is called *bloc de foie gras truffé.* This comes in long, trapezoid shaped cans ranging from 5 to 15 ounces.

Third ranking in quality is *purée de foie grass,* which contains 75 percent foie grass (by French law). It comes in a large variety of can shapes and sizes.

Don't confuse it with *purée de foie d'oie,* which is puree of goose liver, which contains (again by French law) not less than 50 percent goose liver.

The lowest quality is *mousse de foie gras,* which combines pork and eggs with goose liver.

Probably the most famous dish using foie gras is Tournedos Rossini, created by Escoffier for the Italian composer, who was crazy about foie gras.

Craig Claiborne gives an absolutely outrageous version of this dish in his *Classic French Cooking,* part of the Time-Life series. The recipe begins by calling for a cup of *fond lié.* To make it, the reader is directed to page 35. The first ingredient for the *fond lié* is a quart of *fond brun de veau* the recipe for which is on page 33.

This is a simpler version.

## Tournedos Rossini

This is a crash bang finale for a cookbook—or for the bluffer looking to make a super impression. This recipe for fillet steaks with artichoke hearts, foie gras truffles, and Madeira sauce seems horribly complicated, but it is not beyond reach.

Basically it requires that you prepare everything in advance and then combine them at the last minute.

    1 can artichoke bottoms (*fonds d'artichauts*)
    salt, pepper
    ¼ cup butter
    4 slices canned *foie gras en bloc,* cut about ¼ inch thick
    ½ cup (scant) Madeira wine
    ¾ cup canned beef bouillon
    1 thinly sliced black truffle
    1 teaspoon arrowroot or cornstarch
    4 *tournedos*—or filet mignon steaks—each about 1 inch thick
        and 2½ inches in diameter
    1 tablespoon oil
    Juice from the foie gras and truffles

Preheat the oven to 350 degrees. The artichoke bottoms should be about ½ inch thick; slice them in half horizontally if necessary. Season with salt and pepper, dot with butter, and put in a covered serving dish in the oven to warm up.

Slice the foie gras and put the slices in the top of a double boiler. Mix 2 tablespoons of the Madeira and 2 tablespoons of canned beef bouillon and pour over the foie gras. About 10 minutes before you're ready to serve, put it over barely simmering water to heat up.

Slice the truffle. Put the slices and the juice from the can into a small saucepan with 2 tablespoons Madeira, a quick grinding of pepper, and 1 tablespoon butter. Warm this up gently about 5 minutes before serving.

Mix the arrowroot or cornstarch with 2 tablespoons Madeira and set aside.

*To cook the steaks:* Add 2 tablespoons butter and 1 tablespoon oil to the skillet and heat until the butter foams. Add the *tournedos,* and sauté for 3 minutes on one side. Turn them over and sauté for an additional 3 to 4 minutes, or until you see a faint oozing of red juice on the top of the steak. They will be medium rare at this point, so remove them from the heat.

*The Assembly Job:*

Arrange the artichoke bottoms on a warm serving platter and place a steak on top of each one. Add a warm slice of foie gras to the top of the steak and cover with the truffle slices. Keep the platter in a warm spot while you make the Madeira sauce.

*The Madeira Sauce:*

Pour all the fat out of the steak skillet. Pour in ½ cup of the beef bouillon and the juices from the foie gras and truffles. Boil down rapidly, scraping up all coagulated juices until the liquid has reduced by half. Pour in the starch and wine mixture and simmer for a minute. The sauce should be clear and sparkling. Correct the seasoning, pour the sauce over the steaks, and serve at once.

BON APPÉTIT!

# The BLUFFER'S GUIDE

## to

## TRAVELING

by **SANDY GLASS**

Introduced by **DAVID FROST**

# INTRODUCTION

THE MOST SUCCESSFUL and consistently accurate fortune-teller I've ever come across used to tell every one of her clients: "You are soon going to take a journey . . . it will probably be across water . . . but I can't tell from your hand whether it will be a long journey or a short one . . . but believe Gypsy Rosie, you'll soon be going on a trip."

And in every case she was right.

Mind you, she did have her booth just outside London Airport.

I've been through that entrance literally hundreds of times, and when friends ask which I regard as my second home now, England or America, I tell them, "Both." First home is a BOAC jet—once a VC 10, now a 747, and before very long, I suppose, a Concorde, which will be an excitement all its own, crossing the Atlantic in three and a half hours.

It will for instance mean that we'll be able to leave London just after breakfast and arrive at Kennedy, because of the time change, before breakfast in time for another helping of scrambled eggs and the morning traffic jam going into Manhattan.

I used the word "excitement" there about flying because I've had some exciting moments when I've been up in the air—and a few of them were in airplanes as well. (The reader is invited to supply his own sound of a drum making a rim shot sound—baroom-boom).

I found myself once in an emergency landing which was not too worrying until the pilot came on the public address system and you could hear the copilot in the background whistling the theme from "The High and The Mighty." I was sitting next to a churchman and I said, "Quick, do something religious!" So he took up a collection.

Burt Reynolds told me a great story on the show about the time he was in an emergency landing, which mercifully turned out to be a false alarm, but not before somebody had inadvertently started to inflate a rubber dinghy inside the first class cabin. There they were, pushed back into their seats by this great rubber glob—it must have been something like being attacked by The Thing—trying to stab holes in its side with plastic knives and forks.

They were finally saved by an old spinster who pierced the rubber with a Boy Scout knife she produced from her purse. As she

253

explained, "A friend told me to lay in a stock of Boy Scout knives—that I would probably find them very useful in my advancing years; but I don't think this is what she had in mind."

Of course people who deal in travel, particularly those people who write the words for those glossy brochures, rarely say what they really mean. For instance, when you read the words "hundreds of little spots," they mean "all over your body," and when they say, "you'll enjoy the walks," they neglect to add "and the runs."

One of the greatest single dangers encountered by the traveler, though, has nothing to do with mechanical failure or the potency of the local water supply. It's the travel bore, the person who's been everywhere, done everything, and seen it all.

There are two ways of dealing with this particular form of vermin. If you are unlucky enough, yet, paradoxically, lucky enough, to be trapped alongside him in an aircraft, plug your headset in and listen to the Theatre of the Sky or whatever's playing in your plane. In fact, on the off chance that your plane doesn't have that sound system, it's always a good idea to carry with you one of those little transistor radio ear plugs. You can just stick it into your ear, letting the end trail loose in your pocket. Begin slapping the arm rest between you in the tempo of an imaginary song. Do this very hard, and keep altering the tempo every twenty-three seconds. That usually shuts them up.

On the other hand, you can memorize some of the Latin names for various parts of the body and ask how he could possibly have been to Switzerland, say, without having climbed the medulla oblongata, or how anyone could possibly have visited Holland without lunching at Spleen, just outside Amsterdam—that works.

Necessarily, most of my traveling has been in aircraft. I never savored the luxury and elegance of the heyday of the great ocean liners; and somehow the Atlantic doesn't seem the same without the old Queens, if you'll forgive the expression, but I still remember the story of one very rich and very beautiful woman who was sailing to Europe and kept her diary, much as a skipper keeps his log, of the trip.

Monday:    Today the captain asked me to have dinner with him at his table.

Tuesday:   Today the captain asked me to join him for an after-dinner drink in his cabin.

Wednesday: Today the captain made suggestions unbefitting an officer and a gentleman.

Thursday: Today the captain told me that unless I complied with his suggestion he would sink the ship.

Friday: Today I saved two thousand lives.

Somehow I can't see the captain of a 747 getting away with it, can you?

DAVID FROST

# A CAUTION FOR BLUFFERS

FOR THE TRUE BLUFFER, the actual experience of traveling has never been necessary; in fact, he has found that his imagination has only been cramped by the dreary discipline of traveling. To the true bluffer, the point of the game, of course, has always been to bluff without having gone. For him, no risk of intestinal upset through ingesting nasty-tasting foreign food, no danger of stiff neck from leaning into the stiff sea breeze of the English Channel at the bow of the Dover ferry. The true bluffer has stayed serenely at home, relying upon magazines, films, books by present or past travelers, Harrison Salisbury, Mary McCarthy, Sacheverell Sitwell, D. H. Lawrence, and, most of all, upon his own fertile imagination to attain for himself an ambience conveying the mist and spray of fifty Atlantic crossings.

However, the world we live in is steadily becoming smaller and less perfect. Today, the multitudes are free to travel; worse yet, with the ruthless increase of dissemination of information, the basic facts of travel are now available to all. Today the bluffer is forced to perform a certain amount of research in order to perform his historical function and not get caught at it. Let us face, then, at the beginning of this book the hard fact: In order for you to bluff to your own satisfaction and to fulfill what is rightfully expected of you by your associates in the International Order of Bluffers, you are going to need a certain amount of firsthand information to bluff with.

You are going to have to take a trip. Upon this cruel necessity the book that follows is based.

## PLAN

Since this is to be a BLUFFER'S GUIDE to TRAVELING, let us establish now when to bluff and when not to bluff. DO NOT bluff the planning stage of your trip or you will end up bluffing yourself. For some reason, possibly because for most people traveling is associated with "getting away," travelers do not like to plan thoroughly. Perhaps planning is the very thing you're trying to "get away" from.

Whether you've saved for the trip or haven't had to, you don't want to waste either time or money; therefore, you should plan. You should also cut all the corners you know about—and try to figure out new ones to pass along to your friends. You may well get back some wrinkles in exchange, which they've either figured out or learned the hard way.

In planning, make a list of what you enjoy. Is it culture? Food? Scenery? High life? Low life? The beaches, the promenades, the rolling moors? Decide whether you want to concentrate on one or two countries or to see a lot of places. Don't be too much of a glutton about seeing a great number of places or you may end up exhausted and with nothing but a lot of color slides of airports. Know yourself and your own capacity. Learn a few words of the language and some of the customs of each country you expect to visit. This isn't mandatory, but if you don't you'll probably see the country through the eyes of those who speak only to the natives who speak English. Many of these natives tell you anything that will keep you from frowning, and enjoy getting their hands on some of your money.

## PLAN, PLAN, PLAN

If you're a sportsman or a sportswoman and you suddenly say to yourself, "What the hell am I doing in a cheese factory?" you didn't plan.

Be selfish! Don't go with anyone unless he or she enjoys what you enjoy. If you're married and you and your spouse don't like to do similar things, get some good advice about divorce.

If you're under thirty and are looking for action, stay away from the expensive places; invariably, you won't score there.

If you're a girl, don't lock yourself into a big group. Stay loose-ish. It's tough enough to find someone without giving both of you the added problem of how to connect.

One way to plan is to buy a guidebook. I say "buy" instead of "go to the library" because the library will probably provide you with a dated edition. It's worth the five or six bucks to get an up-to-date one. Travel brochures are idealized. Airline guidebooks give you some information—they're free—but you should be sure to get hold of a guidebook for each country PLUS a small language guide AND a currency converter. Once you buy the books, READ THEM. You

will get more out of your stay. You will get out "with the people" and you won't get as gypped as you ordinarily would have.

## GUIDEBOOKS

The best *overall* guidebook for guidebooks is J. A. Neal's *Reference Guide for Travelers*. In it, he covers guidebooks for foreign countries as well as for the United States—and he does this extremely well.

If you are going to Austria, Germany, Italy, Switzerland, the French Riviera, châteaux of the Loire, Brittany, Normandy, or Paris, probably the best books for sightseeing are the *Michelin Green Guides*. They employ a rating system that ranges from three stars (\*\*\*) down to one (\*), like the movies. \*\*\* is worth taking the time; the others indicate "good" or "okay", and no stars ( ) means "forget it." This gives you a standard to follow.

The Michelin Guides are published by the French tire manufacturer and are the size of a large business envelope, so they can slip into your purse or pocket. The star rating system will help you to plan what you want to see. Each booklet is a quite comprehensive guide to general culture, history, and art. It includes cross-references, maps, floor plans of important buildings and ruins, etc. Since they are updated each year, you can rely on the prices of admission as well. They also give directions for getting from one place to another, and are reliable.

If you're a chow hound, the *Michelin Red Guides* are for you. Believe it or not, as anxiously as the film industry awaits the announcement of the winning of the Oscars, so anxiously do restaurant owners in the countries covered by these guides await their publication each year—and there have been some suicides because of them. With remarkably able descriptions the guides tell you where to eat, and they rate the restaurants by two criteria: quality of food and atmosphere. They also list prices, the telephone numbers, days the restaurants are closed, cover charges, free drinks, specialties of the house, the best local wines, and so forth.

Many experienced travelers carry these books prominently, like a chalice, when they go into a restaurant. When the book is noticed by the presiding restaurateur or hotel keeper, he'll know that you've

got the goods on him. Equipped with easily read road maps, the star rating system, information on how to tip, when daylight saving time is in effect, when mountain passes are closed in winter, and so forth, down to the minutest details (such as private vis-à-vis public plumbing), the Michelin Guides are hard to beat. The Red Guides are limited to the Benelux countries (Belgium, the Netherlands, Luxembourg), France, Spain, Germany, and Italy. It's quite okay to mention that you use these, as they separate the amateur from the sophisticated traveler. Also, Michelin makes a very good tire.

The Fieldings, authors of *Fielding's Travel Guide to Europe,* have visited every place about which they write. For sight-seeing, you're still best off with the Michelin Green Guide, but for being "wised up" fast, Fielding's will tell you about the local rackets, what not to buy, where to take your laundry, and which hotels, restaurants, and nightclubs they like. This, too, is an annual. It is honest, easy to read, and realistic about costs. Fielding also publishes the *Fielding Selective Shopping Guide* and *Fielding's Super-Economy Guide to Europe,* the latter written with the help of their college-student son. This is a good book if you're going to hitchhike or "camp out." Young people should definitely read it.

*Fodor* guides cover more countries, including those behind the Iron Curtain and in South America and most of Asia. *Fodor's Guide to Europe* covers thirty-four countries but doesn't go into the critical detail that Michelin gives, nor is it so aware as Fielding; however, Fodor does publish guides to individual countries, and they are well worth the time and money if you're going to concentrate on one or two places.

Some people actually tell me they do all right with the *$5–$10 a Day* series prepared by Arthur Frommer. If, for you, bluffing is simply a matter of covering ground at minimal cost, these books may be useful.

The *Pan Am New Horizons Guide* series is quite complete, in terms of the whole world, and fairly complete with respect to the individual countries.

*Holiday Magazine Guides* cover individual countries in about a hundred or so pages and include maps, language, and a respectable amount of detail.

The *Baedeker* series are closest to the *Michelin*s and cover more countries. They also use the star system.

Do buy *one* of these.

## LANGUAGES

We'll go into basic phrases a little later in the book. It's a "smattering" approach and will help you BLUFF a bit. You would do well to get a simplified "phrase book" before you go to any country whose language you don't speak. Unless you're a silent movie star who can communicate in pantomime, you can get into big trouble if you need a men's room or a doctor quickly.

Do not get cocky with your one or two phrases of French, let's say, if you do not want to receive a short-lived smile and a torrent of French back—to your eventual chagrin. The jig will be up quickly and you'll feel smaller than if you took out the book in the first place and made no secret about the fact that you're an ignoramus. It's a question here of *whom* to bluff.

Figure that you'll have to

1. Order meals (unless you order the same thing every day, or bring sandwiches from home).
2. Ask directions.
3. Gripe—about the price of something.
4. Go to the men's room. This is just as important in case you don't want to go to the men's room.
5. Go to the ladies' room.
6. Possibly call a doctor.
7. Say "Thank you."

Berlitz publishes good phrase books. You can also get language records or tapes if you want to go a little deeper into the subject. You can also take lessons. This, of course, isn't bluffing in one sense, but it will enable you to bluff in another. It will also come in handy when you return home and want a clean fork in a Greek restaurant.

So—you have a choice of

Dictionaries
Phrase books
Guidebook word lists
Flash cards

Taking along a tutor (this opens up interesting possibilities; I
 don't know if she'll be deductible)
Recordings
Sign language
Ignoring everybody

Also, DO NOT holler in frustration when you can't be understood.
The only exception to this is if you want to learn how to curse. You
won't find those words in any of the above-mentioned material. Also,
if you do holler—make sure you're bigger.

## HEALTH

You cannot bluff here, either.
The United States government requires that a returning traveler
show proof of a smallpox vaccination if he is returning from having
visited countries reporting smallpox. If you're going to a cholera
area (and why not?), you'll need proof that you've had cholera shots
in the past six months.
Other inoculations may make sense depending upon your des-
tination. Ask your doctor—or write to the Government Printing
Office, Washington, D.C. 20402, and for thirty-five cents you will
receive advice on avoiding the local disease—at least you'll have a
fighting chance. Besides being told how to escape yellow fever, polio,
cholera, typhoid, hepatitis, tetanus, and typhoid, you learn that it is
a good idea to know your blood type, whether or not you can take
penicillin, what your allergies are, and so forth. You'll also make
your mother very happy that you're taking care of yourself.
*Do not* leave these inoculations until the last minute because
some of them create a slight fever or can make your arm hurt like
hell, *or* tire you so that you won't be alert. Also, some take a period
of time to become effective. If you're going to India, Pakistan, Ceylon,
or that part of the world, you must show proof of protection against
yellow fever. Your shot may not "take" until twelve days after you
get it. Tetanus immunization takes two months to develop full effec-
tiveness. So, if you do wait until the last minute, the little doses of
disease you have been administered to prevent the disease itself, plus
the wearying effect of travel in general, may make you collapse at the

first airport you reach. In this case, the phrase book would certainly be considered a must. Might as well collapse in their language and get your visit off on the right foot.

It is a good idea, when you're packing, to include the following items that may be needed in a hurry—or difficult to explain in a foreign language:

Band-aids (Did you know they're called "plasters" in a lot of places?).

Vitamin C tablets—or whatever helps you with colds.

Eye drops.

An antibiotic ointment.

Heel pads and foot powder.

A cathartic. Constipation can occur abroad because of different water.

An emetic, on the theory that the best thing you could do for your stomach after you found out they were locusts would be to empty it.

Something to stop diarrhea. This you definitely cannot bluff about, and there usually isn't time to go shopping. In Europe, ask for Entero-Vioform, but it's best to have this with you. While on the subject, "Don't drink the water" means don't use the ice cubes, either. There's a perfectly marvelous solution to the water problem, however. Halazone Tablets can be dropped into local water, and after a half hour you'll have safe, vile-tasting water.

Salt tablets—if you're going to the tropics where you're more apt to perspire. Check with your doctor, because too much salt can be worse than the loss of it. Maybe you should get a large hat instead.

Allergy remedies. If you have allergies, consider the fact that another locale's climate may be on a different timetable than your own. Gesundheit!

If you're a hypochondriac, $5.00 buys a directory put out by Intermedic, 777 Third Avenue, New York, N.Y. 10017, listing more than three hundred physicians throughout the world who understand Americans, linguistically and medically.

Later, I will provide you with the phrase "I want a doctor" in several languages.

# PACKING

If you fly, first class allowance is sixty-six pounds; charter flights allow fifty pounds; economy flights, forty-four pounds.

Figure on one large suitcase and one overnight bag. Overweight, say, for ten pounds, New York to Paris, will cost you twenty dollars ONE WAY.

Pack half of what you need. Not only is overweight expensive in airline charges, it will cost you extra porter tips and might become a problem if there are no porters. This can be a bigger problem than you think. As a matter of fact, most smart travelers travel five pounds *underweight*. Why? Because they know they're going to buy things.

The airlines permit you to carry the following without weighing: a camera, an umbrella (get the telescope kind), one overcoat, usually a carryall bag (double check on this as it varies with the airline). The bluffer can tell his listeners how he has gotten away with extra weight and hidden riches, but the wise traveler obeys the rules.

Plastic baggies are very practical. Anything in a bottle might "pop" at high altitudes. Wrap such in a baggie and your baggage won't slosh mysteriously when you claim it.

Always remember: most shoes are heavy, especially if you carry shoe trees in them.

### Luggage

Hand–rubbed leather is beautiful. It shows that you can afford the best. It also is impractical because it will be mangled. Furthermore, since your weight allowance is critical, why get something that weighs ten pounds empty? Fabric is lightest. Plastic is more durable but weighs more. Also, always put something on it that allows you to identify it. Imagine a baggage counter with two hundred grey plastic bags with tiny name tags. This is a good way to use up those ties or scarves your mother-in-law sticks you with because she hates you. Tie one around your bag. If you're self-conscious on arrival, go have yourself a drink and hope that whatever unclaimed bags are left include yours.

### Electrical Appliances

Always ascertain the voltage of the local electricity *before* plugging in appliances. The United States is on 120 volt, 60 cycles (alter-

nating current). Most foreign countries are much higher and go up to 230 volts. This means that if you plug your razor or hot comb in without a CONVERTER or TRANSFORMER, your appliance will at first smoke—and then it will melt, or you'll be electrocuted. In either case it won't work and will be at least temporarily ruined. An ADAPTOR PLUG is not necessarily a TRANSFORMER. It might enable you to plug the appliance in and *then* it will smoke or melt.

If you intend to use any electric appliance while traveling, carry along several extra plugs bought especially to fit into foreign electric outlets. In addition, you will need either a traveling transformer that can be used with all your electric appliances, or appliances already equipped with built-in transformers.

## TRAVEL AGENTS

A travel agent doesn't cost you anything. If you go directly to an airline, ship line, or certain hotels, you won't save any money. The agents are very effective up to a point. They know tricks and short cuts that they've acquired over the years and should be able to compare features among carriers and explain why one, over the others, is the best for your requirements. If you're booking a string of hotels —and they're off the beaten track—the agent will probably charge you for detailed letter-writing. You may, at this point, be better off doing this yourself. (There is an international "language" in ordering accommodations, and it will be listed in the chapter about hotels.)

The agent gets his commission from the carriers and, in some cases, the hotels. There's nothing wrong in comparing travel agents. Ask how much detail one is willing to undertake. He should arrange, in addition to transportation and hotels, car rentals, yacht rentals, sight-seeing tours, rentals of villas, a new car purchase, passport photos (you pay), proper visas, making you part of a group in the sense that you might possibly qualify for a reduced rate (you don't have to stay with the group but that's your business—not the airlines').

There are ways of manipulating flights and time changes so that you possibly get free overnight hotel accommodations. You can get a good night's sleep—on the house, so to speak—and arrive in reasonably good shape instead of feeling like a refugee.

If you're going to London from Los Angeles, for instance, there's

a way to utilize stopover privileges. Few outside of travel agents know that you should buy two separate tickets: Los Angeles to New York; New York to London. For one thing, the total cost will be cheaper than the direct route, and you'll get extra stopover days in New York as a bonus. A good travel agent will know how to manipulate "stopover" privileges, something that might never have occurred to you.

Don't be bashful about asking him what he'll do—and then comparing. If he's just going to phone in your order and doesn't want to know you after that, then find one who will do more for you. If you're going to be bashful and ask for nothing, that's what you'll get.

## AIR TRAVEL

As we all know, in commercial flying there are first class, economy, and charter accommodations. No one can advise you regarding your choice here because your own personal factors will dictate this. Stopover privileges, as mentioned above, are worth examining.

You can use stopovers on standard, individual tour-oriented, and excursion fares. Generally speaking, 20 percent extra mileage is allowed over the shortest distance (commercial airline routes mileage) between destination and starting point. You can therefore make stops along the way as long as you do not exceed the allowed mileage figure and do not go anywhere that costs more than your ticket.

The distance from New York to Rome is 4,280 miles. You are allowed 5,136 miles. You therefore have 856 miles left to use. Why not stop along the way—going or coming? Los Angeles to Tokyo is 5,478 miles. You are allowed 6,900. With 1,422 miles extra, you should be able to see "bonus" places in the South Pacific.

## OCEAN TRAVEL

This mode of transportation is, alas, dwindling. Remember the movies of the 1930s with the Marx brothers, shipboard romances, Busby Berkeley directing thousands of porpoises dressed as chorus girls (or was it the other way around?), everyone in evening clothes, and all that?

Ocean traveling takes longer than flying, which is the chief reason you should consider this mode of going. It offers leisure, fresh

air, nostalgia, an opportunity of "slowing down" from our usual everyday rush approach to life. You can also take lots of luggage, although if you're flying back, watch this. Accommodations and service vary from line to line. Compare several lines before you make your final choice.

If you're traveling alone, inquire about single cabins vis-à-vis "two to a cabin," because fares are usually figured on the latter basis. You never know; you might get lucky—or find yourself sleeping with someone who puts his teeth in your glass. Check this.

Food, of course, is included. You pay for liquor and for the services of hairdressers and barbers, as you ordinarily would.

Fares are figured in three categories:

SUMMER
Eastbound—June 1 to July 31; westbound—July 16 to September 15
INTERMEDIATE
Eastbound—April 1 to May 31; August 1 to September 15
Westbound—January 1 to April 30; November 1 to December 31
THRIFT
Eastbound—January 1 to March 31; September 16 to December 31
Westbound—January 1 to April 30; November 1 to December 31

Approximate fares, New York to Southampton, England, on the *Queen Elizabeth 2* are:

|  | FIRST CLASS | TOURIST |
|---|---|---|
| SUMMER | $648–$1,040 | $370–$518 |
| INTERMEDIATE | $602–$948 | $334–$474 |
| THRIFT | $556–$845 | $297–$420 |

These are ONE WAY FARES and are subject to change AND calculated on occupancy of more than one.

The Italian ships: the *Michelangelo* and the *Leonardo da Vinci* sail between New York and Naples. ONE WAY FARES, again based on occupancy of more than one, range from approximately $250 up to $525, depending on class and time of year.

There are also freighters. Dress isn't so formal and you usually eat with the ship's officers. The service isn't the same as that on "luxury liners" but you may end up with better accommodations. Fares range from a little more than $200 to about $275, one way. If you're strong and want to help them unload, you might be able to do better.

On airlines, of course, you don't tip—unless you're a smuggler. On ocean liners you do. The following approximations have been calculated for *two* per stateroom. Single passengers cut these amounts by, say, 30 to 50 percent. You usually divide 4 to 5 percent of the ticket cost between the cabin steward and the dining room steward with another 1 to 2 percent to the other stewards who serve you. You pay at the *end* of the voyage. If the ship sinks, you're ahead—in tips. It is also customary to place the tip inside an envelope. Don't tip the captain, the purser, or any officer of the ship:

|  | FIRST CLASS | CABIN OR TOURIST |
|---|---|---|
| Cabin steward | $3 per day | $1 to $2 per day |
| Dining room steward | $3 per day | $1 to $2 per day |
| Bath steward | $3 if used | $2 if used |
| Deck steward | $3 to $5 per trip | $2 per trip |
| Head dining room steward | $5 to $15 if used | $5 to $10 if used |
| Night steward | $2 night if used | $2 night if used |
| Wine steward | $5 to $10 if used | $3 to $5 if used |
| Bar or smoking room steward . . . 15 percent of total bill | | |

Again: the above is for *two* passengers per stateroom. Hold the envelopes tightly as it can get windy out there.

## CAR TRAVEL

It is best to rent or buy a "foreign" car abroad because the roads are narrower and the gasoline is different there, and local cars are designed for such conditions. This way of travel can be fun and is really the best way to see the countryside. Get a *small car* with a big trunk that *locks*. Gasoline costs anywhere from fifty cents to a dollar a gallon. Small cars get approximately thirty miles to the gallon.

There are many rental agencies, but Hertz and Avis are most dependable, generally speaking, vis-à-vis airport pickup and delivery, saving you telephone and cab costs that the "economy" rental agencies do not usually provide. Check this. Telephoning in a foreign country can be a frustrating experience because the systems differ and sometimes special coins are needed. Get the reservation confirmed IN WRITING long before you go. Make sure the tank is filled (local racket) and check the mileage carefully. Also, make sure any dents are acknowledged in writing on the agreement so that, when you return the car, you are not charged for damages by someone who knows your plane is leaving in a half hour. See if there is a jack, with instructions for use. There's nothing like spending an evening on a mountain top with a flat tire, a jack, and no way to figure out how to use it.

Hertz and Avis give discounts, too. If your credit card shows the name of a business organization, inquire. They have all sorts of deals, depending on the car. Gasoline or possible drop-off charges are usually extra if you are planning to drop off the car in a location other than your starting point.

## BUYING A CAR

Go to your local dealer first and check out prices. There are "European Car Purchase Agencies" that may be cheaper in other cities, but when you return, service will be a big factor, and it may well be cheaper in the long run to buy it locally where the dealer owes you that obligation. Also, there is a lot of paper work, as well as foreign license plates, registration, and so on, which dealers are equipped to do for you. Furthermore, check with your state tax agency and find out what sales tax may be involved when you return. You may find that there really isn't much saving these days with the taxes, licenses, and other charges plus the shipping. If you need a new car anyway—terrific. Otherwise, compare rental costs with buying the same car. You may well break even with buying the same car domestically. The tax-saving thing has vanished like the prairies and is largely mythological these days.

Driving is really a great way to mosey around countries and to get the most out of your trip if you're going to one or two countries and want to "explore." Make sure you learn the traffic rules thor-

oughly. Nobody will make allowances for the fact that you're from Pittsfield if they see you coming at them on the wrong side of the road. In Europe a "foreign" car is a Ford or a Chevy, not what you'll be driving. They'll expect you to react just as they do.

This brings up the subject of insurance. Check around and ask the local AAA, even if you are not a member, because they also handle foreign insurance at rates usually lower than those of your local insurance dealer.

## RAILROADS

European trains are quite superior to ours, which have fallen into a general state of disrepair that borders on the disgraceful. Other countries are a different story, and this might be a good way to go. EURAIL PASSES mean you can travel unlimited for:

| | |
|---|---|
| 21 days | $125 |
| One month | $160 |
| Two months | $210 |
| Three months | $250 |

Children under ten are charged half-fare; under four, they travel free. Also included along with first-class accommodations are bus, boat, and ferry connections in certain places. While Great Britain is not included in EURAIL, they have their own plan, BRITISH RAILROAD INTERNATIONAL, or BRITRAIL PASS.

EURAIL covers Austria, Belgium, Denmark, France, Germany, Holland, Italy, Luxemburg, Norway, Portugal, Spain, Sweden, and Switzerland.

You might do well to compare the cost of railroad transportation with car rentals. If you have a Eurail pass, reduced fares for certain trips taken by the Europa Bus Company are available to you. In addition, there is a student Eurail pass providing qualified students with unlimited second-class rail travel for two months for $130.

## OTHER MODES OF TRAVEL

Besides hitchhiking, there are camel, burro, bicycles, skis, and so forth. You're on your own.

## MONEY

Insofar as travel is concerned, you would do well to budget by simply taking the large expenditure items that you can estimate, such as hotels, intercity travel, auto rental, and transportation from the total amount of money you are allowing yourself for the trip and dividing the remainder by the number of days you intend to be away. By this elementary process you will at least have some approach to a daily allowance.

PERSONAL CHECKS are very touch and go overseas. It is usually difficult to cash one far away from home, where the little piece of paper with your strange, Yankee-sounding name and remote address look like the furthest thing from money—especially to someone who never saw you before in his life.

TRAVELER'S CHECKS are your best bet. American Express and Thos. Cook & Son have offices throughout the world, and because of this their checks are generally those purchased most often. If you are buying other traveler's checks, make sure the locale to which you are journeying has offices to handle related matters—such as the loss of the checks. This brings up a simple procedure that should be considered MANDATORY in using these checks: Since, if you do lose them, you must prove that you bought them in the first place by showing a receipt, DO NOT CARRY the receipt with the checks because if you lose the checks you will also lose the receipts. Keep the receipts separate and also keep a list of the denominations and serial numbers on still another piece of paper—just to play safe. If you're traveling with someone, swap receipts. If you both lose everything—well, you can yell at each other. Traveler's checks usually cost one percent of their value, and it is wise to get them in small denominations if you're going to several countries, as you don't want to end up with a lot of currency from one country just as you're leaving it.

The DOLLAR BILL trick: Always have a small supply of one-dollar bills for coping with little expenses when you are leaving a foreign country.

## CREDIT CARDS

This "money" has many advantages, the chief one being that you don't have to literally pay for your charges for several months

as it takes a while for them to trickle in. Also, you get a fair exchange rate in the country's currency. For instance, most hotels usually charge a higher rate of exchange when you pay in cash, as do most shops. The credit card companies do better than you do on this.

Be sure and check out the differences in interest if you are going to pay in installments after the trip. American Express and Diners or BankAmericard differ. As you know, if you pay monthly there is no interest rate. If you borrow, the interest rates span from 12 to 18 percent annually.

AMERICAN EXPRESS extends credit for three-, six-, nine-, and twelve-month periods. Once you agree, even if you pay the entire amount prior to the expiration of your deal, you cannot change the deal. In other words, you'll pay for that period at the annual interest rate they charge: 12 percent.

DINERS' CLUB charges an annual rate of 18 percent interest, but they allow you to pay the entire amount earlier *without* the penalty. They allow you up to twenty-four months to repay.

If you are going to borrow, you would do well to consider a less expensive source. Project what you need and go to a bank. Their interest rates are a lot cheaper and you can still use the credit card and pay monthly without the higher interest rate. Credit cards usually will enable you to cash a personal check, or, depending on the amount you need, to borrow in the form of traveler's checks.

As in the case of traveler's checks, keep your credit card number someplace else in case you lose it. If it is lost—or stolen—NOTIFY the nearest office immediately. Also, in the case of credit cards, often local merchants will offer you a discount if you pay him in cash rather than use the card because he saves the percentage the card charges him for the service—and he gets his money immediately.

## MONEY EXCHANGE

This is a science. Carry a currency converter with you—or make your own. There is an OFFICIAL RATE OF EXCHANGE and when you cash traveler's checks, try to go to the state-connected banks. When you cash these checks at hotels, restaurants, shops, and the like, you will invariably pay a higher rate. You can also do better than the "official rate," but this can be flukey and you should know whom you're dealing with. It's not advisable to advertise that you're doing this.

If you buy some currency in the United States (so you will have enough when you arrive to deal with porters, cabs, and so forth), *don't* overdo this. The exchange rate in the United States is less advantageous than the official rate in the country itself.

## TIPPING

For some reason, this tends to get out of proportion. In some instances, it becomes a sort of "bullfighting." It is a case of combat in some situations, and renders you vulnerable through your own insecurities. You want to be fair—but you don't want to be "taken." To begin with: If you get lousy service, don't tip. In some countries, the tip is expected, so the act of tipping is not tantamount to saying, "Thank you." It is a good idea to say "Thank you" when you do tip. It doesn't cost anything. Say it with confidence—and a smile. Always look as though you know what you're doing. While you usually tip after the service is rendered, it may be a good idea to tip in advance if you are traveling around with a crystal chandelier and you want the porter to be careful with it.

Always inquire if the tip is INCLUDED in your bill. If it is, you can still add a little extra if you get outstanding service. A few percents will do it. Tipping is usually 10 to 20 percent, as you know, the difference varying on the quality of the service and how much you've drunk.

## HOTELS

Hotels can be very different in foreign countries. In the United States there are very few European-style hotels. If you've been weaned on motels and big urban hotels, you've got a two-headed treat in store. For instance, there are many variations on the theme "bath." It could mean a sink and some towels, or a bidet ("What the hell is *that*, Minnie?"). It could mean that there's one "close by." It could mean a bathtub but no toilet, etc., etc. Many older hotels do not have private bathrooms. The exceptions are the Hiltons and Sheratons and some individual first class hotels.

You should know that:

EUROPEAN PLAN is room only; no meals.

CONTINENTAL PLAN is room and continental breakfast.

AMERICAN PLAN is room and three meals a day. This is also called "pension" or "full pension" in Europe.

MODIFIED AMERICAN PLAN is room plus breakfast and either lunch or dinner. This is also referred to as "demi-pension" or "half-pension."

You can ask your travel agent to recommend hotels and to make your reservations to a certain extent, but if you are going to do a lot of individual moving around, he's going to charge you accordingly—it is a job to make a large number of individual reservations. You therefore are better off doing this yourself. Also, you'll pay much more attention to details relating to your trip than he will.

MAKE YOUR RESERVATIONS WELL IN ADVANCE.

Decide if you want an "American" or a "European" (or whatever is indigenous) style hotel. The difference is whether or not you want the atmosphere of the country you're visiting. As mentioned previously, there are guides that describe accommodations. There is a book entitled *Castle Hotels of Europe* by Robert P. Long that lists offbeat places such as converted castles.

First class abroad is usually comparable to our second-class hotels. They have a marvelous word called "de luxe" (or sometimes "luxe") for the best. If you're going lower than second class make sure you have a personal recommendation from someone who doesn't hate you. They have bugs in other places, too, and aren't so hysterical with sprays and DDT cans, possibly because they've figured out that there are trillions and trillions of bugs and that the only ones you should worry about are the ones very close to you. On second thought, bring a bug bomb. They (the hotel staff—not the bugs) will know you're an American, anyhow.

A lot of bluffers stay at second-class hotels and use the facilities—pool, bars-for-meeting, skiing—of the de luxe hotels. Many of them allow you to do so for a fee.

In writing to a hotel, use the following International Hotel Telegraph Code. You do not have to send a telegram to be able to use the code; you can write it in a letter. It describes what you want better than English translated imperfectly into another language, as it is a universal code:

## International Hotel Telegraph Code

| | |
|---|---|
| ALBA | 1 single room |
| ALDUA | 1 room with double bed |
| ARAB | 1 room with two beds |
| ABEC | 1 room with three beds |
| BELAB | 2 rooms with one bed in each |
| BIRAC | 2 rooms with two beds in each |
| CIROC | 3 rooms with one bed in each |
| CARID | 3 rooms with 2=1=1= 4 beds |
| CALDE | 3 rooms with 2=2=1= 5 beds |
| CADUF | 3 rooms with two beds in each |
| CASAG | 3 rooms with seven beds |
| DANID | 4 rooms with one bed in each |
| DIROH | 4 rooms with two beds in each |
| EMBLE | 5 rooms with one bed in each |
| ERJAC | 5 rooms with two beds in each |
| FELAF | 6 rooms with one bed in each |
| FERAL | 6 rooms with two beds in each |
| KIND | child's bed |
| SAL | sitting room |
| BAT | bathroom |
| SERV | servant's room |

To specify the type of room:

| | |
|---|---|
| BEST | very good |
| BON | good |
| PLAIN | ordinary |

Arrival will be announced:

| | Morning | After Lunch | Evening | Night |
|---|---|---|---|---|
| Sunday | POBAB | POLYP | RABAL | RANUV |
| Monday | POCUN | POMEL | RACEX | RAPIN |
| Tuesday | PODYL | PONOW | RADOK | RAQAF |
| Wednesday | POGOK | POPUF | RAFIG | RATYZ |
| Thursday | POHIX | PORIK | RAGUB | RAVUP |
| Friday | POJAW | POSEV | RAHIV | RAWOW |
| Saturday | POKUZ | POVAH | RAJOD | RAXAB |

Arriving this morning    POWYS
Arriving after lunch    POZUM
Arriving this evening    RAMIK
Arriving tonight    RAZEM
Staying one night    PASS
Staying more days    STOP

To cancel reservations:    ANUL plus name and address of person making reservation

Very civilized, right? Let's make up a letter:

GENTLEMEN:

Please reserve two good rooms with two beds in each of them, and a bathroom for each room. We will arrive Sunday evening on March 30. Please use the International Postal Reply Coupon [you will learn about this in a minute] to answer and confirm reservations.

<div align="center">Yours truly,</div>

GENTLEMEN:

BIRAC BON BAT. RABAL 30/3    [Always put the day first and the month second if you're going to use dates.]

Make a carbon, in case someone goofs, and take it with you on your trip. It will give you a starting point for an argument. Walk in and smile at the desk clerk as you hand it to him.

The above letter left out one important piece of information that you should give the hotel: your date of departure. If you do not book your departure you may be asked to leave if someone has booked a part of your stay.

Your local post office sells International Postal Reply Coupons. If you include them in your letter, the local manager can exchange them for stamps at his own post office. Believe it or not, this can make a difference sometimes, especially if the hotel knows it's going to fill up with you or without you. The coupons cover only surface mail, so enclose enough of them if you want an airmail reply.

You do not have to enclose stamps if you are reserving de luxe accommodations.

With Hilton, Sheraton, or Intercontinental (Pan Am) or any other American chain-owned hotel, simply call the one closest to you.

Always check your bill very carefully when you leave and don't be afraid to ask questions. This is not the time to BLUFF. There can be tourist taxes or service charges ranging up to 25 percent. They also make mistakes. They also cheat sometimes.

## SHOPPING

There are several approaches: The first is to see what is indigenous to wherever it is you are. In other words, why should you expect to get a great buy on a watch in Italy? In Japan there are cameras and electronic audio products; in Denmark there is Danish furniture; in the Netherlands, Dutch pewter; in Switzerland, Swiss watches; in France, French girls. Always comparison shop, too, before you buy. Don't be bashful. You'll never see the shopkeeper again (unless in a bad dream).

### Bargaining

A rule of thumb is that you can't bargain in a fine foreign shop any more than you can in one in the States. However, if you find yourself dealing with an "open air" store such as a booth or a pushcart of sorts, or a small store, you may test with "It's very nice but it's a lot more than I wanted to pay." The rule here is, every man for himself. Some people have a gift for this kind of thing and others —well, try anyhow. Make a game of it. Start off looking at it and act as if you couldn't care less if you get it. Make a face and shrug, ask indifferently, "How much?" and, whatever the price is, make a face again (try to think of something you don't like to eat). Put the piece down casually and look around at other objects that are adjacent to the one you're interested in. Read the man's face. Send up a balloon with "I don't think it's worth more than half of whatever he said." Give him room to protest and tell you how many hours it took to make, and so forth. At least, now he's on the defensive. If you're with somebody, try to have it established beforehand that he or she will be the "heavy" and will commence saying, "Come on, let's go." Anything to reinforce the notion that you couldn't care less. You could

even yawn and look at your watch—and repeat your price. It's like fishing, except you never know who's going to be the fish. Vibrations, or what the younger generation now call "vibes," are the keynote. If you don't give a damn, you'll obviously out-nerve him and get the item closer to your price. After you've "won" don't hang around. A native might come over and buy the same thing for half of what you've sweated him down to.

## Trademarked Items

The United States Customs issues a book that lists trademarked items that either have quotas or are NOT ALLOWED, in terms of their being brought back into the States. Sometimes the customs officer will obliterate the trademark before you can bring it in. This applies to some tape recorders, jewelry, table silverware, musical instruments, Leica cameras, and the like. Check beforehand.

## Duty

You are allowed duty-free merchandise worth $100 for each member of your family. To qualify, you must be out of the United States for forty-eight hours (Mexico and the Virgin Islands have no time limit); permission to bring into the country the $100 worth of duty-free merchandise renews itself every thirty days. These goods must accompany you. The $100 quota does not apply to goods mailed or shipped. If you are planning a specific purchase BEFORE you go, check the duty on it BEFORE you go. See how much you come out ahead. You are allowed to buy an extra $100 duty-free merchandise in the Virgin Islands.

There are many items that are duty-free: works of art, antiques over a hundred years old (get a signed certificate from the dealer, don't debate it with the customs officer), postage stamps, bagpipes (they must have a hell of a lobby). Also, if you're buying pearls, it might interest you to know that the duty on STRUNG pearls can go to 44 percent, whereas the duty on UNSTRUNG pearls only goes to 4 percent. Why? I don't know. Tradition! Possibly someone in the customs bureau was highly strung, himself. (If you can do better, let's hear it.)

Do you have to pay duty on something you did not purchase, but was given to you as a gift? Yes. On clothes that you'll be wearing? Yes.

### Duty Free Airport Shops

These are shops where departing passengers can buy famous brand liquors, perfumes, watches, and a wide variety of luxury goods at spectacular discounts. You do this just before you leave and the items are delivered to you aboard the plane. The $100 duty-free allowance still applies, but the discount more than makes up for it.

There are very few things left that you can purchase for a dime today. For ten cents, however, you can buy a booklet entitled *Customs Hints for Returning United States Residents* by ordering it from the Superintendent of Documents, United States Government Printing Office, Washington, D.C. 20402.

### Liquor

Every adult is allowed to bring in one quart duty-free under federal law. Each state has a ruling on this. Check into it. You cannot ship by mail. It may pay for you to bring back more than the quart and still pay the duty.

### Gifts

You may send purchases to friends or relatives as long as each package does not exceed $10 in retail value. The words GIFT EN-CLOSED and the fair retail value of the contents should appear on the outside of the package. Alcoholic beverages, perfume above the cost of $1.00, and tobacco products are NOT included in this privilege.

### Shipping Automobiles

Autos are shipped with drained gasoline tanks and drained radiators and with the batteries disconnected. Bring a can of gas, a wrench, and a screwdriver. There will probably be a faucet on the pier at which you can get water for your radiator. Also, the chrome may be covered with some sort of black coating to protect it from the salt air. If anything is missing (and check hubcaps, radios, heaters, VERY carefully), file a claim BEFORE taking possession of the car. Zero deductible insurance is a must on importing cars, because there is a thriving market for "rip-off" stuff. DO NOT leave anything of value in the trunk.

For sensible suggestions along this line, send fifteen cents to the Bureau of Customs, Washington, D.C. 20226 for a copy of *Automobiles Imported into the United States*.

Do yourself a favor and give this type of purchase a great deal of thought and investigation; otherwise, you can end up saving very little if you don't know what you're doing. If you pre-buy through a dealer in the United States, he'll take care of the customs clearance, clean off the protective coating, and so forth. He will also service it. Don't ad-lib your way through this type of purchase.

## CLOTHING SIZES

The following list is something you should know about because the Europeans (and others) use different numbers to "size" things, and if you're going to have a red face it should be from a suntan and not a tight collar.

### MEN'S

| SHIRTS | | HATS | |
|---|---|---|---|
| U.S. | EUROPE | U.S. | EUROPE |
| 13 | 33 | 6½ | 52 |
| 13½ | 34 | 6⅝ | 53 |
| 14 | 35–36 | 6¾ | 54 |
| 14½ | 37 | 6⅞ | 55 |
| 15 | 38 | 7 | 56 |
| 15½ | 39 | 7⅛ | 57 |
| 16 | 40 | 7¼ | 58 |
| 16½ | 41 | 7⅜ | 59 |
| 17 | 42 | 7½ | 60 |
| 17½ | 43 | 7⅝ | 61 |

| SHOES | | SOCKS | |
|---|---|---|---|
| 6 | 38 | 9 | 23 |
| 6½ | 39 | 9½ | 24½ |
| 7–7½ | 40 | 10 | 25½ |
| 8 | 41 | 10½ | 26¾ |
| 8½ | 42 | 11 | 28 |
| 9–9½ | 43 | 11½ | 29¼ |
| 10–10½ | 44 | 12 | 30½ |
| 11–11½ | 45 | | |
| 12–12½ | 46 | | |
| 13 | 47 | | |

WOMEN'S

| DRESSES | | | SHOES | | |
|---|---|---|---|---|---|
| U.S. | FRENCH | ENGLISH | U.S. | ENGLISH | EUROPEAN |
| 10 | 38 | 32 | 4–4½ | 2–2½ | 34 |
| 12 | 40 | 34 | 5–5½ | 3–3½ | 35 |
| 14 | 42 | 36 | 6 | 4 | 36 |
| 16 | 44 | 38 | 6½ | 4½ | 37 |
| 18 | 46 | 40 | 7–7½ | 5–5½ | 38 |
| 20 | 48 | 42 | 8 | 6 | 38½ |
| 40 | 50 | | 8½ | 6½ | 39 |
| 42 | 52 | | 9 | 7 | 40 |
| 44 | 54 | | 9½–10 | 7½–8 | 41 |
| 46 | 56 | | 10½ | 8½ | 42 |
| | | | 11–11½ | 9–9½ | 43 |
| | | | 12 | 10 | 44 |

On the following pages is a capsule *Bluffer's Guide* to some often-traveled countries.

# BLUFFING YOUR WAY THROUGH ITALY

## MONEY AND TIPPING

581 lire = 1 U.S. dollar; * 100 centesimi = 1 lira
1 lira = .17¢ ($.0017); 100 lire = 17¢ ($.17)

The station porter gets 150 lire for the first bag; 100 lire for each additional bag. Taxi drivers get 15 percent and a surcharge of at least 150 lire after 10 P.M. Hotels usually charge service charges, but extra is expected: chambermaid, 150 lire a day or 750 a week; doorman, 100 for calling a cab; luggage porter, 150 at least; breakfast waiter, 100; barbers and beauticians, 15–20 percent. Restaurant and

---

* As of July, 1972; can vary 2¼ percent.

nightclub waiters, 200–300 lire above 15 percent service charge; nightclub maitre d's, 2,000 to 5,000 for a party; hatcheck girl, 50–100; washroom attendant, 100; carpark attendants, 50–100; museum guides, 300; coffee or wine waiters, at least 50 lire unless you are at a stand-up bar, then 10.

## ACCOMMODATIONS

Luxury rates are $14–$22 single, $20–$40 double (bath and service charge, approximately 20 percent); add $10 for two meals. Moderate rates are $8–$17 single, $12–$24 double; add $7–$8 for two meals. Budget rates are $4–$9 single, $7.50–$14 double; add $5 for two meals. Rooms without baths (this occurs in best hotels, too) are cheaper and usually have a wash basin. In the off season, from November to March, they often cut their rates, sometimes as much as 25 percent.

## ARRIVAL, DEPARTURE

Airport bus to Rome is 800 lire ($1.36), to Milan, 900 lire ($1.53). Air departure tax is 1,000 lire ($1.70). Sea arrival taxes go, according to class and range from $10 to $15.

## "IN" THINGS

Opera lovers: San Carlo, Naples; Teatro dell'Opera, Rome; Teatro Massimo, Palermo; La Scala, Milan. In July and August in Rome open-air opera is given in the Baths of Caracalla and concerts in the Basilica of Massenzio, in the Roman Forum. The Spoleto Festival ("Of Two Worlds") is held in June and July.

## GO SEE

In Italy you must definitely buy a good guide book because there is no way to begin to describe "what to see." Practically every city and hamlet has art treasures that cannot be described. There are horse shows, horse racing, night clubs, marvelous restaurants.

## GAMBLING

Venice, San Remo, Saint Vincent, have casinos. Horse and dog pari-mutuel betting is available.

## NIGHT CLUBS

Rome's best clubs are La Cabala, near the Piazza Navona, and the Open Gate, near the Via Veneto. Also around the Via Veneto are Club 84, Capriccio, Il Pipistrello, Old Rome, Waikiki Club, Rupe Tarpea, Jim and Jerry's Luau. For a late drink and guitar music, L'Arciliuto.

## SHOPPING

Specialties are Florentine leather, Borsalino hats, silks, custom-made shirts and blouses, good made-to-measure tailored clothes, religious goods, cameos, handbags and general leather goods, gloves. Perfumes don't really make it. Watch out for phony antiques and paintings. In Rome, at the top of the Spanish Steps and also on the Via Borgognona near the Via Condotti are great boutiques.

## CLOTHES

Wear long-sleeved dresses (men, jackets) in churches and museums in the Vatican. Women can wear pants suits. Rome and Milan are chic so you can do it up.

## LANGUAGE

Remember that Italians use many gestures in addition to their language and get so animated at times that people misinterpret the animation as excitability. If you're intuitive, you can almost "feel" what they are talking about sometimes as they act it out.

| | | |
|---|---|---|
| Mister, Sir | Signore | |
| Mrs., Madam | Signora | |
| Miss | Signorina | |
| Good day, morning | Buon giorno | BWAWN JOHR-noh |
| Good evening | Buona sera | BWAW-nah SAY-rah |
| Good night | Buona notte | BWAW-nah NAWT-tay |
| Good-bye | Arrivederci | ahr-ree-vay-DAYR-chee |
| How are you? | Come sta? | KOH-may STAH? |
| Fine, thanks, and you? | Bene, grazie, e Lei? | BEH-nay, GRAH-tsyay, ay LEH-ee? |
| Please | Per favore | payr fah-VOH-ray |
| Thanks | Grazie | GRAH-tsyay |
| Don't mention it | Prego | PREH-goh |
| Excuse me | Scusi | SKOO-see |
| May I (come in, pass)? | Permesso? | payr-MAYS-soh? |
| Come in | Avanti | ah-VAHN-tee |
| Yes | Si | SEE |
| No | No | NAW |
| May I help you? | In che posso servila? | een KAY PAWS-soh sayr-VEER-lah? |
| I want | Voglio | VAW-lyoh |
| I should like | Vorrei | vohr-REH-ee |
| Give me | Mi dia | mee DEE-ah |
| Bring me | Mi porti | mee PAWR-tee |
| Show me | Mi faccia vedere | me FAH-chah vay-DAY-ray |
| How much? | Quanto? | KWAHN-toh? |
| Too much | Troppo | TRAWP-poh |
| Can you tell me? | Sa dirmi? | SAH DEER-mee? |
| Where is? | Dov'e | doh-VEH? |
| Which way is? | Da che parte si trova? | dah-KAY PAHR-tay see TRAW-vah? |
| Here is | Ecco | EHK-koh |
| This way | Di qua | dee-KWAH |
| That way | Di la | dee-LAH |

| | | |
|---|---|---|
| To the right | A destra | ah DEHS-trah |
| To the left | A sinistra | ah see-NEES-trah |
| Go straight ahead | Vada dritto | VAH-dah DREET-toh |
| Come with me | Venga con me | VEHN-gah kohn MAY |
| Do you speak English? | Parla inglese? | PAHR-lah een-GLAY-say? |
| What time is it? | Che ora è? | KAY O-ra EH? |
| a little | un po' | oon PAW |
| very little | molto poco | MOHL-toh PAW-koh |
| Speak more slowly | Parli piu lentamente | PAHR-lee PYOO layn-tah MAYN-tay |
| Do you understand? | Capisce? | kah-PEE-shay |
| I don't understand | Non capisco | nawn kah-PEES-koh |
| What do you mean? | Cosa vuol dire? | KAW-sah VWAWL DEE-ray |
| What do you call this in Italian? | Come si chiama questo in italiano? | KOH-may see KYAH-mah KWAYS-toh een ee-tah-LYAH-noh? |
| I'm an American | Sono americano (feminine americana) | SOH-noh ah-may-ree-KAY-noh nah |
| I need | Ho bisogno di | AW bee-SAW-nyoh dee |
| the manager | il direttore | eel dee-rayt-TOH-ray |
| a policeman | un agente di polizia | oon ah-JEHN-tay dee poh lee-TSEE-ah |
| a doctor | un medico | oon MEH-dee-koh |
| a porter | un facchino | oon fahk-KEE-noh |
| an interpreter | un interprete | oon een-TEHR-pray-tay |
| the street | la strada | la STRAH-dah |
| the railroad station | la stazione ferroviaria | la stah-zi-ON-ay fer-rov-i-AR-i-a |

| the hospital | l'ospedale | os-pe-DAHL |
| the airport | l'aeroporto | air-o-PORT-o |
| breakfast | prima colazione | PREE-ma col-ATZ-i-o-nay |
| lunch | seconda colazione | se-CUND-a col-ATZ-i-o-nay |
| supper | cena | CHAY-nah |
| water | acqua | AH-qua |
| toilet | gabinetto | ga-bin-ETT-o |
| men | signori | seen-YOR-ee |
| women | signore | seen-YOR-ay |

# BLUFFING YOUR WAY THROUGH SPAIN

## MONEY AND TIPPING

64.47 pesetas = 1 U.S. dollar; * 100 centimos = 1 peseta.
1 peseta = 1.55¢ ($.0155)

The standard tip of 10 pesetas is good for the bellhop who opens your room, the shoeshine boy, hatcheck girl, theatre usher, doorman who calls your cab, parking lot attendants. Luggage porters get 5–10 pesetas per bag. Cab drivers, room-service waiters, barbers, and beauticians get 10 percent of the bill. Tour guides get 25–50 pesetas. Restaurant and bar bills include service charge, but you tip an additional 5 to 10 percent.

## ACCOMMODATIONS

Luxury rates are $10–$20 single, $14–$25 double (without meals). Moderate rates, $4–$14 single, $6–$15 double. Budget rates: $2–$5 single, $4–$8 double for rooms with bath. Service charge, taxes, and so forth are usually included; if not, 15 percent is added. Spain is very inexpensive. There are also government-sponsored

---

* As of July, 1972; can vary 2¼ percent.

hotels (often converted castles) called *paradores* with meals included from $7–$11 per person, daily.

## ARRIVAL, DEPARTURE

Madrid airport (Barajas) is seven miles from the center of the city; Barcelona airport, six miles out. Bus is 15 pesetas (23¢); taxi, 175 pesetas ($2.70) plus tip. International departure tax is 50 pesetas (79¢).

## EVENTS AND "IN" THINGS

| | |
|---|---|
| March | "Fallas" of Saint Joseph, with street dancing and major bullfights in Valencia. |
| April | The Seville Fair (most important in Spain); major bullfights on Easter Sunday. |
| May | Feast of Saint Isidro (patron saint of Madrid) with much bullfighting. |
| July | Commencing July 7: the Running of the Bulls in honor of Saint Fermin—wild and wooly. |
| August | Malaga Festival with some of the best bullfights in Spain; Festival in honor of Saint Lawrence, Madrid; Festival of the Assumption, San Sebastian—bullfighting, folklore festivals, yacht racing; Fiesta of Saint Michael at Seville. |
| September | Wine festivals in Jerez de la Frontera, the birthplace of sherry wine. |

## ART LOVERS

| | |
|---|---|
| Madrid | Prado National Museum, the Royal Palace, Lazaro Galdiano Museum, Cerralbo Museum, Museum of Modern Art, Decorative Arts Museum. |
| Barcelona | Berenguer de Aguilar Palace Museum (Picasso recently donated eight hundred of his early works), Museum of Catalan Art. |

## CLUB LOVERS

Madrid    Real Club, Puerta de Hierro, Club de Campo, Real Automobile Club.

Barcelona    Polo Club, Real Club de Golf el Prat, Real Club Nautico, Real Club de Tenis.

## NIGHT CLUBS

Madrid    Castellana Hilton Rendez Vous Room in winter, the Patio in summer; Balmoral, Los Robles, Pepe's, Bourbon Street (good jazz), Stones, Piccadilly, Royal Bus, J.J. Club, King's. For flamenco (usually 11:00 P.M. to 4:00 A.M.): La Zambra, Corral de la Moreria, Las Brujas, Los Canasteros, Club Flamenco Villa Roas, El Duende. Dancing and floor shows: Pasapoga, Micheleta, Lido, Pavillon, Florida.

Barcelona    La Masia, Emporium, Rio. Flamenco: Los Tarantos. Inexpensive: Las Vegas, Mario's, Bocaccio, Le Clochard, Lord Black.

## GAMBLING

No casinos for gambling. Much action at soccer and jai alai games. There are horse races.

## SHOPPING

Shops open at 9:00 A.M. and usually close at 1:30, reopen again at 4:00 (4:30 in summer), and close about 7:30 P.M. They are closed on local festival days.

## GO SEE

Madrid, Toledo, Barcelona, Costa Brava (Spanish Riviera), Valencia, Malaga, Costa del Sol, Seville, Granada, San Sebastian (summer resort).

## LANGUAGE

Spanish is quite phonetic and you should be able to cope with it easily. The differences in dialects among Spaniards, Mexicans, South Americans, Cubans (you never know), are less varied than, say, among Italians, north and south. Also, the people who speak Spanish don't care if you mangle the language a little if you manage to get through. The highest form is Castilian, but even Castilians generally don't mind if you try. Their "s's" are pronounced as "th's" so you're really in shape if you lisp. Nineteen sovereign nations have Spanish as their official language.

Here is a smattering that will keep you from starving:

| | | |
|---|---|---|
| Mister, Sir | Senor | Seh-NYOHR |
| Mrs., Madam | Senora | Seh-NYOH-rah |
| Miss, Young lady | Senorita | Seh-NYOH-REE-tah |

There are two ways of saying "you":

| | | |
|---|---|---|
| | Usted | oos-TEHD |
| | Ustedes (Plural) | oos-TEH-dehs |
| I | Yo | YO |
| He | El | EL |
| She | Elle | EL-yah |
| We | Nosotros | No-SO-trohs |

"Please" is tricky, because you're really saying "Do me the favor of."

| | | |
|---|---|---|
| Please give me | Hagame usted el favor de darme | AH-gah-meh oos-TEHD ehl fah-VOHR deh DAHR-me |
| Please tell me | Tenga usted la bondad de decirme | TEHN-gah oos-TEHD lah bohn-DAHD deh deh-THEER-meh |
| Thank you | Gracias | GRAH-thyahs |
| Don't mention it | De nada | de-NAH-dah |
| I'm sorry | Lo siento | Loh SYEHN-toh |
| Excuse me | Dispense usted | dees-PEHN-seh oos-TEHD |

| It doesn't matter | No importa | noh eem-POHR-tah |
| yes | si | SEE |
| No | no | NOH |
| With pleasure | Con mucho gusto | Kohn MOO-choh GOOS-toh |
| May I introduce my friend? | Permite que le presente a mi amigo? | Pehr-MEE-teh keh leh preh-SEHN-teh ah mee ah-MEE-goh? |
| Pleased to meet you | Muchisimo gusto | moo-CHEE-see-moh GOOS-toh |
| What do you want? | Que quiere usted? | KEH KYEH-reh oos-TEHD? |
| What do you wish? | Que desea usted? | KEH deh-SEH-ah oos-TEHD? |
| I wish | Yo quiero | YOH KYEH-roh |
| I want | Yo deseo | YOH deh-SEH-oh |
| Give me | Deme usted | DEH-meh oos-TEHD |
| Bring me | Traigame usted | TRAHY-gah-meh oos-TEHD |
| Please bring me | Haga usted el favor de traerme | AH-gah oos-TEHD ehl fah-VOHR deh trah-EHR-meh |
| breakfast | desayuno | deh-sah-YOU-noh |
| lunch | almuerzo | ahl-MWEHR-thoh |
| dinner | comida | koh-MEE-dah |
| a piece | un pedazo | oon peh-DAH-thoh |
| a slice | una tajada | OO-nah tah-HAH-dah |
| a pack (package) | un paquete | oon pah-KEH-teh |
| a box | una caja | OO-nah KAH-hah |
| a bottle | una botella | OO-nah boh-TEH-lyah |
| a glass | un vaso | oon BAH-soh |
| a cup | una taza | OO-nah TAH-thah |
| bread | pan | PAHN |
| soap | jabon | hah-VOHN |
| cigarettes | cigarrillos | thee-gahr-REE-lyohs |
| milk | leche | LEH-cheh |
| beer | cerveza | thehr-BEH-thah |

| water | agua | AH-gwah |
|---|---|---|
| tea | te | TEH |
| coffee | cafe | kah-FEH |
| wine | vino | BEE-noh |
| white wine | blanco | BLAHN-koh |
| red wine | tinto | TEEN-toh |
| waiter | mozo | MO-zoh |
| Show me | Muestreme | MWEHS-treh-meh |
| How much? | Cuanto? | KWAN-toh? |
| It's too much | Es demasiado | EHS deh-mah-SYAH-doh |
| anything else? | algo mas? | AHL-goh MAHS? |
| nothing else | nada mas | NAH-dah MAHS |
| That's enough | Es bastante | EHS bas-TAHN-teh |
| Can you tell me? | Puede usted decirme? | PWEH-deh oos-TEHD deh-THEER-meh? |
| Where is? | Donde esta? | DOHN-deh ehs-TAH? |
| Which way? | Por donde? | POHR DOHN-deh? |
| Here is | Aqui esta | ah-KEE ehs-TAH |
| this way | por aqui | POHR ah-KEE |
| that way | por alla | POHR ah-LYAH |
| to the right/left | A la derecha/ izquierda | AH lah deh-REH-chah/ith-KYEHR-dah |
| Come with me | Venga conmigo | BEHN-gah kohn-MEE-goh |
| the station | la estacion | lah ehs-tah-THYOHN |
| the airport | el aeropuerto | ehl ah-eh-roh-PWEHR-toh |
| the hospital | el hospital | ehl oss-pee-tahl |
| the museum | el museo | ehl moo-SEH-oh |
| the city | la ciudad | lah thyoo-DAHD |
| the street | la calle | lah KAH-lyeh |
| the store | la tienda | lah TYEHN-dah |
| the drugstore | la farmacia | lah fahr-MAH-thyah |
| the postoffice | el correo | ehl kohr-REH-oh |
| the dining room | el comedor | ehl koh-meh-DOHR |

| the telephone | el telefono | ehl teh-LEH-foh-noh |
| the bathroom | el cuarto de bano | ehl KWAR-toh deh BAH-nyoh |
| the lavatory | el retrete | ehl reh-TREH-teh |
| men | senores, hombres | seh-NYOH-rehs, OHM-brehs |
| women | senoras, mujeres | seh-NYOH-rahs, moo-HEH-rehs |
| Do you speak? | Habla usted? | AH-vlah oos-TEHD? |
| English | Ingles | een-GLEHS |
| a little | un poco | oon POH-KOH |
| Speak more slowly | Hable usted mas despacio | AH-vleh oos-TEHD MAHS dehs-PAH-thyoh |
| Do you understand? | Entiende usted? | ehn-TYEHN-deh oos-TEHD? |
| What do you call this in Spanish? | Como se llama esto en Espanol? | KOH-moh seh LYAH-mah EHS-toh ehn ehs-pah-NYOHL? |
| How do you say? | Come se dice? | KOH-moh seh DEE-theh? |
| I am an American | Soy norteameri-cano | soy NOHR-teh-ah-meh-ree-KAH-noh |
| | Soy norteameri-cana | (nah is feminine) |
| the maid | la criada | lah kree-AH-dah |
| a doctor | un medico | oon MEH-dee-koh |
| an interpreter | un interprete | oon een-TEHR-preh-teh |
| a porter | un mozo | oon MOH-thoh |
| the manager | el director | el dee-REK-tohr |
| What time is it? | Qué hora es? | keh OH-rah EHS? |

# BLUFFING YOUR WAY
# THROUGH WEST GERMANY

## MONEY AND TIPPING

3.22 deutsche marks = 1 U.S. dollar; * 100 pfennigs = 1 mark.
1 mark = 31.03¢ ($.3103)

Practically all hotel bills include a "M.W." or value-added tax and a service charge of 10 to 15 percent that covers everything except the porter who carries your bag (50 pfennigs per bag) and the chambermaid (1 DM per night or 5 per week). Doormen who hail taxis get 50 pfennigs. Restaurants and night clubs add a service charge of 10 percent, but you should give another 5 to 10 percent for good service. Barbers, beauticians, and taxi drivers, 10 percent. Railway station porters get 80 pfennigs for the first bag, 50 for each additional, and a tip (since it's a fixed rate) of 50 pfennigs.

## ACCOMMODATIONS

De luxe, about $17–$28 single, $28–$55 double. Luxury, $14–$24 single, $25–$35 double. Moderate, $8–$16 single, $18–$30 double. Budget, $5–$9 single, $10–$15 double. These rates include service charges and taxes and are for rooms with private baths. You might as well have Continental breakfast as it costs 3.00 to 5.00 DM if you have it and 1 or 2 if you don't. There are also many castles and baronial manors, usually furnished with beautiful antiques and equipped with decent plumbing and heating, that go for about $20–$40 a double, meals included.

## ARRIVAL, DEPARTURE

All airport buses going into German cities are DM 2.00–3.50 (from 65¢ to $1.10). Berlin's Tempelhof Airport is right inside the

---

* As of July, 1972; can vary 2¼ percent.

city. If you prefer a taxi it will cost about $2.00 plus 10 percent tip. Hotel porters get 50 pfennigs per bag. Phone Pan Am regarding airport buses.

## EVENTS AND "IN" THINGS

| | |
|---|---|
| January | International ski events at Garmisch-Partenkirchen. In Munich, Mainz, and Cologne (plus other cities throughout the country; you should check on this) there is a hectic "carnival time." |
| April | Walpurgisnacht festivals in the Harz Mountains. |
| May | International May Festival of opera, ballet, and concerts in Wiesbaden; in Bonn, annual Beethoven Festival; Munich Ballet Festival. |
| June | In Cologne, the Lower Rhine Music Festival. |
| July | Music festivals in: Bayreuth, Munich, Stuttgart, Würzburg, Coblenz. |
| September | Berlin Festival: three weeks of international drama, opera, and symphony. |
| October | Marvelous Oktoberfest in Munich; Cannstatt Folk Festival in Stuttgart. |
| December | Kris Kringle Marts, special outdoor toy fairs all over Germany, especially in Nuremberg; winter sports season begins. |

## ART LOVERS

Practically every city throughout the country has art galleries and museums.

## MUSIC LOVERS

Every major city has a philharmonic orchestra; sixty-three have permanent opera companies and ballet.

## GAMBLING

There are many licensed casinos in resort towns.

## CLIMATE

January is rough, the rest of the winter, mild. Spring is long and summer is very nice, stretching into Indian summer almost until November.

## GO SEE

Frankfort, Wiesbaden, Berlin, Munich, Nuremberg, Hamburg, the Harz Mountains, Düsseldorf, Worms (the city of the Nibelungs), Bonn, Stuttgart, the Black Forest, the Bavarian Alps, the Weser Mountains, the Rhine.

There is a wealth of sports, theatre, music, nightclubs, in practically every major city.

## SHOPPING

You can find all photographic equipment and optical goods, china, ceramics, wood carvings, cuckoo clocks, toys (some of the best in the world), watches, jewelry.

## DRESS

Dress pretty much the same way you would in a major United States city. Do *not* wear sports clothes to theatre.

## TRANSPORTATION

Trains are excellent (some with dancing and movies). Some boats carry automobiles aboard.

## LANGUAGE

The most widely spoken language in Europe is German, not French or any of the so-called "romance" languages. Besides West/ East Germany, Austria, and three quarters of Switzerland, there are many neighboring countries where German is a second language because of ancestral ties: Holland, Denmark, Sweden, Poland, Czechoslovakia, Hungary, Yugoslavia, northern Italy, eastern France. Even Yiddish has medieval German (though interspersed with Hebrew, Slavic, and other languages) as its base.

The following are some phrases, words, and expressions useful to the bluffer:

| | | |
|---|---|---|
| Good morning | Guten Morgen | GOOT-uhn MOR-guhn |
| Good day | Guten Tag | GOOT-uhn TAHK |
| Good evening | Guten Abend | GOOT-uhn AH-buhnt |
| Good night | Gute Nacht | GOOT-uh NAKHT |
| Good-by | Auf wiedersehen | OWF VEE-duhr-zayn |
| Hello | | |
| How are you? | Wie geht's? | VEE GAYTS? |
| How goes it? | | |
| Fine, thanks—and you? | Danke, gut, und Ihnen? | DAN-kuh, GOOT, unt EEN-uhn? |
| Please | Bitte | BIT-tuh |
| Thanks | Danke | DAN-kuh |
| Excuse me | Verzeihen Sie | fer-TSI-uhn ZEE |
| I'm sorry | Es tut mir leid | ES TOOT MEER LITE |
| It doesn't matter | Es macht nichts aus | ES MAKHT NICTS OWS |
| Show me | Zeigen sie mir | TSI-guhn ZEE MEER |
| Tell me | Sagen Sie mir | ZAH-guhn ZEE MEER |
| How much? | Wie viel? | VEE FEEL? |
| Too much | Zu viel | TSOO FEEL |
| Sir | mein Herr | MINE HARE |
| Miss | Fraulein | FROI-line |

| | | |
|---|---|---|
| Madam | Frau | FROW |
| Cigarettes | Zigaretten | tsi-ga-RET-tuhn |
| Cigars | Zigaren | tsi-GAR-ruhn |
| Matches | Streichholzer | SHTRIEK-HOL-tsuhr |
| Please give me (I want) | Geben Sie mir bitte | GAY-buhn ZEE MEER BIT-tuh |
| Breakfast | das Frühstück | Das FREE-sthuck |
| Lunch | das Mittagessen | Das MIT-tag-ES-suhn |
| Dinner | das Hauptmahlzeit | Das HOWPT-mal-tsite |
| Water | das Wasser | Das VASS-er |
| Bread | Brot | BROT |
| A bottle of wine | eine Flasche Wein | I-nuh FLAH-shuh VINE |
| A cup of coffee | eine Tasse Kaffee | I-nuh TAS-suh ka-FAY |
| Where is? | Wo ist? | VOH IST? |
| Where are? | Wo sind? | VOH ZINT? |
| Here is/are | Hier ist/sind | HEER IST/ZINT |
| There is/are | Da ist/sind | DAH IST/ZINT |
| Where are you/we going? | Wohin gehen sie/wir? | VOH-hin GAY-uhn ZEE/VEER? |
| In which direction? | In welcher Richtung? | IN VEL-cuhr RIC-tung? |
| In this/that direction | In dieser/jener Richtung | IN DEE-zuhr/YAY-nuhr RIC-tung |
| To the right/left | Nach rechts/links | NAKH RECTS/LINKS |
| The street | die Strasse | dee STRAS-se |
| Come | Kommen Sie | KOM-muhn ZEE |
| The church | die Kirche | Dee KEER-cuh |
| The cathedral | die Dom | Dee DOHM |
| The hotel | das Hotel | Das hoh-TEL |
| The bridge | die Brücke | Dee BRIK-kuh |
| The post office | das Postamt | Das POST-amt |
| The railroad station | der Bahnhof | Dayr BAHN-hohf |
| The toilet | die Toilette | Dee to-a-LET-tuh |
| Attention | Achtung | AKH-tung |

| | | |
|---|---|---|
| Notice | Bekanntmachung | be-KANT-MAKH-ung |
| Keep out | Eintritt verboten | EYN-TRIT fer-BOH-tuhn |
| Keep right/left | Rechts/links fahren | RECTS/LINKS FAHR-uhn |
| Entrance/exit | Eingang/Ausgang | EYN-gahng/OWS-gahng |
| Men | Herren | HARE-uhn |
| Women | Frauen | FROW-uhn |
| What time is it? | Wie spät ist es? | Vee SPAYT ist es? |
| I need: | Ich brauche | IC BROW-khuh |
| a doctor | einen Arzt | I-nuhn ARTST |
| a policeman | einen Schutzmann | I-nuhn SHOOTS-man |
| a porter | einen Gepackträger | I-nuhn guh-PEK-TRAY-guhr |
| a taxi | einen Taxi | I-nuhn TAK-si |
| an interpreter | einen Dolmetscher | I-nuhn DOL-met-shuhr |
| the manager | der Leiter | dayr LIE-ter |
| I should like: | ich mochte gern | IC MOC-tuh GERN |
| to buy | kaufen | KOWF-uhn |
| to sell | verkaufen | fer-KOWF-uhn |
| to visit | besuchen | be-ZOOKH-uhn |
| to ask | fragen | FRAH-guhn |
| to answer | antworten | AHNT-vor-tuhn |
| to pay for | bezahlen | be-TSAH-luhn |
| to rent | mieten | MEE-tuhn |
| to eat | essen | ES-suhn |
| to drink | trinken | TRINK-uhn |
| to wash (myself) | mich waschen | MIC VASH-uhn |
| to wash my hands | mich die Hande waschen | MIC DEE HEN-duh VASH-uhn |
| to go away | fortgehen | FORT-gay-uhn |
| to stay | bleiben | BLI-buhn |
| to arrive | ankommen | AN-kom-muhn |
| to wait | warten | VAR-tuhn |
| to make, do | machen | MA-khuhn |
| to take | nehmen | NAY-muhn |
| to write | schreiben | SHRI-buhn |

Don't be afraid to say, "Ich brauch einen Dolmetscher," or at least "Ich bin Amerikaner (or Amerikanerin for "woman")," which means "I'm an American." A charming shrug along with it at least will convey that you didn't mean to go into the ladies' room. If you did, you're on your own.

# BLUFFING YOUR WAY THROUGH ISRAEL

## MONEY AND TIPPING

1 Israeli pound = $.24; * 100 agorot = 1 pound
1 agora = .24¢ ($.0024)

Tipping doesn't occur as much as in the United States. Taxi drivers are not tipped. Barbers, beauticians, employees in better hotels, are usually tipped 10 to 15 percent. Most hotels and restaurants include a 15 percent surcharge, 25 percent in nightclubs.

## ACCOMMODATIONS

Luxury hotels are $16–$22 single, $28–$35 double; moderate, $9–$16 single, $14–$24 double; better budget hotels, $6–$10 single, $10–$15 double. Most include breakfast. Rooms in kibbutz guest houses are $6–$8.50, including all meals.

## ARRIVAL, DEPARTURE

From Lod Airport, Tel Aviv is 8 miles. Taxi is I£. 15 ($3.60), bus 1.10 (27¢). To Jerusalem (35 miles) by taxi: I£. 35 ($8.40) and I£. 2.20 by bus (53¢). You do not tip taxi drivers. Luggage porters get 50 agorot (12¢) a bag. There is an air departure tax of I£. 10.50 ($2.52).

Israel is 270 miles long and about 70 miles at its widest (latest borders). There are four climates: to the north is Galilee, with hills

---

* As of July, 1972; can vary 2¼ percent.

and fertile soil, a temperate climate with plentiful rainfall. The south is desert, the Negev, with hot days and cold evenings. The coastal plains, where the resorts and cities are found, have weather like that of southern California. The east is the Jordan valley, which is almost tropical. There is a mountain range that curves through the center from Lebanon, on the north, to Sinai. There are valleys in these mountains and in these valleys are the kibbutzim.

The best times to visit are from March to May and from October to November. The climate is nicest and the traditional holidays occur then. Though the temperature gets colder in the winter, it never gets "cold" in the United States sense.

Since it is a small country, getting around is not difficult. In addition to taxis and buses there is an innovation called the "sherut," a taxi that follows bus routes, picking up and discharging passengers at the stops and charging by the seat. Trains are efficient and inexpensive. You can get from Tel Aviv to Haifa for less than a dollar. If you rent a car, watch out for bicyclists at night because they often run around without lights. Also, make sure your brakes are very good.

The food is not exceptional, even at the big hotels (except for staple traditional Jewish cooking; chicken soup cures every disease known to mankind, and if you "have a fruit" you'll abound in Vitamin C). Oriental cooking is very interesting; specialties are lamb, peeta, felafel, taheena.

## SHOPPING

You can revel in Persian and Yemenite filigree work, carpets, embroidery, metalwork, ceramics, religious articles, ladies' and men's made-to-measure suits, knitwear, fashion goods (reduced 15 percent for traveler's checks). Shopping breaks down into two categories: the stores where you don't bargain, and the smaller shops and markets where you do. Israeli sizes correspond to those in Europe.

## GO SEE

New Jerusalem (or West Jerusalem) includes a new Israel Museum, the Hadassah Medical Center with the Chagall windows in the chapel, the Knesset (Israel's Parliament), the Mea Shearim quarter, where the most orthodox Jews live.

Tel Aviv is the commercial, social, and cultural center. It is not the place to seek history. There are sea-front cafés, beaches, shops, theatres, concert halls, museums.

Spend at least a day in Haifa. The view, day or night, from Mount Carmel, high above the harbor of this major Mediterranean port, is breathlessly lovely. You can reach the mountain top in the usual ways or by taking the level-seat funicular that travels up and down inside, not outside, the mountain. Halfway up Mount Carmel gleams the magnificent gold dome of the Bahai Temple. Visit it and its Persian gardens. Haifa has many galleries, craft shops, winding alleyways, nightclubs, cafés, and the like. There is an old-fashioned flea market where you can try out your bargaining prowess with experts.

The ancient city of Beersheba is south of Jerusalem, in the Negev. A highway from Jerusalem takes you to the Dead Sea, which is the lowest point on the earth's surface, and to the biblical city of Sodom.

Bear in mind that the Sabbath is observed throughout Israel. It begins at sunset on Friday and ends at sunset on Saturday. All government offices, shops, places of entertainment, and so forth, are closed. Only a few restaurants remain open. Public transportation ceases, although the sheruts operate. You can drive your own car but you shouldn't drive through the orthodox parts of town. Also, buy your gasoline before the Sabbath or you'll walk. After sunset on Saturday everything starts up again.

## LANGUAGE

(H with a dot under it is pronounced like CH as in Bach)

| | |
|---|---|
| Sir, Mr. | ah-DOHN, MAHR |
| Mrs., Madam; Miss | mah-RAHT; g'VEH-ret |
| I, I am | ah-NEE |
| You, you are | ah-TA (masc.), aht (fem.) |
| He, he is | hoo |
| She, she is | hee |
| We, we are | ah-NAH-noo |
| You, you are | ah-TEM (m. pl.), ah-TEN (f. pl.) |
| They, they are | haym (m. pl.), hayn (f. pl.) |
| Hello, goodbye | sha-LOM |

| | |
|---|---|
| Please | b'vah-kah-SHAH |
| No | loh |
| Yes | kayn |
| Perhaps | oo-LIE |
| Thank you | toh-DAH |
| You're welcome | AYN dah-VAR |
| Good morning | BO-ker tov |
| Good night | LIE-la tov |
| Pleased to meet you | nah-EEM muh-OHD |
| How are you? | ma shlom-ḤA (m.) |
| | ma shlo-MAYḤ (f.) |
| Fine, thank you | b'-SAY-der |
| How much is it? | KAH-mah zeh o-LEH |
| I do not speak Hebrew | ah-NEE loh m'da-BEH-ret iv-REET (f.) |
| | ah-NEE loh m'da-BER iv-REET (m.) |
| Do you speak English? | ḥa-EEM ah-TAH m'dah-BAYR ahn-GLEET (m.) |
| | ḥa-EEM AHT m'dah-BEH-ret ahn-GLEET (f.) |
| I am an American | ah-NEE ah-meh-ree-KAH-nee |
| Say it slowly please | da-BAYR-na le-ATT |
| I am a tourist | ah-NEE ta-YAHR (m.) |
| | ah-NEE ta-YEHR-et (f.) |
| To the right | yeh-MEEN-ah |
| To the left | SMO-lah |
| Straight ahead | yah-SHAR |
| This way | DEH-rech ha-ZEH |
| That way | DEH-rech ha-HOO |
| Where is the bar? | eh-FOH ha-BAR |
| What is the bill? | ma ha-ḥesh-BON |
| Breakfast | ah-roo ḤAHT BO-ker |
| Lunch | ah-roo ḤAHT tso-ho-RAH-yeem |
| Dinner | ah-roo ḤAHT EH-rev |
| Where is there a good restaurant? | eh-FOH yesh mees-ah-DA toh-VAH |
| Water | MAH-yeem |
| Tea | tay |
| Coffee | kah-FAY |
| Sugar | soo-KAR |
| Milk | ḥa-LAHV |

| Bread | LEH-ḥem |
| Butter | ḥem-AH |
| Salt | MEH-lah |
| Pepper | pil-PEL |
| Knife | sah-KEEN |
| Fork | maz-LEG |
| Spoon | kahf |
| Plate | tsa-LA-ḥat |
| Cup | SEH-fel |
| Glass | koss |
| The airport | sdeh ha-te-oo-FAH |
| The railway station | ta-ḥa-NATT ha-rah-KEH-vet |
| Train | rah-KEH-vet |
| Taxi | mo-NEET |
| Please call a taxi | na le-haz-MEEN mo-NEET |
| How much does the trip cost? | KAH-ma o-LAH ha-ne-see-AH |
| How far is it? | ma ha-mer-ḤAK |
| How long will it take? | KAH-ma zmahn zeh yee-KAḤ |
| An interpreter | meh-toor-geh-MAHN |
| A porter | sah-BAHL |
| The manager | ha-ROSH |
| A policeman | shoh-TAYR |
| The bathroom | bayt-ha-shim-MOOSH |
| Men | ah-nah-SHEEM, geh-veer-EEM |
| Women | nah-SHEEM |
| I need a doctor | ah-NEE tso-RAYḤ et ro-FEH |
| au revoir, see you again | leh-hit-rah-OHT |
| The bill, account | ha-ḥesh-BON |

# BLUFFING YOUR WAY THROUGH FRANCE

## MONEY AND TIPPING

5.11 francs = 1 U.S. dollar; * 100 centimes = 1 franc
1 franc = 19.54¢ ($.1954)

---

\* As of July, 1972; can vary 2¼ percent.

A one-franc tip is about the same thing as a quarter tip in the United States.

Hotels charge a 12 to 15 percent service charge plus a 10 percent tax. Baggage porters get one franc per bag; room service, 50 centimes a trip; chambermaids, 25 centimes a day; doormen, 50 centimes to a franc for getting you a taxi; concierge, about two francs daily if you've used him (which you should); waiters, a little extra (depending on service) beyond the *included* 15 percent (*service compris*) added to check. If you consult or order through the *sommelier* (wine expert), give him one to two francs; checkroom and washroom attendants, 40 or 50 centimes; theatre and cinema house ushers, 50 centimes; barbers and beauticians, 15 percent (check to see if included in the bill); tour guides, one franc for a short tour (unless they save you from falling off a mountain); cab drivers, approximately 15 percent of the meter (if it's a little jaunt, at least 50 centimes).

## ACCOMMODATIONS

De luxe hotels range from $25–$50 single, $35–$70 double. Luxury hotels, $20–$35 single, $25–$50 double. Moderate, $14–$25 single, $18–$35 double rooms with bath. Good budget hotels, $7–$15 single, $8–$20 double for rooms with bath. A lot of hotels include Continental breakfast; ask about this. Some resort hotels (beaches and mountains) offer only American plan rates (all meals included). The "season" is from Easter until late October; in between, prices sometimes dip.

## ARRIVAL, DEPARTURE

From Orly Airport to Paris (11 miles), taxi is about 20F ($3.85 plus a 15-percent tip); bus is 5F ($1.00). There is a "departure tax": 5F to other points in France, 10F to European or North African points, 15F elsewhere.

Arriving ship passengers are taxed $3.50 tourist, $6.50 second class, $10 first class.

## EVENTS AND "IN" THINGS

January        International winter games, Chamonix.

February    Parisian *haute couture* showings; Mardi Gras Carnival in Nice (date depends on beginning of Lent).

March       International ski fortnight, Courchevel.

April       International Jazz Festival in Paris; bullfights in Roman arena, Arles; horse show, International Steeplechase, Nice; International Film Festival in Cannes (sometimes held in May).

May         Fair of the Gypsies, held at Saintes-Maries-de-la-Mer (one of Europe's most colorful festivals).

June        Grand Prix auto races, Le Mans; Music Festival, Strasbourg.

July        Bastille Day, fireworks, dancing in the streets; Pablo Casals Music Festival, Saint-Michel-de-Cuxa.

August      Annual International Music Festival, Besançon (sometimes held in September).

October     International Auto Show, Paris (most important in Europe).

November    "Les Trois Glorieuses," three days of celebrating in honor of Burgundy wine, processions, meeting of the Knights of Tastevin, wine auction, and so forth.

December    Opera season opens at Municipal Casino, Nice.

## ART LOVERS

In Paris: the Louvre (Venus de Milo, Mona Lisa, Winged Victory); the Musée d'Art Moderne, Rodin Museum, the Jeu de Paume (impressionist painters), Orangerie, Palais de Chaillot, Musée de L'Armée. (Museums are closed Tuesdays).

## CLUB LOVERS

In Paris: Jockey Club (tough to get into), International Club, Racing Club de France, Touring Club. In Nice and Marseilles: Propeller Club. Try bluffing your way in—this is a good name for bluffers to drop.

## NIGHT CLUBS (PARIS)

Maxim's, La Mendigotte, Tsarevitch, Chez Castel, L'Olympe, Novy, Le New Jimmy's, Danka. These are rough to get into if you look like a tourist.

Lido, Bal du Moulin Rouge, Alcazar, Chez ma Cousine, La Nouvelle Eve, La Grande Eugene, Chez Michou. In these spots you can look like a tourist. All they want is your money.

Crazy Horse Saloon, Pussy Cat, Poppy, La Villa, Moulin à Poivre, Lucky Strip, Crescendo, Le Sexy. If you haven't guessed by now, these clubs are "sexy."

L'Impériale, Elysées-Matignon, La Calavados, Whiskey à Gogo, Sabot de Bernard, Rotisserie de l'Abbaye, Club de l'Étoile, Elysées-Tavern, D'Artagnan Club, La Grignotière, Via Veneto (younger set favorite), École Buissonnière. These are more or less "supper clubs."

## AFTER HOURS IN PARIS

The Halles (the market) is now on the outskirts of the city. The bistros are still going: Pied de Cochon, Le Chien qui Fume, Pharamond. Try onion soup.

Also try: Cloche d'Or, Bar du Vefour, Le Cintra, Harry's Bar, Jour et Nuit, Le Drugstore, London Tavern, Le Grand Pub.

## GAMBLING

You can find horse racing at Auteuil, Chantilly, Longchamp, Saint-Cloud, Vincennes (all around Paris). The nearest casino is Enghien (ten miles). In Deauville and, of course, the Riviera, the casinos are more abundant and world famous.

## BEST BUYS

Clothes, yes. Shoes, no. Hats, yes. Lingerie, blouses, gloves, lace, china, Lalique glass, Daum crystal, cognac and champagne, perfumes, handbags, umbrellas, costume jewelry, leather goods, all cheaper than in the United States.

## GO SEE

Paris, Versailles, the Chateau country, the Pyrenees (Basque region), the French Alps, the Riviera, Normandy, and Brittany.

## LANGUAGE

The following are a few bluffer's phrases and words. The apostrophe in a phonetic pronunciation alerts you to the French nasal "n." Don't pay any attention to the sour faces you'll collect. The French think anyone who doesn't speak French is a barbarian. If you're timid, don't show it.

| | | |
|---|---|---|
| Good morning | Bonjour | bon'-JHOOR |
| Good day | " | |
| Good afternoon | " | |
| Good evening | Bonsoir | bon'-SWAHR |
| Good night | Bonne nuit | bohn NWEE |
| Good-by | Au revoir | oh-ruh-VWAHR |
| How do you do? | Comment vous portez-vous? | kom-MAHN' voo-por-TAY-VOO? |
| How are you? | Comment allez-vous? | kom-MAHN' TA-lay-VOO? |
| Well, thanks, and you? | Bien, merci, et vous-même? | bee-AN', MEHR-see, ay voo-MEHM? |
| Sir, Mr. | Monsieur | muh-SYUHR |
| Madam, Mrs. | Madame | ma-DAM |
| Miss, young lady | Mademoiselle | mad-mwah-ZEHL |
| Please | S'il vous plait | seel voo PLEH |
| Thanks | Merci | MEHR-see |
| Don't mention it | Il n'y a pas de quoi | eel nya PAH duh KWAH |
| Excuse me | Pardon | PAR-DOHN' |
| Yes | Oui | WEE |
| No | Non | NOHN' |
| Gladly | Avec plaisir | a-VEHK pleh-ZEER |
| May I introduce my friend? | Permettez-moi de vous presenter mon ami | pehr-MEH-tay-MWAH duh voo pray-ZAHN'-tay mohn a-MEE |

| | | |
|---|---|---|
| Pleased to meet you | Enchanté | ahn'-shahn'-TAY |
| What do you want/wish | Que voulez-vous | kuh VOO-lay-VOO |
| | Que désirez-vous | kuh day-ZEE-ray-VOO |
| I wish | Je désire | jhuh day-ZEER |
| I should like | Je voudrais | jhuh voo-DREH |
| Give me | Donnez-moi | duh-NAY-MWAH |
| Bring me ("Give me" and "bring me" should be accompanied by s'il vous plait.) | Apportez-moi | a-por-tay-MWAH |
| I should like a pack of cigarettes | Je voudrais un paquet de cigarettes | Jhuh voo-DREH uhn' pa-KEH duh see-ga-REHT |
| Will you bring me a pitcher of table wine? | Voulez-vous m'apporter une carafe de vin ordinaire? | VOO-lay-VOO ma-POR-tay oon ka-RAF duh VAN' awr-dee-NEHR? |
| How much? | Combien? | kom bee-AN'? |
| Too much | C'est trop! | seh TROH |
| Anything else? | Encore quelque chose? | ahn'-KAWR kehl-kuh SHOHZ? |
| That's all | C'est tout | say-TOO |
| Will you tell me? | Voulez-vous me dire? | VOO-lay-VOO muh DEER? |
| Where is? | Où est? | OO EH |
| Where are? | Où sont? | OO SON'? |
| Where are we going? | Oú est-ce que nous allons? | OO EHS kuh noo-za-LOHN'? |
| Which way? | De quel coté? | duh KEHL koh-TAY? |
| this way/that way | par ici/par là | par EE-see/par LAH |
| to the right | à droite | ah DWAT |
| to the left | à gauche | ah GOHSH |
| Come with me | Accompagnez-moi | a-kom-pa-NYAY-MWAH |
| Do you speak | Parlez-vous | PAR-lay-VOOZ |

|  |  |  |
|---|---|---|
| English? | anglais? | ahn'-GLAY? |
| A little | Un peu | uhn' PUH |
| Speak more slowly | Parlez plus lentement | PAR-lay PLEW lahnt-MAHN' |
| Do you understand? | Comprenez-vous? | kom-pruh-NAY-VOO? |
| I don't understand | Je ne comprends pas | jhuh nuh kom-PRAHN' PAH |
| What do you mean? | Que voulez-vous dire? | KUH VOO-lay-VOO DEER? |
| What do you call this in French? | Comment s'appelle ceci en français? | kom-MOHN' sa-PEHL suh-SEE ahn' frahn'-SAY |
| I am an American | je suis américain | jhuh-SWEE za-may-ree-KAN' |
| I am (feminine) | " "  " | za-may-ree-KEHN |
| I need a doctor | J'ai besoin d'un medicin | JHEH buh-SWAN dun mayd-SAN' |
| I am | Je suis | jhuh SWEE |
| You are | Vous êtes | voo-ZEHT |
| He is | Il est | ee-LEH |
| She is | Elle est | eh-LEH |
| We are | Nous sommes | noo SAWM |
| They are | Ils sont | eel SOHN' |
| You have | Vous avez | voo-za-VAY |
| I have | J'ai | JHEH |
| He has | Il a | ee-LA |
| She has | Elle a | eh-LA |
| They have | Ils ont | eel-ZOHN' |
| " feminine | Elles ont | ehl-ZOHN' |
| The manager | Le directeur | le dee-REC-terr |
| A porter | Un porteur | un POR-terr |
| An interpreter | Un interprète | un an'-tehr-PRET |
| The railroad station | La gare | la GAHR |
| The hospital | L'hôpital | low-pee-TAHL |
| The airport | L'aéroport | lah-AIR-o-por |
| The street | La rue | la rhew |
| Breakfast | Le petit déjeuner | le p-TEE DAY-jhe-nay |
| Lunch | Le déjeuner | le DAY-jhe-nay |

| Supper | Le souper | le SOO-pay |
| Water | L'eau | low |
| Lavatory | La toilette | la twah-LET |
| Men | Messieurs | meh-SYUHR |
| Women | Dames | dahm |
| Today | Aujourd'hui | oh-jhoor-DWEE |
| Tomorrow | Demain | de-man' |
| Yesterday | Hier | ee-AIR |

French is really one language you should practice long before you get to France if you intend trying to fudge by.

# BLUFFING YOUR WAY THROUGH GREAT BRITAIN

## MONEY AND TIPPING

1 pound = 2.45 U.S. dollars; * 100 new pence = 1 pound
1 new penny = 2.45¢ ($.0245)
Note: 6 old pence (6d = U.S. 6¢) remains legal tender.
The above applies also to Ireland.

Restaurants: Tips of 10–15 percent; in hotels that *don't* add service charge, divide 10–12 percent to those giving personal service. Even if service charge is included, all doormen, bellboys, taximen, are tipped extra. For luggage, 5p per bag; taxi drivers, 25 percent (5p [12¢] for fare of 20p [50¢], plus 2½p for each 10p above 20p). Hatcheck, 7½p; barber and beautician, at least 10p.

## ACCOMMODATIONS

De luxe, $22–$25 single, $30–$50 double, plus 15 percent for service. Luxury rates are $14–$23 single, $22–$35 double. Moderate: $8–$15 single, $14–$24 double. Budget: $5–$9 for single, $9–$15 for double. All these rates apply to rooms with private baths; it is, of course, much cheaper without baths.

---

* As of July, 1972; can vary 2¼ percent.

## ARRIVAL, DEPARTURE

Taxis from Heathrow Airport to London (14 miles) cost from £2.50 ($5.75) up, depending on distance, plus 25 percent tip. Bus to and from Semley Place Air Terminal, which is just off Buckingham Palace Road, is 35 new pence (85¢). Tip baggage porters 5p each for one to two bags, plus sixpence for all your small pieces.

## EVENTS AND "IN" THINGS

Opera at Royal Opera House, Covent Garden, Coliseum (which is the new home of the Sadler's Wells Opera). The Royal Philharmonic and the London Symphony orchestras are highlights. Horse racing goes on all year: flats from March to December, steeplechasing from December to March. First week in June is the English Derby at Epsom Downs, with royalty attending, a carnival, and so forth. There is the Cup Final of Soccer in early May at Wembley; world-championship tennis, Wimbledon, London, June–July; British Amateur and Open Golf tournaments in May–July.

### Clubs

Churchills Club, New Bond Street; Murray's, Beak Street; Danny La Rue's, Hanover Square; Astor, Berkeley Square; Talk of the Town, Staircase, Samantha's Psychedelic Club.

### Restaurants

Chelsea: Le Français, Le Carrosse (French); Hungry Horse, Land's (Spanish); Meridiana (Italian); Tandoori (Indian).

In London City: Gallipoli (Turkish); Hispaniola Restaurant Ship on the Thames, off the Victoria embankment; Lockets; Samuel Pepys at Brooks Wharf, Thames-side pub.

In Covent Garden: Boulestin (French), The Garden L'Opera.

East End: Anchor Pub on the Thames, two Chinese Restaurants, Good Friends, and Old Friends, in Limehouse. On Fleet Street, Red Lion Pub, Ye Olde Cheshire Cheese, Ye Olde Cock, both pub-taverns. There are more than a thousand casinos in Britain. Bets for horse racing are handled by "turf accountant" shops.

## SHOPPING

There are marvelous tailors along Savile Row; shops along Regent and Bond streets. The leading department stores are Harrods, Simpson's, Fortnum and Mason's, and Dickins and Jones. Boutiques flourish along the King's Road in Chelsea and along Carnaby Street. Clothes and silver are the best buys.

## THEATRE

Check what's playing in the famous West End theatres. London offers a great many attractions, and tickets range from about 60¢ to $4.20—the latter for the best seats. There are also the National Theater Company and the Royal Shakespeare Company. Get seats in advance. Also, plan on visiting the music halls. The Palladium features "name" vaudeville. There are excellent repertory theatres all over Britain.

## GO SEE

In London: the "City"; museums; art galleries; Big Ben; Westminster Abbey; the British Museum; Tower of London; Soho, Chelsea, Fleet Street, Madame Tussaud's Waxworks; the changing of the guard at Buckingham Palace. One of the best ways to meander is to travel by the No. 11 bus, which wanders over a lot of territory. From April to September there is a daily riverboat on the Thames from Hampton Court to Westminster; Windsor Castle is especially interesting.

South of London enjoy the counties of Surrey, Sussex, and Kent; in Kent, note particularly Canterbury; in East Anglia, visit Cambridge. See Winchester, Salisbury, the New Forest, southwest of London.

In the West, visit the towns of Bath, Oxford, and Stratford-on-Avon. If you have time, try to include Wales with its hundreds of coal mines and castles.

George Bernard Shaw, bless him, once said, "America and England are two countries separated by the same language." When you go travelling (two l's) in England, a sense of "belonging" can accompany you as, after all, the words and meanings are the same—people

say, "Good Morning" to you and you say, "It looks like a nice day" and they understand you. You put away your phrase book and relieve yourself of the anxiety of trying to communicate in *their* language. You don't have to say (let's see—page 23—here it is . . .) "Shalom" or "Bon Giorno." Okay, they drive on the wrong side of the road—big deal—you can forgive them that. Then, outside London, you are driving along and you get a flat. Unwittingly, you will pull your auto over to the kerb and get out to inspect the tyre. Some friendly native will approach you with a large smile and tell you that a friend of his, with a lorry, would be more than happy to help because he runs a petrol station. He continues to smile as he rings him up. Somehow, it all's-well-that-ends-wells itself, and as you drive away into the sunset you wonder why there isn't a handy phrase book available. The following is a humble attempt to sort out a few idiomatic differences that you may encounter:

| | |
|---|---|
| Mail | Post |
| Retailer | Stockist |
| Windshield wiper | Windscreen wiper |
| Potato chip | Crisp |
| Elevator | Lift |
| Newsstand | Kiosk |
| Eggplant | Aubergine |
| Long distance call | Trunk call |
| Stop | Halt |
| Cream? (as in coffee) | Black or white? |
| Bookie (as in horse racing) | Turf accountant |
| Baby sitter | Sitter-in |
| Yokel | Hodge |
| Diapers | Nappies |
| Cute | Dinkey |
| Judge | Beak |
| To kid along | Cod |
| Okay | Triggerty-boo |
| Great | Wizard |
| French fried potatoes | Chips |
| Figure pronounced | Figger |
| Schedule pronounced | Shedule |
| Sedan | Saloon |

Have a good trip, and always remember—even if you're going around the world—next year you can still go someplace else.

# The BLUFFER'S GUIDE

*to*

# THEATRE

by **MICHAEL R. TURNER**

Introduced by **DAVID FROST**

# INTRODUCTION

OF ALL THE BREEDING grounds available to the pseudo-intellectual and that other social bird of prey, the intellectual snob, few are returned to as frequently as the theatre.

Perhaps it's because the territory is so especially lush for their particular needs, with a verdant undergrowth of personalities to be pecked away at and an abundance of perches to retreat to, if they are in the slightest danger of being pecked in return, and from which they can safely observe and shrill their call of derision.

And those calls are really shrill. For though you can never be sure where you will come across this particular species, and its plumage varies with the terrain—it might be wearing a five-hundred-dollar gown at a Broadway first night, jeans and a sweat shirt in a converted church, which itself sounds like a contradiction in terms in Greenwich Village, or sensible shoes at a rehearsal for an amateur performance in Duluth—there is one sure-fire giveaway: they are always very, very loud, and the wise man or woman will not try to outsquawk them.

In this respect they are the common grackle of the arts—they simply become deafeningly louder and increasingly repetitive and they won't easily let you escape once they realize they have stimulated a response from you.

But, like the grackle, they will fly off at the merest hint of an authority that's greater than their own, and though this book can only, and indeed, is only designed to, give you a working knowledge of the theatre, any one page of the facts it contains will be enough to send your pseud fluttering away in search of less dangerous meat and leave you free to enjoy the real magic, and the often equally magical anecdotes, of the theatre.

On television I have heard some wonderful stories from actors and performers about their experiences on stage—most of which, like so many great stories, were shattering to the performer when they happened but have become very funny with the healing passage of time.

Marty Brill told us one night about the heckler in a nightclub—because yes, nightclubs are theatre in their way—who'd supped rather

315

more wisely than well and who ordinarily would have been squelched with all due dispatch with lines like "Do you ever talk to your boss like that?" or "I don't care what your wife says to you when you switch off the light!"

But on this night the heckler was a woman. And though we might have finally got around to giving them increasingly equal pay and equal opportunity, there are still situations where a woman has to be handled, well, like a woman.

And this woman was good. Whatever response Marty made to her shouts from the audience she bettered. As he told it, she topped him every time. She was not only getting more laughs than he was, she was deserving them. Finally, in a not unnatural act of desperation he said: "Look, lady, why don't you pick on the band . . . there are ten of them . . . I'm just one guy on his own."

There was a pause, then back from the dark room she shouted: "Yeah? Well, you're a man short."

Marty survived to tell the tale and so did Richard Burton when he told us about the memorable St. David's Day performance of Henry IV, part I.

He had, before the performance, as was his habit on the celebration of the patron saint of Wales, consumed a rather large amount of beer. And once he'd got into his chain mail armor costume there was no getting out of it, nor indeed getting any part of him out of it, until the play was over . . . some three hours later, and well . . . as his co-star Sir Michael Redgrave observed when told afterwards what had really happened . . . "Oh, that's what it was, I thought you were sweating a lot during that fight scene."

But probably my favorite story about actors concerns one great English actor who is no longer with us and whose costar in a Shakespearean play was another celebrated English actor—who was also known by his partiality to a social drink or even ten before a performance.

And as the first actor made his entrance one night, a voice from the upper dress circle shouted down, "So and So, you're drunk."

And without a second's hesitation "So and So" shouted back, "If you think I'm drunk, wait till you see the Duke of Buckingham."

As a postscript, maybe you should jot down Sir Noel Coward's comment on one recent first night. A hundred people wanted to know what he had thought of it. Noel replied succinctly, "I think both the second act and the leading actor's throat should be cut."

DAVID FROST

# WHOM ARE YOU TRYING
# TO KID, ANYWAY?

WHAT TARGET HAVE YOU set yourself? Which theatre are you trying to infiltrate? There are many, but they can be divided for convenience into four—the tight, bitchy little world of the professional actor; the intense, dedicated theatre of the *avant-garde;* the real bluffer's jungle of the amateur; and that heady brew of the last two: university theatre.

This handy compendium can't possibly guide you over the threshold of all four, but you should know in advance those that are easier to enter than others, and the most difficult is recommended only to the really gifted and advanced bluffer.

To begin with, be warned that the most outwardly attractive to the true phony is by far the most dangerous. To mix on equal terms with professional stage people involves more than just dropping a few nicknames and knowing who is currently sleeping with whom. You would have to out-act the actors. For instance, you would be advised to cultivate the pallid, somewhat sickly complexion of those who habitually wear stage makeup. Ideally, you should drink in the right bars, eat at the right restaurants, and dance at the right nightclubs or discothèques: and that comes mighty expensive.

Perhaps your easiest way is via the local theatre group, and this guide assumes that this is your point of attack. To make your way here, spice your conversation with fashionable Continental names. You can be as phony as you like, provided you get the jargon right. The smart bluffer can achieve gratifying success, without having to write, act, direct, design, or sweep the stage, simply on the reputation—which no one will ever want to question—of having translated into Lallans one act of a play by Arrabal.

Your aim, of course, may be humbler. If you want to impress the peasants in the local community Center Drama Group, success is within easy grasp. But there are risks. Even if you aren't forced to participate in their productions, you may have to sit through them. Only the very brave could face that, and I would recommend your joining that particular branch of the amateur theatre known as

the "shamateurs." These worthy devotees of Thespis have a splendid belief in their honest unprofessionalism, a belief that because they act for the love of it, their uncommercial fervor is somehow more to be admired than the efforts of actors who actually have to earn their bread by it. These are dedicated theatre folk who seldom see the professional theatre, but who, when not acting themselves, go to other shamateur productions to criticize everything, often audibly, during the course of the play.

Finally you might like to attempt the most socially acceptable, perhaps the most enjoyable, and certainly the silliest theatre of all: university drama. For success here, however, it is advisable to be either an undergraduate or a freewheeling professor. So, gentle bluffer, unless you are already among their ranks, you will have to talk your way into a university as well as into the theatre.

But it may be that you just want to impress ordinary people in bars or at parties by your racy theatrical presence. If so, a quick glance through this book, the acquisition of a few nicknames, and a copy of *Variety* under your arm will see you through. But take note of the short but true story that follows.

A rather lively party was nearing its climax, and a group of young and admiring ladies was reacting in the most gratifying fashion to the backstage gossip of a gentleman bluffer. He was giving a graphic account of his amorous exploits in the arms of a currently fashionable actress—let us call her Miss Jones. "And next morning," concluded the bluffer, "I just couldn't get rid of her. All over me. Quite a girl." "How fascinating," remarked the smallest and most mouselike of his audience, "Really fascinating. Particularly as I happen to be Miss Jones."

# JARGON

THE FIRST STEP IN YOUR initiation is to equip yourself with the essential jargon, so that you know that stage braces hold up scenery, not your daughter's teeth, and that dropping the asbestos is not a

clumsiness by the wardrobe mistress. The next few sections are spiced with a little history so that you get your jargon in depth.

## THE THEATRE BUILDING

You must always give the impression that the theatre is your home, tossing off terms like "tabs" or "flies" or "cyc" with easy and slightly weary aplomb.

A rapid tour backstage will now follow, and the theatre we are visiting is old-fashioned and Victorian, full of plush and gilt and cherubs and buxom nymphs grasping the masks of comedy and tragedy, and rich, red curtains. Nowadays, of course, the idea of a theatre for innocent thrills and amusement is frowned upon in all progressive circles and a modern auditorium is apt to look like an exhibition piece by a firm of steel scaffolding specialists, all tastefully done over in black and various shades of mud. There will be more on this subject later, but as most technical words and phrases derive from the last century or even earlier, we must trot briskly through a conventional proscenium theatre first of all.

The proscenium arch (or *pros arch*, or plain *pros*)—there's a word, incidentally, that goes right back to ancient Rome—is just the picture frame separating the auditorium from the stage. *Picture-frame theatre* is a useful phrase, to be expressed in tones of distaste in *avant-garde* circles, for the traditional arrangement of auditorium divided from the stage by a curtain. In the seventies, it is the task of the up-to-date architect to avoid having a proscenium in his theatre at all and to build, by the most advanced methods, all the disadvantages of an Elizabethan innyard into a modern structure.

Hanging in the proscenium are the *tableau curtains* or *house tabs*, or *tabs*, or *act drop* (now you can begin to grasp just how tiresome learning about the theatre is going to be. All these terms mean the same thing). They are raised and lowered by motors and counterweights, or just cranked up and down by brute force. Only movie theatres and school auditoriums, as a rule, have tabs drawn from the side.

Just inside the proscenium, in front of the tabs, is lowered the

*safety curtain* or *asbestos,* made of incombustible material with a steel framework. To "drop the asbestos," therefore, is simply to lower the safety curtain.

Let us now go from the auditorium through the *pass door,* also fireproof, and onto the stage. The first thing you will notice is the smell: behind all the glitter and glamor is the unmistakable and powerful aroma of dust and glue sizing. There is normally a pretty sharp draft, too.

Look up, and you will see a tangle of ropes and wires, acres of canvas stirring gently in that breeze, and a jungle of lighting equipment. This cavernous area above you is called the *flies,* and from here scenery is dropped into position on the stage floor. Right in the roof is the hefty steel framework, the *gridiron,* or more usually *grid,* with the pulleys from which the scenery and lights are suspended by ropes and steel cables, the *lines.* On either side of the stage, halfway up the walls, are the *fly floors,* galleries where husky *flymen* tighten up or slacken the lines to raise and lower the suspended scenery. On larger or better equipped stages, human muscle is replaced by counterweights.

Now look down. In older theatres the stage floor is likely to be raked, or sloped, rising from the front to the back wall—hence the terms *downstage,* meaning the front of the stage near the audience, and *upstage,* at the back, away from the audience. When one actor upstages another, the oldest, easiest, and most selfish way of dominating a rival, he is simply placing himself nearer the back of the stage so that his companion has to turn away from the audience to face him. It has been known for two famous and temperamental actresses to upstage each other with such determination that they finished by playing most of their scenes together right up against the back wall of the scenery.

*Above* and *below* are terms of similar origin from the days of the raked stage. One actor is above another if he is upstage of him.

Stage left and right are the actor's left and right, not the audience's. Ignorance of this simple rule has caused badly briefed bluffers acute embarrassment before now.

At this point, you should be able to grasp what is meant by "down left," "up right," and so on, but a little plan of the acting area will help the slow ones among us:

<pre>
                      back wall

up right           up center            up left
  UR                  UC                  UL

  right              center              left
   R                   C                   L

down right         down center         down left
   DR                 DC                  DL

                   front of stage
</pre>

If, however, you want to be really exact, you can go even further:

<pre>
                              back  wall
up right    up right    up center    up left     up left
            center                   center
   UR         URC          UC         ULC          UL

  right      right        center       left        left
            center                    center
    R         RC            C          LC            L

down right  down right     down      down left   down left
            center        center     center
   DR         DRC          DC         DLC          DL

                         front of stage
</pre>

Now, to compound the confusion, we come to the terms *on* and *off*. When an actor moves *on,* he is going "onstage" from the side toward the center. Vice versa, of course, for *off*. *Offstage* is out of the acting area in the wings, in the dressing room, or in the street outside.

Back to the floor of the stage. Beneath your feet you may see *traps* (trapdoors). Through one variety, the *star trap,* the demon king would appear in a flash and a cloud of smoke, and sunk to chest height in another, the *grave trap,* the grave digger in *Hamlet* cracks the unfunniest jokes in English literature.

On really lavish stages, whole sections of the floor can be raised and lowered on hydraulic jacks. Quite modest theatres are likely

to have a *revolve* in the center of the stage. This can be used to help change scenery: large and heavy constructions can be twirled around with ease, and no producer of a revue can leave the revolve alone.

Downstage, on the edge facing the audience, are the *footlights*. These, which light the house tabs in that traditionally thrilling moment before the curtain rises, are now looked upon as very old hat. They are a relic of the candles and later the gas flares of early theatres, and are completely banished from many modern stages.

As you face the audience, on your left and right are the sides of the stage, the *wings*. The prompter sits or stands in either the right or left wing. On the Continent and in opera houses in this country the prompter is apt to live in a little box with a hood over him in the center of the front edge of the stage.

In the corner against the proscenium wall is the stage manager's desk, or *board*. From here, like a pilot in the cockpit of a Boeing, he controls everything during a performance by means of switches, buttons, colored lights, and bells. Here he rings up the curtain and is rude on the telephone to his fellow technicians or the house manager in the auditorium. When you are onstage, the auditorium is known as the front of house, and *out front* just means "in the audience."

The back wall of the stage may just be an expanse of brickwork decorated with fire hoses and exhortations to keep quiet, but in some theatres it may be plastered smooth and perhaps curved. When lit from above, this can represent the sky, and is called the *cyclorama,* or *cyc* for short. Occasionally you see cycloramas made of canvas which are prone to wrinkles, spoiling any illusion.

## THE OPEN STAGE ARENA THEATRE, THEATRE-IN-THE-ROUND, AND ALL THAT

When you begin to pontificate about how vital the open stage is to theatrical health, you ought to know a bit about how this wonder cure started.

As I mentioned earlier, the modern theatre man tends to despise the old-fashioned Georgian and Victorian theatre form of proscenium or picture-frame stage. Closer *contact* (use this word con-

tinually) is what is wanted nowadays—probably because, in the twentieth century, the movies and television can outdo the "picture" or or spectacular aspect of the theatre. So back we go to the Elizabethans.

In Tudor days, plays were performed on a simple wooden platform at one end of an innyard with galleries round the sides. When the theatrical companies of Shakespeare's time began to put up buildings specifically to house plays, they modeled them pretty closely on the innyard. A few refinements were added, like a roof over the stage to keep the rain off the actors—or, to be more precise, off their expensive costumes; the common mob of the audience milling around in the *pit* (what was originally the yard floor) just got wet. If you, the affluent theatregoer, could afford a penny or so more, you would buy a place on a bench in one of the galleries that ringed the "wooden 0."

With the audience on three sides of it, here was the true open or *apron* stage, and there is little doubt that actors and audience exchanged comments and that the contact was physical on occasions.

At the back of the stage was a curtained recess, where a few rudimentary pieces of scenery were probably used to suggest a setting. On the Continent and at court, lavish scenery was the rule. To gain the full effect of expensive staging, the nobility sat at one end of a hall and the performers orated, danced, and sang on a platform at the other end. Behind the actors was a picture frame (which had evolved from the center entrance of the stage façade of the old Roman theatre) containing elaborate scenery. In England, the masque was produced in this fashion.

Cromwell and his not-so-merry men banned the theatre altogether for general sinfulness. The Restoration restored more than the monarchy: it brought back the wicked old theatre, which reappeared as a blend of the old popular theatre of the Elizabethans and Jacobeans, and the procenium form used at court. The actors performed on the front part of the stage, and the area behind the picture frame was reserved for scenery. As time went on, the actors moved back to join the scenery, and the *forestage* that originally jutted out into the audience gradually receded farther and farther into the proscenium, until in the eighteenth century it was just a few feet deep, and then in the next century withered away altogether.

Professional stage people were perfectly satisfied with their picture-frame illusionist theatres of the end of Victoria's reign, despite

the many limitations. But a new kind of theatre man appeared: the intellectual, the theorist. Within a few years a revolution of ideas was in progress, and the first name the bluffer should commit to memory is that of *William Poel*. Shakespeare was currently produced in the most complicated and gorgeous manner, with tons of meticulously painted scenery; Poel returned to the simple open stage of the Elizabethan innyard for his productions of plays of that period. Other theorists followed Poel, notably *Jacques Copeau* in France, who worked with an open stage in his own theatre, the Vieux Colombier, from 1913 onward.

Plain, direct contact between actors and audience were the aims of Poel and Copeau; basically opposed to them were other famous theorists of the time, such as *Edward Gordon Craig* and *Adolphe Appia*. Craig, the brilliant and wayward illegitimate son of Ellen Terry, the actress, and Appia, a Swiss, saw the actor as a puppet in a theatre of visual effect, where dance, mime, monolithic scenery, and atmospheric lighting were paramount. Their theories were based on only a handful of actual productions: magnificent ideas but very difficult to translate into practical theatre terms. In fact, Craig and Appia are chiefly important more for what they said than for what they actually did.

The idea of the open or *arena* stage caught on in a big way only after the second World War. America theatre people took it up with enthusiasm, and the experiments proliferated. *Theatre-in-the-round* is the fashionable phrase. You should let the uninformed know that it's at least twenty years old.

*Theatre-in-the-round* involves having the audience on *all* sides of the actors. Plays are staged on a central platform or in just a circle or a square marked on the floor. This means that the unfortunate spectator has to enjoy large sections of the play spoken with the cast's backs to him. He is usually so close to the acting area that characters onstage are inclined to trip over his feet, and because of the problems of lighting an island stage, he is likely to have a couple of spotlights glaring straight into his eyes.

Nevertheless, the arena stage, with the audience distributed two-thirds or three-quarters the way round the acting area, is still going great guns. Although it avoids the worst excesses of theatre-in-the-round, it is still quite difficult for the director to manage and doesn't suit all kinds of plays—realistic late-nineteenth-century dra-

mas, meant by their authors to be staged with meticulous attention to naturalistic detail, work awkwardly on an open stage.

Although proscenium-type theatres are still being built, most of them can be adapted for open stage productions.

Anyway, by now we are a long way from the crimson plush and tarnished gilt of the Victorian playhouse, from the old illusionistic stage, and the bluffer will be suitably contemptuous of the style of theatre that evolved from that period. You must, nevertheless, pick your company carefully when approving the open stage: many professional actors—the theatre is the most conventional of professions—have a very natural attachment to old methods. Anyone who has gone through a theatre school in the last ten years, however, is likely to be a firm convert.

A thought, though. You could be so *avant-garde* as to be enthusiastic in praise of the proscenium theatre, knowing that the fashion pendulum will swing the other way eventually—but this is not going to happen for a long time yet.

## SCENERY

Not only will you have to seem to know your way about the theatre building, you should also be able to drop the odd technical word now and again about scenery.

Once more, we'll start with the oldest forms. *Backcloths* and *skycloths* are self-explanatory: these large areas of canvas painted with scenes—or in the case of skycloths, quite plain—are dropped into position onstage from the flies. A cloth framing the whole stage, with the center removed, and the onstage edges representing, say, foliage, is called a *cut cloth*. A *gauze* is precisely what it sounds like: with clever lighting it's used for transformation scenes, in which an apparently solid wall dissolves before your astonished eyes. It is all a matter of lighting the gauze from in front to begin with, then fading that illumination out and bringing up the lights on the scene behind. The more satisfactory expedient than a skycloth for representing the limitless depths of the heavens—the cyclorama—has already been mentioned.

To mask the sides of the stage in theatres in the seventeenth and eighteenth centuries were *wings,* sliding in grooves on and off.

These would be painted in perspective to represent walls or, with jagged edges, trees and bushes. Wings no longer run in grooves. Curtains hanging from the flies at the sides of the stage and doing service as wings are called *legs*. Just inside the proscenium arch on either side are narrow wings, generally painted black, the *tormentors*. Often inside the main proscenium you will find another, perhaps cutting down the size of the pros opening. This second pros is the *false procenium*.

Nowadays, in progressive productions it is *de rigueur* to dispense with borders and even wings so that the customers can get a good view of all the untidy lighting equipment and other viscera that the stage designer once went to great lengths to keep decently hidden. Thus the spectator is constantly reminded that he is in a theatre— as if he were ever likely to forget it—and not be deluded into thinking that what he sees on the stage is real life. This is all part of the alienation effect that Brecht went after.

Most scenery representing rooms or walls onstage is composed of flats: framed areas of canvas. They may be hinged together, or more often lashed one to the other with *lash lines* tied off on *cleats*. They are kept firmly in position by means of *stage braces* and weights. Windows (without glass, which would cause unsightly reflections from the powerful lights) and doors, usually like the real thing, are fitted into flats. The flats that stand behind these, providing a view of the Alps or a glimpse of the billiard room, are called *backings*. The complete setting of a room composed of flats, perhaps with a ceiling lowered from the flies, is a *box set*.

Often you will see long pieces of scenery with cut-out edges doing duty as distant hills, or hedges, or a street of buildings: these are *ground rows*. *Set pieces* are single bits of scenery, like a tree, a statue, or a building by itself. Stairs and steps are used, of course, a great deal, rising to folding platforms called rostrums. In a university theatre you are likely to hear learned people call more than one rostrum "rostra."

In big theatres a whole set can be rolled onstage from the wings, on a table.

There is one fashionable stage designer whom you should remember to throw into the conversation. Pick one out of the current crop. You can easily see who is fashionable by reading a few reviews.

## LIGHTING

No bluffer should try to pretend that he knows anything about the technicalities of lighting. A vague intimation that he knows how to use it is enough. He can, and should, say that it is far more important than scenery, and that the most rewarding productions of Shakespeare he has seen have been those on a completely bare stage, the whole mood of the play having been conveyed by subtle lighting.

As the equipment used by lighting men advances steadily into the misty regions of higher electronics, their mystique likewise grows to demigod levels. But signs of a reaction may be visible.

The sensible bluffer, however, will get acquainted with the names of the more obvious pieces of equipment.

We begin with what are termed, in splendid Victorian fashion for this most contemporary of arts, the *lanterns*. The spotlight or *spot* has a narrow beam that can be focused; it comes in several varieties, but the most efficient forms are *mirror spots*. In all theatres you will see spots fixed to the front of the circle, in the ceiling, and in housings at the sides of the auditorium: these are the F.O.H. spots (front of the house). All these lanterns have hard-edged, precise beams; call them *profile spots* if you want to sound really professional.

Out front, incidentally, may be high-powered *following* or *follow spots,* living in a little room high up at the back of the auditorium. These are used to follow the movement of the star about the stage, and once upon a time they were magnificently spluttering *lime lights,* or later, arc lights. In any case, they are likely to be given the generic title of *limes*.

Hanging above the stage on lengths of steel piping called *bars* you will see many spots, most of them today with a large lens, ribbed in concentric circles, the *Fresnel spots,* providing a wider, softer beam than the profile spots. Also hanging up there you will see *floods*, which are basically just metal boxes containing a bulb. Rows of small floods built together in one long unit are called *box battens,* or simply *battens* for short. They are numbered from the proscenium No. 1 batten, No. 2 batten, and so on, to the *cyc batten* lighting the cyclo-

rama, or perhaps a skycloth. The spot bars are numbered in the same way, too. Box battens giving flat areas of light are now old-fashioned. Those amateurs who don't know any better or who can't afford any better are devoted to them. They are anathema to the shamateur. *Footlights,* often missing from progressive theatres, are just box battens on the floor.

The *switchboard* controlling all this equipment is to be found on a platform at the side of the stage, or perhaps on the fly floor of old theatres. In modern buildings it is more likely to be in a room, often doubling as a projection box, at the back of the auditorium, so that the electrician can see the immediate effects of pressing the wrong switch.

The waxing and waning of stage lights is accomplished by means of *dimmers.* Nowadays the old, bulky mechanical dimmers are being replaced by *thyristor* dimmers and similar electronic devices developed for TV studios. The control desk for such systems, including remote controls, memories, and preset keys, remind one of organ consoles.

## JOBS IN THE THEATRE

This is a particular important section, for unless the bluffer knows who is who in the theatre, he is likely to make a fatal slip and give the whole game away.

This is the way it works on Broadway. The *producer* is the one who puts the whole package together. He options the script from the playwright; he arranges for the financing from the *backers* or *angels;* he engages the cast and the creative people; he rents the theatre and sets a date for the opening. In the old days, producers used their own money to put on shows. Today, a producer is paid so much per week for expenses for which he supplies his own services, those of a *production secretary,* and a telephone. After the investors have been paid their share, the producer is entitled to fifty percent of the profits. In Europe, a producer is usually called the *manager.*

If an angel puts up enough money of his own or is able to bring in outside investors, he may be occasionally designated an *associate* or an *assistant producer.*

Serving right under the producer is the *general manager.* This

is the guy who does all the dirty work while the producer is giving out interviews and performing all the other public relations duties. He negotiates with the various unions (everyone on Broadway from the director to the porter belongs to a union); he negotiates the contracts; he hires the crew; he shops around for the theatre; he arranges for the costumes and scenery; in short, he supervises every commercial and financial aspect of the show. He is usually hired by the producer three or more months before the opening, and he draws a weekly salary.

The *director* is the fellow who makes it all happen on stage. He joins the producer and author in casting the show, he stages the action, he artistically supervises the costumes, scenery, lighting (book, music, lyrics, and dances in a musical), and so on. His job ends when the show opens. Technically, he is supposed to check out the performance periodically (assuming there is a long run), but some directors don't bother and the shows sometimes deteriorate in time. The director is one of the first creative people engaged and he is usually paid a flat fee in advance in addition to a percentage of the weekly gross receipts.

Serving under the director is the *stage manager* (sometimes called the production stage manager). Union rules require two stage managers for musicals and three for straight plays. This is one of the most exacting jobs in the theatre, since the stage manager must heed or supervise every creative and technical aspect of the production before the opening night through to its final performance. He makes sure that the director's orders are carried out; he sees to it that the actors, electricians, and stagehands are functioning properly; he sits with the prompt book through every performance and gives the light cues; he supervises the hanging of the show (the placing of scenery and lighting); he makes sure the actors are ready to perform and sees to it that they get off and on at the right time and in the right place.

He must also rehearse and direct the replacements, and generally see to it that everyone is where he belongs and doing that for which he is paid.

The stage manager is given one or more assistants called A.S.M.'s. The stage managers are hired a few weeks before rehearsals begin and continue with the show to its bitter end. They are paid a weekly salary.

Occasionally, there is someone called a *production supervisor,* but this vague term can be applied to a stage manager or to some outside person who is brought in to assist the director.

The *company manager* works under the general manager and is the producer's business representative in the theatre during the run of the show. He is usually hired a month prior to opening and has a variety of responsibilities. He makes up the weekly payroll for the company, he checks the box office to see how many tickets have been sold, he pays the producer's bills—in short, he takes care of a particular show's financial considerations for the general manager who may be supervising two or three shows at the same time.

The *house manager* works for the owner of the theatre and is responsible for the operation of the house itself. He supervises the house staff, which includes the ushers, the backstage doorman, the porters, the box office personnel, the engineer, and the usual stage-hands that are assigned to that particular house.

The *treasurer* is in charge of the box office. He has two or more assistants and a *mail order girl* who answer the phone and sorts the mail orders.

The two *porters* take turns serving as the *front doorman,* who usually fetches the reservations from the box office for the waiting customers. They also clean the house between performances.

The other creative people hired by the producer for the show may include a *scenic designer,* a *costume designer,* a *lighting designer,* and a *composer, lyricist, choreographer* (if the show is a musical). They are paid fees plus a weekly percentage, which varies with every production.

There is also a *press agent* who is paid a weekly salary, various lawyers and accountants, etc.

The crew hired for the show may vary from four to forty stage-hands, depending upon the complexity of the scenery, the variety of offstage sounds, or other technical problems. These are carpenters, flymen, electricians, and *property men.* There is a *wardrobe mistress* who is in charge of the costumes and *dressers* who help the stars put on and take off their clothes.

Back to the creative end. Each *musical* Broadway house is obliged to keep a number of *musicians* on salary whether the theatre is engaged or dark. These gentlemen are known as *walkers.* When a show

comes in, the producer engages a *contractor* to hire the additional musicians for the performance.

Musicals may also require one or many of the following specialists: *orchestrators, copyists, arrangers, hair stylists, dance music composers,* and the like.

# ACTING IN THE SIXTIES: STANISLAVSKI, THE METHOD, AND HAPPENINGS

THE ACTOR'S TRAINING is a long one, and as the bluffer's very last intention is actually (perish the thought) to appear on a stage before an audience, he need only know of the current cults.

We have to go back a bit, to Russia at the turn of the century, to meet the prophet of all modern acting, Konstantin Stanislavski. Your bookshelf, incidentally, should carry copies of his holy writ, *An Actor Prepares* and *Building a Character.*

*Stanislavski* must never be questioned, except by an avowed disciple of Bertolt Brecht. He is supreme as the master teacher of naturalistic acting.

Stanislavski was a director who helped found the Moscow Art Theatre. He reacted against the ham acting of the time, the expansive melodramatic style of stock gestures, sonorous voice, overemphasized enunciation, all of which had no subtlety or relation to how people spoke or moved in real life. To do them justice, the actors of that time had little other than crude scripts to work from, frequently inattentive audiences to dominate, and no director to weld the play into a whole, only a stage manager to see that the actors did not bump into each other in rehearsal.

Such hack styles might have worked with plays in which situation and broadly drawn character were all-important, but were useless when delicate atmosphere had to be created, say, in the new plays of Chekhov.

What Stanislavski taught was minute attention to naturalistic

detail, extensive training and rehearsal lasting months for a single play, and the careful shading of voice and gesture. Suggestion was more important than statement. As his style developed, Stanislavski insisted more and more that the actor immerse himself in his part, sinking into the psychological state of the character.

Stanislavski's system led to the development of the *Method*. The Method as practiced by the *New York Actors Studio* under Lee Strasberg sank the actor into his part completely. The basic difference between Stanislavski and the Method is that the former always insisted that the actor's part should be subordinate to the whole production, whereas in the Method, the complete identification of the actor with his role is everything.

Methods used in teaching the Method include *improvisation* and a great number of demanding physical exercises.

Names that are associated with the Method are, of course, the legendary James Dean and Marlon Brando, and the directors Lee Strasberg and Elia Kazan.

A word about improvisation. This is the technique of the actor's creating his own part, either by mime or by mime and dialogue. An essential part of the training at any school of acting nowadays, it assumed enormous importance for the Method, and in many productions by advanced directors it helps write the play itself. Whole plays have been improvised, one an experiment by William Saroyan, the result bearing the title of *Sam, the Highest Jumper of Them All.*

*Happenings* have no plot, they are simply events, usually as noisy as possible, occurring at random and without premeditation. They are the theatrical equivalents of action painting and in their many varieties they hail from New York and San Francisco.

Examples of this delightful art form are *Poem for Table, Chairs and Benches* performed in California, consisting of the noise made by furniture being pushed around the floor; or an event consisting of a gong scraping for an hour or so over cement; or general smashing up of any objects that come to hand.

# READING MATTER

NATURALLY, YOU WILL WANT to carry around the right magazines and papers. A few years ago it would have been easier when *Theatre Arts* was still being published, keeping us up to the minute with what to think, what to approve of, and what to sniff at. Get the back numbers if you can, and leave them casually about your pad. It will show that you bluff in depth.

You will subscribe to *Variety, Show Business, Billboard, Dance Magazine, The Drama Review, Backstage,* and *Theatre Crafts.*

# THE "ISMS"

THE VITAL PART OF THE bluffer's equipment, if he is to keep his end up in the *avant-garde* theatre, is a nodding acquaintance with the main names of twentieth-century drama. A lot of them fit fairly neatly under the "isms" before the last war, and the "theatres"—of cruelty, the absurd, etc.—since then. Let us now take a very deep breath and launch out into:

## REALISM

A vigorous movement of the late nineteenth century, with Ibsen as the most notable exponent. There isn't space to deal with Henrik here (dip into any history of the drama), but you should know that his idea—and that of the other realists—was to replace the conventional flamboyance of melodrama and the artificiality of the *well-made play* with dramas that looked like real life. Incidentally, you should treasure the phrase "well-made play": it applies to the carefully constructed social dramas of Augustin Eugène Scribe and

Victorien Sardou in France and Arthur Wing Pinero in Britain. There are signs of a revival of interest in their well-carpentered, mechanical work, so make the most of it.

A great disciple of Ibsen and high seriousness was George Bernard Shaw, who is becoming fashionable again but with a strong period flavor. Like most theatrical movements, realism was carried to extremes, and it turned into:

## NATURALISM

Naturalism was so ultrarealistic that it tried to put on the stage all the more horrid aspects of human life. Well-washed actors performed with terrific attention to detail the depredations of bedbugs, lice, fleas, starvation, and alcoholism. There has always been a *nostalgie pour la boue* in the theatre, and naturalism is apt to crop up all over the place.

During the naturalistic craze, a style and method of acting was born under the aegis of Konstantin Stanislavski, and you will find details of the trouble he started later.

Dramatists to note—they were preceded, by the way, by Émile Zola with his nice line in vice and crime—include the Russian Maxim Gorky (author of *The Lower Depths*), Gerhart Hauptmann (who wrote *Rose Bernd* and *Die Ratten*), and the gloomy but important Swede, August Strindberg (like Ibsen, he's too big for treatment here). Naturalists as a school tended to get misty at the edges and evolve into symbolists and expressionists.

## SYMBOLISM

In many ways a reaction against naturalism. It was in full spate by the end of the last century and presented in symbols the drama of the human soul. Sometimes it was very, very beautiful—as with Maurice Maeterlinck's children's play, *The Bluebird*—sometimes powerful, as in Ibsen's last works, and it was certainly invariably sad, like the dreams of the dying girl in *Hanneles Himmelfahrt* (*Hannele's Journey to Heaven*) by Gerhart Hauptmann.

Came the first World War, which shattered theatre intellectuals,

as well as the rest of society, and set in train a whole succession of isms.

## DADAISM

Dadaism reacted against everything, and the desire to shock was paramount. The splendid iconoclast Tristan Tzara, who described his play, *Le Coeur à Gaz,* as "the biggest swindle of the century in three acts," started it all in 1916. Dada didn't produce much of note for the theatre—most of its eccentric fire was reserved for writing, typography, and painting—but it is certainly a handy cult word for the bluffer. "Dada," incidentally, is supposed to come from the baby's first utterance.

In the twenties Dada flared on, but eventually petered out into surrealism and expressionism.

## SURREALISM

Like Dada, surrealism flowered mainly in the visual arts. It influenced the expressionist theatre a good deal, but produced little worthwhile drama of its own. A presurrealist of immense quotability for the bluffer, however, is Alfred Jarry, and you will find something about him under the Theatre of the Absurd.

## EXPRESSIONISM

Expressionism germinated in the German theatre at the turn of the century and produced luxuriant and curious blooms in the twenties.

In expressionism the action on the stage represented psychological conflicts, the frenzied goings-on in man's soul. Every character was heavily symbolic, and humor, when it did appear at all, as in *The Insect Play* by Karel and Josef Čapek, was usually far from jolly— usually harsh and scarifying. The despair, disillusionment, and hysteria of postwar Europe flooded the stage.

The expressionist theatre was a paradise for director and designer, and the actor was often used as a puppet (*see* Mechanism).

The forerunner of the expressionists in the early nineteenth century was Georg Büchner, the author of *Dantons Tod* (*Danton's Death*), which is becoming very fashionable. Another Büchner play to be noted is *Woyzeck* (on which Alban Berg based his opera *Wozzek*). Strindberg was another early expressionist with such plays as *The Ghost Sonata,* and so was Frank Wedekind, a very *in* name at the moment since his main preoccupation was sex, in *Spring's Awakening* and other violent dramas. Both Strindberg and Wedekind are pre-first World War, and none of those that followed, with the exception of Brecht, came close to their standards as playwrights.

The three main expressionist Germans of the twenties are Ernst Toller, author of *Masse Mensch* (*Masses and Men*), Walter Hasenclever, who wrote *Antigone,* and Georg Kaiser, whose best play is the spectacular *Gas.* Bertolt Brecht can be counted as an expressionist in his early years, but more about him later.

## MECHANISM

Just a matter of making actors behave like machines. Indeed in this branch of expressionism the ideal was for actors to be replaced by machines altogether.

## THEATRICALISM

A director's movement in Germany and, especially Russia, a reaction against the naturalistic productions of Stanislavski. Its chief figure was a Russian director, Alexander Tairov.

## FORMALISM

An extension of theatricalism, involving intense stylization of acting, design, and production. *Vsevolod Meyerhold* was the leading formalist director.

## SOCIALIST REALISM

As you can guess, this was another Russian movement. It was supposed to represent a true revolutionary theatre; it extolled the

virtues of the Communist state and poked rather clumsy fun at aristocrats and bourgeois. It was (of course) a reaction against formalism.

The plays of Vladimir Mayakovski, although they had formalist productions by Mayakovski, could be classed under socialist realism. *The Bedbug* is his best-known work.

# OUTSIDE THE "ISMS"

THERE WAS CERTAINLY more frenetic experiment in the twenties than at any time before or since, but many mainstream playwrights were only slightly attacked by the isms, or were infected first by one then by another, and they are listed in this section.

Such dramatists as Bernard Shaw, Sean O'Casey, and Noel Coward only occasionally used expressionist elements in their usually realistic writing. J. B. Priestley woke up to expressionism in the thirties and after, and used the style in warm, misty plays like *Johnson Over Jordan.*

Americans, as usual, showed more liveliness, with Elmer Rice and Eugene O'Neill to a lesser extent trying to break conventional bonds. O'Neill's ambitious dramas deal with big, emotional themes, and you should quote *The Hairy Ape* (which is expressionist), *Desire Under the Elms,* the immense Civil War drama based on the Greek Orestes myth, *Mourning Becomes Electra,* and *The Iceman Cometh.* There is Elmer Rice's *Adding Machine,* a kind of morality play, with the hero called Mr. Zero.

Social consciousness hit the States in the thirties, and political plays about strikebreakers, revolting garment workers, exploited blacks, and fascism were all the rage for a while. In addition to Rice, Clifford Odets (*Waiting for Lefty*), Maxwell Anderson (*Key Largo*), and Sinclair Lewis (*It Can't Happen Here*) are worth remembering.

Back in England, political protest got mixed up with a new poetic school. W. H. Auden and Christopher Isherwood wrote essentially half-baked satirical verse dramas such as *The Ascent of F6.* More muscular new talent arrived with *Murder in the Cathedral* by T. S. Eliot. His distinctive brand of intellectual free verse persisted

into the forties and fifties with *The Cocktail Party* and other plays, but Eliot was a literary rather than a theatrical figure.

A shower of poetic sparks was thrown off by Christopher Fry in the early fifties: *The Lady's Not for Burning* sounded brilliant at first hearing, but Fry was drunk with colorful metaphor. His short vogue in the theatre was abruptly truncated by the emergence of the Angry Young Men.

More vital work appeared in France in the thirties, and two major dramatists, Jean Giraudoux and Jean Anouilh, whose reputations are now a trifle faded, reached their peak during the war and after.

Jean Giraudoux wrote in firm, sophisticated, poetic prose, and his antiwar comedy *Tiger at the Gates* (Christopher Fry's title for his translation of *La Guerre de Troie n'aura pas lieu—The Trojan War Will Not Take Place*) will certainly live. *Duel of Angels,* his last play, written in the forties, shows how dangerous innocence and purity can be for the world. This philosophy is also typical of Anouilh, who achieved more popular success than Giraudoux.

Anouilh is a magnificent theatrical craftsman, but the bluffer will follow current fashion by acknowledging that fact condescendingly and also denigrating him as shallow and sentimental. He is very important, nonetheless, if only as a figure to be sniped at. Anouilh's plays are divided into five groups: *Pièces roses,* the comedies: *Pièces noires,* the tragedies; *Pièces grinçantes,* harsh plays; *Pièces brillantes,* the later glittering comedies; and *Pièces costumées,* costumed plays.

Use the phrase "Anouilh heroine" to describe the waif who looks innocent but who is patiently disillusioned and experienced. She is a representative of that cynical whimsicality of his that works superbly well in performance but doesn't bear close examination. Typical of Anouilh's earlier style are *Ring Round the Moon,* a soufflé-light comedy about twin brothers, one good and one wicked, and *Antigone,* a tragedy about the pointlessness of idealism. Of more recent plays, his version of the St. Joan story, his popular but facile *Becket,* and *Poor Bitos,* in which aristocrats torture a self-made man as cruel as themselves, stand out.

Anouilh is the classic case of the writer who got too successful with his audiences to please the intellectuals.

Jean-Paul Sartre and Jean Cocteau both wrote a number of plays. Sartre's are tough, singlarly effective essays on the themes of his own famous philosophy, existentialism. *Huis Clos* (*No Exit*) is a nightmarish picture of three people torturing one another eternally after death: man alone is responsible for his own tragedy, and "hell is other people." A later play of Sartre's is the much-praised *The Condemned of Altona,* a drama about guilt in Germany after the war, but applicable equally to Algeria, Ireland, or any country where human greed has brought large-scale misery.

Cocteau, once the darling of the intellectuals, has faded badly. He experimented with most of the isms, flitted from poetry to plays to films to design and back again. His obsessive theme, love and death, is invariably presented with a chic French romanticism in works like *The Eagle Has Two Heads, La Belle et la Bête,* and *Orphée,* the last two being splendidly Gothic films.

Now we come to one name the bluffer must remember, Luigi Pirandello. His principal subject is the dance of illusion and reality, and it is brought out most effectively in his famous play, *Six Characters in Search of an Author,* first produced in 1921. Actors who are rehearsing an earlier play of Pirandello's *The Rules of the Game,* are interrupted by six individuals who claim that they are the people created by the author and that they want to finish the play themselves. Each has his own idea about how this should be done, and their versions of the same events are very different. Other plays of Pirandello to be quoted are *Henry IV* and *Right You Are, If You Think You Are.* His importance, you will say, lies not so much in his dramatic skill as in his presentation of the pointlessness of life and the uncertainty of reality that looks ahead to the Theatre of the Absurd.

He influenced Ugo Betti, another Italian, who can be called Pirandello's successor. Betti's themes are responsibility and identity, and his best play so far, *The Burnt Flower Bed,* has as its protagonist a politician, a man who ruins his family's life by allowing ends to justify means.

A more effective poetic dramatist than T. S. Eliot was Federico García Lorca, a young Spaniard killed in the Civil War. *Blood Wedding* consists of savage goings-on among the peasantry, highly symbolic and with magnificent poetry mixed with bad. *The House of Bernarda Alba* is his best play: poetic prose is the medium here,

used with great theatrical power. Again, violence and high passion rage, this time in the house of a matriarch where her five daughters are fighting to be free of her domination.

Two Americans now. Tennessee Williams began with the delicately impressionistic and symbolic play, *The Glass Menagerie,* in which a lame, withdrawn girl blossoms under the attentions of her "gentleman caller" who turns out to be brought along by her brother simply out of pity and to still his mother's nagging. This sad and charming play is overshadowed by such powerful slabs of sexuality and violence as *A Streetcar Named Desire* and *Cat on a Hot Tin Roof.* The former is the better, with its clash between a fragile, genteel woman and a virile apelike man, ending in rape and madness.

Arthur Miller is probably a far more solid and worthwhile playwright. Themes: betrayal and the need for a "clean name" in society. They appear first in *All My Sons,* about a war profiteer whose past erupts to shatter the present, and *Death of a Salesman,* in which a modern Everyman, who is neurotically obsessed by "success," betrays and ruins his sons' chances in life.

You, as a bluffer, should hail this as a modern tragic masterpiece, although you can privately think *The Crucible* Miller's best play. Written after his experiences with McCarthyism, it is a study in mass hysteria based on the seventeeth-century affair of the witches of Salem. *A View from the Bridge,* set in New York's waterfront, is concerned with another tragic obsession, a man's intense love for his niece.

This section ends with a couple of Swiss, Max Frisch and Friedrich Dürrenmatt. The latter is more popular with the public, the former with intellectuals.

Frisch's *The Fire Raisers* was first a failure, but it was not long before its reputation began to soar: nothing, after all, is more helpful to a cult play than a resounding flop. The trappings of *The Fire Raisers* are of the old expressionist type, and the plot follows the mounting panic of a bourgeois businessman who, despite a scare about arson in the district, gives lodging to two strange men. Like a frightened rabbit, he is hypnotized by their bravado and brutality as they fill his attic with drums of gasoline. Finally he lends them a box of matches, and the curtain falls on the house and town in flames. A postcript set in heaven provides justification for the businessman, as

the fire has helped in the city's rebuilding plans. The parallel with the rise of Nazism, appeasement, and German's prosperity after the war are obvious, but in spite of heavy symbolism *The Fire Raisers* has genuine power. Somehow though, it lacks humanity, and the same applies, rather oddly in view of its subject, to Frisch's later play *Andorra*, about a man persecuted because he is supposed to be a Jew.

Dürrenmatt, however, has had more popular acclaim, particularly with *The Physicists*, in which three scientists retire to a mental home in the hope of preserving their discoveries, and recently in *Meteor* and *The Visit*. As with Frisch, Dürrenmatt's plays smack of modern morality plays somewhat in the German tradition of forty years ago.

# BERTOLT BRECHT

THE CULT OF BRECHT, to which the bluffer should piously bow, is a really fascinating one, for its produces violent passions both for and against. Up to 1949, when Brecht had nearly all his important work behind him, many theatre commentators dismissed him as a follower of the expressionists, Toller and Kaiser; a Marxist who wrote rather clumsy and obvious symbolic plays, one of which, *The Threepenny Opera*, was notable for its music and for having been "borrowed" from *The Beggar's Opera*.

The story is curiously sad and even farcical. Brecht, who wanted most of all to influence and instruct the masses, succeeded only in setting intellectuals aflame. The man whose avowed creed as a director and theorist was, by means of the *"V-Effekt"* (Alienation Effect, see below), to dispel illusionistic hocus-pocus in the theatre and replace emotional identification of the audience with characters on the stage by intellectual appreciation of the story, wrote plays like *Mother Courage* which involved the spectator immediately. Such contradictions are fine fare for the bluffer, who should be ready to uphold Brecht as a flawed genius.

One thing must be said right away: Brecht's plays are far from being Germanic and dull (with certain appalling exceptions). At

their best they are hard, muscular, and direct with no naturalistic fripperies. The recurring subject matter of decadence, greed, exploitation, and slum values has generally, of course, enormous appeal to the intellectual; Brecht's didactic works, which are concerned with the honest strivings of the proletariat, are not nearly as interesting. Nevertheless, the bluffer *must* read the main plays, and he should certainly say that he has seen incomparable productions of them by the Berliner Ensemble, Brecht's own East Berlin company.

You need not bother much with Brecht's earliest plays (although you should certainly know of them), including *Baal* and *Mann ist Mann*. They date from 1915 to the mid-twenties and are in the fashionable expressionistic style of the German theatre of the time, and are largely overdone protests against corruption and decadence. Note that already a typical Brechtian paradox is appearing; while expressly antiromantic, the plays use all the wild action and larger-than-life characters of romantic theatre to press home their point.

In 1928 came Brecht's most popular and most immediately enjoyable play. *The Threepenny Opera* is in the ballad-opera style of its original, John Gay's *The Beggar's Opera* of the early eighteenth century, with tart, nostalgic, German cabaret jazz accompaniments by Kurt Weill. It even provided a hit number for the Top Ten in "The Ballad of Mack the Knife."

Set in late-Victorian London, the *Opera* presents the familiar tale of Mackie Messer or Mack the Knife, who marries Polly Peachum, the daughter of a fence and leader of a gang of professional beggars, and is betrayed to the authorities by his other women. The criminals of the play are good bourgeois citizens with normal middle-class tastes and morality: the "wickedness" of the professionals is nothing to what goes on in respectable society—after all, "What is robbing a bank compared to founding a bank?" The sick, sour humor of the play catches exactly the cynicism and disgust of the late twenties, and indeed, of this century.

Two other "musicals" of this time are *Happy End,* involving Chicago crooks and a Salvation Army girl, and *The Rise and Fall of the City of Mahagonny.* This town is founded by crooks so that they can work in real freedom, but it becomes too respectable until an approaching hurricane introduces a policy of do-what-you-like and the city riots itself to pieces.

the fire has helped in the city's rebuilding plans. The parallel with the rise of Nazism, appeasement, and German's prosperity after the war are obvious, but in spite of heavy symbolism *The Fire Raisers* has genuine power. Somehow though, it lacks humanity, and the same applies, rather oddly in view of its subject, to Frisch's later play *Andorra,* about a man persecuted because he is supposed to be a Jew.

Dürrenmatt, however, has had more popular acclaim, particularly with *The Physicists,* in which three scientists retire to a mental home in the hope of preserving their discoveries, and recently in *Meteor* and *The Visit.* As with Frisch, Dürrenmatt's plays smack of modern morality plays somewhat in the German tradition of forty years ago.

# BERTOLT BRECHT

THE CULT OF BRECHT, to which the bluffer should piously bow, is a really fascinating one, for its produces violent passions both for and against. Up to 1949, when Brecht had nearly all his important work behind him, many theatre commentators dismissed him as a follower of the expressionists, Toller and Kaiser; a Marxist who wrote rather clumsy and obvious symbolic plays, one of which, *The Threepenny Opera,* was notable for its music and for having been "borrowed" from *The Beggar's Opera.*

The story is curiously sad and even farcical. Brecht, who wanted most of all to influence and instruct the masses, succeeded only in setting intellectuals aflame. The man whose avowed creed as a director and theorist was, by means of the *"V-Effekt"* (Alienation Effect, see below), to dispel illusionistic hocus-pocus in the theatre and replace emotional identification of the audience with characters on the stage by intellectual appreciation of the story, wrote plays like *Mother Courage* which involved the spectator immediately. Such contradictions are fine fare for the bluffer, who should be ready to uphold Brecht as a flawed genius.

One thing must be said right away: Brecht's plays are far from being Germanic and dull (with certain appalling exceptions). At

their best they are hard, muscular, and direct with no naturalistic fripperies. The recurring subject matter of decadence, greed, exploitation, and slum values has generally, of course, enormous appeal to the intellectual; Brecht's didactic works, which are concerned with the honest strivings of the proletariat, are not nearly as interesting. Nevertheless, the bluffer *must* read the main plays, and he should certainly say that he has seen incomparable productions of them by the Berliner Ensemble, Brecht's own East Berlin company.

You need not bother much with Brecht's earliest plays (although you should certainly know of them), including *Baal* and *Mann ist Mann*. They date from 1915 to the mid-twenties and are in the fashionable expressionistic style of the German theatre of the time, and are largely overdone protests against corruption and decadence. Note that already a typical Brechtian paradox is appearing; while expressly antiromantic, the plays use all the wild action and larger-than-life characters of romantic theatre to press home their point.

In 1928 came Brecht's most popular and most immediately enjoyable play. *The Threepenny Opera* is in the ballad-opera style of its original, John Gay's *The Beggar's Opera* of the early eighteenth century, with tart, nostalgic, German cabaret jazz accompaniments by Kurt Weill. It even provided a hit number for the Top Ten in "The Ballad of Mack the Knife."

Set in late-Victorian London, the *Opera* presents the familiar tale of Mackie Messer or Mack the Knife, who marries Polly Peachum, the daughter of a fence and leader of a gang of professional beggars, and is betrayed to the authorities by his other women. The criminals of the play are good bourgeois citizens with normal middle-class tastes and morality: the "wickedness" of the professionals is nothing to what goes on in respectable society—after all, "What is robbing a bank compared to founding a bank?" The sick, sour humor of the play catches exactly the cynicism and disgust of the late twenties, and indeed, of this century.

Two other "musicals" of this time are *Happy End*, involving Chicago crooks and a Salvation Army girl, and *The Rise and Fall of the City of Mahagonny*. This town is founded by crooks so that they can work in real freedom, but it becomes too respectable until an approaching hurricane introduces a policy of do-what-you-like and the city riots itself to pieces.

Now in the thirties comes Brecht's Marxist period, but he could never toe the party line for very long. You can safely pass over the worthy, rather dreary plays of this time, when Brecht was in Scandinavia where he had fled from the Nazis. You should note, however, *St. Joan of the Stockyards* (Brecht had a thing about Joan of Arc), another play about commercial exploitation in Chicago. Again, his ideas of Chicago are about as odd as his conception of London in *The Threepenny Opera*.

In the late thirties began the series of plays on which Brecht's reputation really rests: *Life of Galileo, Mother Courage and Her Children, The Good Woman* (or *Person,* depending on the translation) *of Setzuan, Herr Puntila and His Man Matti, The Resistible Rise of Arturo Ui, Schweyk in the Second World War,* and *The Caucasian Chalk Circle.* In the middle of this output Brecht fled to America when the Nazis overran Norway. He returned to Germany in 1949 to run the Berliner Ensemble in East Berlin, writing nothing more of note for the stage. He died in 1956. The Ensemble, led by his wife, Helene Weigel, carries on his ideas and a repertoire of his plays.

There is not room here to summarize Brecht's important plays from *Galileo* to *The Caucasian Chalk Circle,* but a number of themes recur, and the bluffer should conscientiously note them:

1. The poor are *basically* good in their earthy vulgarity; the rich are inevitably corrupt and decadent;

2. Goodness in this criminal world is suicidal: to exist, man has always to compromise, at the very least accepting expedients, and to succeed he must outcheat the rest;

3. Each person has two sides, good and evil.

The vigor and variety of Brecht at his best is seen in *Mother Courage,* the story of a tough old canteen woman whose livelihood consists in trailing after the mercenary armies of the Thirty Years' War. She loses her children but still clings with materialistic devotion to her job, in spite of all the tragedy it has cost her, because it is the only way of life she knows. Of all Brecht's plays this is perhaps the most deeply felt: it is definitely the most moving. The "Brechtian" trappings of songs embedded in the action, simple rudimentary staging and placards or projected texts to set the scene are all there, but they are transcended by the power and humor of the writing.

Another example of the main themes effectively presented is *The Good Woman of Setzuan,* in which Shen Te, a warmhearted prostitute, is forced to disguise herself as her (imaginary) ruthless male cousin in order to survive.

The good bluffer will use the word "Brechtian" a lot. It applies not so much to his plays but to Brecht's theories and methods of production. First of all we must get the Alienation Effect clear. Quote it in German if your accent is good enough: *Verfremdungs-effekt.* It does not mean alienating the audience. Brecht rebeled against both romanticism and naturalism, and the intention of the Effect is to set everything on the stage in a new and unfamiliar light. To do this, the director should encourage the spectator to enjoy with the mind, rather than be taken in by cheap illusion and emotion. He must be constantly reminded that he is in a theatre and he must be critical. Staging, therefore, must never outdo reality, and the actors must remain at a distance from the characters they are playing, taking an obvious attitude to these characters. This is in direct opposition to the Stanislavski and Method schools of acting.

"Brechtian" at its cheapest level means plays with bare, uncompromising staging with songs during the action and often a general air of earnest gloom—you will find that newspaper critics apply it indiscriminately to any recent play of even slightly unconventional form.

A somewhat earlier theory of Brecht's, but leading to the Alienation Effect, is the idea of *Epic Theatre,* a phrase you should find useful. It belongs to the twenties and means, as you have probably already guessed, a style of production that is directed at the audience's reason instead of the emotions. It has nothing whatever to do with Cecil B. de Mille, but precisely the opposite: it is argument, generally political, presented in bare, spare fashion and the spectator has to be convinced, not swept off his feet by feelings.

Brecht's disciples have followed Brecht's dictums far more closely than the master could himself. He was a theatre man through and through, and as much as he fought against the old glamour of the stage he could not avoid it, and his best plays will always be those with tough, earthy characters, intensely human, that immediately catch an audience's sympathy.

There are many admirers of the great man; there are many who hate his guts.

# THE ''THEATRES''—OF CRUELTY, THE ABSURD, AND FACT

THESE ARE HANDY, RATHER vague terms, but be careful not to apply them to the wrong playwrights and directors. However absurd you think Brecht, say, he is definitely not Absurd. The first two, the Theatres of Cruelty and the Absurd, can be bracketed to some extent as the Theatre of the Sick. The Theatre of Fact, however, is very different indeed and harks back to the political, didactic theatre of the thirties.

*The Theatre of Cruelty* is director's rather than dramatist's theatre, in which the author's text is only a starting point in an effort to liberate the audience's subconscious, to bring out those repressions that are usually safely locked up in order to make the audience react and sit up. Naturally, as these involve the nastier aspects of human nature, the Theatre of Cruelty puts on the stage the extremes of madness, torture, and perversion. These aspects are generally set in an atmosphere of ritual, fantasy, and magic; reason and logic are anathema.

Cruelty is far from new on the stage. The ancient Greeks gorily removed Oedipus's eyes, Shakespeare did the same for Gloucester in *King Lear,* and the number of ingenious deaths and tortures in Elizabethan and Jacobean plays must rival the number of Indians who bite the dust in Westerns. All the same, it took the twentieth century to turn cruelty into a theatrical movement of its own.

The important name in the T. of C. is Antonin Artaud, a surrealistic Frenchman who founded in the mid-thirties his own Théâtre de la Cruauté. The dedicated bluffer should try to read Artaud's theories in *The Theater and Its Double,* for its influence and inspiration for Peter Brook. This British director made an astonishingly Cruel foray in his famous production of *The Persecution and Assassination of Marat as Performed by the Inmates of the Asylum of Charenton Under the Direction of the Marquis de Sade* (usually known, affectionately, as the *Marat/Sade*), written by Peter Weiss. In

this graphic and exact representation of lunacy, the minutiae of madness were exploited to the full. You must not, at the moment, be the slightest bit critical of this particular *tour de force*—but be ready to attack as soon as theatrical fashion changes.

This theatrical horror-comic movement is, in a curious way, rather romantic, and you will notice, and say, how violently opposed this is to Brecht's theories of a theatre appealing to reason, not the emotions. A neat and useful phrase for the all-out assault on the senses that characterizes the T. of C. in the Artaud style is *total theatre*.

There is only one major dramatist of the T. of C. and he is claimed partly by the Theatre of the Absurd. He is Jean Genet.

Most little boys grow up with ambitions to be locomotive engineers, pilots, doctors, or policemen. Not so Genet: he wanted to be a thief. He did not find it difficult to achieve this wish, and he added to it by becoming a homosexual and, while in prison in occupied France, a poet. You should know of three plays by Genet: *The Maids, The Balcony,* and *The Blacks*. Ritual and fantasy are strong in all of them.

*The Maids* is about two sisters united in hatred who resolve to kill their young and lovely mistress. They are in the habit of working out their fantasies by acting the parts of mistress and servant, and when their murder attempt fails, they continue this game and one maid poisons the other. Genet originally required the three women's parts in *The Maids* to be played by young men, and the key to understanding the play lies in the envy the underlings have for the attractive life of their social superiors, whom they ape ritually.

Ritual occurs again in *The Balcony*. The regulars of Madame Irma's brothel express their fantasies by dressing up and acting the parts of bishops, judges, or generals. When revolution comes to their country, Madame Irma's customers take up real-life roles as bishop, judge, and general with a plumber as chief of police. Wish-fulfillment in the realms of sex and power are once more a main theme.

*The Blacks* has no plot; Negroes act out their resentment against white domination, and a high spot of the play is the ritual murder, performed in loving detail, of a white woman. The blacks are a symbol for the outcasts of society. The play had considerable success in Paris and New York but baffled most of those who saw it.

Genet's intention is to shock the audience, by means of scenes

of degradation onstage, into a realization that their own fantasies are identical with those of society's dregs.

*The Theatre of the Absurd* seems to be largely based on the hopeful maxim that human life has no purpose: man is born to be frustrated and out of key with the universe. Nothing is rational or logical in real life, so the keynote of the Theatre of the Absurd is tragic farce.

The plays tend to be set on rubbish dumps, in automobile junk-yards, tottering tenements, and other locations with potent symbolism for the twentieth century. Although most of the exponents of this cheerful philosophy live in Paris, not all of them are French. It all began, however, with the Frenchman Alfred Jarry (who ended up appropriately enough in an asylum), someone whom we shall hear much more of in the next few years.

Jarry wrote a play called *Ubu Roi* (*King Ubu*), and its first night in 1896 caused a glorious scandal in Paris. To begin with, the first word spoken was the expletive "Merde!"—which had the effect of a depth charge, rather as though an actor had come through the curtains of a New York theatre of the period and shouted "Shit!" at the audience. Not surprisingly, it was a quarter of an hour before the uproar subsided enough for the performance to continue, and from them on the evening was stormy, to say the least.

Ubu, Jarry's "hero," is the personification of ugly, Rabelaisian bourgeois greed and cowardice. As King of Poland he attacks Russia, murders and swindles, but is beaten in the end. The actors performed rather like puppets and the scenery was derived from children's drawings. Other Ubu plays followed: *Ubu Enchaîné* and *Ubu Cocu,* and Jarry was also the founder of a zany philosophy, pataphysics, the "science of imaginary solutions." It is wildly serious, wildly farcial, and the bluffer should get to know something about this particular brand of deliberate nonsense.

The Theatre of the Absurd was off with a bang, although it did not achieve its name until the fifties. The next manifestations were a surrealist squib by the poet Guillaume Apollinaire in 1917, *Les Mamelles de Tirésias* (The Breasts of Tiresias), and various bits and pieces by the Dadaists. A particular failing of the genre, incidentally, is the difficulty Absurd dramatists have found in sustaining full-length plays. Brecht flirted with the Absurd, notably in *Mann ist Mann,* but the next important name is the director Antonin Artaud,

whom we have already met in the Theatre of Cruelty: his style of production was influenced by both Balinese dancing and the Marx Brothers. Artaud's assistants included Jean-Louis Barrault, later famous as actor and director, and Roger Blin, who became the leading Absurdist director in France.

The Absurd hit New York in 1956 with the brilliant staging by Herbert Berghof of *Waiting for Godot* by Samuel Beckett, an Irish novelist writing in French and living in Paris. The play in which "Nothing happens, nobody goes, it's awful" presents two decrepit tramps (there are so many in current drama that it might be called the Theatre of the Bum), Vladimir and Estragon, waiting by the roadside for someone who will alter their lives, Godot, to turn up. He never does, but two other characters appear from time to time, master and servant, Pozzo and Lucky. Yearning and futility are two of the themes, but you can read all sorts of messages into *Godot,* and that, no doubt, is partly the reason for its enormous success. It is without question one of the most important works of twentieth-century drama, and the bluffer should not only know it, he should also be able to quote from it.

Beckett's next essay in the Absurd was *Endgame,* the dustbin play. Hamn, blind and ancient, and his servant Clov (note the parallel with Pozzo and Lucky in *Godot*) with Hamm's legless parents, Nagg and Nell, in ashcans, are going to leave the room in which they are the sole survivors of some unspecified world catastrophe. The characters hate one another and are on the point of departing forever. They don't.

The bluffer should also know of, and perhaps even read, *Krapp's Last Tape, Happy Days* (in which the heroine ends up being buried up to her neck), and *Play* (which has three characters with their heads sticking out of urns. In performance, the actors go through the text twice).

Not as widely known other than as a name, and therefore good bluff material, is Arthur Adamov. Of his work you should pretend knowledge of *Ping Pong* (use the original French title, *Le Ping-Pong*), a lesson in the danger of falling victim of illusion. Futility, it goes without saying, is also a theme. A medical student and an art student play through their life at a pinball machine, becoming more and more at its mercy, until one of them drops dead. Adamov, by

birth a Russian, now living in Paris, is a Marxist, and his later plays have become political rather than simply Absurd.

Now a really big fish. Eugène Ionesco also lives in Paris but comes from Romania. Like many Absurd writers, he is at his best with short pieces, and his first, *The Bald Soprano,* is, you should remember, of dazzling brilliance. The difficulty of communication between people is an Ionesco theme, "the tragedy of language." It all began when Ionesco started to learn English, and found that the dialogue of his conversation primer, largely the cliché and truism of characters busily telling each other what they already know, made him dizzy. Thus, *The Bald Soprano,* acted with deadly seriousness as an "antiplay," on its first night was a dead flop. Undeterred, Ionesco continued writing.

His second play, *The Lesson,* in which the teacher rapes his pupil, is also concerned mainly with language. A vital work in the Ionesco canon is *The Chairs.* In this, two old people attempt to pass on a message to posterity, and employ an orator to do so. The stage becomes crowded with an imaginary audience, and assured that the orator will now communicate the message, the couple jump out the window. The orator can produce nothing but a meaningless jumble of sounds and letters on a blackboard. A great many Absurd ideas come together here, and Ionesco himself says helpfully that the theme is "nothingness."

These plays, and several others, are all short. *Amedée, or How to Get Rid of It* is full-length. A writer, who after years of effort has produced only two lines of a play, and his wife live in a room from which they have not moved for fifteen years. In the next room is a corpse. It grows bigger and bigger and toadstools flourish on the stage; eventually a gigantic foot smashes into the couple's room. The body represents their dead love, now poisoning their lives. Amedée, the husband, manages to push the corpse out of the window, and in the last act it floats away with him like a balloon. This, you will be relieved to hear, is a hopeful play for once, showing the necessity of striking out for a new life.

*Tueur sans gages (The Killer)* is about the inevitability of death. Bérenger, the little Chaplin-like hero, is introduced to a Utopian town, the radiant city where even permanent sunshine is built in. To his horror, Bérenger learns that a merciless killer is abroad in

this paradise, and the play follows his search for this character and his eventual discovery. At the end is an immensely long speech in which he pleads with the killer, who remains silent except for a quiet giggle, but finally and willingly, Bérenger succumbs to the knife. The moral is, roughly, that human life can be only fitfully happy, that behind every silver lining is a dirty great cloud.

Bérenger appears again in *Rhinoceros,* as the only man to stand out against a monstrous attack of rhinoceritis that is infecting every person in his town, turning them into rhinos. The theme, very obviously, is the fatal lure of brute political movements like fascism, but Bérenger is also seen as a ridiculous individual who makes a virtue of futile individuality.

Ionesco is a magic name for the bluffer; he is a playwright of astonishing brilliance who is likely to outlive mere fashionable success. Note, however, that some intellectuals don't love him.

Such are the major dramatists of the Absurd, but there are many others, minor and major, whose work contains Absurd elements. It may be useful to note the following names.

Jean Tardieu, the poet, has written little more than sketches for the stage, but they are numerous and anticipate Ionesco in their subject matter, but are even more experimental and surrealistic.

Boris Vian is best known for his one Absurd play, *The Empire Builders,* which introduces a family trying to escape in their own house from a peculiar and terrifying noise that chases them from room to room. One of the characters is a silent subhuman, the *schmurtz,* constantly kicked and battered by the others. In the end the peculiar *schmurtz* dies, but an army of other *schmurtzes* replaces him. The symbolism of the noise is clear—death—but no one has yet explained the scapegoat *schmurtz* satisfactorily.

Fernando Arrabal is a Spaniard writing in French of whom we shall hear more—so take note. His plays have a somewhat frightening mixture of childishness and cruelty, and he is an acknowledged disciple of Beckett. Of his several plays in which he seems to say that goodness is utterly futile, *Le Cimetière des voitures (The Automobile Graveyard)* is his most accomplished. It is both blasphemous and innocent, the passion of Christ played out by people living among the corpses of cars. Arrabal has also flirted with abstract theatre that consists of the mechanical movements of three-dimensional shapes. His latest play is *And They Put Handcuffs on the Flowers.*

Dino Buzzatti, the Italian novelist, has written one important Absurd play, *Un Caso Clinico* (*A Clinical Case*). It has a curious affinity with Vian's *The Empire Builders* in its theme of the approach of death. A rich businessman goes into a strange clinic for observation on the top floor. Gradually, he is transferred downward, floor by floor, among cases who are progressively more seriously ill. He ends up on the ground floor where every patient dies. The prosperous man is reduced by life and the bureaucracy around him to utter degradation, in the style of a morality play.

America has produced two playwrights in the style, Edward Albee and Arthur L. Kopit. Albee's plays, *Zoo Story* and *The American Dream*, attack comfortable American ideals and commercial habits. The latter makes great fun of cliché and homey sentimentality in presenting the perfect American male: healthy, keen, but devoid of soul. His best-known play is *Who's Afraid of Virginia Woolf?* But in this he departs from the Absurd to comedy of manners *cum* domestic drama. A picture of American campus life, of two couples tearing each other to pieces, it is nevertheless very good theatre, and the bluffer will praise it, if only for its title.

Arthur L. Kopit is notable for having won second prize for the longest title in modern drama with *Oh Dad, Poor Dad, Momma's Hung You in the Closet and I'm Feeling So Sad* (the first prize, of course, is held by *Marat/Sade*), and that for the shortest title, by The Royal Shakespeare Company with *US*. One great sick, tragic joke, *Oh Dad* is a Freudian fantasy about a young man and his dragon of a dominating mother who travels everywhere with her husband who is dead, stuffed and in a coffin. Kopit's other play, *Indians*, failed on Broadway.

*The Theatre of Fact* is simply documentary theatre. As is the case with most up-to-the-minute theatrical movements, its roots lie some time back. In this case, the American social-consciousness theatre of the thirties can be said to have started it all, with the presentation of actual events in the *Living Newspaper* productions. The Theatre of Fact offers an interpretation of real happenings by re-creating them —as far as possible on the stage—either verbatim, using actual recorded speeches, or in fictionalized reconstructions.

A few years ago Rolf Hochhuth, an intense young German dramatist, cause riots all over Europe for daring to attack Pope Pius XII for his alleged failure to speak out against Hitler's persecution

of the Jews. *The Deputy* is a great chunk of debate dressed up with classy contemporary production, but it blazed the trail for the political playwrights of 1966 and 1967.

Hochhuth's other play is *The Soldiers,* with its theme of the moral responsibility of those who ordered the mass bombing of Germany.

A colorful example of the Theatre of Fact was the Royal Shakespeare Company's *US* (you can make of the title what you will: it can mean both "us" and U.S.—United States), a highly theatrical essay on the war in Vietnam. The front row of the audience found that they were inclined to participate in this experience a little too much when actors with paper bags over their heads, representing the dumb masses of Vietnam, fell over their (the audience's) legs. Animal lovers got hot under the collar because a butterfly appeared to suffer immolation on stage. At the end of the evening, the cast remained staring stonily at the audience, daring it to leave the theatre. In fact, a high old time was had by everyone concerned with the production. It was an all-out assault on the senses and the mind in the style of "total theatre" after the prophet Artaud.

A much quieter example of the Theatre of Fact was *In the Matter of J. Robert Oppenheimer* by Heinar Kipphardt. This was selected material from transcripts made at the Congressional investigation into the loyalty of nuclear scientist Oppenheimer, who had been instrumental in producing the first atom bomb but who got cold moral feet about going on with the infinitely more destructive hydrogen bomb. The whole effect is unsatisfying compared to a work of imagination.

It is not clear which way the Theatre of Fact will develop: in the all-out, emotive, sweep-em-off-their-feet style of *US,* or the sober presentation of unalterable fact of *In the Matter of J. Robert Oppenheimer.* Anyway, the ambitious bluffer should follow the next moves with passionate interest.

# IN AMERICA

TO BLUFF SUCCESSFULLY IN THE theatre, certain basic bits of information must be dredged up and disseminated at proper intervals so that the bluffer appears equally equipped to pontificate upon the threatre's past, present, and future. In this section, we will, therefore, be supplying names of directors, producers, actors, designers, composers, lyricists, choreographers, and so on, who have added to the luster of the American theatre, since the previous chapters have dealt with the major theatrical movements in Europe at some length. We will include pertinent facts regarding some of the more interesting aspects of Off-Broadway, Off-Off-Broadway; touch on stock theatre, regional theatre, and repertory theatre, and offer other tidbits that help make the theatre such a rich source of fascination to the so-called "civilians."

Let us consider some of this lore.

## OUT OF THE PAST

American theatre goes back to the early 1800s (who can forget Mr. Lincoln's theatre party?) but its Golden Era commenced around the late 1880s and is either still going on, or it ended in 19___ (supply your own year).

Be that as it may, the following were among the luminaries who set Broadway aflame in the gaslight era. It pays to commit their names to memory since it immediately establishes you as a serious student of the theatre. In the parentheses, we will list the stars' most famous role or roles for additional bluffing impact:

Edwin Booth (*Hamlet*) He was, of course, the brother of John Wilkes Booth, the pioneer of the popular American sport of assassinating public figures.

Edwin Forrest (*Metamora*) Supporters of this gentleman once started a riot that killed over twenty people.

Adah Isaacs Menken (*Mazeppa*) The nation's first glamour girl.

Joe Jefferson III (*Rip Van Winkle*)
Lotta Crabtree (*Little Nell*)
John Drew (Various roles) John Barrymore's uncle.
Richard Mansfield (*Dr. Jekyll and Mr. Hyde*)
James O'Neill (*The Count of Monte Cristo*) Eugene's pappy.
Minnie Maddern Fiske (*Becky Sharp*)
William Gillette (*Sherlock Holmes*)
Maude Adams (*Peter Pan*)
Julia Marlowe and E. H. Sothern (*Macbeth*)
Sarah Bernhardt (*The Lady of the Camillias*) Miss Bernhardt is to
    be remembered for her wooden leg and her iron will. Sarah was
    one of the first women to essay the title role in Hamlet.
Helena Modjeska (Beatrice in *Much Ado About Nothing*)

Latter-day stars included:

Ethel Barrymore (*The Constant Wife*) She scored her first triumph
    in *Captain Jinks of the Horse Marines*.
John Barrymore (*Hamlet*)
Lionel Barrymore (*Peter Ibbetson*)
Laurette Taylor (*Peg o' My Heart*) She later made a big hit as the
    mother in *The Glass Menagerie*.
Otis Skinner (*The Taming of the Shrew*) Cornelia's father.
Frank Bacon (*Lightnin'*)
Eleanora Duse (*The Lady of the Camillias*)

Some early theatre entrepreneurs were:

Charles and Daniel Frohman
David Belasco (He always wore a priest's collar)
Steele Mackaye (the Mike Todd of his day)
William A. Brady

Early playwrights were:

Clyde Fitch (*Beau Brummel, The Truth, The City, Captain Jinks
    of the Horse Marines, The Climbers, Barbara Frietchie, Her
    Own Way*)
James Barrie (*Peter Pan, The Admirable Crichton, Little Mary*)

The Incomparable G. B. Shaw (*Arms and the Man, The Devil's Disciple, Man and Superman, Mrs. Warren's Profession, Androcles and the Lion,* etc., etc., etc.)
Arthur Wing Pinero (*The Profligate, The Second Mrs. Tanqueray*)
Edward Sheldon (*The Nigger, Salvation Nell, The Jest, Romance*)
Owen Davis (*Nellie the Beautiful Cloak Model, Ethan Frome*)
Eugene Watter (*Paid in Full, The Easiest Way*—both real shockers of the day).

## MUSICAL COMEDY

The first stupendous musical hit in the American theatre was *The Black Crook*. The next was *The Little Tycoon,* and finally, *Florodora,* which gave birth to the famous Florodora Sextette, six fetching ladies who set male hearts afire and created a nationwide sensation.

Other musical hits of the earlier days were Victor Herbert's *Babes in Toyland, Naughty Marietta,* and *The Red Mill;* Florenz Ziegfeld's annual Follies; George M. Cohan's *Little Johnny Jones, Forty-Five Minutes from Broadway.*

## COMPOSERS

Some early composers on Broadway were:

Rudolf Friml (*The Firefly, Rose Marie, The Vagabond King, The Three Musketeers*)
Sigmund Romberg (*Maytime, The Desert Song, The Student Prince, Blossom Time*)
Jerome Kern (*Showboat, Roberta, Sally, Very Warm for May, Sunny, Music in the Air*)
George Gershwin (*Strike Up the Band, Of Thee I Sing, Porgy and Bess, Let Them Eat Cake, Lady Be Good, Girl Crazy*)

Other significant composers have been:

Cole Porter (*The Gay Divorce, Anything Goes, Kiss Me Kate, Leave It to Me, Du Barry Was a Lady, Panama Hattie, Let's Face It,*

Something for the Boys, Mexican Hayride, Can-Can, Silk Stockings)

Irving Berlin (*As Thousands Cheer, Call Me Madam, Face the Music, Louisiana Purchase, Annie Get Your Gun, Miss Liberty*)

Kurt Weill (*Street Scene, Lost in the Stars, Love Life, Lady in the Dark, Knickerbocker Holiday*)

Richard Rodgers (*On Your Toes, Babes in Arms, I Married an Angel, The Boys from Syracuse, I'd Rather Be Right, Pal Joey, Oklahoma!, Carousel, No Strings, Allegro, The King and I, South Pacific, The Sound of Music, Pipe Dream, Me and Juliet.*

Frank Loesser (*Guys and Dolls, Where's Charley?, The Most Happy Fella, How to Succeed in Business Without Really Trying*)

Leonard Bernstein (*On the Town, Wonderful Town, Candide, West Side Story*)

Frederic Loewe (*My Fair Lady, Brigadoon, Paint Your Wagon, Camelot*)

Richard Adler and Jerry Ross (*Pajama Game, Damn Yankees*)

Harold Arlen (*Bloomer Girl, Jamaica, St. Louis Woman, House of Flowers*)

Harold Rome (*Pins and Needles, Call Me Mister, Wish You Were Here, Destry Rides Again, I Can Get It For You Wholesale, Fanny, Gone With the Wind*)

Arthur Schwartz (*The Little Show, Three's a Crowd, The Bandwagon, Inside U.S.A., A Tree Grows in Brooklyn, By the Beautiful Sea*)

Jule Styne (*High Button Shoes, Gentlemen Prefer Blondes, Bells Are Ringing, Gypsy, Two on the Aisle, Funny Girl, Sugar*)

Jerry Bock (*Fiddler on the Roof, Mr. Wonderful, The Apple Tree, Fiorello!, Tenderloin*)

Jerry Herman (*Dolly, Mame, Milk and Honey*)

Mitch Leigh (*Man of La Mancha*)

Burton Lane (*Finian's Rainbow, On a Clear Day You Can See Forever*)

Bob Merrill (*Carnival; Henry, Sweet Henry; New Girl in Town, Take Me Along*)

John Kander (*Cabaret, The Happy Time, Flora the Red Menace*)

Cy Coleman (*Sweet Charity*)

Charles Strouse (*Bye Bye Birdie, Golden Boy*)

Meredith Willson (*The Music Man, The Unsinkable Molly Brown*)
Harvey Schmidt (*The Fantasticks, 110 in the Shade, I Do! I Do!*)
    And of course, George M. Cohan.

Other important composers for the American musical stage were Vincent Youmans (*No, No, Nanette, Hit the Deck*); Gian-Carlo Menotti (*The Medium, The Consul, The Saint of Bleecker Street*), and Marc Blitzstein (*The Cradle Will Rock, No for an Answer, Regina*).

Harry Ruby contributed music for musicals as did Sammy Fain, J. Fred Coots, Vernon Duke, Jimmy McHugh, and Harry Tierney. Some latter-day names are Lionel Bart (*Oliver*) and Anthony Newley (*Stop the World—I Want to Get Off; The Roar of the Greasepaint— The Smell of the Crowd*); Melvin Van Peebles (*Ain't Supposed to Die a Natural Death, Don't Play Us Cheap*); Galt MacDermott (*Hair, Two Gentlemen of Verona*).

## LYRICISTS

Noted lyricists of past and present include:
Lorenz Hart who teamed with Richard Rodgers and Oscar Hammerstein II
Betty Comden and Adolf Green (*On the Town, Wonderful Town, Two on the Aisle, Bells Are Ringing*)
Ira Gershwin (*Lady Be Good, Lady in the Dark, Porgy and Bess, Of Thee I Sing*)
Alan Jay Lerner (*My Fair Lady, Camelot, What's Up?, The Day Before Spring, Brigadoon, Paint Your Wagon, On a Clear Day You Can See Forever*)
Stephen Sondheim (*West Side Story, Gypsy, Follies, Anyone Can Whistle, Do I Hear a Waltz?, Company—*Sondheim is also a most talented composer)
Sheldon Harnick (he collaborates with Jerry Bock)
E.Y. (Yip) Harburg (*Finian's Rainbow, Dorothy and the Wizard of Oz, etc.*)
Dorothy Fields
John La Touche
Howard Dietz (teamed with Arthur Schwartz)

Sammy Cahn
E. Ray Goetz
Irving Caesar
Johnny Mercer
Fred Ebb
Lee Adams
Buddy de Sylva
Tom Jones
Carolyn Leigh
 Also, many of the aforementioned composers wrote their own lyrics (Porter, Berlin, Loesser, etc.).

## CHOREOGRAPHERS

Well-known choreographers on Broadway are or have been:

Agnes de Mille
Jerome Robbins
Bob Fosse
Ron Field
George Ballanchine
Gower Champion
Hanya Holm

Jack Cole
Helen Tamiris
Robert Alton
Michael Kidd
Onna White
Peter Gennaro

## MUSICAL DIRECTORS

Successful musical directors have included:

George Abbott
Harold Prince
Joe Layton
Moss Hart
Joshua Logan
Hassard Short
Gower Champion
Jerome Robbins
Abe Burrows

George S. Kaufman
Bob Fosse
Albert Marro
Joe Anthony
Rouben Mamoulian
Tom O'Horgan
Peter Coe
Herb Ross

# LIBRETTISTS

Well-known librettists (book writers) have been and are:

Arthur Laurents (*West Side Story, Company, Gypsy*)
Comden and Green
James Goldman (Follies)
Joe Stein (*Fiddler, Zorba*)
Neil Simon (more about him later)
Alan Jay Lerner
Oscar Hammerstein
Michael Stewart
Abe Burrows
Herbert Fields, Dorothy Fields, and Joseph Fields
George Abbott (again)
Josh Logan
Howard Lindsay and Russel Crouse
Guy Bolton
E.Y. (Yip) Harburg
Otto Harbach
Moss Hart
Laurence Schwab
George S. Kaufman
Morrie Ryskind
N. Richard Nash
Peter Stone (*1776, Skyscraper, Sugar*)

# STARS AND SEMISTARS

Some of the more popular musical stars on Broadway have been:

George M. Cohan
Elsie Janis
Eddie Foy
Lillian Russell
Fanny Brice
Jimmy Durante
Ed Wynn
Eddie Cantor
Al Jolson
Marilyn Miller
William Gaxton
Joe Cook
Victor Moore
Ethel Waters
Fred Stone
Gertrude Niesen
Bert Lahr
Bea Lillie
Ann Pennington
W. C. Fields
Fred and Adele Astaire
Gertrude Lawrence
Willie and Eugene Howard
Ina Claire
Will Rogers
Helen Morgan
Ray Middleton
Olsen and Johnson
Ella Logan
Ray Bolger
Sophie Tucker
Danny Kaye

Alfred Drake
Jimmy Savo
June Havoc
Vivienne Segal
Ronny Graham
Celeste Holm
Howard da Silva

Howard Keel
John Raitt
Gwen Verdon
Mary Martin, and the incomparable
Ethel Merman

Other well-known musical performers have been:

Betty Garrett
Walter Slezak
Patsy Kelly
Helen Kane
Clifton Webb
Helen Broderick
Jack Haley
Shirley Booth
Nanette Fabray
Robert Preston
Cyril Ritchard
Phil Silvers
Carol Haney
Jack Whiting

Doretta Morrow
Monty Woolley
Tamara
Kate Smith
Charles Winninger
Charles Ruggles
Mitzi Green
The Marx Brothers
Ruth Etting
Wilbur Evans
Helen Gallagher
Allyn McLerie
Joan McCracken
Irene Bordoni

and more recently—

Carol Channing
Julie Andrews
Zero Mostel

Angela Lansbury
Robert Morse
Richard Kiley

The alert theatre bluffer will frequentiy announce that *Oklahoma!* changed the American musical picture, and that *Hair* represented the next revolutionary phase.

# DRAMA

Once the mainstay of the American theatre, there is little room for drama on the Broadway stage—these days it is mainly confined to

the university and the experimental theatres. The reason—as given by the so-called experts—is that people will not shell out eight dollars to watch serious theatre, but will pay up to fifteen dollars to watch grimy, naked children somnambulate through such musical extravaganzas as *Hair, Jesus Christ Superstar, Grease, Godspell,* or *Two Gentlemen of Verona.*

Until the beginning of the 1920s, Broadway dramas ran almost exclusively to the *East Lynne* mold: the stalwart hero, the pure heroine, the scenery-chewing villian, the kindhearted grandfather. Then, several things happened. One was the war that banished American's innocence forever. Another was the emergence of muckraking American novelists, critics, and opinion molders who felt the time ripe for a more mature approach in the arts. A third was Eugene O'Neill.

Mr. O'Neill, a tortured and highly introspective personality, began to write plays that grated on the American conscience and made theatregoers sit up and listen to the turgid words and passions being declaimed before them. He wrote about the sea in symbolic terms derivative of Herman Melville; he plumbed the depths of human emotion and laid bare a fabric of national existence heretofore largely unexplored on the American stage.

Beginning with his three one-acters about the sea produced by the Provincetown Players, he followed with play after play to establish himself as the foremost dramatist of the American theatre, a position he still maintains despite powerful challenges by Messers. Miller and Williams.

O'Neill, whose father, the mercurial James, was one of the nation's foremost stage idols of his day, was a prodigious worker. Between bouts of drinking, illness, melancholia, and general cussedness, he managed to turn out such memorable dramas as: *Beyond the Horizon, Anna Christie* (later, the musical, *New Girl In Town*), *All God's Chillun Got Wings, Desire Under the Elms, The Great God Brown, The Hairy Ape, Mourning Becomes Electra, Strange Interlude, Emperor Jones, Marco Millions; Ah, Wilderness!* (in which George M. Cohan played a leading role), *The Iceman Cometh, A Moon for the Misbegotten, Long Day's Journey Into Night, More Stately Mansions,* and many, many more. He left a mark on the Broadway theatre that, most authorities agree, will never be equalled.

Another serious playwright of the era was Elmer Rice, whose ex-

perimental *The Adding Machine* represented a powerful indictment of anti-individualist society. He also wrote on *Trial!; We, the People; The Left Bank, Judgment Day, Cue for Passion!, Counselor-at-Law, The Grand Tour, Flight to the West, The Winner, For the Defense, American Landscape,* his most famous play, *Street Scene* (subsequently a musical with a score by Kurt Weill), and *Dream Girl* in which his wife, Betty Field, starred (later, the musical *Sky-scraper*).

Sidney Howard wrote a number of significant, truly American dramas. His *They Knew What They Wanted* (later the musical, *The Most Happy Fella*) won him a Pulitzer Prize in 1925. He also wrote *The Silver Cord; The Bewitched; Casanova; The Ghost of Yankee Doodle; Dodsworth; Yellow Jack; Alien Corn; Lucky Sam McCarver; Madam, Will You Walk; Ned McCobb's Daughter,* and others.

An important dramatist of the twenties and thirties and afterward was Maxwell Anderson, who wrote: *What Price Glory, Elizabeth the Queen, Mary of Scotland, Valley Forge, Winterset, High Tor, Night over Taos, Truckline Cafe, Knickerbocker Holiday, Saturday's Children, Gypsy, Both Your Houses, First Flight, The Masque of Kings, Gods of the Lightning; Cry, the Beloved Country; Joan of Lorraine, Barefoot in Athens, The Bad Seed, Candle in the Wind, The Star-Wagon, The Eve of St. Mark, Ann of the Thousand Days,* and other plays.

Robert Sherwood was a distinguished figure in American drama from the 1930s until the 1950s. He won the Pulitzer Prize no less than four times and authored such memorable works as *The Petrified Forest, Reunion in Vienna, The Queen's Husband, The Road to Rome, There Shall Be No Night, Idiot's Delight, Abe Lincoln in Illinois,* and *Small War on Murray Hill.*

Sidney Kingsley contributed a searing social awareness in his earthy, powerful dramas *Men in White, The Patriots, Dead End, Darkness at Noon, Detective Story. Lunatics and Lovers* and *Night Life,* written somewhat later, reversed his early pattern.

Lillian Hellman commenced her career during the Great Depression. Out of this traumatic period she fashioned a talent that has produced such meaningful works as: *The Children's Hour, Days to Come, The Little Foxes,* and *Another Part of the Forest* (the two plays deal with the rapacious Hubbard family), *Watch on the Rhine,*

*Toys in the Attic, The Searching Wind, Montserrat, The Lark; My Mother, My Father, and Me,* and *Candide.*

Another important playwright of the Depression was Irwin Shaw, who expressed his sense of outrage at society's inequities in such works as *Bury the Dead, The Gentle People, The Assassin, Patate,* and *Children from Their Games.*

A playwright who verbalized the social unrest and the economic uncertainty of the thirties was Clifford Odets, who contributed such passionate theatrical works as: *Waiting for Lefty, Awake and Sing!, Rocket to the Moon, Night Music, Paradise Lost, Golden Boy, The Country Girl, Clash by Night, The Big Knife,* and *The Flowering Peach* (which later became the musical *Two by Two* starring Danny Kaye).

A few years earlier, George Kelly wrote two memorable satires of middle-class America—*The Show-off* and *Craig's Wife.* His other plays lacked the bite of those enormous successes.

Paul Green wrote several moody, realistic dramas that made a strong theatrical impact on serious playgoers. These include: *In Abraham's Bosom, The House of Connelly,* and *Hymn to the Rising Sun.* His later works, extolling the Old South, stand in complete contrast to his earlier efforts.

John Steinbeck is best known for his prodigious contribution to American literature with such novels as *The Grapes of Wrath* and *The Red Pony.* He did, however, write a magnificent drama, *Of Mice and Men,* which won the 1938 New York Drama Critics Award.

Thornton Wilder wrote three important full-length plays, *Our Town, The Skin of Our Teeth,* and the comedy *The Matchmaker* (originally *The Merchant of Yonkers),* from which the musical *Hello, Dolly!* was fashioned.

William Saroyan deviated between drama and comedy in his efforts for the stage. He wrote such memorable theatre pieces as: *My Heart's in the Highlands; The Time of Your Life; The Cave Dwellers; Get Away Old Man; Hello, Out There; Lily Dafon;* and the aforementioned *Sam, The Highest Jumper of Them All.*

Moving into the 1940s, we encounter two of the most significant dramatists in the history of American theatre, Tennessee Williams and Arthur Miller. Their collective output represents the most impressive array of American drama, second only to the enormous output of Mr. O'Neill.

Williams's works include: *The Glass Menagerie, A Streetcar Named Desire, Cat on a Hot Tin Roof, Summer and Smoke, The Rose Tattoo, Camino Real, Sweet Bird of Youth, Period of Adjustment, Night of the Iguana, The Milk Train Doesn't Stop Here Anymore, Orpheus Descending, The Seven Descents of Myrtle, Slapstick Tragedy,* and, his most recent, *Small Craft Warnings.*

Miller distinguished himself with such memorable theatre pieces as *All My Sons, Death of a Salesman, The Crucible, After the Fall, Incident at Vichy, The Price, A View from the Bridge, A Memory of Two Mondays.* His most recent play is *The Creation of the World and Other Business.*

William Inge, a dramatist in the tradition of Williams, wrote several successful plays in the fifties and sixties, including *Come Back, Little Sheba; Picnic, Bus Stop, The Dark at the Top of the Stairs.* Three other plays, *A Loss of Roses, Natural Affections,* and *Where's Daddy?,* didn't fare as well.

Carson McCullers's tender, poetic *The Member of the Wedding* won the New York Drama Critics Circle Award and introduced a fresh new talent to the American public, the enchanting Julie Harris. Mrs. McCullers's *The Square Root of Wonderful* did not do well at all.

William Gibson contributed *Two for the Seesaw, The Miracle Worker,* and *A Cry of Players.* Robert Anderson wrote *Tea and Sympathy, All Summer Long, I Never Sang for My Father; Silent Night, Holy Night; Dinny and the Witches,* and *I Can't Hear You When the Water's Running.*

Paddy Chayefsky wrote several successful Broadway dramas— *Middle of the Night, The Tenth Man, Gideon,* and two that didn't fare as well, *The Passion of Josef D.* and *The Latent Heterosexual.*

Edward Albee's plays include *Zoo Story, The American Dream, The Death of Bessie Smith, Who's Afraid of Virginia Woolf?, Ballad of the Sad Café, A Delicate Balance, Tiny Alice, Malcolm, The Sand Box, Quotations from Chairman Mao Tse-tung, Everything in the Garden,* and *All Over.*

The poet Archibald MacLeish contributed the religious drama *J.B.* to the American stage. It won the Pulitzer Prize.

Arthur Laurents, now better known for his enormously effective librettos for musical plays, wrote such searing dramas as *The Home*

*of the Brave,* the expressionist *A Clearing in the Woods, The Bird Cage, The Time of the Cuckoo* (later, the musical *Do I Hear a Waltz?*), and *Invitation to a March.*

Dore Schary contributed *Sunrise at Campobello, The Devil's Advocate, The Highest Tree,* and *One by One.*

Robert Ardrey gave us *Thunder Rock, Sing Me No Lullaby,* and *The Shadow of Heroes.*

Jerome Lawrence and Robert E. Lee wrote *Inherit the Wind, The Gang's All Here, Only in America, A Call on Kuprin,* and *The Night Thoreau Spent in Jail.*

Other occasional American dramatists have been: Joseph Hayes, Tad Mosel, James Costigan, Dale Wasserman, Jack Richardson, Jack Gelber, William Hanley, Lewis John Carlino, Arnold Weinstein, Kenneth Brown, Michael Gazzo, James Baldwin, LeRoi Jones, Lorraine Hansberry, John Patrick, Millard Lampell, Sidney Michaels, Ed Bullins, Howard Lackler, Paul Zindel, Charles Gordone, Saul Bellow, David Rayfiel, Frank Gilroy, William Alfred, Ronald Ribman, Megan Terry, Jean-Claude van Itallie, Terrence McNally, Tom Eyen, Rochelle Owens, Kenneth Koch and Israel Horovitz, Leonard Melfi, Sam Shepard, Frederic Knott, David Rabe, Jason Miller, Lucille Fletcher.

Which of these can or will become the Miller, Williams, or Inge of the 1970s and 1980s remains to be seen.

## THE BRITISH ARE COMING!

British dramatists who have made an impact on American theatre include: Noel Coward, Terence Rattigan, Graham Greene, Brendan Behan (God forgive me for calling him British), John Osborne (one of the Angry Young Men of the 1950s), Robert Bolt, Arnold Wesker, Shelagh Delaney, Charles Dyer, Tom Stoppard, Joe Orton, Peter Shaffer, Anthony Shaffer (twins), John Whiting, and the latest darling of the theatre aficionados, Harold Pinter, whose menacing, incomprehensible (to many) theatrical excursions have captured the imagination of the "serious" theatregoers. His better-known plays are *The Homecoming, The Birthday Party, The Caretaker,* and *Old Times.*

## COMEDY TONIGHT

Comedy is as old as theatre itself. It was the staple of the American stage as early as 1796 when Joe Jefferson I cavorted in the farce *A Budget of Blunders.* Abe Lincoln was shot while watching Laura Keene's popular comedy *Our American Cousin.*

*Humpty Dumpty* was another early comedic hit. Edward Harrigan, of the comedy team Harrigan and Hart, was a prolific comedy writer.

James M. Barrie wrote some delightful comedies besides his immortal *Peter Pan. What Every Woman Knows* was an immensely popular success. Clyde Fitch wrote a few comedies, although he was best known for his turgid dramas.

Avery Hopwood was a succesful author of farces, the most famous of which was *Getting Gertie's Garter.*

Marc Connelly can be designated a writer of comedies although his most important play was *The Green Pastures*—a kind of fable and not exactly a comedic excursion. His other works, written alone or in collaboration, include: *Dulcy, To The Ladies, Merton of the Movies, Beggar on Horseback, The Farmer Takes a Wife, The Wisdom Tooth, The Wild Man of Borneo, Everywhere I Roam,* and *A Story for Strangers.*

George S. Kaufman is a legend on Broadway. He was, at times, a writer, critic, actor, and director of straight and musical plays. His plays, written alone or with others, include: *I'd Rather Be Right, Of Thee I Sing, Beggar on Horseback, The Royal Family, Dulcy, The Butter and Egg Man, To the Ladies, Merton of the Movies, Once in a Lifetime, You Can't Take It with You, The Man Who Came to Dinner, George Washington Slept Here, The Fabulous Invalid, The American Way; Merrily, We Roll Along; The Solid Gold Cadillac, First Lady, Let 'Em Eat Cake, The Cocoanuts, Strike Up the Band,* and many others.

Moss Hart wrote a number of spectacularly successful comedies and musical comedy books, alone or in collaboration. His plays include: *Once in a Lifetime, You Can't Take It with You, The Man Who Came to Dinner, The Fabulous Invalid, The American Way, Merrily We Roll Along, Face the Music, As Thousands Cheer, Jubi-*

*lee, Lady in the Dark, Winged Victory, Light up the Sky, I'd Rather Be Right, Miss Liberty,* and *The Climate of Eden.*

S. N. Behrman is the master of the sophisticated comedy. His efforts include: *The Second Man, Meteor, Biography, End of Summer, Wine of Choice, Rain from Heaven, Brief Moment, No Time for Comedy, The Talley Method, Amphitryon 38, Jacobowsky and the Colonel, Serena Blandish, I Know My Love, The Cold Wind and the Warm, But For Whom Charlie, Dunnigan's Daughter, Lord Pengo,* and *Fanny.*

Philip Barry wrote comedies and dramas. Some of his better-known plays are: *The Philadelphia Story, In a Garden, Paris Bound, White Wings, Hotel Universe, You and I, The Youngest, Tomorrow and Tomorrow, The Animal Kingdom, Here Come the Clowns, Liberty Jones, The Joyous Season,* and *Second Threshold.*

Sam and Bella Spewack were a successful husband and wife comedy writing team. Some of their plays were: *Boy Meets Girl, Leave It to Me, Kiss Me Kate, My 3 Angels, Clear All Wires, Two Blind Mice, Under the Sycamore Tree, Woman Bites Dog,* and *Miss Swan Expects.*

Howard Lindsay and Russel Crouse wrote such memorable hits as *Life With Father, State of the Union, Life with Mother, The Great Sebastians, Anything Goes; Red, Hot and Blue; Hooray for What!, Call Me Madam, The Sound of Music, Mr. President,* and *Tall Story.*

Samuel Taylor has contributed *Sabrina Fair, The Happy Time, The Pleasure of His Company, Beekman Place, First Love,* and *Avanti!*

Ronald Alexander wrote *The Grand Prize, Holiday for Lovers, Nobody Loves an Albatross.*

John Van Druten wrote *I Remember Mama, I Am a Camera, The Damask Cheek, The Voice of the Turtle; Bell, Book and Candle; Young Woodley* and other brilliant comedies.

George Axelrod made his mark with *Seven Year Itch, Will Success Spoil Rock Hunter?,* and *Goodbye, Charlie.*

Murray Schisgal made a small sensation with his modern comedy, *Luv.* His other efforts include *Jimmy Shine, The Typists, The Tiger, Ducks and Lovers, Knit One, Purl One,* and *Windows.*

Bruce Jay Friedman has written *Scuba-Duba* and *A Mother's Kisses.*

Neil Simon is probably the most successful comedy playwright of all time. His brilliant record includes: *Come Blow Your Horn, Barefoot in the Park, The Odd Couple, Plaza Suite, Sweet Charity, Little Me; Promises, Promises; Star Spangled Girl, The Gingerbread Lady, The Prisoner of Second Avenue, The Last of the Red Hot Lovers,* and his most recent, *The Sunshine Boys.*

Other comedy writers on and off Broadway have been: F. Hugh Herbert, Norman Krasna, Harry Kurnitz, Garson Kanin, Gore Vidal, Joseph Fields and 'Jerome Chodorov, John Cecil Holm, Ruth Gordon, Ben Hecht and Charles MacArthur, Frederick Lonsdale, Leonard Spigelgass, Jean Kerr, Clare Boothe, Muriel Resnik, Howard Teichmann, Norman Barasch and Carroll Moore, Herb Gardner, Arnold Schulman, Carl Reiner, Henry Denker, Peter Ustinov, Ira Levin, Mary Chase, Woody Allen, and Elaine May.

## DIRECTORS

Directors of straight plays on and off Broadway are and have been:

Alan Schneider
Ulu Grosbard
Jack Garfein
Mike Nichols
Elia Kazan (to be really *in*, call him Gadge)
Arthur Penn
Lloyd Richards
William Ball
Harold Clurman
Lee Strasberg
George S. Kaufman
Jed Harris
Orson Welles
Cheryl Crawford
Philip Moeller
John Houseman
Guthrie McClintic

John Gielgud
Joshua Logan
Gene Saks
Arthur Storch
Robert Lewis
Gerald Freedman
André Gregory
José Quintero
Joseph Anthony
Peter Koss
Fred Coe
Michael Bennett
Tyrone Guthrie
Howard da Silva
Peter Hall
Peter Brook
Michael Langham
Robert Moore

José Ferrer
John Hancock
Michael Kahn

Stuart Vaughan, and many, many others.

The really *big* names in theatre direction are Stanislavski, Max Reinhardt, Erwin Piscator, Margaret Webster, Vsevolod Meyerhold, Louis Jouvet, Jean-Louis Barrault, Joan Littlewood, and Jerzy Grotowski.

## SCENIC DESIGNERS

Some of the good ones are or have been:

Jo Mielziner
Boris Aronson
Robert Edmond Jones
Oliver Smith
Lee Simonson
Norman Bel Geddes
Donald Oenslager
Gordon Craig
Woodman Thompson
Aline Bernstein
Rollo Peters
Lemuel Ayres

Howard Bay
Ming Che Lee
Robert Randolph
William and Jean Eckart
Tony Walton
Raoul Pène du Bois
Rouben Ter-Arutunian
Lloyd Burlingame
Sam Love
Ralph Alswang
William Ritman

## LIGHTING DESIGNERS

Many of the abovementioned scenic designers also double as lighting directors. A few others are or were: Jules Fisher, Abe Feder, Jean Rosenthal, Tharon Musser, Martin Aronstein, Peggy Clark, and Will Steven Armstrong.

## COSTUME DESIGNERS

A few of the good ones are or were:

Irene Sharoff
Freddy Wittop

Motley
Alvin Colt

Noel Taylor
Theoni V. Aldredge
Winn Morton
Jane Greenwood
Patricia Zipprodt
Raoul Pène du Bois
Cecil Beaton

Lucinda Ballard
Patton Campbell
Miles White
David Ffolkes
Adrian
Donald Brooks

## PRODUCERS

Following the Frohmans, Ziegfeld, and Belasco, the most famous producers since the beginning of the century have been: The Shuberts, Gilbert Miller, Arthur Hopkins, Sam Harris, Winthrop Ames, Charles Dillingham, Al Woods, Brock Pemberton, Max Gordon, Morris Gest, John Golden, and several group efforts—namely The Theater Guild, Actors Studio, The Playwrights Company, and the celebrated Group Theater, an offshoot of the Theater Guild, which gave rise to such stellar talents as Elia (Gadge) Kazan, John Garfield, Luther Adler, Clifford Odets, Frances Farmer, Cheryl Crawford, Franchot Tone, Morris Carnovsky, Stella Adler, Lee J. Cobb, Sanford Meisner, Boris Aronson, and others.

Other producers have included:

Billy Rose
Mike Todd
Herman Shumlin
Kermit Bloomgarden
Joseph Hyman
Leland Hayward
Feuer and Martin
Fryer and Carr
Joseph Kipness
Vinton Freedley
Herman Shumlin

Fred Coe
Frederick Brisson
Robert Whitehead
Alexander Cohen
Harold Prince
Saint Subber
Herman Levin
David Merrick
Dwight Deere Wiman
Alfred de Liagre, Jr.

## MORE STARS

Names that have glittered in comedy and drama on Broadway include:

Charles Coburn
Dudley Digges
Katharine Cornell
George Arliss
Edward Arnold
Tallulah Bankhead
Gertrude Berg
Charles Bickford
Sidney Blackmer
Mary Boland
Shirley Booth
Claude Rains
Cornelia Otis Skinner
Helen Hayes
Judith Anderson
Lionel Atwill
Paul Muni
James Barton
Cedric Hardwicke
Fredric March
Jane Cowl
Spencer Tracy
Louis Calhern
Basil Rathbone
Charles Boyer
Barry Nelson
Raymond Massey
Marlon Brando
Edward J. Bromberg
Yul Brynner
Howard da Silva
Walter Hampden
Leora Dana
Noel Coward
Charles Laughton
Lillian and Dorothy Gish
Grace George
Julie Haydon
Leo Genn

Dennis King
Billie Burke
Florence Eldridge
Ralph Meeker
Joseph Schildkraut
Edith Evans
George C. Scott
Maurice Evans
Kim Hunter
Arthur Kennedy
Alice Brody
Elaine Strich
Margaret Sullavan
Deborah Kerr
Ina Claire
Ruth Chatterton
Colleen Dewhurst
Henry Fonda
Alexander Knox
George Coulouris
Jeanne Eagels
Eleanora Duse
Alfred Lunt and
  Lynn Fontanne
Frank Craven
Tyrone Power
Eva Le Gallienne
Josephine Hull
Rip Torn
Margaret Leighton
Walter Huston
Eli Wallach
Viveca Lindfors
Sylvia Sidney
Tom Ewell
Kim Stanley
Frank Fay
Gene Lockhart
Uta Hagen

Aline MacMahon
Julie Harris
Paul Lukas
Hume Cronyn
Burgess Meredith
Eileen Heckart
Jack Albertson
Art Carney
David Warfield
Sam Levene
Maureen Stapleton
Michael O'Sullivan
Barbara Loden
Ben Gazzara
Menasha Skulnik
Blanche Yurka
May Robson
Charles Winninger
Salome Jens
Pat Hingle
Katharine Hepburn
Paul Ford

Pauline Lord
Geraldine Page
Ruth Gordon
James Stewart
Jessica Tandy
Edward G. Robinson
Nazimova
Lenore Ulric
Barbara Harris
Christopher Plummer
Paul Newman
Laurence Olivier
Mitchell Ryan
Rosemary Harris
Jason Robards, Jr.
Walter Mathau
Martha Scott
Lucile Watson
Roland Young
Louis Wolheim
Barbara Bel Geddes

Irene Worth, and dozens and dozens of other talented people.

## CRITICS

Important critics in the theatre have been: George Jean Nathan, Alexander Woollcott, Percy Hammond, Burns Mantle, Brooks Atkinson, John Anderson, John Mason Brown, Elliot Norton, Walter Kerr, Robert Garland, Robert Coleman, Ward Morehouse, Richard Watts, Howard Barnes, Robert Benchley, John Chapman, and Clive Barnes.

## OFF-BROADWAY AND OFF-OFF-BROADWAY

The powerful Off-Broadway movement peaked in the 1960s. Today, things are as rough Off Broadway as they are on.

A few better known Off- and Off-Off-Broadway enterprises are, or have been:

The Lincoln Center Repertory Theater directed by Jules Irving, which occasionally fizzles to life, then quietly goes back to sleep again.

The Phoenix Theatre which for a time combined with the Association of Producing Artists, or APA. Ellis Rabb directed the APA and Edward Hambleton ran the Phoenix. The current status of both groups can, at the moment, be best described as fluid.

The American Place Theater under the direction of Wynn Handman seems to be going strong in its new home on West 46th Street in New York City.

The New York Shakespeare Festival Public Theater under the dynamic Joe Papp is flourishing, both in its home base, on Broadway, and in Central Park.

The Negro Ensemble Company is going on.

The Roundabout Theater is bravely keeping its head above water.

The LaMaMa Experimental Theatre Club under Ellen Stewart is hanging in there.

The Living Theater run by Julian Beck and Judith Malina is dead.

The Open Theater run by Joseph Chaikin is closed.

The American Shakespeare Festival at Stratford, Connecticut, is moving right along.

The Arena Stage in Washington, D.C., is still alive.

There is some action at the Mercer-Hansberry Theatre.

The McCarter Theatre of Princeton University is keeping on.

There is a New Jersey Shakespeare Festival in New Jersey.

The straw-hat circuit is alive and flourishing with theatres cropping up like mushrooms all over Long Island, New Jersey, Pennsylvania, Connecticut, Massachusetts, Maine, Vermont, New Hampshire, and everywhere.

Yale University Repertory Theater is thriving under Robert Brustein's care.

Circle-in-the-Square under Theodore Mann and Paul Libin is moving uptown.

There are festivals all over the map—the Lenox Arts Festival, The Shaw Festival, the Festival of American Theatre, and what not.

Regional theatre is strongly entrenched, with permanent companies in most major cities in the country.

Even the Yiddish theatre, which has been "dying" for forty years, manages to mount productions here and there.

In the meantime, the various churches, garages, supermarkets, and lofts that have been converted into acting companies—most bearing pretentious names—are still proliferating in and around New York City. American theatre lives!

## ADDENDA

The more things change the more they stay the same. Sardi's is still the prime hangout for theatre buffs and professionals. Other *in* spots in New York where you might encounter theatre folk are: The Gaiety Delicatessen, Joe Allen's, Frankie and Johnnie, Delsomma, Broadway Joe's Steak House, Clarke's Bar, and Downey's Steak House.

Happy bluffing.